A History of Aerial Photography and Archaeology

Mata Hari's glass eye and other stories

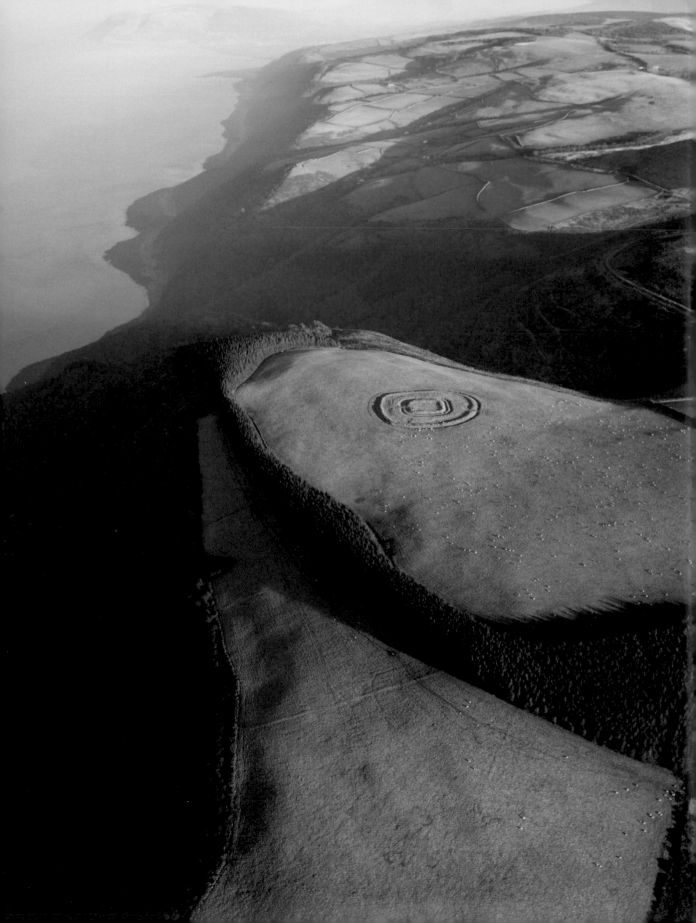

A History of Aerial Photography and Archaeology

Mata Hari's glass eye and other stories

Martyn Barber

ENGLISH HERITAGE

Published by English Heritage, The Engine House, Fire Fly Avenue, Swindon SN2 2EH

www.english-heritage.org.uk

English Heritage is the Government's statutory adviser on all aspects of the historic environment.

© English Heritage 2011

First published 2011

ISBN 978-1-848020-36-8

Product code 51250

British Library Cataloguing in Publication data
A CIP catalogue record for this book is available from the British Library.

For more information about English Heritage images, contact Archives Research Service, The Engine House, Fire Fly Avenue, Swindon SN2 2EH; telephone (01793) 414600.

Typeset in Charter ITC Regular, 10pt.

Brought to publication by René Rodgers and Susan Kelleher, Publishing, English Heritage

Edited by René Rodgers
Indexed by Chris Dance
Page layout by Kerry Griffiths of Ledgard Jepson Ltd

Printed in England by Butler Tanner & Dennis.

Frontispiece: Old Burrow Roman fortlet, Countisbury, Devon, constructed in the mid-1st century AD and built to overlook the Bristol Channel. [NMR24932/039, 12 Feb 2008]

MIX
Paper from
responsible sources
FSC® C023561

Contents

Acknowledgements

This book has had a lengthy gestation, its origins lying in the preparation of a heavily illustrated travelling exhibition created to mark the 100th anniversary of the 1906 Stonehenge photographs. In the course of preparing that exhibition and the subsequent researching and writing of the book, many people inside and outside English Heritage have provided invaluable assistance – supplying images or information, suggesting books and articles to read, people to track down, or places to go, and so on. There isn't space to list everyone, but the following people and organisations deserve a mention.

Outside English Heritage, a large number of individuals have been of tremendous assistance. They include Christine Halsall and Mike Mockford (Medmenham information and illustrations); Jane Mills (the Charles Pulman album of First World War photographs); Harold Wingham; Diana Twist; Derek Mitchell and Lieutenant Colonel Huw Parker RE for adventures with the current Royal Engineers Club balloon at Stonehenge; Rosemary Meeke (Drumbeat); Nicholas Willmott (Frank Willmott's photographs); Francesca Radcliffe; Anthony Crawshaw; Richard Osgood; Peter Chasseaud; Kitty Hauser; and Pamela Jane Smith. Helen Wickstead read the whole thing and offered plenty of thoughts, ideas and encouragement.

Organisations that provided help with research and images include the RAF Museum, London (Peter Elliott); the Royal Aeronautical Society (Brian Riddle); the Royal Aero Club (Andrew Dawrant); the National Archives, Kew (Steven Cable); the Imperial War Museum; Aldershot Military Museum (Sally Day); RIBA (Eleanor Gawne); the Society of Antiquaries, London (Bernard Nurse and Adrian James); the Royal Engineers Library; the National Army Museum; and Library and Archives Canada.

Within English Heritage, members of the Aerial Survey & Investigation team past and present have been of great help: Cinzia Bacilieri, Bob Bewley, Sharon Bishop, Yvonne Boutwood, Edward Carpenter, Ann Carter, Simon Crutchley, Roger Featherstone, Damian Grady, Cain Hegarty, Dave MacLeod, Jane Monk, Sarah Newsome, Matt Oakey, Fiona Small, Cathy Stoertz, Krystina Truscoe and Helen Winton. Pete Horne read all the chapters and made plenty of useful comments and suggestions. I'd also like to thank staff from English Heritage's archive: Luke Griffin, Lindsay Jones, Liz Jenkins, Ian Leith, Fiona Matthews, Damon Spiers, Katy Whitaker and Ann Woodward. Sarah Prince also provided valuable assistance. Dave Field, Mark Bowden and Trevor Pearson have also helped with the occasional facts and illustrations, while Stuart Maughan and Peter Carson greatly facilitated two successful and one unsuccessful balloon event at Stonehenge in 2006. Thanks are also due to René Rodgers – with help from Susan Kelleher, Jess Ward and Naomi Birbeck – in the Publishing Department for seeing the book into print, and to Kerry Griffiths at Ledgard Jepson Ltd for the design and Chris Dance for the index.

Picture credits

English Heritage images

The reference numbers for English Heritage images are noted in square brackets in the captions; their copyright details are as follows: p 113l, Figs 5.1, 5.6, 5.11, 5.12, p 166 and 8.3 are © Crown copyright.NMR; frontispiece, back cover, Figs 3.19, 4.21, 4.22, pp 112 and 113r, 5.2, 5.4, 5.7, 5.8, 5.14, 7.8, p 198, 7.18, 8.1, 8.4, 8.6, 8.7, 8.9, 8.10, 8.11, 8.12, 8.13, 8.14, 8.15, 8.16, 8.18, 8.19, 8.21 and 8.24 are © English Heritage.NMR; Figs 1.4 and 3.23 are reproduced by permission of English Heritage.NMR; Figs 4.7, 4.20, p 127, 5.13, 5.15, 5.16, 5.17, 6.2, 6.5, 6.7, 6.8, 6.9, 6.10, 6.12, 6.13, pp 165 and 167, 6.15, 6.17, 6.19, 6.20 and 8.17 are English Heritage (NMR) Crawford Collection; Fig 8.5 is English Heritage. NMR (Derrick Riley Collection); Figs 7.1, 7.6, 7.13 and 7.14 are English Heritage (NMR) USAAF Photography; Figs 7.2, 7.4, 7.7, 7.10, 7.12a and b, 7.15, 7.16 and 7.17 are English Heritage (NMR) RAF Photography; Figs 5.3, p 231 and 8.20 are Air photo mapping © English Heritage.NMR; topographical detail based on Ordnance Survey mapping (© Crown Copyright and database right 2011. All rights reserved. Ordnance Survey Licence number 100024900); and Fig 8.22 is © English Heritage (source: Environment Agency).

The aerial photographs were taken by Damian Grady (frontispiece, back cover, Figs 4.21, 4.22, p 112 and 113r, 5.2, 5.4, 5.7, 5.8, 5.14, 7.18, 8.4, 8.6, 8.7, 8.9, 8.11, 8.12, 8.13, 8.14, 8.15, 8.16, 8.19, 8.21), Roger Featherstone (Figs 5.1, 5.6, 5.11, 5.12, pp 113l and 166) and Dave MacLeod (Fig 8.18). Fig 5.3 is by Fiona Small, the figure on p 231 is by Fiona Small, Cathy Stoertz and Helen Winton, and Fig 8.20 is by Cathy Stoertz. The survey for Fig 8.24 was principally carried out by David Field and Trevor Pearson; the plan is by Deborah Cunliffe.

External images

English Heritage is also grateful to various individuals and institutions for permission to reproduce the following images: Figs 1.1 and 1.2 (Science Museum/SSPL); Figs 2.1, 2.14, 2.15, 5.5, 5.9 and 5.10 (Reproduced by permission of the Society of Antiquaries of London); Figs 2.3, 2.7, 2.8, 2.9, 2.13, 2.16, 2.23, pp 92 and 93 (Photographs reproduced with the kind permission of the Royal Engineers Museum, Library and Archive); Figs 2.5, 2.6, 3.27, 3.28 and 3.29 (The Royal Aeronautical Society (National Aerospace Library)); Fig 2.10 (Henry Elsdale/Library and Archives Canada/PA-172326); Figs 2.11, 2.12, 2.19 and 2.20 (Courtesy of the Council of the National Army Museum, London); Figs 2.18, p 76, 3.25 and 3.26 (Reproduced by kind permission of the Royal Aero Club); Figs 2.21 and 2.22 (Frank Willmott/Nicholas Willmott); Figs 2.24. 2.25, 2.26, 2.27, 2.28, 2.29, 2.30, 2.31, 2.32, 2.33, 3.24 and 4.1 (Imperial War Museum); front cover, Figs 4.2, 4.3, 4.4, 4.5, 4.6, 4.8, 4.9, 4.10, 4.11, 4.16a, 4.18, 4.19, 6.1 and 6.11 (Pulman Collection); Figs 4.12, 4.13, 4.14, 4.15a and b, and 4.16b (Royal Air Force Museum); Figs 4.17, 8.25 and 8.26 (The National Archives); Fig 7.5 (© Medmenham Collection); Fig 7.9 (Courtesy of Diana Twist); Fig 5.18 (Reproduced by courtesy of Peter Goodhugh); Figs 6.3 and 6.4 (© Keiller Collection); Figs 6.14, 6.16, 7.11 and 8.2 (Ashmolean Museum, University of Oxford); Fig 6.18 (Reproduced from the 1939 unpublished Ordnance Survey map); Fig 8.8 (Francesca Radcliffe); and Fig 8.23 (Lidar © Forestry Commission, source: Cambridge University ULM, May 2006).

1 '...summer scenes of fairy-land...'

Archaeology and the aerial view

The initial stimulus for this book was a centenary – the 100th anniversary of the first aerial photographs to be taken of an archaeological monument in the British Isles. There is, of course, a certain inevitability to the fact that those first photographs are of Stonehenge, and also that the only previous (and almost certainly unsuccessful) attempt to photograph an archaeological site from the air involved Stonehenge. However, once it had been decided at English Heritage that this centenary was worth celebrating – a celebration that was largely centred around a photographic exhibition that visited numerous venues in 2006–7 – it quickly became apparent that we needed to look beyond a single balloon flight over Stonehenge sometime in 1906 in order to put the photographs taken on that flight into context – to explain their place in the broader history of aerial photography.

Consequently, although the main emphasis of this book is on how aerial photography developed over the last hundred years into such an important tool for archaeologists, it also proved necessary to go further back in time to look at the beginnings of aerial photography, within both military and civilian contexts. Therefore, after briefly looking at the interest in aerial views prior to the invention of photography, the book turns to the taking of those 1906 Stonehenge photographs, an event set within a chapter dealing with the history of military airborne reconnaissance and photography until around 1910. Aerial photography in Victorian and Edwardian Britain is then explored from the civilian perspective.

Crucial to the development of the technique within archaeology were the experiences of the First World War, although in truth many of the elements of aerial survey adopted by archaeology in the 1920s had origins that long pre-dated 1914. Nonetheless, it was during that conflict that, for the first time, the true potential of aerial photography as a reconnaissance and intelligence-gathering technique – and, even more important, the use of skilled staff to interpret and map detail from those photographs – was realised. During the Second World War, even greater resources were put into aerial photography and the training of highly skilled specialist staff to interpret the millions of photographs taken by Allied reconnaissance aircraft. However, it was in the years immediately following the First World War that a number of individuals with experience as either pilots or

observers realised how something that had developed so rapidly within the context of warfare could serve a number of non-military uses, including archaeology.

Between the wars, aerial photography and air photo interpretation had a considerable impact on the understanding of the past, particularly once the significance and extent of cropmarks became apparent – the airborne camera was able to record sites and, indeed, landscapes that were extremely difficult, though by no means impossible, to detect on the ground. There had been an awareness of cropmarks since at least the 16th century, but it wasn't until the early 1920s and the dawning comprehension that the phenomenon was more widespread than previously realised that the search for them really took off, so to speak (*see* Chapters 5 and 6).

Initially the preserve of military or ex-military flyers, after 1945 the number of people taking photographs for archaeological purposes gradually increased, as did state involvement through organisations such as the Royal Commission on the Historical Monuments of England (RCHME) and English Heritage. The final chapter of the book explores examples of more recent and current work, which demonstrates just how far we have progressed since 1906 in the use of aerial photography to record and interpret past landscapes. It is particularly important to recognise the fact that millions of existing aerial photographs still await archaeological analysis – it is not just the examination of new photography that produces important results. At the same time, developing technologies – again, usually military in origin – offer not just new and very different ways of investigating the ground surface from above, but also raise questions about how to deal with the vast amounts of data being generated now and in the future.

A brief note on the geographical scope of the book is worth making here – the chapters dealing with the archaeological uses of aerial photography are primarily confined to England, in line with the general remit of English Heritage. The earlier chapters exploring the development of aerial photography in the Victorian and Edwardian eras are necessarily more wide-ranging.

Aerial views before cameras

Early myths dealing with flight are known from all over the world and Britain is no exception. Here, the honour goes to Bladud, legendary king of Bath, who created for himself feathered wings, an invention that allowed him to plummet to his death on his maiden flight and placed his son, King Lear, on the throne.[1]

Interest in the aerial, or bird's-eye, view originated long before the first successful attempts at flight. Changing conceptions of space and place in Renaissance art led to an interest in depicting landscape from an imaginary raised vantage point, something that was also partly inspired by contemporary developments in cartography. By the middle of the 16th century, perspective views of major European cities were fairly common – for example the Prague-born etcher Wenceslaus Hollar[2] produced a variety of bird's-eye views of London. Many of his better-known works, such as his *Bird's-Eye Plan of the West Central District of London* (*c* 1658), are essentially pictorial perspective maps. However, they are not maps in the modern sense – they resemble rather than accurately represent their subject.

This type of view was particularly popular in Britain during the later 17th and early 18th centuries. Antiquarian examples include William Stukeley's perspective views of Avebury and Stonehenge.[3] More widely known are the apparently realistic portrayals of formally laid out Renaissance-style gardens, generally attached to one of the great houses. These were generally depicted as though seen from an imaginary raised viewpoint – usually but not always a low, oblique angle. The best-known exponents are the Dutch pairing of engraver/draughtsman Johannes Kip (1653–1722) and artist Leendert Knijff (1650–1722); many of their topographical views were reproduced in *Britannia Illustra*, first published in 1707.[4]

The imaginary, sometimes idealised, bird's-eye view remained a popular means of depicting formal gardens deep into the 18th century. Appearing more realistic to the viewer than a straightforward measured plan, it reflected the fact that these sometimes extensive planned landscapes – and the design principles they embodied – were best appreciated from above. Indeed, many were arranged specifically with the intention that at least part of the layout could be seen from a raised vantage point, whether from within or on top of the house itself, or from a specially constructed feature incorporated within the garden layout, such as a gazebo or mount.

The first real aerial views, as in depictions arising from a genuine airborne perspective rather than an imagined one, were produced by Thomas Baldwin in September 1785 and published by him the following year in his book *Airopaidia*.[5] Baldwin appears to have been so enthused by his first aerial voyage – in a balloon borrowed from pioneer Vincent Lunardi – that he managed to churn out a whole book on it within a matter of months. If it is remembered today at all, it is for the illustrations.

The first-ever balloon ascent had occurred in France as recently as 1783 and barely a handful of ascents had occurred in Britain since Lunardi's first brief flight over London in September 1784. Baldwin took off from a spot within the yard of Chester Castle at 1.40pm on 8 September 1785 and landed on Rixton Moss near Warrington, having made a brief unscheduled touchdown at Frodsham en route. While airborne he apparently produced two illustrations of the view below (Figs 1.1 and 1.2). A certain degree of caution is advisable in regarding Baldwin's colourful representations of the ground below as wholly airborne creations. His account of the flight does not give the impression that he spent too much time capturing the view. He did, however, carry with him a map of the countryside around Chester – Peter Burdett's 1777 map of Cheshire, produced at a scale of one mile to the inch – mounted on a board. It may well be that this map formed the basis of his *Balloon Prospect from Above the Clouds*.

Baldwin's enthusiasm for the view from above is fairly typical (if more long-winded) of early balloonists, few of whom were born writers:

> Things taking a favourable Turn, he stood up … and took a full Gaze before, and below him.
> But what Scenes of Grandeur and Beauty!
> A Tear of pure Delight flashed in his Eye! of pure and exquisite Delight and Rapture; to look down on the unexpected Change already wrought in the Works of Art and Nature, contracted to a Span by the NEW PERSPECTIVE, diminished almost beyond

the Bounds of Credibility.
Yet so far were the Objects from losing their Beauty, that EACH was BROUGHT
UP in a new Manner to the Eye, and distinguished by a Strength of Colouring,
a Neatness and Elegance of Boundary, above Description charming!
The endless Variety of Objects, minute, distinct and separate, tho' apparently
on the same Plain of Level, at once striking the Eye without a Change of its Position,
astonished and enchanted. Their Beauty was unparalleled. The Imagination itself
was more than gratified; *it* was overwhelmed.
The gay Scene was Fairy-Land, and Chester Lilliput.[6]

Whilst airborne, apparently, Baldwin
also put his mind to the possible uses
of balloons, including

A new System, that of Balloon-
Geography … in which the Essentials
of *Proportion* and Bearings would be
far more accurate, than by the present
Method, both for *Maps and Charts*, viz.
To make Drawings by SIGHT, from the
Car of a Balloon with a *Camera Obscura*,
aided by a Micrometer applied to the
under Side of the *transparent* Glass.
 The Season proper for such an
aeronautic Expedition, would be
any calm *bright* Day…[7]

Baldwin's aerial views are unlike anything
produced by subsequent generations of
balloonists. We may suggest that he based
his *Balloon Prospect from Above the Clouds*
on an existing map and may take the
accuracy of his flight trace with the odd
pinch of salt, but nothing else quite like it
seems to have been attempted until well
after the advent of airborne photography.
Instead, aerial imagery tended to focus on
the panoramic view. The balloonists, or
the artists who went up in balloons, were
concerned with the breadth and depth
of the view presented to them – with the
spectacle of vision offered by altitude.

The word 'panorama' was apparently coined
in the early 1790s by friends of Robert
Barker, who in 1787 had patented the idea
of creating large 360-degree paintings
intended to be viewed from within in order

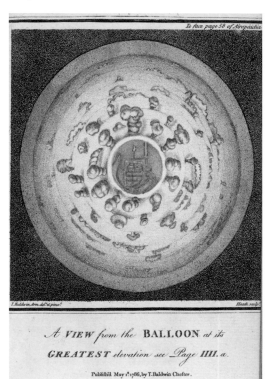

Figure 1.1 Baldwin's caption to *A View from the
Balloon at its Greatest Elevation* explains that '[t]he
Spectator is supposed to be in the Car of the Balloon,
suspended above the *Center* of the View: looking *down*
on the Amphitheatre of *white* Floor of Clouds, and seeing
the *City of Chester*, as it appeared throu' the *Opening*:
which discovers the Landscape *below*, limited, by surrounding
Vapour, to something less than *two* Miles in Diameter.
The Breadth of the *blue* Margin *defines* the *apparent*
Height of the Spectator in the Balloon (viz 4 Miles)
above the *white* Floor of Clouds, as he hangs in the
Centre, and looks *horizontally* round, into the *azure* Sky.'
Baldwin suggested that '[t]he Circular View is seen to the
best Advantage, when placed *flat* on a Table or Chair; and
rather in the Shade: the Eye looking *directly* down upon
the Picture' (Baldwin 1786, IV). [Science Museum/SSPL]

to create the impression that the visitor was experiencing a real, rather than a painted, scene. One of Barker's first successes was a panoramic view of London as seen from a lofted viewpoint – the roof of the Albion Mills adjacent to Blackfriars Bridge.[8]

The idea of the panorama was rapidly taken up by other artists, particularly once Barker's patent had expired in 1801, and proved a remarkable success across Europe and the United States. Bird's-eye views were a common subject, situating viewers at an imaginary viewing point somewhere above the scene – usually a city – presented to them. However, not all these views were 'panoramic' in the sense that Barker originally intended. They still presented the viewer with a combination of breadth, depth and detail but didn't

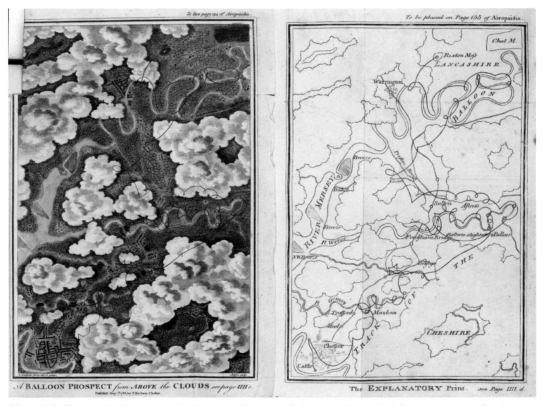

Figure 1.2 The world's first aerial vertical image and flight trace. Baldwin's caption to the left-hand image describes it as 'A Balloon Prospect from above the Clouds, or *Chromatic* View of the Country between Chester, Warrington and Rixton-Moss in Lancashire: shewing the whole Extent of the aerial Voyage; with the *meandering* Track of the Balloon throu' the Air.' On the right is 'The Explanatory Print, which elucidates the former by giving the Names of the principal Places mentioned in the Excursion.' As with Figure 1.1, Baldwin's caption offered readers a viewing hint: 'Whoever will be at the Trouble of viewing *distinct* Parts of *the Balloon-Prospect*, throu' a very small Opening, made by rolling a Sheet of Paper into the Form of a hollow Tube, and applying it close to either Eye, at the same Time shutting the other; or by looking throu' the Hand, held a little open, and close to the Eye, may form a very accurate Idea of the Manner, in which the *Prospect below* was represented *gradually in Succession*, to the Aironaut; whose Sight was bounded by a Circularity of Vapour...' (Baldwin 1786, IV–V). [Science Museum/SSPL]

provide the all-round view. An example is the so-called 'Rhinebeck' panorama, which seems to belong to the first decade of the 19th century. A watercolour spread across four sheets, around 8ft in total length, it presents a detailed view of an extraordinarily busy London, with the City and Southwark in the foreground, Windsor Castle on the distant horizon and the viewpoint somewhere above the River Thames.[9]

The advent of the balloon allowed similar scenes to be created from direct experience, rather than from a combination of maps, sketching on the ground and experimenting with perspective. These scenes continued to be drawn and published well after the advent of photography, perhaps in part because early cameras simply could not compete with the panoramic view offered by the artist. An excellent late example was published in *The Graphic* in May 1884 – a large bird's-eye view of London that also gives an insight into the way in which these views were often compiled. Introducing the quite stunning and dramatic view of the city, H W Brewer stated that it had

> been compiled and worked out by sketches taken from nature … from a point 1,400 feet above Brewer's Row … [O]wing to the rate at which the balloon passed over London it was found impossible to obtain sufficient detail. But this want has been supplied by sketches taken from the Victoria Tower, Westminster Abbey, the Shot Towers, and the top of a house at Westminster. Fortunately during the May and June of last year the weather was singularly clear and well adapted for the purpose. On the 22nd May the whole valley of the Thames as far as Woolwich was visible from the towers of Westminster Abbey at two o'clock in the afternoon; the shipping in the docks, the various buildings of the City, and even the distant heights of Erith told out sharp and distinct.[10]

A short note at the end of Brewer's article outlined another difficulty encountered: 'While prying about for some architectural detail, with a black bag, a folding easel, and a map marked with suspicious red lines and crosses, Mr Brewer was arrested as a possible Fenian outside the Houses of Parliament.' Brewer's depiction of London from above in 1884 was paired for comparison with an even more imaginative image – the same view, from the same viewpoint, in 1584 'compiled from ancient maps and views of London, chiefly those by Aggas, Norden, Hollar &c., compared with descriptions given by Stowe, Speed, and other writers'.[11]

The emphasis on city scenes in particular naturally means that archaeological sites are scarce on these early bird's-eye views. The occasional example is known, however, and tends to conform to the pattern of resembling rather than accurately depicting the site and its surroundings (Fig 1.3).

The camera and the aerial view

The appearance of the daguerreotype camera in 1839 had a considerable impact. Among other things, it led to attempts to capture images from high vantage points, with the occasional claim that a balloon was used although none of these assertions have been substantiated. Generally, it is a sketch or engraving of the aerial image that survives, if at all, making appraisal somewhat difficult. For example, visitors to

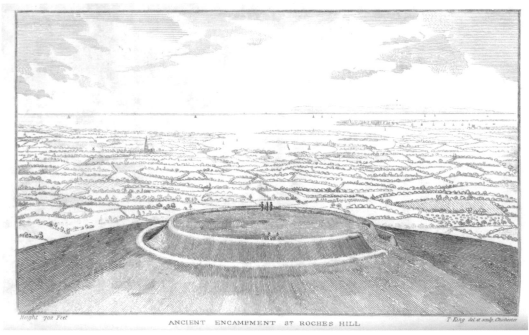

Figure 1.3 An imaginative bird's-eye rendering of the Iron Age hillfort known as The Trundle on St Roche's Hill near Chichester, West Sussex, first published in 1839. Comparison with Figure 6.19 might suggest that the artist – Mr T King of Chichester – did not have an eye for earthworks, but to be fair, those on St Roche's Hill continue to challenge archaeologists. [Mason 1839, 172]

the Great Exhibition at the Crystal Palace in 1851 could buy prints made from a wood engraving entitled *A Balloon View of London Taken by the Daguerreotype Process*. In his history of aerial photography, Beaumont Newhall noted of this particular image that a photograph was unlikely to be the original source. Apart from problems with perspective – the relative heights of buildings seem wrong, for instance – even under ideal circumstances, a daguerreotype would require an exposure time measurable in seconds and the camera would need to be still for the duration. But, as Newhall noted, '[t]he balloon car is a poor camera platform. Even when it is not rotating and gyrating, it trembles… .'[12] Successful balloon photography would require shorter exposure times, something made possible from 1851 following Frederick Scott Archer's invention of the collodion or wet-plate process (*see* p 67).

The use of high vantage points continued, of course. Indeed, the earliest 'aerial' views of Stonehenge were taken from specially erected scaffolding in order to achieve the desired perspective (Fig 1.4). These photographs – along with several others shot with his feet firmly on the ground – were taken late in the summer of 1881 by the architect John Jenkins Cole while conducting a survey of the monument for its owner Sir Edmund Antrobus (*see* Cole's survey of Stonehenge, pp 17–18).

Figure 1.4 One of John Jenkins Cole's 'aerial views' of Stonehenge. It is not clear if Cole stood on the scaffolding or if he clambered on to the sarsen lintels to take this shot. This particular example was taken from on or adjacent to the lintel connecting stones 4 and 5, on the monument's eastern side, and shows the view to the north-west with some of the Cursus Barrows visible in the distance. [AL0913/008/01]

Cole eventually published several of his photographs of Stonehenge in 1895 in a booklet entitled *The People's Stonehenge*, in which he also aired some of his ideas about the original purpose of the stones. For example, he argued that '[i]t was not for the slaughter of human beings, but for animals for the sacrifice, and for the Serving Priests of the Temple. For Priests must live.' Three of the photographs are said to have been taken from the scaffolding placed outside the Sandstone Circle (the sarsen stone circle). One reviewer of the booklet noted that the author's ideas 'have the merit, at least, of being many of them original' and 'regretted that such purely fanciful analogies should be presented as *facts* for the enlightenment of "the people" in the last decade of the nineteenth century'.[13] Missing from the collection of bizarre and ingenious ideas is Cole's apparent belief that 'the temple had a conical roof of fir poles, resting on the outer lintels, with a covering of some kind of thatch'.[14] By 1895, of course, genuine aerial photographs were being taken – the first ever in 1858, the first in Britain in 1863 (*see* pp 66–7 and 69–70) – and published regularly. And just 12 years later the first real aerial views of Stonehenge, those taken in 1906, appeared in print.

Cole's survey of Stonehenge

John Jenkins Cole (1815–97), originally from Plymouth, trained as a solicitor before qualifying as an architect in the 1840s. Based in London, he was appointed architect to the (old) Stock Exchange in 1855. He was a Fellow of the Royal Institute of British Architects (RIBA) and the Royal Astronomical Society, as well as an active photographer, occasionally exhibiting his work from the 1860s onwards.

Cole – later described by his son as a 'great Stonehengist' – had first encountered Stonehenge, prior to permanently moving to London, in 'our Stage Coach days, on the road through Andover, and across Salisbury Plain to the West, [when] we passed so near to Stonehenge that we were allowed to stop a few minutes and run up and look at it; sometimes by moonlight'.[a] The condition of the monument had long been concerning antiquaries and archaeologists, particularly the likelihood of a trilithon or two tumbling to the turf. Its owner, Sir Edmund Antrobus, was reluctant in the extreme to allow anyone, especially the government, to undertake any work at the site, instead arranging his own assessment of its state. In 1881 he asked Cole to undertake a survey of the stones causing the most concern and to take any steps he considered necessary to prevent a collapse. Cole also planned 'to ascertain the exact degree of inclination of the leaning stone of the central trilithon and to test it by photographs taken 22 years ago', though prior to his survey he doubted there had been any change over the past century.[b] The photographs taken 22 years previously seem to have been a set of three taken in or before January 1859 by a Mr Fisher of Salisbury. Sadly, they appear to have been lost.[c]

Antrobus subsequently reported that Cole's survey had confirmed his own suspicions about 'the safety of the eastern trilithon … he also thinks its condition may occasion danger to visitors. Under these circumstances and under his advice the props … have been put up, so as to insure absolute security until the time arrives to take further steps.' Twelve years later, no such steps had materialised and the first Inspector of Ancient Monuments, General Augustus Henry Lane Fox Pitt-Rivers, reported that a collapse was certain 'sooner or later, more probably soon than later … This fact is recognised by the useless and unsightly wooden props that are set up against two of them.'[d] As the 1906 aerial photographs of Stonehenge were to show, many more unsightly props had appeared by then. Cole, 80 in 1895 and retired, was unlikely to have been directly responsible for these additional props, but can probably be credited with inspiring their use.

Inevitably, the collapse, when it came on the last day of 1900, didn't involve the stones propped up by Cole, but one of the outer stones on the western side.

Forced to act, the owner – Antrobus' successor and nephew, also named Edmund – allowed some work to be undertaken under the auspices of the Society of Antiquaries and other interested organisations. Under the supervision of William Gowland, another stone that was causing concern – stone 56, which had gradually leaned so far forward that it had made contact with one of the smaller bluestones in front of it, raising the possibility that both might crack and fall – was to be restored to an upright position.[e] Cole's props (and others) remained in place until further stabilisation work was undertaken during the excavations by William Hawley in the 1920s.

Notes

a Cole nd, 2.

b *The Times*, 18 Aug 1881, 4.

c Cole had presented Fisher's three photographs of Stonehenge to RIBA in January 1859 (information courtesy of Eleanor Gawne, RIBA librarian).

d The information on Cole's survey is from *The Times*, 18 Aug 1881, 4 and TNA AM 71786/1. The Pitt-Rivers quote is from his report into the state of Stonehenge following a visit there in September 1893 (TNA WORK 14/213).

e For Stonehenge under Antrobus and nephew, and for Gowland's work at the site, *see* Chippindale 1994, Cleal *et al* 1995 and Richards 2007.

2 '…interesting as curiosities…'

The Stonehenge photographs and the Royal Engineers

If the few brief published notices are anything to go by, contemporary reaction to
the first aerial photographs of an archaeological monument in Britain was distinctly
underwhelming. They may have been deemed worthy of display at the premises
of the country's oldest established antiquarian body, and of publication within the
pages of their prestigious journal, but it appears to have been no more than their
curiosity value – a well-known monument captured from a novel viewpoint – that
attracted attention.[1]

On the evening of 6 December 1906, at the regular weekly meeting of the Society of
Antiquaries, an audience of 150 gathered at the society's Burlington House headquarters
for a typically varied programme of speakers and subjects. The audience represented a
fair cross-section of the society's Fellows, among the most notable today being the likes
of William Gowland (who had excavated at Stonehenge in 1901; see p 18), Reginald
Smith and Charles H Read (both of the British Museum). After the usual preliminaries,
they heard W R Lethaby discuss some sculptures in Lincoln Minster; John Bilson then
read some notes on 'a remarkable sculptured representation of Hell Cauldron, lately
found in York'; and John Noble exhibited a silver parcel gilt chalice of the early 16th
century. Finally, according to the brief published record of the meeting, 'Colonel J. E.
Capper, R.E., exhibited some photographs of Stonehenge, taken from a balloon, which
illustrate in a remarkable and unique manner the relative positions of the stone circles
and accompanying earthworks'.[2]

The absence of any further detail or reported discussion suggests that the Stonehenge
photographs were exhibited rather than being formally presented and explained
by Capper. He may have been able to supply some detail regarding when, how and
why they were taken, though if he did so, such information clearly wasn't considered
important enough to record. Also, Capper is not known to have had an active interest in
archaeology, so it is extremely doubtful that he could have told the audience anything
about Stonehenge that they didn't already know themselves. If anyone that night saw
anything previously unobserved about Stonehenge, or recognised any potential in aerial
photography for archaeology, they kept pretty quiet about it and certainly no record of
any discussion among the assembled Fellows appears to survive.

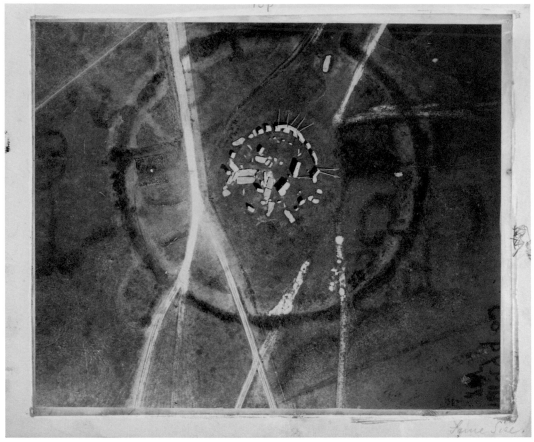

Figure 2.1 This original 1906 print of Sharpe's vertical image of Stonehenge shows several tracks scarring the monument, while larch poles prop up some of the sarsens. The contrast between the enclosing bank and its surrounding ditch is a product of parching – the summer of 1906 was much hotter and drier than normal. The deeper soils within the ditches of the henge and Avenue have promoted slightly more successful grass growth, which appears darker on the photograph. [Reproduced by permission of the Society of Antiquaries of London]

The following year, two aerial views of Stonehenge were published in the society's journal, *Archaeologia* (Fig 2.1; *see also* Fig 2.14), along with the briefest of explanatory notes, attributed to Capper and simply stating:

> The accompanying illustrations were recently taken from a war balloon by Lieut. P. H. Sharpe, R.E., and represent Stonehenge from a point of view from which that famous monument has probably never before been photographed.
>
> The photographs give a very complete record of the stones in their present position and of the paths leading to them. They also illustrate in a remarkable and unique manner the relative positions of the stone circles and the accompanying earthworks.[3]

Over the years, the 1906 photographs have been happily acknowledged in the appropriate places, although in none of these places is there any suggestion that the photographs added anything to the accumulated sum of knowledge or understanding of Stonehenge. At the same time, the story of their origin has grown a little in the retelling. For instance, in 1969 Leo Deuel wrote that '[d]uring a routine practice from war-balloons in 1906, Lieutenant P. H. Sharpe took, more or less by accident, the first pictures aloft of an archaeological site…'.[4] More recently, in Stonehenge Complete, Christoper Chippindale described how in the early years of the 20th century '[m]ilitary observation balloons drifted across [Salisbury] Plain. From one of these were taken, in 1906, the first aerial photographs of Stonehenge…'.[5] In fact, this scenario of an Army balloon carrying a lieutenant of the Royal Engineers – camera in hand and drifting slowly with the breeze across Salisbury Plain – who chanced upon Stonehenge and managed to expose a few plates before the wind carried him out of range is as attractive as it is implausible. To explain why, it is necessary to look a little closer at Victorian and Edwardian military ballooning.

Military ballooning and reconnaissance to the 1870s

The Montgolfier brothers were aware of the military potential of their invention, the hot-air balloon, almost from the time of their first experiments in 1782. However, it was the hydrogen-filled balloon of fellow Frenchman Jacques Alexandre César Charles – which first flew in 1783 – that ultimately offered the way forward for active service. Hydrogen, identified as an element by Henry Cavendish in 1766 and known variously as 'inflammable air' or 'phlogiston' until 1790, was considerably more difficult to produce than hot air but offered significant advantages. For example, instead of taking a fuel source up in the basket and constantly tending the flames in order to generate sufficient hot air, the hydrogen balloon could be filled prior to flight and effectively sealed. Altitude could then be adjusted simply by releasing small amounts of hydrogen through a valve or by chucking ballast out onto the passing countryside. Aside from hydrogen production, the only other real difficulty concerned the permeability of the balloon envelope itself, although in time this problem was also largely overcome (see p 24). The hydrogen balloon did not have long to wait for its first tour of duty. Following the French Revolution, an advisory commission suggested the use of observation balloons to assist military efforts against France's enemies. The world's first military observation balloon, L'Entreprenant, was demonstrated in March 1794, with the creation of the Aerostatic Corps of the Artillery Service following within days.

The Aerostatic Corps first saw service at Mauberge, close to the modern border with Belgium, shortly afterwards. On the first ascent, the observer was able to report on the positions and movements of Austrian and Dutch troops in some detail, much to the annoyance of the enemy who apparently regarded the use of the balloon as unsporting and vowed to shoot it down.

Reconnaissance techniques were fairly straightforward. The balloon was 'captive', held in position by a tethering rope. Only commissioned officers were allowed to ascend – the rest acted as ground crew. The observer used the naked eye, aided when necessary by a telescope. Communication with those on the ground required either flags, or written messages hauled up and down the cables.

Despite the clear value of balloon reconnaissance, the French Aerostatic Corps proved short-lived, with Napoleon disbanding them in 1799. A variety of reasons have been offered – indiscipline among the Corps (primarily concerning the use of the airborne basket for 'entertaining' visitors of the opposite sex); poor performance (in military terms) in Egypt in 1797; and even Napoleon's apparent belief that the use of balloon reconnaissance undermined his reputation as a master of battlefield tactics.

During the first half of the 19th century, balloons saw sporadic service in various military conflicts around the globe, but it was their use during the American Civil War that proved the real catalyst to airborne reconnaissance being taken seriously once again by the major European powers. Several balloonists had offered their services to the Union Army during the Civil War, of whom the most important was Thaddeus Lowe, an experienced civilian balloonist who stepped forward at an early stage of the conflict and was able to convince some – including Abraham Lincoln – of the military potential of lighter-than-air flight. Lowe was allowed to launch a civilian unit attached to the Union Army Bureau of Topographical Engineers.

Establishing a pattern that was to be repeated elsewhere in the future, Lowe's unit encountered a mixture of enthusiasm and antipathy. Some doubters had their misgivings assuaged by personal experience. For instance, Lieutenant George Armstrong Custer, who had noted a widespread belief that the balloonists might be exaggerating their accounts of what they saw in order to play up their importance, changed his mind about the potential of airborne reconnaissance after being ordered to go up himself, despite his reluctance. The pilot, James Allen, did little to help Custer's nerves – once airborne, when Custer queried the apparent fragility of the basket, Allen responded by 'jumping up and down to prove its strength'. However, it seems that some never adjusted to the 'idea of former carnival and circus performers running intelligence-gathering operations'.[6]

Ballooning in the Royal Engineers

After a few false starts, the British Army began to take a serious look at balloons during the 1860s. Those lobbying hardest included Lieutenant G E Grover RE, who had been putting forward the case for military reconnaissance balloons since the late 1850s at least, and Captain F Beaumont RE, who had observed Lowe's ballooning exploits at first-hand during the American Civil War.[7] Beaumont was just one of many foreign observers who had travelled from Europe to follow the Union Army's progress, including the balloons. Among them was the 25-year-old German count, Ferdinand von Zeppelin, whose meeting with John Steiner – a member of the Union Army's Balloon Corps – is often credited with stimulating his interest in lighter-than-air flight.[8]

In 1863 Beaumont and Grover arranged for experimental ascents to take place at Aldershot on 14 July and Woolwich on 6 October, using a balloon and equipment borrowed from the famous civilian aeronaut Henry Coxwell. But it was to be another 15 years before the War Office consented to the construction of Britain's first Army balloon. There were several reasons for the delay, including a desire to overcome the practical difficulties inherent in generating hydrogen as cheaply and efficiently as possible both at the base and in the field. The principal reason, however, was a belief that it was not appropriate to pursue the matter in peacetime.[9]

Nonetheless, some experimentation did occur, primarily connected with the production of hydrogen. Also, the use of military balloons elsewhere during the 1860s and 1870s – particularly during the Franco-Prussian War of 1870–1 – ensured that balloons rarely fell from view. In that conflict, the use of balloons for both reconnaissance purposes and to get messages, supplies and people in and out of a heavily besieged Paris received considerable press attention.

In 1873 the War Office considered sending balloons as part of the British military expedition to Africa's Gold Coast to deal with the Ashanti. Coxwell offered to supply two silk balloons and the necessary equipment for a total of £2,000. This cost, combined with the amount of time Coxwell claimed was necessary to manufacture the balloons, led to the idea being abandoned. Nonetheless, the notion of doing nothing in peacetime had been undermined.

Meanwhile, by the mid-1870s, Captain Charles Watson[10] had become an active member of the Royal Engineers committee overseeing ballooning matters and by 1875 he had made the acquaintance of Captain J L B Templer of the Middlesex Militia. Templer, variously described as a 'martinet – with snuff box in one hand and a long coloured handkerchief in the other' and a 'strapping John Bull figure with one of the most extraordinary waxed moustaches in England', was a keen and active sporting balloonist (Fig 2.2).[11] He had his own balloon – the *Crusader* – in which Watson had participated in several 'free' (untethered) runs.

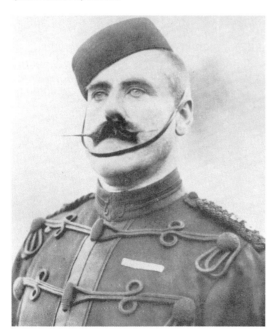

Figure 2.2 James Lethbridge Brooke Templer, photographed in the mid-1890s and reproduced in a number of late 19th-century magazines. Never a Royal Engineer, Templer served with the balloons for around 30 years, beginning as a captain and leaving as a colonel.

During the summer of 1878, Templer offered to construct a balloon and equipment for the Army at a cost of no more than £150. With the aid of friends such as Watson, Templer had little trouble in fulfilling his promise with money to spare. *Pioneer* – a 10,000-cubic-foot capacity hydrogen balloon – was in use by August 1878. Templer was taken on as an instructor in ballooning, being paid a rate of 10 shillings per day (but on ballooning days only) to train officers of the Royal Engineers how to undertake both free and captive ascents, and in all associated matters.

Templer was also largely responsible for some additional developments crucial to the future of British military ballooning. As well as devising ever more efficient ways of generating hydrogen, he came up with methods for compressing the gas into steel tubes, easing the problems of inflating balloons away from base. With a

colleague outside the Army – Walter Powell, MP for Malmesbury – Templer was also responsible for the British Army's adoption of a novel but expensive material for balloon manufacture – goldbeater's skin. Made from the intestines of oxen (each animal apparently capable of yielding around 1.4m²), it was far less susceptible to leakage of hydrogen than any other material previously tried and was also far stronger and much lighter. However, it was not an easy material to work with.

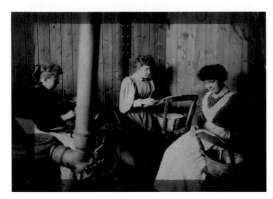

Figure 2.3 Women, some or all of them Weinling family members, preparing goldbeater's skins for balloon envelopes, either at Chatham or Aldershot. [Photograph reproduced with the kind permission of the Royal Engineers Museum, Library and Archive]

Powell had found an East London family, the Weinlings, who were experienced in manufacturing toy balloons from goldbeater's skin, which they imported from the Continent in barrels. As well as toys, this material had been used for small unmanned balloons in scientific experiments since the late 18th century.[12] Powell engaged the Weinlings to make him a full-sized balloon but, doubtful of success with the means at his disposal, he allowed Templer to take over. Before long, the entire Weinling family was in the employment of the British Army and had been moved to Chatham (Fig 2.3).

It has been claimed that they were taken on because of their unwillingness to share the family secret of working the skin into a good-quality balloon envelope. The technique, though, would not have been beyond the capabilities of the average serving soldier and was far from secret. According to Percy Walker, overlapping lengths of the material were gently pressed together when clean and wet, and the tissues gradually 'grew' together to produce a permanently sealed join. Early balloons had as many as seven complete layers, which would clearly have accounted for a considerable number of oxen. It is most likely that the Weinling's long experience in using goldbeater's skin counted heavily in their favour, along with general perceptions about the nature of the work. More than one contemporary observer suggested that the preparation and sewing of the skins was work best undertaken by women – 'The work being extremely monotonous, and requiring much deftness, patience, and delicacy of touch, is naturally more suitably performed by the defter, more patient sex.'[13] Indeed, most of the Weinlings working for the Royal Engineers were female.

The Royal Engineers balloonists led a somewhat precarious existence for several years to come and it wasn't until they had seen successful service abroad and in combat situations, and perhaps more to the point until other nations such as France and Germany were seen to be taking military ballooning seriously, that they could regard themselves as a permanent fixture within the military set-up. The first real test – manoeuvres and training camps aside – came in the Sudan and Bechuanaland in the mid-1880s, although their involvement with actual fighting was minimal. Nonetheless, it gave the Royal Engineers balloonists an opportunity to demonstrate the potential of

the balloon as a reconnaissance platform to Army officers while on active service. It also offered an insight into how the locals would react. As early as the 1790s, the French had noticed their opponents – most, if not all, of whom had never seen one before – reacting to the appearance of a balloon with almost superstitious awe. Similar reactions were observed in Africa wherever the balloons were inflated and raised.

After the Bechuanaland adventure, the Royal Engineers balloonists were confined once more mainly to training, manoeuvres and offering courses to officers from other parts of the Army (Fig 2.4). These activities were mostly based in the British Isles, with occasional foreign forays. The next test for the Royal Engineers balloons – indeed, the only real test they were to face in a conflict – was the Boer War of 1899–1902 (Figs 2.5 and 2.6).

Preparations had already begun during the summer of 1899, some

Figure 2.4 Royal Engineers balloonists almost certainly posing for the camera. The officer casually sitting on the edge of the basket is Lieutenant H B Jones. The unidentified man in the netting above would be responsible for piloting the balloon, leaving his superior free to study the landscape. [Whittington 1893]

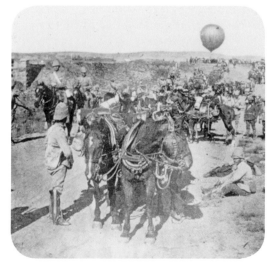

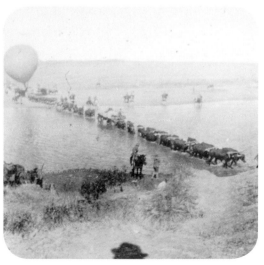

Figures 2.5 (*above left*) and 2.6 (*above right*) Two views from the Boer War, both showing troops and fully inflated balloon on the move, and in Fig 2.6 about to cross the Modder River. [The Royal Aeronautical Society (National Aerospace Library)]

months before the war officially commenced. Two detachments of balloonists were sent out to South Africa, while a third was improvised – hastily put together in the wake of the Ladysmith siege – while out there (Figs 2.7 and 2.8). A third 'regular' detachment was dispatched as late as 7 March 1900 and continued in service until May of that year. However, for the most part after March 1900, as the Boer War changed from a more conventional form of armed conflict to a guerrilla war on less suitable terrain, the balloonists' war (as balloonists, anyway) was effectively over.

In the aftermath of their South African exploits, the need for reconnaissance balloons in a modern army was at least recognised, even if not everyone was happy with them. Walker, for instance, noted that as far as the Boers were concerned, 'to a great many soldiers the use of balloons against burghers and farmers was not fair. Analogies with sport and games were prevalent in those days, and balloon warfare in South Africa would have been described as "not cricket" or "hitting below the belt".'[14] Similar objections had, of course, been aired the previous century and, remarkable as it may seem now, would resurface in the early months of the First World War as airborne reconnaissance took on a renewed lease of life.

Figure 2.7 Royal Engineers balloon inflated within the besieged area at Ladysmith, October or November 1899. This particular detachment was among the last Army units to reach Ladysmith before the siege. Their hydrogen supplies lasted 27 days, after which the balloonists were assigned to other duties. [Photograph reproduced with the kind permission of the Royal Engineers Museum, Library and Archive]

Meanwhile, after returning from South Africa, the whole ballooning operation was thoroughly evaluated, internal workings and organisation tinkered with, and enlargement recommended, though never seen through in full. Templer, who had actually been in charge of steam transport during the Boer War rather than balloons,[15] was now back to take charge once again of instruction, development and manufacture. Leading the operational side was Colonel J E Capper.[16] Capper already had more than 20 years' service under his belt and had served briefly with the balloonists in the early 1880s at Chatham. By the time Capper took over in 1903, the balloonists were firmly established at Aldershot, having moved there in 1892; they would soon begin a much shorter move to Farnborough.

Reconnaissance and photography in the Royal Engineers

Although there were occasional experiments with dropping bombs from both free and captive balloons, it was reconnaissance – observation of activity in the surrounding area – that was viewed as the principal purpose of the military balloon. As early as

the 1860s the Royal Engineers had recognised that photography might have a part to play in reconnaissance operations. Their own School of Photography was situated at Chatham, in close proximity to the balloonists until the latter's move to Aldershot. As the only official body engaged in the practice and, from 1856, the teaching of photography, the levels of knowledge and skill available were second to none. However, when it came to balloons rather than ground-based photography there were obvious problems to be overcome, particularly in regard to the amount of time necessary for an exposed plate to be returned to the ground, developed and a decent-sized print made available to those who needed to see it. Consequently, until the early 1880s, photography is scarcely mentioned in the surviving records.

Captain Henry Elsdale (Fig 2.9) joined the balloonists in 1880 after several years in the Ordnance Survey, another branch of the Royal Engineers.[17] As well as this background in surveying, he also brought with him an interest in photography. While on foreign tours of duty – first to Gibraltar and then to Halifax, Nova Scotia – Elsdale began to experiment

Figure 2.8 Captain G E Phillips RE (centre, shielding his eyes) organised an improvised balloon force using equipment and supplies intended for the balloonists who had been cut off in Ladysmith. The location of the camp in this photograph is unknown. [Photograph reproduced with the kind permission of the Royal Engineers Museum, Library and Archive]

with small unmanned balloons, both free and captive, in conjunction with automatic cameras that he devised and built.[18] Elsdale's camera was capable of being operated from the ground, via a cable attached to the tethering rope. For both captive and free flights, it could also work automatically, with a succession of plates being exposed at pre-set intervals from the unmanned balloon once aloft, thus taking a sequence of photographs as the balloon drifted.

While there were obvious potential advantages for reconnaissance purposes, Elsdale saw the true potential of his experiments in terms of map-making. Vertical aerial photographs – those taken with the camera facing straight down to the ground – produced images offering a similar perspective to maps. Elsdale reasoned that if the scale of the photograph could be calculated by reference to known fixed points, then it should be possible to amend or create maps from such images. This was hardly a new idea, but actually putting it into practice was a major step forward.

At Halifax, Nova Scotia, Elsdale took a succession of vertical images of the fortifications from his unmanned balloons and produced measured and scaled plans from them, with the aim of comparing them with mapping of the same areas already completed by the Ordnance Survey (Fig 2.10). He was quickly able to demonstrate two key outcomes: firstly, that the photographs offered a useful check on existing mapping, enabling errors in the latter to be identified and quickly corrected; and secondly, that any changes on the ground since the initial survey had occurred could also be quickly identified and mapped

accordingly. Elsdale argued that should photographs of sufficient quality and clarity be obtained, then all that should be required of the Ordnance Survey on the ground was an outline survey – a basic triangulation. The aerial photographs could be used to plot the fine detail at far less cost in terms of time and manpower than was normally necessary, and with far less scope for mathematical error.

Elsdale's experiments in Gibraltar and Nova Scotia were entirely self-funded and, in seeking both recompense and further funds, he explained his experiments and ideas in considerable detail to both the Army and the Ordnance Survey. Both saw the potential of his cameras and the use of unmanned balloons, though the Ordnance Survey in particular was none too keen on the idea of replacing tried-and-tested methods with photography from balloons. Using aerial photographs was regarded as both impractical and unnecessary, and extensive ground checking would

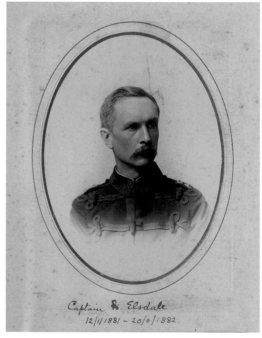

Figure 2.9 Captain Henry Elsdale, photographed c 1881–2. [Photograph reproduced with the kind permission of the Royal Engineers Museum, Library and Archive]

Figure 2.10 One of Elsdale's vertical images of the Citadel Barracks, Halifax, Nova Scotia, taken in 1883 (before 26 July). [Henry Elsdale/Library and Archives Canada/PA-172326]

still be needed in order to ensure accuracy and to deal with things hidden from the camera's eye.

With hindsight, the rejection of the technique, particularly one that is today so crucial to the work of the Ordnance Survey, can seem perverse – amusing even – but in addition to the difficulties faced in converting an aerial photograph into a map, there were many other problems that seemed equally insurmountable in the 1880s. The quality of Elsdale's aerial views was variable, while Elsdale himself had pointed out the unsuitability of parts of the British Isles for ballooning, especially Chatham where the prevailing winds had a tendency to blow balloonists towards the Thames Estuary. British weather made for a rather limited flying season anyway. Elsdale's proposals seemed better suited to military use, particularly in foreign locations where reliable mapping was at a premium, if it existed at all. However,

the Ordnance Survey was to offer remarkably similar objections when pressed once again to consider aerial photography as a surveying tool four decades later (*see* pp 141–2).

Elsdale's experiments continued to be interrupted by foreign postings and a lack of official funds, but he persisted throughout his stint with the balloonists (Figs 2.11 and 2.12), which ended prematurely in 1888 following his role in a farcical attempt to court martial Templer. Templer had been arrested in February of that year on suspicion of passing details of balloon-related equipment to the Italian military. Elsdale appears to have been the prime mover behind the prosecution and a principal witness. Among other weaknesses in the case, he also provided Templer with an alibi.[19] The court martial collapsed without the defence having to put forward their case. Although publicly stated to have acted with honourable motives ('What I did I was bound to by my Queen'), Elsdale had to leave the balloonists immediately, while Templer was free to continue his career as though nothing had happened. After spells in limbo and Exeter, Elsdale spent the remainder of his military life in Natal (South Africa) and Hong Kong before retiring on 20 January 1900 and departing to San Francisco, where he died of 'typhoid fever' a month later.[20]

Experiments with photography dwindled somewhat with Elsdale's departure, though one interesting footnote remains. He was briefly replaced in 1887 by Charles Close as the officer commanding the balloonists (Fig 2.13).[21] Close remained in post for just a year or so before being moved on and in 1891 ended up in India. While there he hatched a plan to map some of the extensive archaeological remains at places like Agra and Old Delhi from aerial photographs and asked permission to have one of Elsdale's unmanned balloons, with automatic

Figures 2.11 and 2.12 Two aerial views of the military camp at Lydd, both taken in 1887 from a Royal Engineers balloon using one of Elsdale's automatic cameras from around 370ft. [Courtesy of the Council of the National Army Museum, London]

camera and some tubes of hydrogen, to be sent out to him. Despite official approval for his request, once the equipment had arrived he was refused permission to actually use them for his intended task. Instead, he had to make do with taking a few aerial views of Calcutta, which he naturally considered a poor substitute for his original choices:

> Calcutta was not a very suitable place. There was no freedom, the place was a mass of houses and gardens, and worse than all, the weather was bad. Well, we flew the small balloon from the roof of the office, but it was rather windy, and not very bright, so we got rather poor results. I had to go off in two days to Burma for my work on the survey of that country, and that was all.[22]

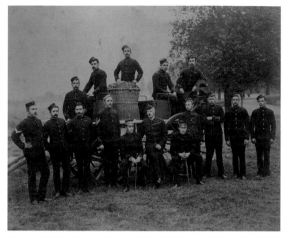

Figure 2.13 Group photo of Royal Engineers balloonists, 1888. Back row, left to right: Sappers Sykes, G Allen, J Allan and Price, Lance Corporal Champion; front, left to right: Corporals Greener, Fitzpatrick and McEwen, Sergeant Smith, Lieutenant Charles Close, Major Charles Watson, Lieutenant H B Jones, Corporal Bryant, Sappers Wookey, Wiffen and Walker. [Photograph reproduced with the kind permission of the Royal Engineers Museum, Library and Archive]

After Elsdale, references to aerial photography among the balloonists are scrappy to say the least until around 1905, with most detail coming not from official documents or archives but from the press (*see* Military ballooning in the press, p 33). One wonders whether there was some encouragement from within the Royal Engineers, as press articles – including some highly illustrated 'tours' of their Aldershot headquarters – were particularly numerous in the years immediately prior to 1897, when the balloonists were finally made 'official'.[23]

Despite the obvious interest of some serving balloonists, there is little to indicate that photography from balloons was regarded as an essential part of their training and practice. The *Manual of Military Ballooning*, published in 1896,[24] featured a short chapter on photography written by Lieutenant A H W Grubb and offered a remarkably limited range of uses for balloon photography. More space is given to describing the use of a Cavalry Sketching Board. There is no indication in the manual that the balloonists still possessed any of Elsdale's cameras, though they still had a number of small balloons of 1,000-cubic-foot capacity or less that could be used for signalling and photography. The photography chapter notes that the camera being used at the time consisted of 'a 1/1 plate, 8½ inches by 6½ inches, fitted with a lens of 16-inches focal length, a Thornton-Pickard extra rapid shutter, working from 1/20th to 1/100th of a second, a focussing rack and pinion, and horizontal and vertical swingbacks. The camera complete folds up to a size of 8" × 9" × 10", and with three double dark slides or changing box, weighs 13¼ lbs.' The changing box, containing 12 plates or films, apparently 'does not always work smoothly in the balloon'.[25]

The manual's limited text on balloon photography probably explains why hardly any aerial photographs are known from the Boer War,[26] and why those that can be attributed to a

photographer appear to have been taken either by or for the press. In contrast, plenty of images exist of balloons on the ground (being transported, inflated, deflated, prepared for ascent etc). When a revised edition of the manual appeared a few years later, the chapter on photography had gone.

There were other problems to be dealt with apart from photography, of course. Reporting in the wake of the summer training of 1903, it was noted that

> the equipment of officers and men is entirely unsuited to ballooning. Generally, every effort should be made to do away in dress with anything that can catch in the net or tear the skin of the balloon. Officers' belts should be abolished, an officer in a balloon does not want to carry a revolver, and he has to take off his belt and revolver before entering the car, with every prospect of losing it. Spurs should not be allowed near the balloon...[27]

Then there was the matter of persuading people to try ballooning. Captain H B Jones, who was for a while in charge of the balloonists in the 1890s, recalled that every year from about 1892 onwards a class of officers from the Staff College – usually about nine in number – did a ballooning course. Those participating had to be under a certain weight and it was claimed that lightweight officers with nervous wives were fed as never before in order to get them safely above the maximum weight.[28] After the Boer War, Lieutenant Grubb complained that it had been 'very difficult to persuade officers to go up and see for themselves and I think only three of four availed themselves of going up for short ascents (10 to 20 minutes) ... consequently I was up almost every time, and never spent anything like so many hours captive in the air before. NCO's were generally averse to ascending and their observations were not very satisfactory.'[29]

Francis Westland served with the balloonists from 1905 and his account of his service suggests that getting airborne was not a popular choice among those completing their initial training:

> We were due to leave the SME [School of Military Engineering] in March 1905 and were naturally rather anxious to know where we were going to be sent. I had applied for 1. India 2. Railway Traffic 3. Railway Mechanical 4. Ordnance Survey but didn't get any of the above, having a reputation that didn't do me much credit in the eyes of my superiors, not that I minded much as my choice was not entirely of my own free will. I was finally given the choice of a Balloon Company, and one or two other things and chose the Balloons because the other choices were worse...[30]

According to Westland, the '[b]alloons were rather looked down upon by the others, as the last formed unit and as a useless "scientific" toy, amusing no doubt ... but no earthly use...'. Once attached to the Royal Engineers balloonists, some eventually found a need to move on. In the spring of 1907, Westland reported that one of his colleagues 'had asked to be exchanged to a field company as he was losing his nerve. One does lose it after a bit. I have found that myself.'[31]

Military ballooning in the press

Press articles published around this period contain a lot of useful background detail on the Royal Engineers balloonists and their activities, as well as putting some faces to names. Typical was an article that appeared in *Strand Magazine* during 1895:

> The balloon inflated, we will suppose that Lieutenant Hume and a brother officer are told off for the duty of reconnoitring the enemy's position. The two officers take with them a map of the surrounding country, on the scale of 2in. to the square mile. Of course, they are provided with field glasses, and the moment they are able to gauge his strength, they make certain notes upon the map, using for this purpose pencils of various colours; one colour denotes cavalry, another infantry, and so on…
>
> …the immense aerostat shoots straight up like a rocket, but pressure is gradually brought to bear on the connecting rope, and when at an altitude of several hundred feet, the upward course of the huge machine is checked, and it sways gently to and fro, while the skilful officers in the car anxiously scan the magnificent prospect of the country far below them. The moment any definite information is obtained as to the enemy's movements, the map spoken of above is marked according to such information, and then placed in a canvas bag to which a ring is attached in such a way that it glides swiftly down the rope to the ground, where a mounted orderly is waiting. The orderly immediately gallops off with the very latest intelligence to the General in command…
>
> The system of reconnaissance by pencil-coloured maps dropped from the balloon at present holds the field against photography; but it must not be assumed that the camera is a wholly futile ally on the battlefield. As a matter of fact, the most successful and valuable pictures are constantly obtained, showing in most beautiful detail the nature of the surrounding country and the obstacles to be encountered. You must remember, though, it takes at least half an hour to photograph, develop and dry the negative, and print a proof; from which it is obvious that information given to the commanding officer by this means is a little stale, as it conveys to him rather where his opponent was, than where he is at the moment.[a]

Notes

a Knight 1895, 309–12.

Capper, Sharpe and Stonehenge

At the end of the summer of 1904, Capper summed up the state of photographic work undertaken by the Royal Engineers balloonists. Results weren't good, for which the British weather took its share of the blame. Most of the cameras available belonged not to the Royal Engineers but to individual officers. Two corporals possessed some technical ability and know-how but otherwise 'we are all merely amateurs'.[32]

The following year, Capper oversaw a thorough reorganisation of the balloonists' tasks. Each officer was now given a principal area of responsibility, along with a secondary role in another area of the balloonists' work. For once, the section's photographic responsibilities were also laid out in some detail. All photographic equipment was to be collected, catalogued and stored together, and the existing photographs were to be gathered 'with if possible details of nature of plate, exposure, light &c, camera used, recorded against the photo'. All were expected to improve their knowledge of how to use the cameras, especially in different weather and light conditions, while officers were encouraged to apply to attend a photographic course at Chatham.[33]

Capper also explained the sort of photographic work that he wanted to see, asking for experiments to be made

> ...for the purpose of obtaining satisfactory results in:–
> (1) Balloon or kite photography of ground at a distance of 2 to 3 miles from captive man-lifting balloons or kites.
> (2) Photography from free balloons. Camera plates and instructions to be handed to officer in charge of each free run.
> (3) Photographs, from small balloons or kites, of particular positions.
> (4) Survey photographs from captive balloons of ground immediately below, and comparison of results with Ordnance surveys.
> (5) Apparatus for speedy development and enlargements in the field.[34]

This brings us back to the Stonehenge photographs, which, as we saw at the beginning of this chapter, were taken by Philip Henry Sharpe in 1906 from a Royal Engineers balloon (Figs 2.14 and 2.15). Over a century later, there are a number of basic questions about these photos that have never been answered and, perhaps, never even been asked. Chief among these, of course, are the most obvious – when, how and why were the photographs taken?

Sharpe was born in Kentish Town, London, on 7 February 1884 (Fig 2.16). He joined the Royal Engineers aged 20 on 23 March 1904 as a 2nd lieutenant, joining up with the balloonists at Aldershot on 15 September 1905. Shortly after arriving at Aldershot he became the officer in charge of balloon photography as part of Capper's reorganisation (with a secondary role dealing with man-lifting kites). It is unclear if he brought any photographic knowledge and experience with him to Aldershot, or whether this was a case of the new boy being given the short straw. From February to mid-September 1906 he was based at Aldershot before moving to Bulford Camp on Salisbury Plain on 15 September 1906, where he remained until the following February, at which point, if not before, he left the balloons for another part of the Royal Engineers.[35]

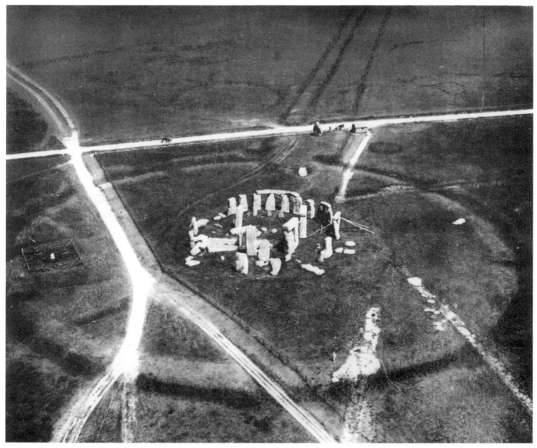

Figure 2.14 Sharpe's oblique view, as published in *Archaeologia* in 1907. The ditches of the Avenue can be seen heading off to the north-east, picked out by the deeper growth of grass among the more general parching. [Reproduced by permission of the Society of Antiquaries of London]

Bulford Camp lies just 6km or so north-east of Stonehenge and had not long been connected with the main railway line. It would have made an obvious base for ballooning on Salisbury Plain and appears to have been frequented by the Royal Engineers balloonists in previous years. However, while hardly any detail about Sharpe's ballooning and photographic activities during 1906–7 has yet materialised, the little information that is available shows that the photographs must have been taken before he moved to Bulford.

When Capper visited the Society of Antiquaries in December 1906, Sharpe's photographs of Stonehenge were said to have been taken 'recently'. In fact, they were taken several months earlier, during the summer. They certainly existed before 31 July 1906, because that is the date on which – remarkably – Capper registered himself as the owner of the copyright of Sharpe's photographs. Narrowing down the likely time-frame any further is

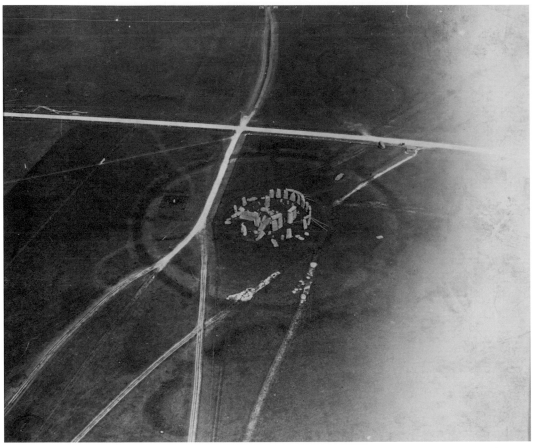

Figure 2.15 This second oblique view, also by Sharpe and from the same 'flight', was recently uncovered by Bernard Nurse at the Society of Antiquaries. It is clear why it was never published, some light having strayed in during developing. [Reproduced by permission of the Society of Antiquaries of London]

difficult, although a possible clue is provided by a request Capper made on 18 June 1906 for money to fund various experiments with balloon photography. This included the setting up and kitting out of a darkroom, and purchasing various items of photographic apparatus. Perhaps the trip to Stonehenge provided Capper and Sharpe with an opportunity to try out their new equipment. A date in June or July would certainly fit with the degree of parching evident in the photographs.[36]

As to how they were taken, no records exist to tell us what kind of camera Sharpe may have used. However, it is known that during a short spell of ballooning in Malta in January and February 1904 'two cameras belonging to the section were brought out – a whole plate and a 5" × 4" ... Several photos in a ¼ plate (No. 3 Folding Pocket) Kodak, with ordinary lens were taken ... Some were also taken by Lieutenant Dalrymple ... with a smaller size Kodak ... The 1/1 plate camera (at any rate the one in possession of the section) is rather unwieldy on a windy day.'[37]

The overwhelming majority of flights made by the Royal Engineers balloonists were 'captive' – the balloon was tethered, connected by a cord to a winch either on the ground or on a wagon, which enabled the ground crew to raise or lower the balloon according to instructions or conditions, or to allow it to drift with the breeze towards a target (Fig 2.17). On active service, it was unlikely that a free run would be permitted – balloons could not be steered, of course, and in any case, setting a balloon free would reduce its reconnaissance value somewhat. All of the balloonists were required to undertake occasional free runs, mainly to ensure they knew how to handle and land the balloon should it break free. It was these less common free runs that saw the most accidents. For example, on Tuesday 28 May 1907 the balloon *Thrasher* left Aldershot, taking off in front of the king. In the basket were Lieutenants W T Caulfield and T E Martin-Leake. Later that day, the balloon ditched into the sea near Weymouth – Caulfield's body was found on 23 June off Wyke, Dorset; Martin-Leake was never found.[38]

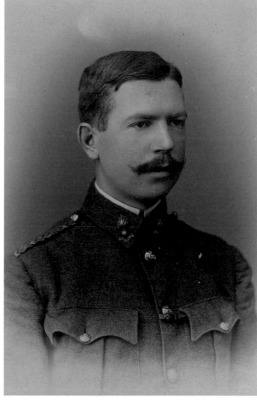

Figure 2.16 2nd Lieutenant Philip Henry Sharpe, photographed c 1904–5. [Photograph reproduced with the kind permission of the Royal Engineers Museum, Library and Archive]

On balance, then, it seems likely that Sharpe took the photographs from a captive balloon. The evidence of the images themselves suggests that it was tethered a short distance south or south-west of Stonehenge and allowed to drift with the breeze until over the stones. The only possible reason for tethering a balloon there, given the wind direction, was to take aerial photographs of Stonehenge. This was no happy accident in a drifting balloon.

The photographs also sit comfortably within Capper's aims for photographic experiments. He had highlighted a need to take oblique views in order to gauge the amount of detail visible on both originals and enlargements, and a desire to take overhead views to compare with available measured surveys in order to evaluate the possibility of mapping from such images. Stonehenge offers an obvious target, particularly on what can seem an otherwise featureless plain (military structures excepted) and in view of the extremely detailed surveys of the site already in existence.[39] However, the date the photographs were taken – June or July, while Sharpe was still based at Aldershot – coupled with Capper's claim to be copyright holder suggests an intention to photograph Stonehenge in order to show off his section's photographic capabilities, particularly in the light of recent equipment purchases and the setting up of a darkroom.

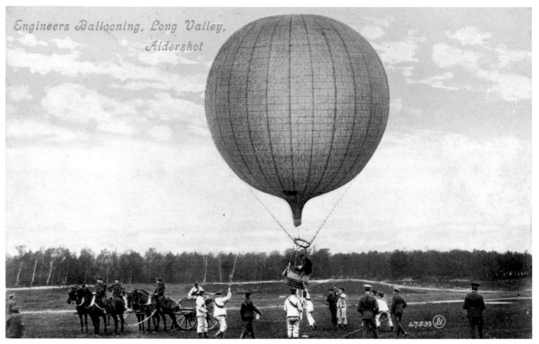

Figure 2.17 A coloured postcard showing a tethered Royal Engineers balloon about to get airborne at Long Valley, Aldershot, sometime during 1906.

The existence of clear aerial views of Stonehenge gave Capper the opportunity, as commanding officer, to spend an evening in London as a guest of the Society of Antiquaries, almost certainly without Sharpe.[40] Capper was well known outside the Army at the time, having recently received extensive and worldwide press attention for his endeavours in the highly prestigious first annual international Gordon Bennett contest, which began on 30 September 1906.[41] Capper had assisted Charles Rolls (Fig 2.18), co-founder of Rolls-Royce, the pair eventually finishing third by reaching Shernborne in Norfolk, a distance of some 461km from the starting point in Paris. The victor, the American Frank Lahm, managed to reach Fylingdales in North Yorkshire, though he was actually airborne a few hours less than Rolls and Capper.

Archaeology from the air before Sharpe

To date, no other aerial photograph taken from a Royal Engineers balloon featuring an archaeological monument as its subject has been discovered. In fact very few of their photographs survive at all (Fig 2.19).[42] Even accidental incorporation of an archaeological monument seems to have been rare. A few photographs feature the hazy outline of Caesar's Camp (Fig 2.20) – a hillfort on the outskirts of Aldershot – on the horizon, while other hillforts, including Sidbury Hill, occupy an equally distant position on later photographs (Figs 2.21 and 2.22).[43]

Figure 2.18 In late September 1906, Capper was in Paris for the start of the Gordon Bennet contest. Here, the balloon *Britannia*, weighed down with ballast, is almost ready to lift off. Charles Rolls is on the left in the basket with Capper to the right and a little behind him. [The Royal Aero Club]

As we shall see in the next chapter, aerial photography was not an exclusively military practice in Victorian or Edwardian Britain. The first aerial photographs date from 1858. By 1900 dozens of individuals were regularly taking cameras with them on balloon flights. However, there appear to be no photographs of archaeological sites taken from balloons, military or civilian, at all prior to 1906 – in Britain at least. The first archaeological photographs from a balloon were taken of excavations in the forum at Rome from an Italian tethered military balloon in 1899.[44] It is not clear how widely known outside Italy this episode was, but certainly no British archaeologist appears to have had the idea of photographing their excavations from above, let alone grabbing a quick snapshot of a monument as it passed below.

The unpredictable nature of balloon flights didn't help – direction depended on the weather and even altitude was not entirely in the control of the balloonist. Moreover, few if any active balloonists had more than a passing knowledge of archaeology, let alone an understanding of earthwork remains. They may have seen little interest in photographing them. The sole exception concerns the one known attempt prior to 1906 to photograph Stonehenge from the air (*see* John Bacon bombs Salisbury Plain, pp 42–3).

Figure 2.19 One surviving photograph shows a view of the Lambourn Downs at 11.50am on 14 September 1893, from an altitude of c 1,000ft in a wind measured at 8 to 10 miles an hour. The camera was pointing north-east – the village to the left is Bishopstone and right of centre is Idstone with Ashbury beyond. Towards the top, just left of centre, is a military tented camp. [Courtesy of the Council of the National Army Museum, London]

Figure 2.20 The view west from 'Balloon Yard', Aldershot, from a Royal Engineers balloon on 17 August 1893, c 7am and from an altitude of about 600ft. The tented camp in the centre lies in Long Valley (see Fig 2.17). Almost lost in the haze is the distant outline of the Iron Age hillfort known as Caesar's Camp. [Courtesy of the Council of the National Army Museum, London]

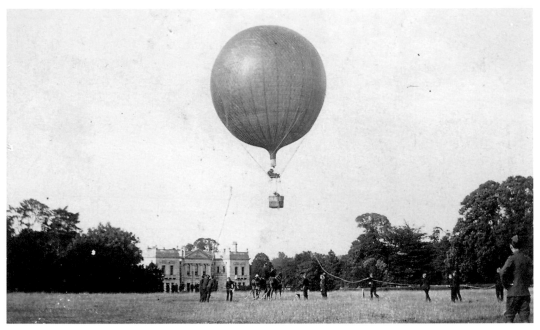

Figure 2.21 Royal Engineers balloonists at Tidworth, c 1905 – the ground crew and balloon are in front of Tedworth House. [Frank Willmott/Nicholas Willmott]

Figure 2.22 Royal Engineers balloonists at Tidworth, c 1905: an aerial view from the balloon featured in Fig 2.21, showing the camp and Tedworth House. Beyond, some barracks are under construction, while in the distance is Sidbury Hill, home to an Iron Age hillfort. [Frank Willmott/Nicholas Willmott]

John Bacon bombs Salisbury Plain

The Reverend John Mackenzie Bacon
(*see* pp 53–60 and 64–5) came to ballooning
relatively late in life, his first flight in 1888
coming at the age of 42. Born and raised on
the Lambourn Downs, he had been educated
at a preparatory school in Chiseldon, near
Swindon in Wiltshire, and then at Trinity
College, Cambridge. This was followed by an
assortment of generally unpaid posts within
the Church. His interest in archaeology
long predated his first balloon flight and
included an all-night vigil at Stonehenge
one midsummer in order to observe the
relationship between stones, sun, moon and
stars.[a] Bacon's aerial photographic career will
be explored in more detail in the next chapter,
but this seems a more appropriate place to
describe, largely in his own words, his one

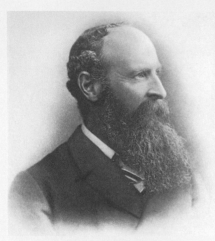

An undated portrait photograph of the
Reverend John Mackenzie Bacon. [Bacon 1907]

airborne encounter with Stonehenge. The reason for Bacon being above the site in the
first place concerned one of his many scientific experiments:

> In the summer of 1900, Salisbury Plain, our English veldt, was in the military
> occupation of a large force of British troops. Five important camps were
> established, occupying central positions, and here the plain was rendered
> gay with patches of white canvas and the daily manoeuvres of the soldiers.
> This circumstance led to my making a novel experiment, and attempting to
> carry out a new method of military signalling…

Inspired, if that is the right word, by difficulties encountered with sending messages
into and out of Mafeking during the famous Boer War siege earlier in the year,
Bacon sought to demonstrate the potential of the balloon as a means of signalling,
presumably oblivious to over 20 years of signalling with flags or heliograph by Royal
Engineers balloonists. As we shall see in the next chapter, Bacon was as keen on
making loud noises as he was on ballooning, so his method of attracting the attention
of the troops on the ground will have come as no surprise to his companions. Bacon
explained exactly what happened once they were above one of the army camps:

> Over a windlass was hanging the loose end of a spool of twin insulated wire.
> To this a blasting charge of gun-cotton was quickly attached, then run out and
> lowered 120 feet below, and instantly fired electrically. A sharp report rang
> out, high-pitched and ear-splitting, then a long pause, followed by a deep full
> thunder peal echoing back from earth and rolling on indefinitely. It was grand.
> It was also a valuable experiment in acoustics. On many occasions I had fired
> bombs in a similar way over broken country as well as over London house-tops,
> and had heard the roar of thunder given back from the many surfaces of the

uneven ground below.[b] But here for the first time I was firing over a dead flat, and eagerly awaited to note any difference in effect. Let me then place on record the fact that the reverberations seemed undiminished.

But firing this blank cartridge was but the call to 'attention', and without the smallest loss of time I was making … dots and dashes in the sky, my companions closely watching for any response from below. They had not long to wait. The ordinary wave of a signalman's flag could hardly have been observed from overhead … Perhaps this suggested itself to the troops below. At any rate, with remarkable alacrity a heliograph was brought out in front of a tent … and made to commence a series of familiar flashes, distinct enough but intermittent and undecipherable; and indeed, this might have been anticipated, for, as was explained by a member of the signalling corps afterwards, with an object moving so rapidly as our balloon, it was almost impossible to keep that form of instrument truly directed.

It was probably just as well that Bacon couldn't decipher the message being aimed at him. In any case, there is seldom any turning back when in a balloon, so he looked around to see what else he could do:

And so we looked out over the plain for fresh objects, and what we saw, or thought we ought to see, was the actual sight of Stonehenge 'right ahead'.

The old cromlech afforded a useful study for the signaller or marksman – a study in contrast. The sun, which was within two hours of its setting, had temporarily gone behind a cloud, and there were no shadows; yet the light was still good and our height less than a mile. For all that, however, Stonehenge was to us in hiding. This was, of course, partly due to our particular point of view, for the grandeur of the stones lies in their towering height. Raised more than twelve feet above the plain, to the ordinary visitors their summits show clear against the sky-line, and thus are imposing beyond words; but regarded from above, the object presented is at best but Stonehenge in ground plan – a few stones ill seen, save those that are prone and dotted over a spot scarcely 100 yards across.

But it is the colour of the stones to which I would call attention. The camera refused to distinguish them at all, though but a short while before the dull-covered heavy foliage in Lord Carnarvon's Park at Highclere had shown up fairly well in a photograph, as also the lake … [but] the stones were practically invisible against the short dry grass…[c]

Did he take a photograph or not? There is ambiguity in his choice of words – was he disappointed with the view through the camera, or with a resulting print? With the whereabouts of his photographs and diaries unknown, it is impossible to be sure.

Notes

a Bacon 1900b.

b This episode is described within the chapter 'How I Bombarded London' in Bacon 1900a.

c The Bacon quotes in the text box are taken from Bacon 1902b. The story is also recounted in Barber 2005.

The Royal Engineers balloonists after 1906

By the time Sharpe's photographs had been taken, Capper's balloonists were looking beyond stationary reconnaissance platforms (Fig 2.23). Regarded within the Army as the natural home for any means of getting airborne, they conducted experiments with other modes of flight, including kites, airships and aeroplanes. Templer had actually begun working on airships after his return from the Boer War, while Capper had been dispatched to meet the Wright brothers, among other pioneers of powered flight, as early as 1904. However, it was a new twist on an old idea that was first to reach fruition.

Kites

By 1903 the Royal Engineers had begun experimenting with a new design of man-lifting kite. This was the invention of Samuel Cody, a man whose past can best be described as colourful.[45] An illiterate American who had come to Britain some years earlier to perform in Wild West shows

Figure 2.23 By the time Sharpe photographed Stonehenge, the balloon was already regarded by many as outdated. Here, an inflated reconnaissance balloon – a 'palaeolithic contrivance' in the words of a character in H G Wells' 1907 book *The War in the Air* – is being manoeuvred into an airship shed at Farnborough *c* 1906. [Photograph reproduced with the kind permission of the Royal Engineers Museum, Library and Archive]

and revues, latterly of his own devising, somewhere along the line Cody had developed an interest in kite-flying which, by the turn of the century, had led to experiments with his own designs for kites capable of lifting men into the air (Figs 2.24 and 2.25). These were soon adopted by Capper's balloonists – not only could they lift a man as high as a reconnaissance balloon, but the basic principle of kite-flying meant that they worked best in the stronger winds that were proving unsuitable for captive balloons. Consequently the Iowa-born Cody found himself in the employment of the British Army. Cody's kites were also tested twice – in 1903 and 1908 – by the Navy to see if they were suitable for ship-board reconnaissance at sea, but ultimately they were not adopted (Figs 2.26 and 2.27).

Attempts to use kites to lift men off the ground had been far from uncommon during the later 19th century. Within the British Army, Captain B F S Baden-Powell – brother of the scouting Baden-Powell – had succeeded in lifting a man as high as nearly 200ft by 1895, but never managed to arrive at a reasonably safe and practical model. In contrast, it was said that Cody's kites 'will take a man in the air to practically any required height, and will keep him steady there so he can observe'.[46] Indeed, after Army trials in the summer of 1904, it was claimed that '[t]he car is as steady in a 30 mile an hour wind as the car of a balloon is in a 10 mile an hour wind, and probably keeps its actual position on the air better than

does the car of a balloon. There is no reason why observations should not be safely made in winds of well over 50 miles an hour.'[47] Certainly, Cody's kites are still renowned for their stability today, but the suggestion in 1904 that '[t]he danger … is, I think, even in very high winds, more apparent than real'[48] contrasts with Francis Westland's experience of not being able to use kites in tricky winds on exercises in Wales and his account of a man falling to the ground from one.[49] On another occasion, one of the kites was cut away by lightning whilst an officer was airborne.[50] Cody's kites were never tested 'in action' and had ceased to be used sometime prior to 1914, the aeroplane having effectively made them redundant.

Sending up kites with cameras rather than men has an even longer history. Aimé Laussedat, a French colonel, was experimenting – unsuccessfully – in the 1840s (*see* p 66), but real progress had to wait until the 1880s. For example, by 1887 Douglas Archibald, an English meteorologist, had developed a method of flying kites in tandem that allowed him to send a camera up some 1,500ft. The lens pointed straight down in order to obtain vertical map-like views and a small explosive charge released the shutter.[51]

The Frenchman Arthur Batut, who in 1890 published the first book on aerial photography, preferred a single lozenge-shaped kite with long tail, his shutter operated by a burning fuse. Batut attached an aneroid barometer to his kite to record the camera's altitude at the instant the shutter was triggered.[52]

In the USA William Eddy began experimenting in the 1890s, initially using a basic Kodak (*see* pp 60 and 63) adapted so that its shutter was operated by a dropping lead weight. He took his first successful photograph at Bayonne, New Jersey, on 30 May 1895 and it wasn't long before it saw military use. In 1898, during the Spanish-American War, his kite cameras were a qualified

Figure 2.24 Samuel Cody amongst a range of his kites on display at Alexandra Palace in 1903. [Imperial War Museum; RAE-O 142]

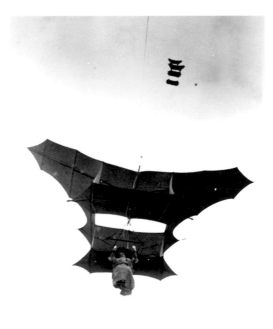

Figure 2.25 Lela Cody, suspended from one of Cody's man-lifting kites, probably 1906 or later. [Imperial War Museum; RAE-O 1083]

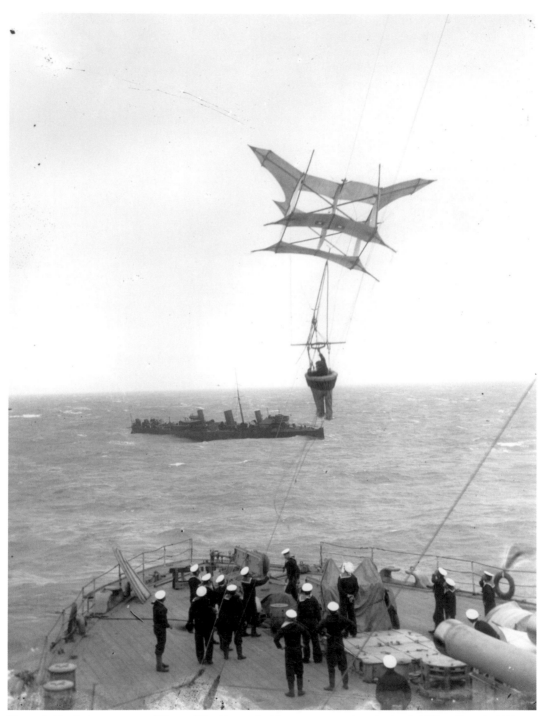

Figure 2.26 Cody demonstrated his man-lifting kites to the Navy on two occasions, the first in 1903 and here in 1908. This occasion saw him using a breeches buoy rather than the usual seating arrangement as he lifted off from the deck of the battleship HMS *Revenge* in the English Channel. [Imperial War Museum; RAE-O 564]

Figure 2.27 The view from Cody's kite whilst hovering above HMS *Revenge* in 1908. [Imperial War Museum; RAE-O 486]

success. Many photographs were taken and were of undoubted value, but there were problems. The kites were difficult to control once airborne; the cameras might have been able to 'see' the enemy, but there was no guarantee that the ground-based kite-flier could. In any case, it was a struggle to get the camera pointing in the right direction.[53]

Nonetheless, photographers persisted with kites (and still do, of course). Perhaps the most spectacular example was George Lawrence's remarkable panoramic view of San Francisco taken in the wake of the 1906 earthquake. Lawrence – who had been using balloons and kites for aerial photography since 1901 – was in Chicago when he heard about the earthquake. Hurrying to the scene, he flew his 17-strong kite contraption from the deck of a ship in the San Francisco harbour, a panoramic camera dangling below capturing the extent of the earthquake's damage from around 2,000ft.

Airships

Cody also became involved in airship design and construction, alongside Capper and Templer. The design of Britain's first military airship had begun under Templer around 1901. *Nulli Secundus* ('Second To None') first flew on 10 September 1907. Its most famous

flight came a few weeks later on 5 October, when Capper and Cody flew it from Farnborough to London, taking in Hyde Park, Buckingham Palace, Whitehall, Trafalgar Square and The Strand, among other landmarks, before circling the dome of St Paul's Cathedral (Fig 2.28) and eventually landing in the grounds of the Crystal Palace. The distance covered – 40 miles – and the flight's duration – 3 hours and 25 minutes – were both world records for a non-rigid airship. As a result, the airship and its occupants received extensive press coverage. Unfortunately, while moored at Crystal Palace, it suffered severe damage during a storm and never flew again.

Its replacement, the oddly named *Nulli Secundus II* ('Second To None the Second'), emerged from its shed at Farnborough on 24 July 1908 (Fig 2.29). Essentially a redesigned version of its unlucky predecessor, and incorporating some of its parts, it proved remarkably unsuccessful and flew for the last time on 15 August 1908. Nonetheless, efforts and experimentation continued. For example, Capper oversaw the design of a small airship, *Baby*, intended initially for research purposes but later extended in length and renamed *Beta 1* (Fig 2.30).

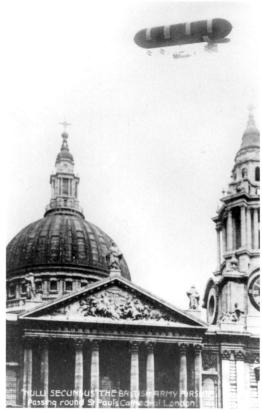

Figure 2.28 *Nulli Secundus* negotiating some prominent landmarks. This was not the closest that a Royal Engineer had ever come to the dome of St Paul's. Captain Henry Elsdale narrowly missed the cross at the top during a free flight across London c 1881. [Imperial War Museum; RAE-O 998]

Under this guise it served successfully for several years and played an important role in aerial photographic experiments in the years immediately preceding the First World War.

Aeroplanes

Cody also quickly became occupied with the problems of heavier-than-air flight, although Capper at best tolerated rather than encouraged his efforts. Capper had already arranged for a Boer War veteran, Lieutenant J W Dunne, to join the balloon section in order to pursue his interest in aeroplane design. Dunne had been sent home twice from the Boer War due to ill health, but his time in South Africa had brought home to him the value of aerial reconnaissance and, as a result, he became determined to solve the problems of powered flight. Despite his status as Capper's favourite, he was singularly unsuccessful during his stint at Farnborough, although his fortunes improved considerably after leaving the service.[54]

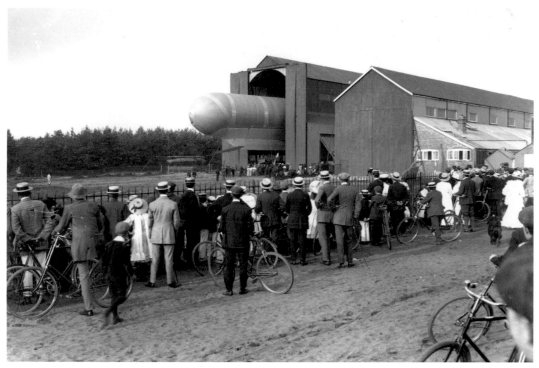

Figure 2.29 *Nulli Secundus II* emerging in public for the first time on 24 July 1908. The distant figure in the white coat on the far left is Cody. [Imperial War Museum; RAE-O 282]

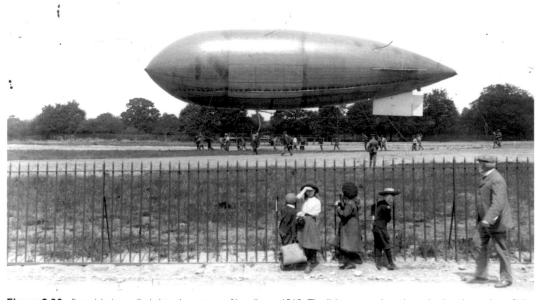

Figure 2.30 *Beta 1* being pulled along by a team of handlers *c* 1910. The lighter central patch marks the place where *Baby* was extended to become *Beta 1*. [Imperial War Museum; RAE-O 301]

Figure 2.31 Lela Cody on 14 August 1909, with skirts tied down to protect her modesty when airborne. [Imperial War Museum; RAE-O 183]

Cody's first successful, albeit brief (1,390ft), aeroplane flight occurred on 16 October 1908 at Farnborough, in the vicinity of Cove Common. However, because Cody was still an American citizen at the time, the honour of being the first Briton to fly actually went to J T C Moore-Brabazon, who covered 1,350ft at Issy-les-Moulineaux in France on 4 December 1908. To put these efforts into perspective, on 21 September 1908, at an airfield at Auvours, France, in front of around 10,000 spectators, Wilbur Wright covered 41 miles in a single flight.

On 14 August 1909 Capper became the first passenger to fly in an aeroplane in Britain when he clambered in behind Cody on one of his flights. After landing, Capper was replaced in what passed for a passenger seat by Cody's wife Lela, who therefore became the first British woman to experience heavier-than-air flight (Fig 2.31). Because the full details of her husband's military adventures didn't become public knowledge for some time, however, that honour has often been given erroneously to Gertrude Bacon, daughter of the Reverend John Mackenzie Bacon, who first flew with Roger Sommer at Rheims in France a couple of weeks later on 29 August 1909. Capper's wife Edith also got a chance to fly in one of Cody's planes in September 1909 (Fig 2.32). The privilege of being the first British passenger had

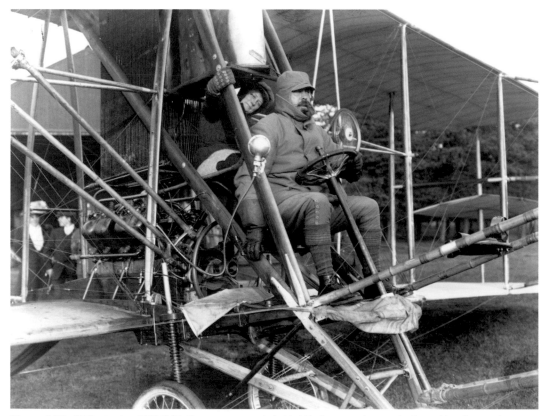

Figure 2.32 27 September 1909: Edith Capper squeezes in behind Cody, among the wood, wire and bamboo, and machinery of Cody's Mark 1C. [Imperial War Museum; RAE-O 562]

already gone the previous year, when Griffith Brewer was treated to a spin above Le Mans by Wilbur Wright on 8 October 1908. By the time Cody flew his Mark 1C (Fig 2.33) some 40 miles across country on 8 September 1909 – at that time the longest flight outside an aerodrome anywhere in the world – it had already been decided that the aeroplane was likely to be of little or no military value to the British Army. Dunne and Cody were effectively dismissed from service, while a civilian engineer, Mervyn O' Gorman[55] was placed in charge of the Balloon Factory, which was now to prioritise airships. Capper, who remained in charge of the operational side, departed in 1910 on promotion, becoming the commandant of the School of Military Engineering, Chatham.[56]

As it turned out, the dismissal of the aeroplane was only temporary and before long the Royal Engineers balloonists had been replaced by the Royal Aircraft Factory and the Royal Flying Corps (RFC).

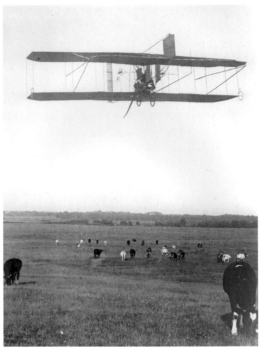

Figure 2.33 Cody's Mark 1C in flight in August 1909 above some cows who appear as unconcerned with aeroplanes as some of the senior military and government figures of the day. [Imperial War Museum; RAE-O 468]

Outside the military, Cody continued to flourish, becoming a popular public figure through his exploits; however, in the end he was unable to contribute to aeroplane development, military or civilian, in the long term. In 1912 one of his planes came first in military trials undertaken at Larkhill on Salisbury Plain. The aim of the trials had been to determine the most suitable aircraft for the fledgling RFC, but Cody's winning design was not adopted. The following August, Cody was killed when another of his aircraft crashed at Farnborough.

3 'Quick! The Kodak!'

Victorian and Edwardian aeronauts and aerial photographers

'I left this world about 5.15 on August 20th, 1888.'[1]

So began the Reverend John Mackenzie Bacon's account of his first balloon ascent, a treat he had arranged for himself with little idea of the long-term consequences it would hold for him. Bacon had originally sought a full-time career in the Church, but his own ill health and that of his first wife had intervened. In 1882 he became the unpaid curate of Shaw in Berkshire, not too far from where he had grown up. However, Bacon also saw himself as a man of science and his dissatisfaction with the Church's views on scientific progress led to him quitting his post at Shaw in 1889. The final straw was a meeting of local clergy who 'discussed the position of Hell, and fixed it comfortably to their own satisfaction, and in accordance, they said, with the latest scientific discovery, in the centre of the earth'.[2]

Much of the remainder of Bacon's life would be spent on ballooning and related activities (Fig 3.1), including his journey over Stonehenge in 1900 (*see* pp 42–3). This was partly through necessity – balloons provided him with a new source of income. He would write prolifically for newspapers and magazines about his exploits, become a popular public lecturer on his aeronautic adventures and author several successful books.[3] Ballooning also offered a new outlet for his scientific curiosity and stimulated his interest in photography, an interest that would result not only in a vast collection of aerial photographs, but led to involvement in early moving pictures as well.

Bacon's first flight began in the grounds of the Crystal Palace in London, where the aeronaut 'Captain' William Dale,[4] employed by the Crystal Palace Company, made regular ascents in his balloon *Victoria*, with places in the basket available to paying customers. Dale was one of a handful of individuals in the London area offering the opportunity of flight to those with sufficient courage and cash. These flights were normally of fairly short duration in order to minimise inconvenience to balloonist and passengers, and maximise receipts. For his first voyage, however, Bacon was already displaying the sort of ambition that would characterise his own subsequent flying career – he arranged with Dale to wait for a full moon and stay up for as long as possible, coming down only when absolutely necessary.

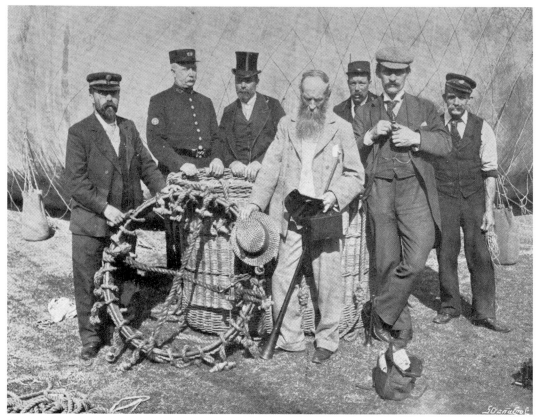

Figure 3.1 This photo – 'Ascent from the Crystal Palace' – was probably taken in 1898. Bacon is in the centre; on the far left is the balloon pilot, Percival Spencer, and to the right of Bacon is Dr R Lachlan, a mathematician and late Fellow of Trinity College, Cambridge. The other gents, sadly, are not named. The photograph was taken by Lachlan's wife. [Bacon 1900a]

The crowd at the Crystal Palace on Monday 20 August 1888 numbered, according to Bacon, around 20,000, most of whom were actually there for the annual festival of the Total Abstinence League of the Cross, a Catholic organisation founded by Cardinal Manning in 1873 and firmly opposed to the demon drink. According to Bacon, 'the most noteworthy feature … seemed to me to be the very large number of intoxicated people taking part in it'.[5]

Eventually, sometime after the festival had ended, the aeronauts' moment arrived and the balloon ascended. Almost immediately, Bacon found that 'the anchor had slipped behind my back and now had penetrated my leather wallet, riddling its contents and harpooning me like a whale, until I was rescued by my companions' (Fig 3.2).[6] The balloon drifted across London, with Bacon occasionally taking snapshots of scenes below on his Kodak until, eventually, they came to ground near Hatfield.

Like many before and since, Bacon was clearly taken with the unfamiliar viewpoint of familiar places, beginning with the Thames, which from the air was

Figure 3.2 'Rising above the Crystal Palace grounds', 20 August 1888. This was almost certainly Bacon's first aerial photograph, presumably taken after he had been freed from the anchor. [Bacon 1907]

a truly noble sight. Yes, to us Father Thames was in truth a noble river. What was it to us if his banks were unsavoury and his flood were mud? From our point of view his surface mirrored only the sunlit sky, and up and down, to us, his stream was all pure silver, and innocent of cats. Low-lying Lambeth looked almost lovely, her Palace part of Paradise – let us hope it is. Westminster, of course, was very conspicuous, so also was the huge unlovely roof at Charing Cross. But it was downstream, below the Docks, below where the Tower stands proudly, that Thames stretched out his grandest reach. Sweep away the bricks and mortar, and where in all England would you find so fair a valley?

…There was no haze nor a trace of smoke that lovely summer evening, and every detail of the great capital city lay mapped out below us … What a sight, and what a rare chance was ours! … In two respects the appearance of the streets was remarkable. They were not nearly so closely crowded as to passengers they seem to be, and the traffic, what there was, seemed scarcely moving. But one could grasp as never before what were the lungs of London and what her arteries. For Oxford Street had lost its title to the name; it was the Oxford highway now. The Northern tramways were the ways towards York and Cambridge, and Piccadilly was the Bath Road. And there were those great arteries that carry England's life-blood to and from her heart. We struck them now, three at once, over Euston, St. Pancras, and King's Cross, along which latter line one of the company's splendid trains, going north, was trumpeting.

At length we were out over the open country, the first time since the start; the last trace of cockneyism being the Alexandra Palace … We were traversing Hertfordshire, and here in its own way the northern side of London has as many beauties as the Surrey side. Rich pastures everywhere, chequered with the last of a late hay harvest; on all sides country houses with extensive parks. We could trace the plan of their lawns and gardens as we passed over…[7]

Ultimately it was bad weather that forced them to come down, after which Captain Dale and his passengers engaged in the normal post-landing routine of negotiating appropriate payments with farm labourers (who had run after the balloon when they saw it descending) for folding and packing the balloon and transporting it to the nearest railway station.

Then there was the small matter of compensation:

> Their leader, a man of upwards of sixty … had run as fast as the youngest, and was
> out of breath to the point of collapse. Still with his hand to his chest he rattled on
> in broken sobs, 'Who ever knowed a thing like this! To think of my living to see
> this happen on my farm! Lor, what a sight you was, to be sure!' But our Captain
> had an eye for business, and cut in, 'Look here; you've a horse and cart somewhere,
> and I must have it. What will you want?' 'Ah! You may well ask. I'm broken-winded
> now for life, and you'll have to pay for that; then there's my hay-rick getting wet,
> that'll be another five shillings'; and so on.[8]

Bacon's career as aeronaut and aerial photographer had begun, though the humorous tone
he often used in describing his exploits, even those that exposed him to considerable risk,
tended to play down the element of danger (Figs 3.3–3.6). Captain Dale's successful career
as an aeronaut ended less than four years later, on a flight not dissimilar to Bacon's first.
On 29 June 1892, he took off from the Crystal Palace grounds in a balloon that had been
cut down to size from an earlier, giant balloon and had been subject to emergency repairs
in the hours before the flight commenced. Dale's passengers this time were one of his sons
(William, age 19) plus two friends – John Macintosh, and the photographer-aeronaut Cecil
V Shadbolt (*see* pp 71–3). The balloon shot up to around 600ft, at which point it split open
and plummeted to the ground. Captain Dale was killed instantly and Shadbolt died from his
injuries several days later. Remarkably, Macintosh and William Dale survived.[9]

With the exception of a handful of articles dealing specifically with the subject, Bacon
seldom wrote about photography from balloons, although he frequently made use of his
own photographs, as well as those taken by companions (including his daughter Gertrude),
as illustrations for his writings and lectures (Figs 3.7– 3.9). It is unlikely that he ever took to
the skies without a camera of some kind, although he appears to have regarded it as but one
of many pieces of apparatus necessary to record various aspects of each flight.

For several years Bacon was at best an occasional balloonist – there were many demands
on his time (though most were self-inflicted) and, in any case, he did not have easy
access to a balloon from his Berkshire home. That all changed during the early months
of 1898, when he recognised the potential of using balloons as a platform for scientific
experiments connected with his longstanding interest in sound (*see* Bacon's first 'scientific
ascent', pp 64–5). Balloons had long been employed for conducting scientific research,
mainly meteorological in nature. Bacon's experiments, along with his ballooning exploits,
would be far more wide-ranging, though ultimately of rather less long-term value to
science (Figs 3.10–3.12).

Bacon was frequently accompanied on his balloon excursions by Gertrude (Fig 3.13),
who took photographs (indeed, she may well have been the world's first female aerial
photographer) and followed her father's lead in writing and lecturing about both her
own experiences and aviation in general. She continued writing until the late 1930s
and was one of the first British women to experience both airship and aeroplane flight.[10]

As far as aerial photography in general is concerned, Bacon was rather fortunate in the
timing of his aeronautical career. The world's first aerial photographs (*see* pp 66–7) were

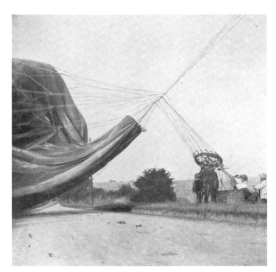

Figure 3.3 'An awkward descent', August 1898, somewhere between Baldock and Ashwell, Hertfordshire. [Bacon 1900a]

Figure 3.4 'Descending into the sea', 1898. Any balloon flight that took off in London ran the risk of coming down in the Thames Estuary, as demonstrated in this Bacon photograph of ships and boats near Gravesend. Bacon and Stanley Spencer managed to reach dry land near Greenwich. [Bacon 1907]

Figure 3.5 A more serious crash landing occurred on 16 November 1899 after an unsuccessful attempt at viewing the Leonid meteor shower. The large branch in the foreground was ripped from a tree as the balloon bounced along the ground. See also Figs 3.13 and 3.15. [Bacon 1907]

Figure 3.6 'Swanley Junction, Kent', 10 September 1898. The camera is pointing east. Anyone visiting the spot today would find Junction 3 of the M25. Bacon was wary of flying over Kent because of the proliferation of hop poles, which might make for a memorable landing. [Bacon 1907]

Figure 3.7 'Crystal Palace grounds'. The banked cycle track, which surrounds a running track, was constructed in 1896. [Bacon 1907]

Figure 3.8 'Rising above Fulham', 30 August 1902. Bacon wanted to test the practicalities of balloons in warfare. Taking off from Stamford Bridge, which for the occasion represented a besieged town, the idea was to see how far the balloon could outrun pursuing troops, represented by various military cycle corps. [Bacon 1907]

Figure 3.9 '2,000 feet above Trafalgar Square', probably August 1901. Bacon described an ascent when he exchanged greetings with workmen on the roof of Buckingham Palace and this image may have been from that flight. [Bacon 1907]

Figure 3.11 'The first sight of Scotland', 10 November 1902. This photograph is from the final stages of the flight from the Isle of Man. [*The Graphic*, 29 Nov 1902, 732]

Figure 3.10 'A thousand feet above Clifton', 5.20pm, 12 September 1898, taken during a demonstration flight for the British Association's annual meeting. The large building at the top is Bristol Grammar School, while at the bottom the tram lines, with tram, following Queen's Road can be seen. [Bacon 1900a]

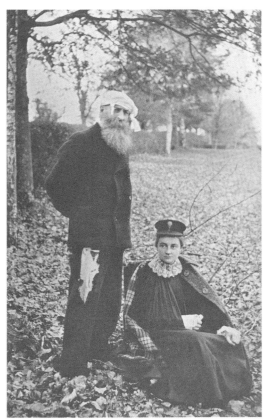

Figure 3.12 'Derby Castle, Isle of Man (from aloft)', 10 November 1902. This photograph was taken shortly after the start of a flight from the Isle of Man to Scotland, the aim of which was to try and make telegraph contact from the air with a Royal Navy vessel. [Bacon 1907]

Figure 3.13 John and Gertrude Bacon, patched up for the camera the morning after the crash landing shown in Fig 3.5. The only other casualty (of sorts) was a labourer who, on seeing the balloon swooping down at speed, locked himself in a stable in the apparent belief that the Boers were invading. [Bacon 1907]

already 30 years old by the time Bacon first took to the skies, but those three decades had not exactly produced an abundance of successful aerial views.

As we've already seen, Bacon's first flight was in 1888, the year that also saw the introduction of the first Kodak camera. Invented by George Eastman, it was simple to use and considerably more affordable than anything else on the market. The camera comprised a small, light, wooden box around 7in (180mm) long that contained a roll of film capable of holding 100 exposures rather than the usual plates. With a simple fixed focus lens and a shutter speed set at around 1/25 of a second, it could be used anywhere given the right lighting conditions. The photographer merely needed to turn a key to wind the film on, pull a string to set the shutter, point the camera at the desired subject and then press a button to release the shutter. Once the whole film of 100 exposures had been used up, the entire camera was returned to the factory, where the film was removed, processed and replaced with a new roll.

In Britain these first Kodaks cost 5 guineas, while developing and printing (initially) cost another 2 guineas a time – not cheap by any means, but it made photography far more accessible. Indeed, it has been argued that its appearance marked the beginnings of popular photography. Over the years, of course, it was refined and improved, and competitors appeared on the market, resulting in even cheaper cameras becoming available. Bacon himself made few comments on the nature of his camera equipment. However, in 1899 he did publish an article in *Cassell's Magazine* entitled 'A Kodak in the clouds' while, after his death, his daughter Gertrude referred to his use of an 'ordinary five-guinea Kodak camera' as late as 1902.[11]

Bacon's flying career also coincided with increased opportunities for the publication of photographs (Figs 3.14 and 3.15). Hitherto, their reproduction had been difficult and expensive. Clarity could leave a lot to be desired so publishers often relied on drawings or sketches of photographs instead. From around 1890, technological advances – notably the development of the half-tone process – made the whole business of reproducing photographs on the printed page a more achievable proposition. Partly as a consequence, the 1890s saw a considerable growth in the number of illustrated magazines on sale to the public.

The aerial view – a novel perspective on familiar places and landmarks – was already an occasional feature of illustrated magazines before the 1890s. Some, such as the *Illustrated London News* and *The Graphic*, either owned or regularly hired balloons for the purpose of illustrating particular events from above (Fig 3.16). Normally, the balloon would be tethered close to the action and

Figure 3.14 Newbury, *c* 1898 or 1899. The camera is looking north. [Bacon 1907]

Figure 3.15 'Filling the balloon at Newbury', 15 November 1899, photographed by Gertrude Bacon. Pictured is the 56,000-cubic-foot balloon brought to Newbury by Stanley Spencer for a voyage to view the Leonid meteor shower (*see also* Fig 3.5). [Bacon 1900a]

Figure 3.16 'Our artist in air – the car of the "Graphic" balloon' at the Easter Volunteer Manoeuvres, Portsmouth. [*The Graphic*, 19 Apr 1884, 369]

a sketch artist sent up to produce some kind of visual record. The Kodak and the half-tone process allowed for an increase in the number of aerial views being printed and meant that most sketch artists could keep their feet firmly on the ground.

Among the first illustrated articles dealing with aerial photography to appear in Britain was 'London from aloft', which featured in one of the earliest issues of *Strand Magazine*. Published anonymously, the accompanying photographs were taken by Griffith Brewer (*see* pp 74–7; Figs 3.17 and 3.18).[12] The balloon flight took place on 9 May 1891 and involved Percival Spencer[13] and his balloon *City of York*. The launch site was at the Royal Naval Exhibition in the grounds of the Royal Hospital, Chelsea. Near the beginning of the article, the author notes the intention to make use of 'an instantaneous "Kodak" camera', in order to record the views from above for 'those who will not easily be persuaded to practical "balloonacy"...'.[14] A subsequent flight from the same venue, with Brewer piloting for the first time will have done little to win over the doubters. According to a Mrs Creyke, who accompanied Brewer, they collided with the top of a pagoda in the exhibition grounds shortly after lifting off, before drifting through some wires carrying electricity to the lighting over the lake. The rest of the journey was comparatively uneventful ('...an extra sandbag was discovered under my petticoats, which relieved my mind a little about our descent'), the flight ending with 'a good bump' on Dartford Heath.[15]

Figure 3.17 'The Embankment and Exhibition Grounds', 9 May 1891. This is probably the second aerial photo taken by Griffith Brewer on his ascent (the first showed the crowd below just after the balloon took off). [*Strand Magazine* **2**, Jul–Dec 1891]

Figure 3.18 'Millbank Prison and its surroundings', 9 May 1891. Built 1812–21, the prison was pulled down in 1902; the Tate Gallery is among the buildings occupying the site today. [*Strand Magazine* **2**, Jul–Dec 1891]

Bacon's first 'scientific ascent'

The Reverend John Mackenzie Bacon's first 'scientific ascent' took place on 27 July 1898, from the grounds of Shaw House, Newbury. Gertrude Bacon later recounted:

There seemed scarcely room for the passengers in the car of the balloon, so packed was it with cameras, telescopes, electrometers, chronometers, thermometers, barometers, speaking-trumpets, ear-trumpets, horns, 'dust-counters', and every conceivable variety of portable acoustic and meteorological implement. They managed to wedge themselves in somehow, however, and when the moment of ascent came they were wafted up and away, notebooks, ear-trumpets, and stop-watches in hand, till they disappeared into the sky: while there followed them at preconcerted intervals, singly and together, in unison and discord, the lustiest hootings, tootlings, screechings, brayings, whistlings, and explosions, that continued long after the balloon, like a drop in the air, had faded into the clouds.[a]

Much of the noise came not from the balloon but from various points on the ground:

There was apparatus in plenty for both hearing and making a noise; giant 'ears', speaking-trumpets, and huge 'receivers'. Bandsmen with musical instruments, volunteers with rifles, a stationary engine to which were attached every variety of steam hooter, siren, whistle, and other ear-piercing invention to be obtained; while ever and anon there broke over the field the terrific report of a cotton-powder fog-signal, such as Trinity House uses for its lighthouses and lightships all round the coast. These were fired by the Secretary of the Cotton Powder Company himself, Captain Lynn-Smart, and each stunning explosion, louder than all the artillery of the battle …

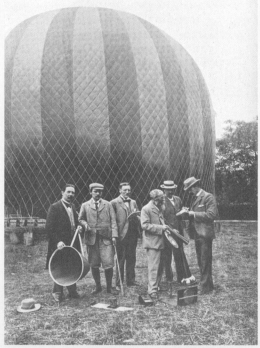

Bacon's first 'scientific' ascent, 27 July 1898, Shaw House, Newbury. Pictured are – from left to right – John Nevil Maskelyne, Dr R Lachlan, Captain Lynn-Smart, Bacon, H H Turner (Professor of Astronomy, Oxford University) and Nevil Maskelyne. [Bacon 1907]

was followed by an answering crash from the refreshment tent, where startled customers and waiters had dropped their cups and saucers. There were more noisy possibilities than met the eye. Three miles off the Sexton of Thatcham Church was preparing to ring up the heavy tenor of that steeple; while thirty miles distant, as the crow flies, artillerymen at Portsmouth, by special favour, were making ready at a given signal to fire the big guns.[b]

According to an article in *The Times*, the main aim of all this noise was 'to discover in what measure the intensity of sound is influenced by altitude, by the presence of clouds, &c'.[c]

Another piece of equipment used on that particular day was a kinematograph – an early cine film camera. The precise make is unclear, but it probably belonged to Bacon's friend John Nevil Maskelyne, the famous stage magician, exposer of bogus spiritualists and inventor of the first coin-operated lock for public toilets.[d] In her account, Gertrude Bacon made no mention of this particular instrument, but *The Times*' report of the day's events stated that '[d]uring a preliminary captive ascent Mr. Bacon succeeded in taking some excellent photographs from the car with a kinematograph'.[e]

An article published by Bacon later in 1898 in *Strand Magazine* included 11 frames of a kinematograph film, which was taken as the balloon ascended. They show the crowd below watching the balloon's ascent. It is presumed, but not certain, that these frames are taken from the 27 July flight. If so, it is a fragment of the first aerial footage filmed in Britain, if not the world.[f] Whether Bacon ever took a film camera up in a balloon again is unclear.

Notes

a Bacon 1907, 216.

b Ibid, 215–6.

c *The Times*, 28 Jul 1898, 10.

d Maskelyne's 'entertainment of pure trickery', in conjunction with George Cooke, ran at the Egyptian Hall in Piccadilly from 1873 to 1904. By the mid-1890s, Maskelyne had also developed an interest in moving pictures – other performers had begun featuring short 'living photographs' in their Egyptian Hall shows. Bacon accompanied Maskelyne in 1897 when he took a film camera to record – on the ground – Queen Victoria's Diamond Jubilee celebrations. The pair also filmed eclipses of the sun – again from terra firma – in India in 1897 (though the film was lost) and North Carolina in 1900 (the first successful filming of an eclipse). *See* Steinmeyer 2005; Herbert and McKernan 1996 (entries for both Bacon and Maskelyne); and www.victorian-cinema.net. The DNB also provides further details on Bacon and Maskelyne.

e *The Times*, 28 Jul 1898, 10.

f Bacon 1898. *See also* Fielding 1990. The Lumière Brothers also filmed from a balloon sometime in 1898 (Castro 2009, 14).

The first aerial photographs

Individuals like Bacon and Brewer may have done much to bring aerial photography to the attention of the general public, but they were a long way from being the first successful aerial photographers. The earliest known aerial photograph was taken some 30 years before Bacon's first balloon flight and was taken not over London but Paris.

By the time Gaspard-Félix Tournachon (known as 'Nadar') took that first photograph in 1858, the camera was no longer a novelty item. The pioneering days of Joseph Nicéphore Niépce, Louis Daguerre and William Henry Fox Talbot were in the past, and photography had progressed fairly rapidly from early attempts to permanently fix the image created by a camera obscura to the point where a captured negative image could be reproduced in the form of countless paper positive prints.

As we have seen, claims had already been made for capturing aerial views as daguerreotypes (*see* pp 14–15), although even considering the excellent lighting conditions available at altitude, the amount of time needed for a successful exposure would not have been achievable in a balloon basket. The degree of movement experienced by balloonists hindered attempts at airborne photography until much later in the century, when shutter speeds measurable in fractions of a second became widely available.

The earliest attempts at using an airborne camera were made by Aimé Laussedat, a colonel in the French Army's Corps of Engineers. He had suggested as early as 1845 that aerial photographs might have some value for map-making, but experiments in the late 1840s – using balloons and kites – appear to have been unsuccessful. Later attempts using a glass-plate camera lifted into the air by several kites also ended in failure.[16]

Nadar took up photography in the early 1850s, retaining the name he had used during his previous career producing caricatures for various journals.[17] He was first and foremost a portrait photographer and it is as a portrait photographer than he remains best known today. His approach to his subjects – including Charles Baudelaire, Gustave Doré, Sarah Bernhardt, Alexandre Dumas and Georges Sand – drew on his earlier career as a caricaturist and sketch artist, as well as a concern with developing photography as an art form. He wrote, for example, that

> …the theory of photography can be learnt in an hour and the elements of practising it in a day … What cannot be learnt is the sense of light, an artistic feeling … What can be learnt even less is the moral grasp of the subject – that instant understanding which puts you in touch with the model, helps you sum him up, guides you to his habits, his idea and his character and enables you to produce, not an indifferent reproduction, a matter of routine such as any laboratory assistant could achieve, but a really convincing and sympathetic likeness, an intimate portrait.[18]

However, Nadar's plan to photograph the ground from a balloon had practical rather than artistic aims – in October 1858 he made various patent applications for the idea of using aerial photographs for surveying and map-making. In these applications, he explained that the camera would be operated 'by means either of a lever attached to the car, and worked by a cord, so as to bring or remove a cap or cover over or from the lens, or if preferred,

a horizontal disc turning on a vertical axis…'.[19] His first real attempts at aerial photography soon followed.

Nadar was able to take advantage of important developments in photography that drastically reduced the exposure time required by the daguerreotype. In 1851 Frederick Scott Archer had invented the collodion (or wet-plate) process – this involved the use of a sheet of glass hand-coated shortly before exposure with collodion (essentially gun-cotton dissolved in ether and containing potassium iodide). The plate would be 'sensitised' by being coated (in darkness) in silver nitrate. The main difficulty was that the plate had to be both exposed and developed while still wet – effectively, Nadar had about 20 minutes to play with.

To give himself a fighting chance of success, Nadar converted the basket of his balloon into a darkroom, in which plates could be both prepared and developed. Initial attempts ended in failure and it was not until early December 1858, tethered 262ft above the Val de Bièvre on the outskirts of Paris, that he managed to capture something:

> It is nothing but a simple glass positive, very weak because of the smoky atmosphere, stained after so many vicissitudes, but no matter! It cannot be denied: here right under me are all of the three houses in the little village: the farm, the inn and the police station … You can distinguish perfectly a delivery van on the road whose driver has stopped short before the balloon, and on the roof-tiles two white pigeons who have just landed there.[20]

Nadar believed that the reason for his earlier failures was the coal gas escaping from the balloon above his head, desensitising his carefully prepared plates in the process. Gas would be blamed for photographic failures for some time to come – according to Nadar, it 'vomited forth in a torrent' during his flights, expanding as the balloon gained altitude and emerging through the open neck at the base of the balloon envelope.[21]

Nadar continued to make occasional forays into the air with his camera, although results were only sporadically successful. In 1859 he was approached on behalf of the French Army by a Monsieur Prevot, who offered Nadar money if he was willing to undertake aerial photography for military purposes. Apparently Napoleon III was interested not only in the use of balloons for military reconnaissance, but also in the use of photography from those balloons. Clearly this wasn't too far removed from Nadar's idea of mapping the earth from above, but in the end he rejected the approach after some unsuccessful trials.[22] Instead, he turned his thoughts towards heavier-than-air flight. On 30 July 1863, a meeting at his photographic studio saw the formation of the 'Society for the Encouragement of Aerial Locomotion by Means of Machines Heavier Than Air'. Members included Georges Sand, Alexandre Dumas and son, as well as aviation enthusiasts. Nadar himself was president, while the secretary was his friend Jules Verne, who had recently published his first novel *Five Weeks in a Balloon*.[23]

Nadar founded a magazine, *L'Aéronaute*, and sought to raise funds for the society by constructing the largest balloon ever seen, which would be made available for flights to the general public. Named *Le Géant*, its maximum capacity was a monstrous 210,000 cubic feet. The car was equally enormous, containing triple-decker beds for 12 passengers,

Figure 3.19 The basket of Nadar's *Le Géant*. Nadar actually brought the balloon to London in 1863, displaying it at the Crystal Palace. Although he never flew it there, it was partially inflated on at least one occasion. [NMR SC/00710/38A/01]

a darkroom, a printing press, a lavatory and much more (Fig 3.19). However, Nadar was keen to stress the serious nature of this venture: 'We are not about to amuse ourselves … in making portraits in the air. The balloon *Le Géant* will be employed in various works of aerostatic photography … and the results of which will be so valuable for all planispheric, cadastral, strategical, and other surveys.'[24] The balloon had a short, spectacular and near disastrous career with Nadar finally forced to sell it in 1867 to avoid financial ruin. Few photographs seem to have been taken from it and no surveys of any kind appeared, but he did get two books out of his exploits.[25]

Aerial photography in Britain before Bacon

The earliest known attempt at aerial photography in Britain occurred on 5 September 1862. Dr James Glaisher, head of the Meteorological Department at the Greenwich Observatory, and the balloonist Henry Coxwell were undertaking some experimental flights aimed at studying meteorological matters from balloons. Coxwell's balloon, later named *The Mammoth*, was around 90,000 cubic feet in maximum capacity (Fig 3.20). They chose Wolverhampton Gasworks as the venue for their 1862 flights and a gasholder there was specially reserved for their use. The first two flights saw them reach altitudes

Figure 3.20 Coxwell's balloon *The Mammoth* is seen here above the Crystal Palace grounds. Built in 1862 and intended initially for 'scientific' purposes, this was the balloon from which Negretti took his first aerial photograph in 1863. [Coxwell 1889]

well over 20,000ft. The third flight was even more remarkable. Reaching around 5 miles (26,400ft) in just under two hours, they were by now higher than anyone had ever been before.

The physical effects of extreme altitude on the two men were graphically recorded by Glaisher. At 5 miles high, Coxwell was already experiencing breathing difficulties and soon Glaisher was to have trouble seeing well enough the read the instruments. Briefly losing consciousness, he came round to find that Coxwell, having temporarily lost the use of his hands, had used his teeth to pull the cord to release some gas from the balloon, allowing them to descend. Eventually, they touched down near Clee St Margaret, Shropshire, having reached somewhere between 30,000 and 37,000ft, an altitude not subsequently survived without breathing apparatus. Perhaps unsurprisingly, Glaisher's attempts to take photographs during the rapid ascent were unsuccessful – the balloon was simply moving too fast. Despite their experiences, Coxwell and Glaisher continued with high altitude flights and Glaisher made further unsuccessful attempts at aerial photography.[26]

However, the first successful aerial photographs in Britain weren't much longer in coming. Coxwell was involved in another attempt in 1863, this time with the London-based photographer and maker of scientific instruments, Henry Negretti.[27] On Thursday 28 May 1863, with a temporary darkroom fitted into the car of the balloon and manned by an assistant, they took off from the gasworks in Lower Sydenham, London. Rising quickly, the balloon also began to revolve rapidly. After about 15 minutes, they had reached an estimated 4,000ft and the balloon had more or less ceased spinning. Drifting over the

Medway, Negretti readied his camera and exposed a plate: 'The exposure was almost instantaneous; but the brief period that elapsed between pouring on the developing solution and the appearance of the image was to me one of the most anxious suspense … and it was with some pardonable degree of exultation that I heard my assistant say "the picture has moved"… .'[28] In other words, there was a successful image, but not a very good one. Movement continued to be problem throughout the flight, but Negretti was content – he had demonstrated that photography from such altitudes was possible.

A *Daily Telegraph* correspondent who saw the photographs described them as 'tolerable', agreeing that

> [t]he net result of Mr. Negretti's aerial essay is … an establishment of the fact that photography is just as feasible an idea 5,000 feet above the level of the sea as in a commodious glass house in Regent Street or the Champs Elysées. The beautiful valley of the Medway has not been flattered by its *carte de visite*, taken in the car of the mammoth balloon; but, on another sitting, its fair face may possibly 'come out' more truthfully charming in the novel exposition of its loveliness…[29]

The Medway flight was partly a response to some recent experiments by Glaisher, which seemed to suggest that longer periods of exposure were needed at altitude. Negretti showed that the reverse was true.[30] However, he appears not to have persisted for long with aerial photography, presumably content to have established that it was achievable. Instead, others took on the challenge, particularly after the appearance in 1871 of the gelatine dry plate, which, unlike the wet-plate technique, didn't require an airborne darkroom.

However, there was one curious footnote to Negretti's adventure over the Medway. Publicity surrounding his achievement led to some unfortunate claims being made, prompting Nadar to respond:

> M. Negretti, the celebrated optician of London, has obtained this year, according to what has been stated, some beautiful negatives, of which it affords me great pleasure to hear, since it has ended in demonstrating that *I was right*. I shall only permit myself to observe to M. Negretti, that he deceives himself in claiming priority. The dates of my patents prove it, on the one hand; and besides, I have myself obtained, in spite of the most detestable materials, results (a simple positive on glass, it is true), above the valley of the Bièvre, at the beginning of the winter of 1858.[31]

Unlike Nadar's 1858 flight, Negretti took his photographs in 1863 from an untethered balloon; however, even if the claim of precedence for Negretti concerned photographs taken on a free run, successful untethered balloon photography had already been achieved across the Atlantic in 1860 (*see* American adventures, pp 72–3), an episode that Negretti also seems to have been ignorant of. Negretti's lack of awareness of Nadar's earlier success seems all the more remarkable given Nadar's presence – with his giant balloon – in 1863 at the Crystal Palace, where the firm of Negretti & Zambra held the photographic franchise.[32]

After Negretti, little serious experimentation appears to have occurred – in Britain, at least – the next episode of note occurring in 1877, when the photographer and inventor Walter Woodbury patented in outline a camera that could utilise either dry plates or a roll of film and was intended primarily for aerial use.[33] The camera would be used in conjunction with an unmanned tethered balloon where the tethering cable would contain wires that conducted electricity to the camera at the push of a button. One simple operation would cause the shutter to open and expose the plate, while a second button would cause a cube within the camera to revolve, resulting in a fresh plate being in position ready for the next exposure. Once the four plates had been exposed, the balloon was brought back to the ground, 'the plates developed into negatives, and by means of a magic lantern their image was thrown upon a screen or large piece of paper'. The film on the other hand was essentially paper coated with rubber, collodion emulsion and gelatine. Woodbury was not overly enthusiastic about it. The camera weighed 12 pounds in total and Woodbury claimed that the entire gear, balloon included, could be carried around in a hand cart 'like those used by Bakers in London suburbs'.[34]

Woodbury explained his ideas at a meeting of the Balloon Society of Great Britain, held at the Royal Aquarium, London, on 11 November 1881. In his lecture on 'Balloon Photography', he expressed his belief that 'though little had been done at present in the advancement of the science of photography for balloon purposes … the day was not far distant when they should be able to obtain bird's-eye views of all the principal towns and villages of the world, photographed, and laid map-like before us for our minute inspection'.[35]

Woodbury was quite explicit about the purpose and value of air photographs – each image should be 'an absolutely vertical picture such as would be necessary to get a correct map of the earth … We must not expect to get artistic pictures so much as plans.'[36] He also spoke of the military potential of his invention, a matter he had previously raised in a letter to *The Times* two years earlier – in the wake of the Zulu War of 1879 – arguing that the availability of aerial reconnaissance may have prevented the military disasters there.[37]

In fact, Woodbury appears to have viewed the military as the most likely beneficiaries of his camera, although he was to be disappointed. The Royal Engineers, to whom his invention was referred, opted to persist with a camera being developed by one of their own officers, Captain Henry Elsdale (*see* pp 27–8). Despite his extensive work on the subject, it is unclear if Woodbury ever took a successful aerial photograph. The lack of interest shown in his camera and his ideas led Woodbury to abandon them in 1882.

However, 1882 was the year in which Cecil V Shadbolt conducted his first successful experiments in photographing from balloons. As he explained to the readers of the *British Journal of Photography*, 'up to the time of undertaking the trip in question it had never been my good fortune to meet with any satisfactory photograph from a balloon, and, having a decided preference for practical results rather than for any amount of theory, I had long cherished the idea of making an ascent, accompanied by my camera'.[38]

His starting point was the Alexandra Palace in *Reliance*, a balloon belonging to a Mr Barker. Apparently the balloon was involved in a race, although Shadbolt claimed he never found out who won. Unusually, Shadbolt had decided not to hold the camera himself – instead,

he fixed the camera to the outside of the balloon car. As the balloon rose, Shadbolt tried to take a photograph, but was foiled by the amount of movement. However, once the balloon had steadied somewhat, Shadbolt returned to his camera:

> My third and most successful 'shot' was taken … just over the district of Stamford Hill, at which point the barometer recorded an altitude of 2,000 feet. In the resulting picture the streets, railways and houses below are clearly distinguishable. In this view, also, can be seen the vehicles beneath, while people walking on the pathways, although almost too small to be recognizable, are nevertheless to be distinguished.

Shadbolt continued to expose plates, until Barker persuaded him it was time to descend. Shadbolt's Stamford Hill print was included in the Photographic Society's annual exhibition held at the gallery of the Society of Painters in Water Colours, Pall Mall, beginning on

American adventures

In North America, the first successful aerial photographs were taken in 1860 by the photographer James Wallace Black, floating above Boston in Samuel Archer King's balloon *The Queen of the Air*.[a] They were almost certainly unaware of Nadar's achievements. On 13 October 1860, King and Black made two ascents. The first was a tethered flight, the balloon reaching around 1,200ft, at which height Black

> succeeded in getting some fine views of different parts of Boston. But we wished to get more extended views than could be obtained at such a height, and so after being drawn down, and detaching the rope, we ascended in the usual manner. Soon an expansive field was opened to us, and we hoped to be able to secure some magnificent scenes which we now scanned. Everything was in readiness, and an attempt was made to take the city, that was now sitting so beautifully for her picture.[b]

But at that point, an unforeseen problem – albeit one with which Nadar would have sympathised – intervened: 'The gas expand[ed] as the balloon rose freely from the neck, and filled the surrounding atmosphere, penetrating even into the camera, neutralizing the effect of the light, and turning the coating on the glass plate to a uniform brown colour. Several plates were spoiled in this manner before we discovered the cause; by which time we lost precious time, as we were rapidly drifting away in a southerly direction.'[c]

When exhibited soon afterwards, the photographs caused quite a stir. Oliver Wendell Holmes later commented that 'Boston, as the eagle and the wild goose see it, is a very different object from the same place as the solid citizen looks up at its eaves and chimneys … As a first attempt it is on the whole a remarkable success; but its greatest interest is in showing what we may hope to see accomplished in the same direction.'[d]

9 October 1882. An article in *The Times* noted that a 'photograph taken by Mr. Shadbolt from the car of a balloon at the height of 2,000ft, showing the streets and houses below, is also curious, though to those who do not know the difficulties attending this class of work it is a little disappointing'.[39]

Shadbolt continued with balloon photography – for example, on 15 September 1884, he participated in an event marking the centenary of the first balloon flight in England. Three balloons ascended from ground to the rear of the Finsbury Armoury, one of them being Captain Dale's balloon *Monarch*, 'in the car of which, besides the owner, were Mr. Shadbolt, with a photographic apparatus, and Mr. Emmett'.[40] Shadbolt became a regular companion of Dale's, making at least 60 ascents with him, many from the Crystal Palace, until both were killed in 1892; Shadbolt was 33 (*see* p 56).

One journalist suggested that the photographs should be adapted for viewing on a stereoscope, something with which Holmes – the designer of a particularly popular model of stereoscope – no doubt fully agreed.[e]

King insisted that 'no one can look upon these pictures … without being convinced that the time has come when what has been used only for public amusement can be made to subserve some practical end'.[f] However, efforts at achieving practical results tended for some time to end in disappointment and, in one case, disaster. Salamon Andrée, a Swedish engineer and explorer, sought to combine several of his interests in planning a balloon expedition to the North Pole. He devised a system of guide ropes that would drag along the surface beneath the balloon and hopefully give some control over direction, while photographs taken from the air would be used to map the terrain they passed over. The first attempt, in 1896, was aborted due to bad weather. Andrée and his team had another go the next year. The remains of the expedition were found 33 years later, including Andrée's journals and a number of photographs taken after the balloon had been forced down by freezing fog. The explorers had somehow survived for several months before the arctic conditions overwhelmed them.[g]

Notes

a For more on these first American aerial photographs, *see* Newhall 1969, 22–6; Doty 1983 and *The Photo-Miniature* **V** no 52.

b *The Photo-Miniature* **V** no 52, 155. This particular issue of the magazine was dedicated to aerial photography. Its full contents can be seen at http://robroy.dyndns.info/KAP-history/photo_miniature/aerial_photography.html, accessed 22 Apr 2009.

c Ibid.

d Holmes 1863, 12.

e Doty 1983, 11. For Holmes and stereoscopes, *see*, for example, Holmes 1859.

f *The Photo-Miniature* **V** no 52, 156.

g There are numerous sources for the Andrée expedition. *See*, for example, Rolt 1985, 152–8.

Brewer, balloons and precision photography

When Brewer set off on his first solo flight in August 1891, he became a member of a very small and select band of pilots; he reckoned there were not more than a dozen active balloon pilots in the whole country at the time.[41] Things began to change over the next decade or so, as ballooning slowly drifted from the showground and became an acceptable pastime for those with the money to pay for it (*see* The Aero Club of Great Britain, pp 76–7). Along with other balloonists, including Bacon (Fig 3.21), Brewer covered some of his ballooning costs by agreeing on occasion to hurl large quantities of advertising leaflets out of the basket once he was airborne. Brewer's first experience of airborne advertising came in May 1893, when he flew from Sheffield in a balloon designed to resemble a bottle of Gosnell's Cherry Blossom perfume with a rather phallic-looking neck and cork standing proud of the bottle's shoulders. During the ascent, Brewer was expected to throw thousands of handbills advertising the scent over the side. 'This was the equivalent of throwing out ballast, and the effect on the balloon was somewhat disquieting.'[42]

His ballooning ambitions grew rapidly. After failing in an attempt to become part of the ill-fated Andrée expedition (*see* p 73), he hatched his own plans to fly across the North Pole, going so far as learning to ski on a slope near Leeds and trying out kayaking at Teddington. He settled in the end for ballooning across the English Channel. This had been achieved on several previous occasions, but never by a woman – therefore on 20 February 1906, Mrs Griffith Brewer squeezed into the basket

Figure 3.21 'Leaflets thrown from a balloon', December 1903 or January 1904. Bacon wanted to undertake some experiments with his detonators in a London fog and to fund them accepted an offer to undertake some balloon flights for advertising purposes. [Bacon 1907]

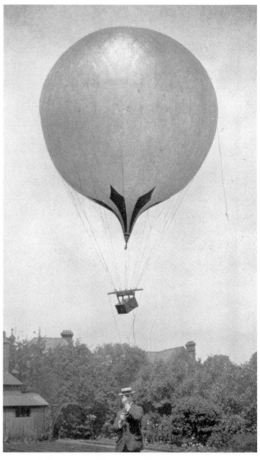

Figure 3.22 One of Brewer's 10ft-diameter balloons with automatic camera attached. [Brewer 1946]

along with her husband, Percival Spencer and Frank Hedges Butler. They took off from Wandsworth Gasworks on a day so cold that the sandbags froze, forcing the balloonists to dig out chunks of sand whenever they needed to offload ballast. On landing some 20 miles from Boulogne three hours later, Mrs Brewer 'ran up and down the sand-dunes to get warm. A little French padre ran alongside, firing questions at me, and very excited.'[43]

By 1902 Brewer had further developed his photographic ambitions and had gone beyond merely taking aerial snapshots with his Kodak. Instead, he was interested in what he called 'precision aerial photographs':

Figure 3.23 One of Brewer's 10ft-diameter balloons in 1903, inflated and stored in his garden shed. He could fill the balloon via his domestic gas supply, but hydrogen generated greater lifting power.

> My idea was to raise to a predetermined height a camera set at such an angle as to direct its lens at that height on to the piece of country to be photographed and then to release the shutter by electricity from the ground. This involved making an adjustable attachment to carry a camera beneath the balloon, arranging an indicator to show the direction in which the camera was pointing and fitting an electrical release for the shutter.

His chosen direction indicator was a white handkerchief, tied on to the camera equipment in such a way that it was possible to tell from the ground roughly which way the lens was pointing, even when the balloon had reached the limit of its 1,500ft of cable.[44]

Initially, he experimented with small balloons 6ft in diameter before moving up to a larger 10ft-diameter balloon (Fig 3.22). Made from goldbeater's skin, they were also filled with hydrogen, which provided better lift for the camera equipment. Hydrogen was, of course, both expensive and awkward to handle. It was sent by train from a firm in Wolverhampton, arriving compressed in steel 'bottles' weighing 80lbs each. Brewer built a shed in his garden large enough to contain one balloon fully inflated (Fig 3.23).

Brewer used this balloon-and-camera set-up at a number of locations, but was disappointed with the general response:

> I thought these demonstrations would in themselves be sufficient to introduce precision aerial photography from small captive balloons, but no one seemed to be interested in obtaining views from the air, and it required the coming of the aeroplane and the taking of photographs from aeroplanes to create the demand for air pictures. Then photographs taken from aeroplanes of seaside towns and other well-known localities followed and seemed to supply all the requirements.[45]

However, one subsequent use of Brewer's equipment pleased him. In the early 1920s, Brewer was contacted by P L O Guy, director of the University of Chicago's Meggido Expedition. Guy had a longstanding interest in the aerial view:

It is of a great help to the understanding of a piece of country, a town or a building to get to some high point in the vicinity and look down upon it, and the more nearly vertical one's point of view the more accurate is one's impression. In the 'nineties, as a boy, I used to spend hours at the top of the spire of Rouen Cathedral gazing down upon the city below, and it was only a step from this to record such a view photographically…[46]

While with the Palestine Department of Antiquities in 1922–3, Guy had been able, with the help of the RAF, to examine and photograph sites from the air. He wanted to use aerial photography at Meggido 'as an aid to recording ruins progressively exposed, and as a help in the often puzzling task of distinguishing excavated buildings of one stratum from those of another'.[47] Aeroplanes and full-sized balloons were beyond his financial reach, but he recalled

The Aero Club of Great Britain

The increasing respectability of ballooning was underlined in 1901 by the establishment of the Aero Club of Great Britain, later the Royal Aero Club.[a] It came into being following a flight undertaken by Frank Hedges Butler, his daughter Vera and Charles Rolls, soon-to-be co-founder of Rolls-Royce. They had planned a motoring tour, but when Vera's car caught fire, she arranged a balloon flight with Stanley Spencer instead. During the flight, as the champagne fizzed, the passengers discussed the idea of establishing an airborne equivalent of the Automobile

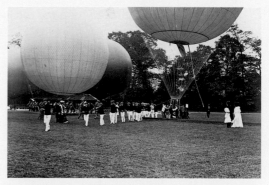

Ranelagh, 25 May 1907. Competitors for the Harbord Cup included Charles Rolls, Griffith Brewer, Frank Hedges Butler, Colonel Capper, J T C Moore-Brabazon, Major B F S Baden-Powell and Thomas Sopwith. [The Royal Aero Club]

Association. Vera Butler's presence ensured that, unusually for the time, membership was available to both ladies and gentlemen. However, there was not absolute equality. Ladies could not enter the club's premises, nor could they pilot their own balloons, instead relying on male members to take them up. As Griffith Brewer noted: 'They had the excitement and distinction of flying occasionally as passengers in their own balloons.'[b] Overall, the aims of the club conformed with J T C Moore-Brabazon's later reflection that 'to go up in a balloon is the only way to go into the air like a gentleman'.[c]

Nonetheless, Vera became a frequent flyer under the auspices of the Aero Club, and defended her participation and reputation vigorously:

reading about Brewer's earlier exploits with his unmanned goldbeater's skin balloon and camera. With advice from Brewer, Guy successfully obtained the necessary equipment and materials – even down to the shed in which to store the inflated balloon – and took his photographs. His only real problem was ensuring that the camera was at exactly the same height for each photograph as well as guaranteeing that it was pointing straight down each time. Like many before and since, he found ways to correct the scale and distortion to suit his purposes. Guy published an article in the archaeological journal *Antiquity* explaining his use of balloons and it inspired a few other archaeologists to try similar methods. Notable examples included German archaeologists attached to the SS, who used the technique to photograph excavations at Tilsit in eastern Prussia and an ancient inscription on a sheer cliff face at Bisitun in Iran.[48]

> Ballooning ranks as one of the most delightful and exhilarating pastimes of the twentieth century, in which women, without loss of dignity or affectation of 'mannishness', can share; and it has always rather amused me that whenever I confess to an unalloyed delight in the pastime, people should still regard me as avowing myself endowed with a spirit of foolhardiness and an unconventional love of adventure beyond the average of my sex.[d]

The Aero Club chose not to rely on the Spencers for their balloons. Instead, Moore-Brabazon and Rolls found another pair: 'We discovered two delightful young brothers named Short, who were doing ballooning shows, and we asked them if … they would make us a balloon.'[e] After a trip to France to check on the latest developments, the Short brothers established themselves in premises under the railway arches at the bottom of Lower Sloane Street, Battersea, and began making balloons. The Aero Club's main aims were to bring together people interested in ballooning and also to obtain balloons for members to fly, hence the need for the Short brothers. The Club helped establish ballooning as a fashionable activity through weekly events, including contests held at places like Ranelagh and Hurlingham. Their many private flights ascended from the less grand surroundings of the Battersea Park Gasworks, close to the Short brothers' premises.

Notes

a *See* www.royalaeroclub.org for details of the club's history and current activities.

b Brewer 1946, 63.

c Brabazon 1956, 38.

d Nichol 1906.

e Brabazon 1956, 33. Moore-Brabazon is referring here to the brothers Eustace and Oswald Short. The third brother, Horace, became involved with the firm in 1909 when they turned towards aircraft production, though they had trouble tracking him down. As Moore-Brabazon later explained, Horace 'had a deformity which consisted of an abnormally large head, quite alarming to view the first time you saw him. Eventually it was discovered that he had landed in Buenos Aires and walked to Mexico … falling ill on the way and being treated by the natives as if he were a god. He was finally found in Mexico managing a mine' (Brabazon 1956, 51).

Figure 3.26 Leysdown, Isle of Sheppey, 4 May 1909. The car is Charles Rolls' own Rolls-Royce. The occupants, left to right, are Rolls, Orville Wright, Griffith Brewer and Wilbur Wright. Note that two other individuals, presumably workmen, have been removed from the photograph. The Wrights were visiting the Short brothers' new factory, in which they were putting together six Wright Flyers under licence. Their sister Katharine gave Sheppey a miss, instead visiting Colonel Capper and his wife at Farnborough. [The Royal Aero Club]

ground on the Isle of Sheppey in 1909. It was soon followed by the world's first aeroplane factory, operated on Sheppey by the club's former balloon-builders, the Short brothers. The Shorts had obtained a licence to produce Wright aircraft, the result of longstanding contacts between the Wrights and Rolls (Fig 3.26). The following year, Rolls was killed when his aeroplane crashed near Bournemouth, an incident that prompted Moore-Brabazon's decision to quit flying. Aviation was no longer chiefly occurring on the ground.

Rockets and pigeons

As well as balloons, kites and aircraft, other – and more unusual – means of getting cameras off the ground were attempted. For instance, the idea of firing a camera into the air was first mentioned in the magazine *La Nature* in 1888; three years later in Germany, one Ludwig Rahrmann patented a system for sending a camera up using either a large gun or rocket, the idea being that the camera would slowly parachute back to the ground, snapping away as it did. Another patent was issued to Alfred Maul in 1903, again involving rockets that, this time, would launch the camera up to 2,600ft into the air. At that point the nose cone would come off and the camera, again attached to a parachute, would be set free. Camera plates were exposed using a pre-set timer.

Meanwhile, in 1903 and again in Germany, Julius Neubronner patented a pigeon camera weighing just 2½ ounces and taking negatives 1½ inches square. It proved particularly popular at the 1909 International Photographic Exhibition in Dresden, where pigeons were sent aloft with cameras strapped to their chests, the photographs being quickly processed and enlarged for sale as postcards. In 1912 Neubronner developed a panoramic camera for his feathered photographers.[54]

A sense of purpose?

But despite the developments in aerial photography with balloons, kites and aeroplanes – and such attention-grabbing novelties as rockets and pigeons – aerial photography itself seemed to have developed little sense of purpose beyond being a supplier of unusual views of the ground at a time when few had experienced any form of flight. By 1914 thousands of aerial photographs had been taken and hundreds had been reproduced on the pages of books and magazines, or as postcards. However, aesthetic appreciation of the aerial photograph had barely begun to take off, while practical applications seem to have stalled. Many aerial views had been taken by individuals who were fliers first and foremost, and in any case, when a professional photographer did go up, it was usually with strictly practical aims in mind (Figs 3.27–3.29). Nadar, Shadbolt and others had been quite explicit about

Figure 3.27 Stamford Bridge, 12.23pm, Saturday 7 November 1908. This view was taken at 1,300ft from the balloon *Britannia*. The photograph is possibly by Brewer. The stadium was built 1904–5 on the site of the former athletic ground. It was initially offered to Fulham Football Club, who rejected it. Instead, a new club, Chelsea, was formed to play there. [The Royal Aeronautical Society (National Aerospace Library)]

Figure 3.28 Wanstead Flats from *Corona*, 1909. This vertical view – again possibly by Brewer – appears to have been taken because of the balloon passing below rather than any interest in the landscape. The rope seen on the left side of the photograph is *Corona*'s 300ft-long trail rope. North is to the top of the photograph. [The Royal Aeronautical Society (National Aerospace Library)]

their intentions – aerial photography was a potential means of mapping the earth's surface. However, although real progress had been made over the same period in using cameras for terrestrial survey – photogrammetry, in other words – there had been little collaboration with aerial photographers. It was the First World War itself that proved to be the real catalyst for more significant developments.

Figure 3.29 Parliament and the Thames from the balloon *Corona*, 4.30pm, 22 May 1909. The photograph was almost certainly taken by Brewer, who seems to have undertaken numerous flights over London for photographic purposes between 1905 and 1910. [The Royal Aeronautical Society (National Aerospace Library)]

4 '…a diary of German doings'

Aerial photography and the First World War

Nine decades after it ended, the First World War offers a remarkable degree of contrast in apparently defining images – the aerial dogfight and the muddy stalemate of trench warfare – though the connection between the two may not be immediately apparent, beyond a drastically reduced life-expectancy once at the front. In fact, the Royal Flying Corps' primary role when the war began was reconnaissance. Airborne observation and intelligence gathering were essential to the war on the ground.

Although remarkable progress had been made in the six years since Samuel Cody's first flight on British soil, by 1914 British military aviation was less advanced, especially when compared with France and Germany. The reasons were many and complex, but chief among them was a belief in senior military and political circles that the aeroplane would have little to offer in war. Airships were perceived as a greater threat, but even then there were doubts about their ultimate effectiveness. These attitudes had led to the services of Cody and J W Dunne being dispensed with five years prior to the outbreak of war and all military interest and participation in experiments with aeroplanes ended. Fortunately, sense soon prevailed, but the whole episode underlined the difficulties some senior figures were having in trying to deal with matters beyond their experience and, for some, their understanding.

A swift change of heart followed Louis Blériot's crossing of the English Channel on 25 July 1909, as well as recognition of the serious attention certain foreign countries were paying to air power. In October 1910, in a complete turnaround, the War Office announced that the Balloon Factory at Farnborough would now be expected to maintain and repair the Army's aeroplanes (which, in fact, still belonged to the balloonists – flight still remained a function of the Royal Engineers). April 1911 saw the Balloon Factory renamed His Majesty's Aircraft Factory (and subsequently the Royal Aircraft Factory; Fig 4.1), while the Royal Engineers balloonists became the Air Battalion, Royal Engineers. The Royal Engineers' responsibility for military aviation finally ceased with the creation of the Royal Flying Corps (RFC) in May 1912. Although the RFC was initially intended to be a distinct organisation with separate naval and 'military' (that is, Army) wings, the Navy declined to play along and established instead what was to become the Royal Naval Air Service (RNAS). By 1914 all airships had been transferred to the Navy, leaving the RFC with aeroplanes, kites and balloons (Figs 4.2 and 4.3).

Figure 4.1 An aerial view of the Royal Aircraft Factory immediately prior to the First World War. A balloon shed can be seen top left (left of the first airship shed). The Farnborough Road crosses the bottom right corner of the photograph and the lighter coloured building closest to the road is the Swan Inn. [Imperial War Museum, RAE-O 605]

Figure 4.2 Rigid airship R23 being towed out for its initial trials, which began in August 1917. Four airships of this class were built. Note the manpower involved. [Pulman Collection]

Figure 4.3 A non-rigid airship of the RNAS patrolling the coast. [Pulman Collection]

Military aerial photography to 1914

Experiments with photography during this period continued pretty much as before. The use of cameras was tolerated, encouraged even, but practice and experiment continued to be left in the hands of interested individuals. As aircraft were mainly intended as reconnaissance vehicles, this may seem surprising, but set against the record of the previous 30 years, this absence of organised experimentation and development is less remarkable. In any case, it seems that aerial reconnaissance was initially regarded as an extension of traditional reconnaissance techniques – it was a matter for trained observers.[1] It was the practical experience gained in the early stages of the coming war that brought home the real value of aerial photography, and eventually of aerial survey, but the nature of that war – relatively static trench-based warfare highly suited to aerial observation – was largely unforeseen.

Nevertheless, some in the RFC recognised a need to experiment with photography from airships and aeroplanes long before August 1914.[2] Frederick Laws arrived at Farnborough as an air mechanic first class in August 1912. Breaking with tradition somewhat, he was also a keen and experienced photographer who, while in the Coldstream Guards, had set up his own darkroom. At Farnborough he was soon in charge of photographic matters and was provided with a cupboard under the stairs in the building that had previously housed the balloonists, plus a couple of men to assist him. Keen to get involved with aeroplanes, Laws was initially disappointed to be posted to No. 1 Airship Squadron.

As Laws later recalled, 'I soon found that air photography did not receive a very high priority. The impression given was that its importance was more or less what I chose to make of it. The greatest problem confronting the photographer was to get into the air.' Laws had to make a nuisance of himself to ensure regular rides as a passenger but was far from being alone in trying to attract the attention of pilots. Competition to get airborne wasn't solely connected with a desire to experience flight, or in Laws' case, to practice photography: '[T]o qualify for daily flying pay it was necessary to take off, if only for a few minutes, but I still believe that primarily my desire to fly was to take more and more photographs, and so to gain experience in this new profession.'[3]

Some of the aerial photographs that Laws managed to take were included in the Royal Photographic Society's annual exhibitions from 1912 and by 1914 these included examples taken from aeroplanes. More importantly, in 1913 Laws went up in the airship *Beta 1* and returned with a series of vertical images of the Basingstoke Canal, apparently in order to experiment with mapping from air photographs. The Watson Air Camera, as used on that flight, was the first camera purposely designed and constructed for aerial photography by the RFC. Fixed in place rather than hand-held, the camera had a 6in lens and used plates measuring 12.5in by 4in. However, although it was designed to take overlapping images, it was not built to a survey specification.[4]

With war seeming imminent, Laws – indeed, the whole RFC – moved to a camp on Salisbury Plain in the summer of 1914. One incident while he was there further emphasised the potential of aerial photography. Flying one day as a passenger in a Farman biplane, he took photographs of a parade. Studying them later, Laws spotted that tracks left in the grass by a sergeant major chasing off a dog were still visible several hours after the chase had ended.[5]

The reconnaissance experience

Aerial navigation was still in its infancy in 1914 and even a map might not help. Insall, who felt that during the early days of the RFC, 'the main function of an observer ... was to act as ballast', described a practice reconnaissance flight with Captain C C Darley at the controls one day in June 1914. The idea was to take off from Netheravon on Salisbury Plain and fly to Bath and back. Insall was perched on the petrol tank, right behind Darley's seat and with his knees pressing hard into his chest. After reaching around two or three thousand feet, '...we pottered along across the western half of the Plain, the horizon beginning to drape itself in the normal sepia-tinted veil of a summer heat-haze, and it was not long before I began to look for some sign of the city of Bath, which I knew lay somewhere on our right quarter'.[13] They never did find it and eventually a broken strut forced them down near Wells. The RFC's first reconnaissance mission of the war fared little better. On 19 August 1914, two planes took off, but each contained just a pilot. Although they were reminded to keep each other in view, inevitably they lost sight of each other before losing their way completely. Both had to land and ask for directions back. Subsequently, an observer generally accompanied the pilot (Fig 4.5).

Getting used to being airborne could be just as much of a problem. Shortly after the war, Air Commodore C A H Longcroft reminisced about his pre-war days in the fledgling RFC. Expecting to fly immediately, he was more than a little disappointed to discover that in April 1912 Farnborough was home to just four working aeroplanes. Instead, he recalled how his 'instruction started by a series of ascents in captive spherical balloons, of which several were available. I have never discovered a better test for finding out whether a prospective pilot is likely to be air-sick or not than the test of a captive spherical balloon.'[14] Lengthy spells in the basket of a spinning balloon, counting the cows on the common, were eventually followed by the occasional trip in an airship.

Aeroplanes first took part in training manoeuvres during 1912 and 1913, putting their reconnaissance potential to the test. Inevitably there were problems to be overcome, including some difficulty in getting airborne. The use of aeroplanes was often hindered by the size of the crowds collecting around the hangars to see them. Once in the air, given good weather there was little that could escape the attention of the flyers, although finding quick and efficient means of getting their intelligence to the appropriate recipients on the ground took a while. Matters weren't helped by a decision to destroy any intelligence report obtained at a height of less than 2,000ft. It was felt that in real combat, no aircraft would survive infantry fire at such low altitudes.[15]

These pre-war exercises also saw the first attempts at camouflaging ground troops and equipment from aerial observation.

Figure 4.5 An observer in an RE8 stands to take a photograph of the plane from which he is being photographed. The RE8 was noted for its stability; however, because reconnaissance and photography work made this plane into a sitting duck at times, it was not universally popular. [Pulman Collection]

Initial results were less than satisfactory. Simply covering equipment with any foliage handy made it no less conspicuous than if it had been left uncovered, while efforts at concealment in woodland were undermined by the sheer whiteness of the faces of the soldiers, who couldn't help looking upwards at the aircraft.[16]

Another role that the RFC needed to prepare for was one that had been previously undertaken from balloons – observing and correcting artillery fire. Although this continued to be undertaken from balloons during the war (see The 'balloonatics', pp 92–3), it became an important job for aeroplanes as well, although it was subject to some teething troubles both before and during the war. As Moore-Brabazon explained, 'gunners are brought up in the firm belief that ballistics is an exact science and that, wherever they point their guns, so the projectile goes exactly where they think'.[17] In other words, they didn't take kindly to being told by RFC observers where to shoot. This wasn't a short-lived problem, nor was it an exclusively British one. In 1917 Colonel du Peuty, a leading figure in the French Air Force, was reported as saying that he always dressed his observers up as gunners because the 'gunners then believed what the observers said'.[18]

Once war had begun, the RFC's pilots and observers found that reconnaissance sorties required more than just training. Flying back and forth in straight lines over enemy positions – within range of anti-aircraft fire and prone to attack from the air – required, as pilot Cecil Lewis emphasised, nerve: 'And it had to be done twice a day, day after day, until you were hit or went home.'[19] On top of that were the difficulties in recognising what was beneath you. Decades earlier, the Ordnance Survey had rejected Elsdale's aerial views as a cartographic aid (see pp 28–30); now it seemed that mapping conventions were not ideally suited to dealing with the reality of the aerial experience. As Lewis observed, there was a resemblance between the map and the ground, but the latter featured

> a bewildering amount of extra detail, a wealth of soft colour, of light and shade, that made it, at first, difficult to reconcile with its printed counterpart. Main roads, so importantly marked in red, turned out to be grey, unobtrusive, and hard to distinguish from other roads. Railways were not clear black lines, but winding threads, even less well defined than the roads. Woods were not patches of green, except in high summer; they were dark browns and blacks, merging, sometimes imperceptibly, into the ploughed fields which surrounded them…[20]

The trenches were just as confusing. On the ground it was possible to appreciate how they related to the local topography, taking advantage wherever possible of any significant variation in the lie of the land. From the air, that perspective was lost as the lofted view created the illusion of a landscape far flatter and smoother than it was in reality. Beyond the front line trenches, the network of second- and third-line trenches, communication trenches and much more besides displayed a bewildering complexity, particularly as new trenches were added and old ones abandoned and backfilled, or lost and regained. Given time, a luxury not allowed to many, it could all start to make sense, as Lewis recalled: '[W]hen I came to know my own section of the line as well as the palm of my hand, I could tell at a glance what fresh digging had been done since my last patrol.'[21]

Archaeologist O G S Crawford managed, via a mutual friend's contact with Moore-Brabazon, to get himself into the RFC as an observer in 1917. Anxious to avoid artillery

Figure 4.6 The Farman Experimental 2 two-seater biplane – or FE 2b – was first introduced in mid-1915 but didn't reach the front in any numbers until 1916. Capable of reaching around 72mph, it could reach its ceiling height of 9,000ft in a little over 40 minutes. [Pulman Collection]

spotting, which he considered both dull and dangerous, Crawford felt that the knowledge of the topography that he had gained while photographing and mapping the Somme front when he was attached to the 3rd Army (*see* pp 94–5) would be more useful in a reconnaissance or fighting squadron.[22] He was soon assigned a role as an observer in one of No. 23 Squadron's collection of FE 2b aeroplanes (Fig 4.6):

> The machines were prehistoric monsters whose motive power was a propeller placed amidships behind the pilot. The observer squatted in the nacelle in front; the Lewis gun was tied to an upright pole, and to fire it the observer had to stand with his feet on the top of the framework of the nacelle and fire backwards, avoiding if possible shooting his own aeroplane. This was not at all easy, nor could he see his objective without giving visual directions to the pilot.[23]

Crawford's plane was shot down – by the enemy – on just his second flight and he was sent back to Britain to recover from his injuries. After recuperating a while – including a weekend stay with H G Wells, whom Crawford had met the previous year when Wells visited France – he was sent to Farnborough. There he found himself among 'some

malingerers, and others who had committed misdemeanours. It was a curious way of disposing of the wounded, but observers in the RFC in this state were rare – they were usually killed outright – and I suppose this was the only place they could find to put them.'[24] Desperate to get away from there, Crawford again made contact with Moore-Brabazon, this time ending up in No. 48 Squadron where, much to his relief, his main role was to act as observer on planes escorting a naval squadron engaged in dropping bombs on enemy airfields. Given his post-war achievements (*see* Chapters 5 and 6), it seems a little surprising to find Crawford glad that 'we did not have to do much photography which we all, myself included, loathed'.[25]

Like Lewis and many others, Crawford also took a while to adjust to the aerial view of the ground. Fortunately, his archaeological knowledge came in handy when all else failed: 'I found the Roman roads very useful for locating positions, on account of their straightness – often prolonged, as in England, by hedges. Once when we had got lost I located our position by flying till we crossed – as I knew we must – the Roman road running south from Cassel.'[26] His archaeological knowledge also attracted officers with similar interests seeking his opinion on features seen on aerial photographs.

The archaeological aspects of the First World War landscape were not only noticed by those with a background in the subject. Servicemen who had spent any time in the military camps on Salisbury Plain will have found that some stretches of the Western Front closely resembled their training grounds (Fig 4.7). John Masefield, later to become Poet Laureate, wrote how 'the whole field of the Somme is chalk hill and downland, like similar formations in England. It has about it in every part of it, certain features well known to everyone who has ever lived or travelled in a chalk country.' Two particularly familiar formations were 'those steep, regular banks or terraces, which the French call *remblais* and our own farmers lynchets, and the presence, in nearly all parts of the field, of roads sunken between two such banks into a kind of narrow gulley or ravine'.[27] In gently rolling or even flat downland, banks and gulleys – lynchets and hollow ways – offered an obvious military advantage (or disadvantage, of course), particularly as, according to Masefield, both seemed ubiquitous. Naturally, advantage was taken if possible: 'Outside Gommecourt, a slight lynchet near the enemy line was prepared for at least a dozen [sniper or machine gun] posts invisible from any part of our line and not easily to be picked out by photograph and so placed as to sweep at least a mile of No Man's Land.'[28]

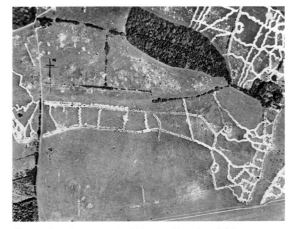

Figure 4.7 This is not the Western Front but Salisbury Plain. The trench system at Perham Down, part of which is pictured here, extended over some 100ha. As in France, such training trenches made use of both natural and archaeological features, in this case the earthworks associated with an extensive later prehistoric 'Celtic' field system – note, for example, the right-angled turn towards the bottom right of the photograph. [CCC 11753/9185]

The 'balloonatics'

O G S Crawford and his colleagues were not the sole undertakers of aerial observation. Tethered balloons continued to be used throughout the war, though the spherical balloons of old were rapidly dispensed with in favour of the elongated kite-balloon. Both use and design followed French practice after early recognition of their success at spotting and directing artillery fire. Ultimately this job was far better suited to the balloon – it could stay up for lengthy periods, all day if necessary; its position was fixed, so observation on particular points could be maintained as long as necessary; and the balloon could be hauled down and moved to a different location relatively quickly. One disadvantage was that the observers needed to be based at the front – there were 'no cosy safe billets as the aeroplane flyers had'.[a]

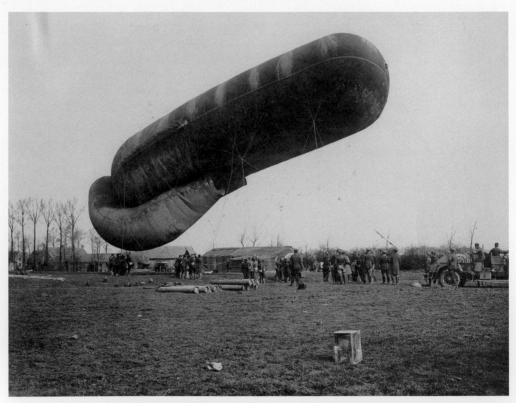

A British Spencer-Drachen kite-balloon about to ascend near Locre, *c* 1916. The photograph is stamped on the reverse side: 'Official photograph taken by permission of the Commander-in-Chief, BEF, and passed by the Chief Field Censor for publication'. [Photograph reproduced with the kind permission of the Royal Engineers Museum, Library and Archive]

In the words of Cecil Lewis, the kite-balloons 'hung in the sky like pensive and somewhat inebriated tadpoles'.[b] Suspended beneath them in baskets were the observers, directing artillery fire by telephone. Photography was undertaken occasionally, but does not seem to have been an important function of the 'balloonatics', as they became known. The main disadvantage of the tethered balloon was that it was something of a sitting duck (or tadpole). Guns were far more powerful – with greater range and accuracy – than in the Boer War, while the existence of aircraft meant that the balloons were particularly susceptible to high-speed aerial attack. As the war went on, the observers themselves, rather than the balloon alone, increasingly became targets.

This was a practice indulged in by all sides by 1918. RFC pilots 'could see no point in setting the cumbersome looking sausage on fire if the observers were allowed to get away with their information and their lives. I think I hit them. I hope I did.'[c] As for the German flyers who did likewise, Captain J E Doyle argued that they were simply doing their duty: 'In wartime the soldier's task is to defeat the enemy, and to treat a falling balloon observer as though he were a non-combatant is a neglect of duty … I have done it myself. I am not proud of the action but consider it fully justified.'[d]

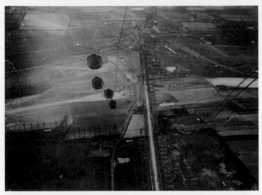

Aerial view taken from a British kite-balloon somewhere on the Western Front. The photograph features the same stamp on the reverse as the *c* 1916 kite-balloon image, so was presumably not taken purely for intelligence-gathering purposes. [Photograph reproduced with the kind permission of the Royal Engineers Museum, Library and Archive]

Notes

a G D Machin, quoted in Barker 2002, 89.

b Lewis 1936, 98.

c Ira 'Taffy' Jones, quoted in Morris 1970, 157. Jones added: 'Really, a balloon observer must expect to be killed, like any other combatant. After all, he is responsible for many enemy casualties. I shall always try to kill the observer if I can – distasteful as the job may be.'

d Captain J E Doyle, quoted in Morris 1970, 157.

Aerial photographs and interpretative mapping

RFC pilots and observers may have had trouble getting used to the differences between what they saw on their maps and what they could see hundreds or thousands of feet below them, but this wasn't just because mapping conventions and colours gave a false clarity to features in the landscape. Available maps of Belgium were of reasonably recent date, but those of France had Napoleonic origins. The areas occupied by British and French forces, especially around the front, urgently needed resurveying. Much of this work was undertaken using traditional ground-based methods, but from the early months of 1915 onwards, aerial photography was also used, particularly when seeking detail of the otherwise unreachable German trenches and the territory behind them (Figs 4.8–4.11).

One of those involved in this new survey work in France was Crawford, whose first attempts at survey had been on the Hampshire Downs a few years earlier. He had attempted a plane-table survey of the lyncheted field systems of Great Litchfield Down, but 'it was a difficult business because the banks were so ill-defined and eventually I gave up the attempt. Then the First World War broke out and I had to take part in it, rather unwillingly, because there were so many much more interesting things to do.'[29] Nonetheless, war didn't completely interfere with archaeological pursuits. One of Crawford's early duties was to take panoramic photographs across No Man's Land of the German trenches, placing his camera on suitable vantage points.[30] His commanding officer, Major H St J L Winterbotham RE, later recalled how 'Mr Crawford developed an extraordinary aptitude for taking these photographs, and displayed such an enthusiasm for unhealthy places that one wondered, until one came across a large bag of flint implements which he used to find in the Somme trenches in the course of his duties'.[31]

Surveying on the Western Front offered a range of new challenges. Initially, existing French maps were simply enlarged to a scale of 1:10000 and improved by getting hold of any plans available from municipal repositories and archives. Eventually, more

Figure 4.8 An oblique view looking north-east towards Poelcapelle during the Passchendaele Offensive of 1917. Note the long shadows cast by the surviving trees lining the road to Poelcapelle. [Pulman Collection]

Figure 4.9 Water-filled shellholes dominate this vertical view of an area just north-east of Broodseinde, a few kilometres south of Passchendaele. The most prominent surviving features are the pre-existing field and property boundaries, although some military structures can be made out. The darker areas on the right and bottom left were areas of woodland, known to the Allies as Daisy Wood and Dairy Wood respectively. [Pulman Collection]

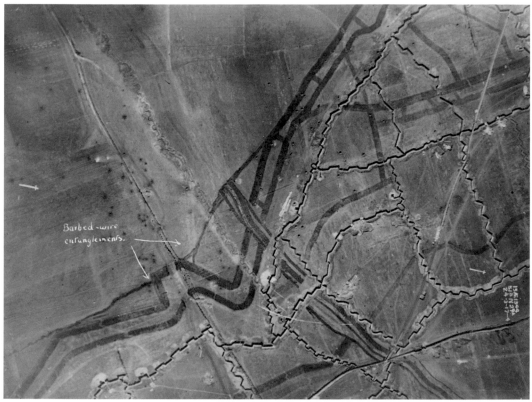

Figure 4.10 A vertical view of a stretch of the Hindenburg Line, a carefully prepared defensive position to which the German Army retreated in February 1917. The trench system appears chaotic in places, incorporating as it does elements of earlier defences. Note the backfilled trench extending eastwards, part of the earlier Wancourt Line. The thick black bands are multiple lines of barbed wire. [Pulman Collection]

up-to-date information flowed in from ground survey units and in the form of aerial photographs. Crawford later recalled the excitement felt at examining each new batch as they came in to 'see how the German trenches really ran'.[32]

Such excitement wasn't always shared by others. Crawford later recalled thinking that a map of the whole front in the 3rd Army's area of operations might prove useful, so he had one drawn up in generalised fashion. Copies were distributed to Corps and Divisional Headquarters, and to GHQ. The response was unexpected. An order came to withdraw the map immediately as 'the production of maps on unauthorised scales can only lead to confusion and disaster in battle'. As Crawford noted, 'the idea of a commander going into battle armed with my map was fantastic; it would be like making a town planning scheme on a map of Europe'.[33]

Similar difficulties were encountered by others. The first time that Moore-Brabazon and his colleagues produced a map of enemy trenches from aerial photographs, they

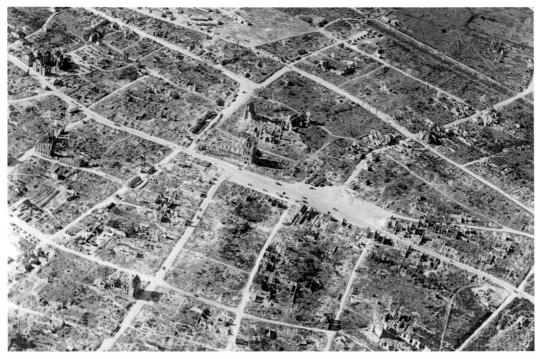

Figure 4.11 Oblique view of the centre of Ypres, probably early 1918. The 13th-century Cloth Hall and cathedral – both of which were rebuilt after the war – can be seen in the centre of the photograph. [Pulman Collection]

had the audacity to circulate these – would you believe it? – to the Army most interested, whereupon there was a great commotion. I was hauled up before Trenchard and smartly told off for butting into affairs I had nothing to do with. Maps were to be done by Maps GHQ, and nobody else had any right to go making them, and it was a disgraceful thing, and I ought to be ashamed of myself.[34]

Colonel Trenchard followed this dressing down, presumably requested by GHQ, with words of congratulation for the initiative taken, but suggested working with GHQ to take things forward in future. Later, concerned that the information visible on air photographs was not being fully explored or appreciated, Moore-Brabazon arranged production of a manual on air photo interpretation and again circulated it to interested parties – 'Again, I was hauled up and duly cursed, but again I was congratulated privately afterwards.'[35]

These were far from isolated incidents, particularly during the earlier years of the war, but for the most part the critics were soon won over. Moore-Brabazon later attempted to rationalise the initial opposition: 'All armies are curious organisations. They like to go on in the way which has been laid down ... and it didn't seem to be playing the game to use photographs of the enemy's lines.'[36] Such views may not have been widely shared.

As far as interpretative mapping was concerned, Moore-Brabazon 'never thought that the time I wasted in my youth putting jigsaws together would ever be of use in a war, but the

way I could fit all the pieces together of a sequence of photographs was the admiration of all my friends'.[37] He was referring here to the creation of 'mosaics' by joining together overlapping photographs. Actually interpreting the contents of such photographs was another matter altogether. The first real use of interpretative mapping to assist battle plans occurred in March 1915. The whole of the German defences at Neuve Chapelle up to a depth of 1,500yds were photographed from the air by Nos 2 and 3 Squadrons. Enemy trenches and other key features were mapped at a scale of 1:8000, with details of the British plan of attack then being superimposed. Copies of the map were then made available to all key personnel involved in the forthcoming battle. Implementation of the plan was a far from total success, but the need to photograph and map the enemy positions and supply lines when preparing such plans had been established.

After the war, the contribution of aerial photography was emphasised by Lieutenant Colonel M N MacLeod[38] during a lecture to the Royal Geographical Society on 17 March 1919. MacLeod argued that '…the aeroplane camera became the strongest weapon of the "Intelligence" staff and the topographer'. For the topographer, the photography allowed the natural and man-made aspects of the landscape to be accurately mapped in relation to each other. For the intelligence officer, the aerial photographs showed 'what is on the ground at any moment, so that … by studying successive photographs, and then watching the enemy's organisations, their natural change and development, [he] is enabled to detect and forecast his military plan'.[39] But as MacLeod also pointed out, it took a while for the 'intelligence' content of the photographs to be appreciated as fully as their topographical detail. It was one thing to map what could be seen, but to understand and interpret that detail required a different set of skills altogether. Reliable assessments also required additional information from other sources – intelligence summaries, prisoners' statements and so on – in order to build up a fuller picture of what was happening at particular places along or behind the German lines.[40]

It was partly Moore-Brabazon's realisation that there was more to be gained from studying aerial photographs that prompted the appearance of the first British guides or manuals to air photo interpretation: 'There were things like barbed wire and holes and paths and camouflage which we knew all about, and which I did not think were appreciated enough by Intelligence; so we got out a book on the interpretation of aerial photographs … [It] was tied up with the most gaudy R.F.C. ribbon, but it was the best we could do and we circulated that to Corps Headquarters.'[41] Indeed, the growing use of camouflage was something that demanded closer attention. For the first time, the armed forces on both sides of the conflict recognised the need to conceal troops, equipment and positions from aerial observers.

This first guide, dated 8 September 1916, was little more than a bound album of RFC aerial photographs, put together 'in the hope that they may be of use in furthering the closer study of aerial photographs as an aid to reconnaissance'.[42] Each vertical photograph featured annotations plus additional notes by Lieutenant St B Goldsmith of the 3rd Field Survey Company on 'points of interest', allowing the viewer to appreciate the difference between open, protected and concealed gun emplacements; to spot the presence of shelters, covered cable trenches, dummy trenches (they generally threw little or no shadow), railways and tramways of various gauge, vehicle tracks, dug outs and so on, as well as

(d) Examine the photograph as an item of independent evidence and then compare this evidence with reports of visual observation, locations given in Intelligence Summaries, and evidence of reliable prisoners. Eliminate those portions of this evidence which are obviously wrong; consider the likely places for the objects referred to in the remainder, and verify them. Avoid 'special pleadings' and do not allow yourself to read in a photograph what you *want* to see.

(e) Compare the photograph with earlier photographs of the same locality; it is from such comparisons that valuable results are obtained. This applies in particular to the appearance of objects on a photograph as affected by the changes of season.

(f) Be particularly careful to avoid obliterating detail when annotating or marking photographs.[46]

Perhaps with regard to the sort of error noted by Crawford, it was also emphasised that particular attention should be paid to shadow: 'Shadow plays a most important part in the interpretation of photographs. It is essential to ascertain the direction of light in order to decide whether the point under observation is convex or concave, and in order to get an idea of the depth or height of cuttings and embankments by comparison with the length of shadow cast by other objects.'[47]

As well as identifying and describing what could be seen on aerial photographs, the interpreter was also required to use skill and judgment to assess what these features might mean. Clearly, such guidance could only be offered at a basic level – there is little substitute for experience when it comes to the interpretation of aerial photographs – but it does reiterate the value of regularly rephotographing enemy territory. Thus indications that an attack could be anticipated included 'new lines of barbed wire, behind which occasional

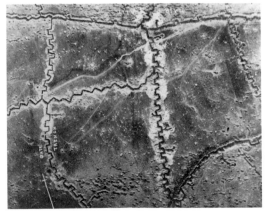 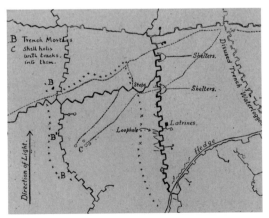

Figures 4.16a and 4.16b Photo and transcription of a trench mortar emplacement and environs somewhere between the Rivers Scarpe and Ancre in 1917. Note the relative invisibility of the barbed wire (marked by a line of Xs on the map). Lighter trench mortars were often located in open emplacements to allow a rapid movement to another location if necessary. These were notoriously difficult to distinguish on photographs from other small and/or temporary attachments to the trench lines, such as stores or latrines. Heavier mortar emplacements were more easily spotted, their presence often advertised by a mound or a surrounding ring of earth. [Pulman Collection; Royal Air Force Museum]

traverses and dug-outs appear, marking the trace of an intended new line; general strengthening and deepening of trenches; addition to existing wire; rapid construction of intermediate and switch lines; and an increase in battery positions'.[48] Indications that an attack was likely, if not imminent, included

> [a] sudden increase of artillery activity or in the number of battery positions; an increase in the number of communication trenches; a series of saps pushed forward and hastily linked up; possibly, in the case of small attacks, new assembly trenches in or behind the front line trenches, or numerous small T shaped trenches or recesses for holding extra groups of men belonging to the second wave of the assault; and a rapid increase in the number of light railways.[49]

As well as the obvious military features, it was also essential that the interpreter be familiar with the more mundane and the non-military elements. To be able to identify ordinary everyday structures from above took a certain amount of experience and was one of those areas where the chance to take to the skies occasionally proved invaluable. This was, of course, difficult enough in one's own country, but could be even more so when abroad.

Thus Lieutenant I M Bonham-Carter of the RFC circulated some brief notes as early as 1 November 1914 to assist both observers and photographers on the lookout for enemy activity. He noted, for instance:

> In the S.W. district of BELGIUM, tobacco or some sort of herb is hung up to dry under lean-to straw shelters, which from the air look like bivouac shelters. These shelters have been usually seen in paddocks and orchards near hamlets, and are placed in series of even rows. I have also observed straw litter in their vicinity, where doubtless the shelters were made, which gives them the appearance of being occupied by troops. It is conceivable that these are being reported as the enemy's bivouacs. I have observed them both from the air and the ground.

Bonham-Carter also recalled that in the same region, '[r]oots (beet or turnip), when gathered, are put in large piles by farm buildings and covered by earth, which is dug from the sides. From the air these piles have the appearance of trenches.'[50]

Of more concern to the troops on the ground were other unfortunate resemblances between unrelated structures or features. As Edmund Blunden complained, 'it is the case that a trench latrine and a trench mortar emplacement mapped from the air look alike, and one's visits were always the worse for that knowledge and occasionally for directed or misdirected shells'.[51]

Aerial photography: Different views

Two contrasting kinds of aerial photographs – verticals and obliques – have already been noted in earlier chapters. Although vertical images were by far the most numerous and valuable during the First World War, oblique views continued to be taken and could fulfil quite valuable functions. For the British forces at least, the war also saw the first real use of stereo photography, offering the interpreter a three-dimensional view of the ground.

The various interpretative guides produced from late 1916 onwards dealt almost entirely with vertical photographs – with most cameras by then being fixed to the planes and facing straight down, such views would clearly account for almost all photographs encountered by the interpreter. Nonetheless, oblique aerial photographs – views taken with the camera pointing at the ground at an angle rather than straight down – were taken. Again, the camera was often fixed, but obliques could also be taken with hand-held cameras. *Notes on the Interpretation of Aeroplane Photographs* explained the value of these oblique views:

> Oblique photographs give a view such as an observer from a high hill is accustomed to see. Hence, though necessarily somewhat distorted, they convey more information to the *unskilled* student of air photographs than do vertical photographs. They disclose details such as machine gun emplacements otherwise hidden, identify individual trees of which only the tops can otherwise be seen, and indicate the contours of the country. They also give valuable assistance in working out the heights of embankments and the depths of sunken roads.[52]

Thus they provided one means of checking maps compiled from vertical photographs. They served other purposes too. Moore-Brabazon recalled taking 'oblique photographs, for tank attacks, with cameras of up to seventy-two-inch focal length',[53] the aim being to give those driving the tanks some indication of what obstacles lay ahead, from a perspective somewhat closer to their own. Obviously, taking obliques was a more dangerous task for aeroplanes, as it usually required flying from lower altitudes than would be the norm with vertical photography. All photography from balloons during the war also comprised obliques (vertical images from a balloon tethered behind one's own front line were of rather limited value).

The principles of stereo photography had been long understood – indeed the first stereoscope pre-dated photography. It had been invented in 1838 by Sir Charles Wheatstone and used drawn images to achieve the three-dimensional effect. Moreover, it was designed not as a means of presenting or displaying images, but as a device for investigating binocular vision. However, it quickly became adapted as a means for viewing photographic images.

A stereo view is created by taking two photographs of the same object from the same distance but from a slightly different viewpoint (Fig 4.17). When examined through a stereoscope – which ensures that each eye views only one image – a three-dimensional image can be 'seen' once the photographs are correctly lined up. No special cameras are needed to take a stereo pair – all that is required is that the photographs are not quite identical. Thus the earliest three-dimensional photographs, taken with an ordinary plate camera on a tripod, involved exposing the first plate, moving camera and tripod a few inches to the left or right and then exposing a second plate. Stereo cameras, with twin lenses spaced 2½in apart – regarded as the average distance between a pair of human eyeballs – quickly followed.

The popularity of the stereoscope during the late Victorian and Edwardian periods in particular was considerable, with many specially taken stereo pairs of photographs on the market to satisfy demand. Typical subjects included famous places and landmarks, scenic

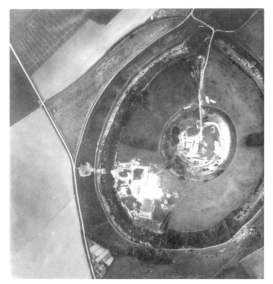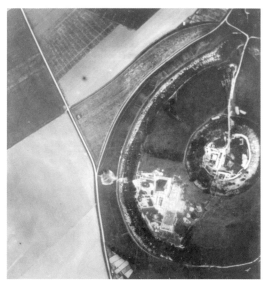

Figure 4.17 A stereo pair of vertical aerial photographs of Old Sarum, near Salisbury, Wiltshire, November 1915 or earlier. During the autumn and winter of 1915 experimental stereo photography was undertaken from Upavon with the aim of evaluating (a) the ability of pilots to take overlapping pairs and (b) the military potential of the technique. Coincidentally, the photographs captured the final season of archaeological excavations, led on the ground by William Hawley on behalf of the Society of Antiquaries. [The National Archives, ref AIR 1/506/16/3/45]

views at home and abroad, and, inevitably, pornography. One individual who encountered the 'old queer magic' of the stereoscope during this period was the young J B Priestley, who after the Second World War recalled how 'you never get tired of the thing ... Nothing that we have invented since the stereoscope ... has to my mind offered us an adequate substitute for its peculiar enchantment.'[54] That the 'old queer magic' might be of surveying or cartographic value had long been recognised, particularly for terrestrial surveying, but it was the advent of the aeroplane and the particular circumstances of the First World War that prompted serious military investigation of its potential. Even so, by November 1918 the use of stereo photography, especially for mapping purposes, was still very much in its infancy.

The problem faced by military cartographers during the war was the same as the one that had been faced by ground-based surveyors during the later 19th century – how to measure angles and distances in the stereoscopic image and then transfer that detail to a map. Experiments in using cameras for surveying had been taking place almost since the advent of photography, with the first photo-theodolite appearing in the 1860s, but attempts to use the three-dimensional image provided by the stereoscope didn't really begin until the 1890s. For surveying purposes, however, replicating the view seen by human eyes was inadequate. A significant property of the stereoscopic view is that the greater the distance between the point at which the two photographs are taken, the more exaggerated the third dimension appears to be. In a stereoscopic image, the height or depth of a particular object is not proportionate to its length or width, but to the distance travelled by the camera between successive exposures. Thus when Edouard Deville began using stereo photography to speed up his surveys of remote or rocky parts of Canada in the 1890s, the baseline – the distance he moved the camera between successive photographs – was typically 300ft.

The difficulty in making practical use of a stereo image, of course, is that the stereoscopic view has no external reality – it exists solely in the mind of the observer. Nonetheless, during the first decade of the 20th century, plotting devices had been developed – for example by Henry Fourcade in South Africa, Carl Pulfrich in Germany, Frederick Thompson in Britain and Deville in Canada – that allowed mapping to be undertaken directly from a stereoscopic image. However, they could not be used for plotting from aerial photographs – it was impossible to ensure that the photographs making up the stereo pair were taken in the same plane; it was also impossible to know the position of the camera at the moment each plate was exposed.

On the Western Front, the progress that had been made prior to the war with stereo-plotting machines was ignored altogether. Indeed, within Britain there had been far less enthusiasm shown towards surveying with cameras – photogrammetry – than in other countries. Consequently, while the Germans, for example, put a lot of effort into improving mechanical techniques for mapping from stereo aerial photographs, the British effort focused on methods for rectifying individual images, usually involving some form of tilting and rephotographing to adjust for the distortion caused by the aeroplane not being truly horizontal to the ground. The stereoscope was used primarily for interpretation, not cartography.[55]

For First World War aerial photography on the Western Front, once the faster automatic cameras became available, it became possible for pilots to take photographs at sufficiently short intervals to ensure enough overlap between successive plates so that, when viewed through a stereoscope, the interpreter was greeted with a three-dimensional view of the ground.

Experimental flying in southern England during 1915 brought home both the benefits and simplicity of the technique:

> [T]he process has now been made very simple and easy. Undoubtedly it has great military value and the subject should certainly be included in the training of all photographic Officers and men in the RFC … [If] certain simple rules are observed, the taking of stereo photography from a moving aeroplane is as easy as making ordinary ones … It is not necessary to have a special camera for this work, but it is necessary to have a method of changing plates or film fairly quickly … With the Moore-Brabazon magazine changer, however, plates can be changed in about one second, so that this makes the ordinary Royal Flying Corps pattern camera with this fitment an ideal one for stereo work.

It was felt that the basic principle could be taught to anyone in a couple of hours, while two or three days' of practical instruction was said to be sufficient to teach officers or men enough for them to be able to work efficiently in the field.[56]

Once the technique had been perfected, Moore-Brabazon demonstrated it to Staff via stereoscope, one officer at a time. He also tried a less time-consuming means of getting his point across. The 'anaglyph' method – probably the most familiar means of viewing three-dimensional images until recently – was patented in 1891 by French scientist Ducos du Hauron, although he had first outlined the principle as early as 1869. Moore-Brabazon

arranged for stereoscopic views to be projected 'to show relief, on the well known principle of projecting one photograph through red and the other through green and viewing them through red and green spectacles. By this means the eye can see only the one picture it is meant to see, and so a stereoscopic effect is maintained.'[57] While the anaglyph technique was eminently suitable for demonstrating stereoscopic images to a roomful of officers kitted out with coloured spectacles, it proved less useful for interpretation and mapping purposes. Overall, it was felt that the anaglyph method added little to the standard stereoscope experience, particularly given the additional apparatus, time and costs involved.[58]

The three-dimensional view provided by overlapping vertical photographs was, of course, of immense value, though as we have seen, its potential was not fully recognised or realised during the war. Lewis's complaint that the landscape appears to lose its contours when viewed from the air has already been noted (*see* p 89) and this apparent flattening of the ground surface is equally evident when viewing single vertical photographs, whatever the altitude from which they were taken. Overlapping verticals have precisely the opposite effect. When seen through a stereoscope, the interpreter is provided with a view denied to the photographer.

The wider view

As well as the Western Front, aerial photography and interpretative mapping were also undertaken with great success elsewhere during the war – for example German East Africa, Salonika, Palestine, Mesopotamia, some of these being mapped for the first time as a result. Hugh Hamshaw Thomas, a palaeobotanist based at the University of Cambridge prior to the war, undertook pioneering work in this respect in Palestine, constructing air photo mosaics that formed the basis of the first accurate maps of the region. These included a map at 1:40000 scale produced in advance of the Battle of Gaza. Hamshaw Thomas returned to Cambridge and his studies after the war, but was to reappear as an air photo interpreter during the Second World War (*see* p 202).[59]

The rapid growth of aerial photography on the Western Front during the First World War is evident from the available statistics. In October 1918 Moore-Brabazon contrasted the situation then with that at the outset of the war – 'though it took us nearly six months to get the first 100 aerial photographs taken, it is not an uncommon thing now in the summer days during the war for the Flying Corps to take over 4,000 photographs in one day'.[60] By the end of the war, more than 5,000 cameras had been supplied for aerial use, while personnel had grown from three to around 250 officers and 3,000 other ranks, in addition to a specialist School of Photography at Farnborough. As for the number of photographs, Moore-Brabazon estimated that the number of prints issued from early 1915 to the end of the war was as follows:

1915	80,000 (presumably an estimate)
1916	552,453
1917	3,925,169
1918	5,676,101[61]

traces of the conflict on camera in exactly the same way as it records the traces of more distant times – as earthworks, cropmarks and soilmarks. A war that has long relied on contemporary documents and eyewitness testimony is increasingly being studied using archaeological techniques. As Nicholas Saunders noted: 'When the last old soldier passes away, anything new about the war will … belong in the realm of the archaeologist.'[69] To date, the main archaeological methods employed have been excavation and the analysis of the material culture – the artefacts, both personal and military – of the war. The potential contribution of aerial photographs old and new to the study of the landscapes of the conflict has yet to be fully realised.[70]

As already noted, much photography also occurred over the British Isles during the war and those photographs have a role to play in understanding the 'home front', even if their actual military content is minor. Many, though not all, were taken during training flights and subjects include famous landmarks (Fig 4.18), cities, towns, villages, historic sites, military camps and airfields (Fig 4.19). Photography continued over the British Isles after the war, again often as part of training for pilots and observers; the photographs

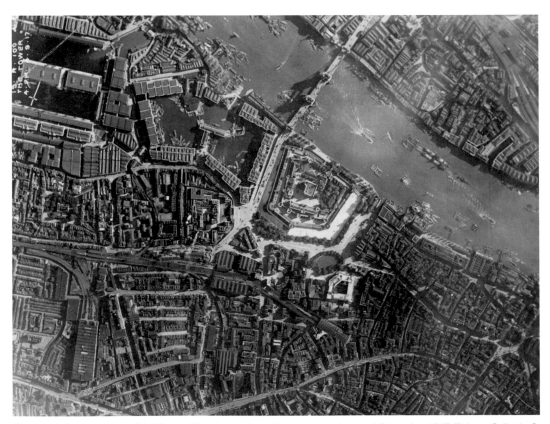

Figure 4.18 Vertical view of the Tower of London and its environs, taken at 4pm on 4 September 1917. [Pulman Collection]

Figure 4.19 Oblique view of the southernmost of two RFC training aerodromes at Yatesbury, Wiltshire. [Pulman Collection]

Figure 4.20 First World War practice trenches adjacent to Yambury Iron Age hillfort, Wiltshire, photographed on 3 May 1923. Top left is the former RFC practice bombing target and top right are the plough-levelled traces of much earlier archaeological features. [CCC 11822/130]

Traces of the past

Why should traces of something that happened centuries, or perhaps millennia, ago be visible today in a field of, say, wheat, barley or peas?

Buried archaeological features can affect the rate of growth of crops planted into the soil above them. Ditches, pits and other features dug into the subsoil have, over the centuries, become filled by a variety of means. They provide a greater depth of soil than can be found in their immediate surroundings, something that can lead to enhanced growth of the crop immediately above them. Alternatively, a reduction in soil depth caused by the presence of, for example, buried wall foundations or compacted surfaces such as floors or Roman roads can inhibit growth. From above, the patterns created can be observed from the differences in crop colour and height during various stages of the growing season.

The key factor in all this is the amount of moisture retained within the soil. A lack of moisture – generally caused by a lack of rainfall before and during the growing season – can exaggerate the effects of greater or lesser soil depth, making archaeological and natural features easier to spot. Visibility varies considerably according to the nature of the soil and subsoil, with the better-draining soils on chalk or gravels, for instance, more likely to produce cropmarks than clay soils, which tend to be better at retaining moisture. In addition, the type of crop can play a part, with cereals being the most likely to produce distinct cropmarks.

Cropmarks including the ditches of a probable Iron Age enclosure at Whaddon, Cambridgeshire. [NMR 23036/08, 15 Apr 2003]

There are a number of potential pitfalls to be borne in mind, in particular the fact that variations in soil depth can occur for a number of reasons, not all of them due to human intervention or of archaeological interest. Pipelines, land drains, recently removed field boundaries – all can produce cropmarks, while agricultural practices such as irrigation and weedkilling techniques can also affect crop growth, often producing circular or linear variations that can resemble the shapes and forms of particular archaeological monuments. 'Natural' causes include patterns in crops forming above geological features such as fissures and frost-cracks.

When there is no crop currently planted and growing, the observation of ploughed fields can still be productive

as the action of the plough reveals differences in colour and texture between the infill of ditches, the material used to construct banks or walls and the surrounding soil, a phenomenon that also demonstrates the destructive nature of the processes that the aerial archaeologist has to rely on.

Finally, there are the slighter earthworks – slight either because they were low to begin with or because they have at some point been subject to some process of erosion, including ploughing. These can best be observed from a higher vantage point at times when the sun is low and more likely to cast shadows. By the early 1920s, even before O G S Crawford first observed cropmarks and soilmarks on aerial photographs, there was a reasonable understanding of their causes, although those with that understanding were in a distinct minority with previous discoveries and discussion having been intermittent, seldom leading to any further investigation. It was their recognition on aerial photographs that led to greater and more considered discussion on their causes, meaning and extent, with the starting point being the summoning of Crawford to RAF Weyhill in 1922 (*see* p 132).

Long barrow at Nutbane, Hampshire. Largely levelled by ploughing, excavations in 1957 showed that a long and complex sequence of construction was still evident. This photograph shows what was visible in bare ploughed soil 40 years later. Note the way the plough has moved material back and forth, giving the chalk mound a jagged appearance. [NMR 15719/10, 25 Sep 1997]

Some of the earthworks surviving around Little Sodbury in Gloucestershire. The main features here are the ridge-and-furrow representing medieval or post-medieval arable agriculture and some pillow mounds, or artificial rabbit warrens. Note how the direction of sunlight can enhance or reduce the visibility of features. [NMR 21475/01, 15 Nov 2001]

'The assistance of the sun'

What is probably the earliest written description of a cropmark was made by poet and antiquary John Leland, who visited the site of the former Roman town of *Calleva Atrebatum* – modern Silchester (Fig 5.1) – during the course of the extensive travels that provided the basis for his famous *Itineraries*. The precise date of his visit is unclear but it was probably around 1540. Among his general comments on the place, he noted: 'There is one straung thing seen ther that in certen Partes of the Ground withyn the Waules, the Corne is mervelus faire to the Yee, and ready to show Perfecture, it decayith.'[2]

The centuries separating Leland from Crawford saw many similar comments made by antiquarian visitors to ancient sites, but while the phenomenon was accepted as genuine, it was some considerable time before observers began to understand what they were seeing. Around half a century after Leland, the historian William Camden also commented on Silchester in his *Britannia*: 'The inhabitants of this place told me, it had been a constant observation of theirs, that though the soil here be fat and fertile, yet in a sort of baulks that cross one another, the corn never grows so thick as in the other parts of the field; and along these they imagine the old streets of the city to have run. Here are commonly dug up British Tiles and great plenty of coins.'[3]

Another edition of Camden's *Britannia* also referred to a similar phenomenon at the Roman settlement site beside the fort at Richborough, Kent (Figs 5.2 and 5.3): 'But now age has

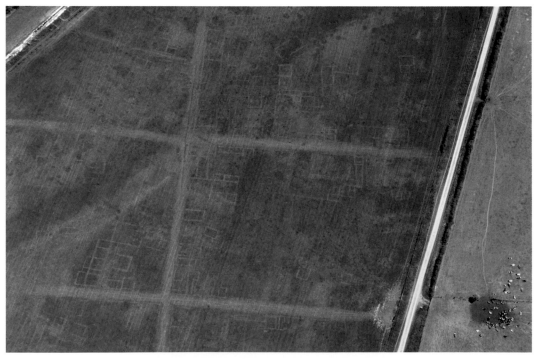

Figure 5.1 Silchester: roads and buildings still visible, given the right conditions, within the Roman town some 450 years after Leland's visit. [NMR 15292/05, 27 Jun 1995]

eras'd the very tracks of it; and to teach us that Cities dye as well as men, it is at this day a corn-field, wherein when the corn is grown up, one may observe the draughts of streets crossing one another, (for where they have gone the corn is thinner) and such crossings they commonly call S. Augustine's Cross.'[4]

The next antiquarian to record the phenomenon was John Aubrey and once again Silchester was the subject of his attention. He visited the place in 1667, but presumably the corn wasn't cooperating when he was there. Instead, he offered the observations of 'two learned prelates ... who went together to see these ruins (1658) who did affirm, that one might discern in the corn-ground ('twas about April) the sign of the streets, passages, and also of the hearths'.[5] Silchester was also visited by the antiquary Thomas Hearne c 1714, apparently following up Leland's note. Hearne also spotted something similar at Dorchester-on-Thames, Oxfordshire, in 1722, writing: 'Above the stone that shows Oxford way around Dorchester is the trace of a strange old path, as appears from the corn when it comes to be almost ripe, which is then of quite a different colour from the rest, like that at Silchester.'[6]

Generally, these antiquaries were describing what they saw, or what others told them about, with little or no additional comment. As with their antiquarian writings generally, they were recording observations at or about ancient sites without any further analysis which, in any case, may have seemed superfluous. What was so surprising about a Roman town possessing streets and hearths?

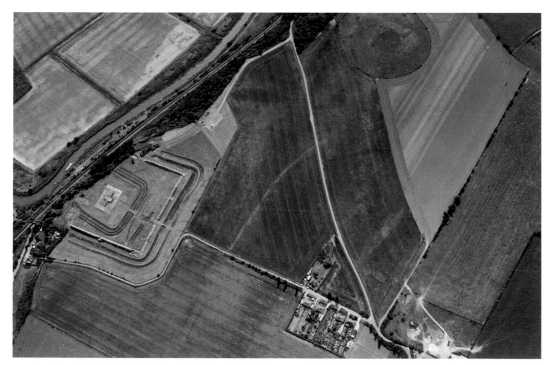

Figure 5.2 Richborough, Kent, during the summer of 2001. The faint cropmarks of Roman settlement can be seen in between the more visible Roman fort (left) and amphitheatre (top right). [NMR 21266/05, 16 Jul 2001]

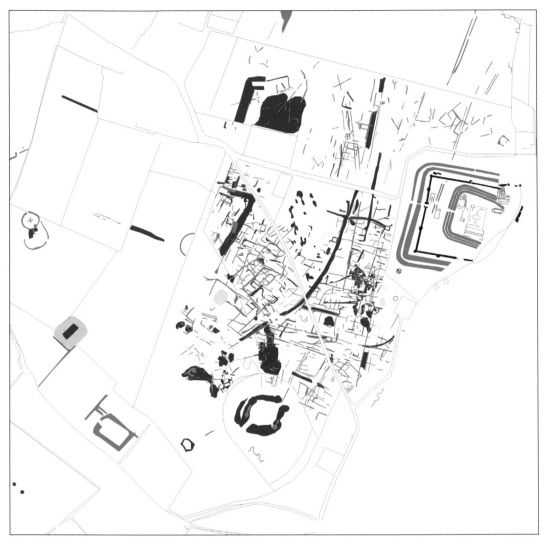

Figure 5.3 Richborough: The 'draughts of streets' and much more besides in 2002, nearly four centuries after they were first noted in Camden's *Britannia*. Features that are, or were, upstanding to some degree (banks, roads) are in red, ditches in green and extant stonework in purple. Excavated features within the fort are also highlighted. [Air photo mapping © English Heritage.NMR; topographical detail based on Ordnance Survey mapping (© Crown Copyright and database right 2011. All rights reserved. Ordnance Survey Licence number 100024900)]

In fact, by the time Hearne was writing, the first lengthy discussion of cropmarks had already been published, but it appears to have gone largely unnoticed at least partly because – to the contemporary reader – Dr Robert Plot may not have seemed to be discussing the same phenomenon at all. What concerned Plot were circles, as observed in grass and crops, and their causes. Although the specific examples he mentions occurred in the vicinity of Oxford (where Plot was curator of the Ashmolean Museum and Professor of Chemistry, among other things), Plot's thoughts appeared in his *Natural History of Staffordshire* of 1686. As well as

noting and describing occurrences of circles, Plot was also concerned with explaining their causes to the extent that he

> thought fit to examin the nature of the <u>Soile</u> under the <u>Rims</u> of them, especially how it differed from the adjoining <u>earth</u>, and found by digging up several, that the ground under all of them, was much <u>looser</u> and <u>dryer</u> than ordinary, and the parts interspersed with a white <u>hoar</u> or <u>vinew</u> much like that in <u>mouldy</u> bread, of a musty rancid smell, but to tast insipid and this scarce anywhere above six inches deep, the <u>earth</u> again below being of its due consistence and genuine smell, agreeable to the rest of the <u>soils</u> thereabout.[7]

Plot described a considerable variety of circles – they ranged in diameter from 2yds to more than 50; the 'rims' were generally between a foot and a yard across; sometimes the 'rim' was 'as bare as a pathway', while on other occasions the vegetation there varied in colour from its surroundings; some were perfect circles, others not, while still more were incomplete circles – semicircles, arcs, quadrants and the like; some were the same size every time they were seen, while others grew over the years; some continued across hedges and boundary ditches; some comprised two or three concentric circles, while others seemed to feature a rectangle within the circle (Fig 5.4).

The causes he offered were almost entirely natural. He was particularly keen on lightning, but also noted the actions of animals (especially deer, cattle and moles) and farmers

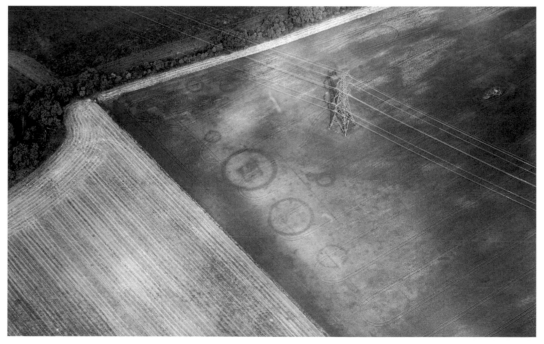

Figure 5.4 Ring ditches and other features visible as cropmarks north of Buckland, Oxfordshire. Note that two of the ring ditches contain square features reminiscent of those described by Plot. [NMR 23092/09, 24 Jun 2003]

(former sites of hayricks). He was more reluctant to accept some of the traditional explanations such as fairies, elves and witches ('my faith be but weak in this matter'). The growing circles he attributed to 'a creeping disease of the nature of herpes or shingles, introduced by a lightning strike'.[8]

With a few centuries of hindsight and experience, some of the circles he described can be regarded as undoubtedly of archaeological rather than natural causes, particularly the concentric circles, those with rectangular internal features, those that grew across boundaries and those that were the same size every time they were noted. Many are now lost to us – some, for which he gives a reasonable idea of their location, had disappeared beneath Oxford's urban expansion before the end of the 19th century. Referring to his desire to dig for an explanation, Plot wrote that he had 'good opportunity in New-Parks near the City of Oxford, where there is always plenty of them…'.[9]

In the early 18th century William Stukeley referenced cropmarks at several locations – generally Roman settlements, plus a Roman road near Bicester, of which he wrote: 'It is visible enough to the nice eye, the grass being poor, and much abates its verdure for its whole breadth.' When referring to cropmarks at the Roman site at Castor he added that 'the vulgar have a foolish story about it as at other places'.[10]

Stukeley's visit to Great Chesterford, Essex, in 1719 led to an early attempt to produce a plan of what later proved to be a Roman villa visible as cropmarks. On 12 July 1719 Stukeley wrote to Roger Gale: 'Thither I summoned some of the country people and, over a pot and a pipe, fished out what I could from their discourse, as we sat surveying the corn growing on the spot … The people say, let the year come as it will, the place is ever visible, and that it has been so ever since the memory of man, and fancy the fairies dancing there causes the appearance.'[11] Stukeley believed he was seeing the 'proper vestigial of a temple, as easily discernible in the corn as upon the paper'. Nonetheless, when the site was excavated by R C Neville in 1848, despite Stukeley's claim that 'the poverty of the corn growing where the walls stood, defines it to such a nicety, that I was able to measure it with exactness enough', Stukeley's plan was not quite a faithful representation of the Roman foundations beneath the soil. Possibly the cropmarks lacked the degree of clarity implied by Stukeley's account. Alternatively, his plan may have been influenced by his ideas of the form the site should take, something entirely in keeping with Stukeley's fieldwork elsewhere and with contemporary notions of scientific objectivity.[12]

In August of 1848, Neville also examined a cropmark site at nearby Ickleton, 'in the tenancy of Mr Samuel Jonas, who had noticed that in certain places the crops every year were "burned"'. One of Jonas's sons had made a rough plan of these marks. 'On the 21st August Mr Neville ascertained, by the use of a crow-bar, the existence of foundations, on the spots pointed out, and the next day his men commenced the work of disinterment.'[13]

Perhaps as early as the 1730s, one John Stair, a publican, was not only drawing plans of cropmarks but digging across them to see what they represented. We lack his own testimony – instead his work is described in letters passing between a couple of antiquarians, John Collet of Newbury and John Ward of Gresham College, London. Once again, Silchester was the focus of attention. In one letter, it is stated that the

method he took to discover where the Streets formerly ran, was by observing just
before the Harvest, for several years, the places where the Corn was stunted and did
not flourish as it did in other parts. These places are very easily distinguished on a dry
summer and run in straight lines, crossing one another. Then, on digging there, he
found a great deal of Rubbish and the plain Rooms, and foundations of Houses on each
side of the Streets. Whereas in the middle of the Squares there is no such Rubbish, nor
any appearance of the ruins of foundations of houses, & moreover the Corn flourishes
there very well.[14]

Further records of such phenomena are scarce until the middle of the 19th century, at least
in the antiquarian literature, though the occasional poet made use of the phenomenon. For
example, John Kenyon's *Poems, for the Most Part Occasional* of 1838 included an effort
entitled 'Silchester', which included the lines:

Yet eyes instructed, as along they pass,
May learn from crossing lines of stunted grass,
And stunted wheat-stems, that refuse to grow,
What intersecting causeways sleep below.[15]

The writer Mary Russell Mitford, an acquaintance of Kenyon's, had also been inspired by
Roman Silchester's impact on the crops growing above it:

That land where once a city fair
Flourished and pour'd her thousands there,
Where now the waving cornfields glow
And trace the wide streets as they grow...
Oh chronicle of ages gone![16]

Perhaps the most noteworthy archaeological reference from this apparently unproductive
period was by Sir Richard Colt Hoare who, in his *Ancient History of Wiltshire* of 1812–21,
made a note of Leland's observations on Silchester, but added only one example of his own
– describing the course of the Wansdyke in the vicinity of Stantonbury Camp hillfort, he
remarked that at one point, where it was not visible as an earthwork, 'I easily recognized by
the colour of the corn, its course over an arable field...'.[17]

This apparent absence of recorded observations may be overcome by further documentary
research, but in the meantime, the lengthy gap makes it difficult to establish any real link
between the seemingly haphazard references of these earlier antiquarians and the work
of Stephen Stone. Stone published an account of his work at Standlake in Oxfordshire
in 1857, but gave no real clues as to how long he had been aware of the phenomena he
described. He presumably knew of Neville's work at Ickleton and Great Chesterford, but
the features he observed and recorded were not Roman – these were not known sites, or
missing links in otherwise extensive earthworks. More importantly, his understanding of
the underlying causes of these occurrences was far in advance of any of his predecessors,
and probably based on personal observation and experience. He concluded his 1857 report
on the Standlake site with the following:

Advantages are offered by the nature of the soil in this neighbourhood which are not generally met with: in the first place the soil is easily worked, and the relics which lie beneath the surface will be found at no great depth. But an advantage of far greater importance consists in the fact, that, from the shallowness of the soil, and its inability to retain moisture for any length of time, lying as it does upon a bed of gravel, which acts as a most effectual drain, the crops of corn, or clover, or whatever else may chance to have been planted, are so quickly affected by drought, that a few successive days of dry sunny weather in summer are sufficient to show the situation and extent of every excavation underneath the soil as clearly as though a plan had been prepared and drawn upon paper. The explorer, therefore, will have no need to probe the soil, open trenches, or otherwise spend time and labour in endeavouring to discover what, after all, he might not perchance succeed in finding; he has merely to mark, in a time of drought, while the corn &c. is yet green, the situation of such excavations as may appear to him desirable to open, and after harvest proceed with his work, having previously obtained leave of the occupier of the land to do so, which I do not apprehend he will find much difficulty in doing.[18]

Stone's pioneering work and understanding would be overlooked until the following century. The next milestone in cropmark history – Francis Haverfield's 1899 report on the Northfield Farm site near Long Wittenham, Berkshire – even contained a summary list of similar sites, but Stone's work at Standlake was not mentioned, though it is difficult to understand how Haverfield could have missed it.

Northfield Farm (Figs 5.5 and 5.6) first came to the public's attention on 12 August 1893, when a letter from Walter Money of Newbury, the Society of Antiquaries' local secretary for Berkshire, was published in *The Times*. Money explained that 'due to the abnormal dry season which has prevailed', the attention of tenant farmer Henry J Hewitt 'was arrested by the increased fertility of the crops in certain parts of the field, which in outline indicate in a most distinct manner a block plan of supposed foundations of buildings and boundaries of roads, of such a vast extent and variety of form as to be at first sight almost bewildering'. Hewitt sank a trench or two, uncovering Roman material in the process. Money concluded his message by arguing that

this discovery is of no ordinary archaeological interest, and one so fruitful in questions for future solution that it would be unsafe to hazard any further speculation until we are better acquainted with the ground-plan defined so distinctly by the waving corn, which occupies a considerable portion of the

Figure 5.5 The cropmarks at Northfield Farm as surveyed on the ground over several summers in the 1890s. [Reproduced by permission of the Society of Antiquaries of London]

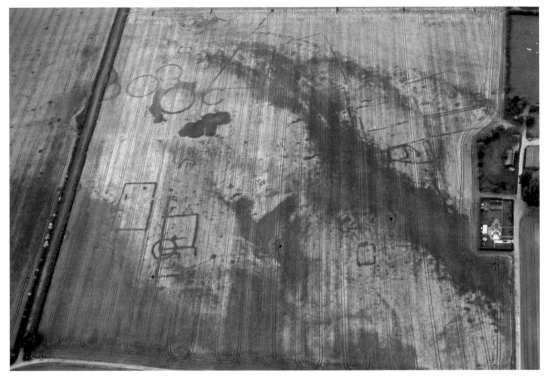

Figure 5.6 Part of the Northfield Farm complex photographed as cropmarks in the summer of 1995, around a century after they were initially mapped. [NMR 15282/27, 14 Jun 1995]

field at the present time. Meanwhile Mr Hewitt has employed a professional surveyor to make a plan of the ground, in order that after harvest we may be enabled to learn something more as to the character of these supposed vestiges of the early conquerors of Britain, who undoubtedly had an extensive settlement in this locality.[19]

On 7 December 1899 Haverfield reported on the planning and digging at Northfield Farm to the Society of Antiquaries. According to Haverfield, Hewitt, 'struck by the curious growth, … commenced excavations, and continued them at convenient periods in the next three or four years'. Haverfield made regular visits and arranged for the surveying work to be continued. He informed the Fellows that 'the lines and patches where the crops grew richer and taller correspond to pits and trenches sunk in the gravel and filled with clay or with other soil which retains moisture longer than gravel does; hence in time of drought the superior richness of the crops above'. Excavations continued to yield 'Late Celtic and Romano-British objects and very little else'.[20]

Haverfield concluded his report on Northfield Farm with a list of further examples of sites where archaeological remains affected crop growth, highlighting

the fact, not yet noted, that the same marks in crops, the same lines and patches, rectangles and circles, can be detected in dry summers in other low-lying places

Notwithstanding his age – he was in his 70s – Moule anticipated the question 'what have you yourself done' by going out to look for such traces. He was disappointed with the lack of results at Maiden Castle, but not at Poundbury, where

> it was easy to see, as it has been in several summers of late years, the line of a third and now wholly levelled vallum on that eastern side of Poundbury. The line of scorching could be seen from the southern fence of the down to the railway, and corresponded with the fine section made by the company's surveyor when the cutting there was carried out, and showed the great elaboration of the fortifications of old. Again, there was a puzzling, though distinct, line of scorching which turned westward at the end. It thus joined the second vallum, of which … there is a small bank remaining…[26]

Within the hillfort itself 'there was a rather general look of patchy burning of the grass', though nothing specific could be identified. However, he spotted one further cropmark that seemed safely ancient. One mound, generally regarded as a round barrow but claimed by some to be of military origin (Fig 5.12), caught his attention during the drought,

Figure 5.9 In 1834 parchmarks visible in the grass within the ramparts of Old Sarum revealed the location of the cathedral that had once stood there. [Reproduced by permission of the Society of Antiquaries of London]

Figure 5.10 A sketched 'oblique' view of the Old Sarum 1834 parchmarks. [Reproduced by permission of the Society of Antiquaries of London]

> at least before all was burnt to a sameness of brown … Standing on the top of the barrow you could trace, first faintly and then afterwards entirely, a clearly marked circle of scorching girding the barrow with what looked like mathematical precision. This could show nothing else, it seems, but that originally there was a chalk bank or dwarf vallum round it. Now this is almost certain not to have been added to any but a burial-barrow – not to a mound for a look-out or any purpose of that kind.[27]

He also noted several instances across Dorset where slight earthworks had been revealed simply by waiting for the sun to fall low enough to cast shadows.

A few years previously, the dry weather had also yielded traces of the past at Windsor Castle. Writing in 1924, an anonymous correspondent to *The Times* recalled:

Figure 5.11 Parchmarks were also visible in the grass of Salisbury's Cathedral Close in the summer of 1994 showing the locations of, among other things, grave slabs and the former bell tower. [NMR 15182/27, 1 Aug 1994]

Figure 5.12 Parchmark ring ditches visible within the ramparts of Poundbury Iron Age hillfort, Dorchester, Dorset. The largest, surrounding a still extant mound, is probably that referred to by Moule. [NMR 15372/23, 4 Aug 1995]

Crawford, cropmarks and the Ordnance Survey

Crawford had spent the last nine months or so of the war as a prisoner, initially at Landshut in Bavaria, where he made one unsuccessful escape attempt, and subsequently at Holzminden, Lower Saxony. Although, according to *The Times*, the latter was notorious for the 'petty tyranny, … the wild punishment for absurd so-called offences, the needless restrictions' and profiteering of its commandant,[29] Crawford later claimed – with tongue not too firmly in cheek – to have found Holzminden far more tolerable than his schooldays at Marlborough, from where he had also made one unsuccessful escape attempt.[30]

When he arrived at Holzminden, preparations were already well underway for the famous tunnel escape of July 1918. As a recent arrival to the camp, it was made clear to Crawford that he stood little chance of being involved, although he did provide some advice on local soils and geology.[31] One way he found to pass the time was to begin preparations for what was to be his first book on archaeology – *Man and His Past* – which appeared in 1921.

After release Crawford returned to England with little immediate prospect of employment in archaeology. Instead, he chose to do fieldwork and complete *Man and His Past*.[32] He also renewed contact with Sir Charles Close, who was to prove an important acquaintance. Close had already had a long and varied career in the Royal Engineers, including spells with the Ordnance Survey and the balloonists (*see* pp 30–1). He had become Director-General of the Ordnance Survey in 1911 and, in among the various pressing concerns of his day, had managed to find some time for archaeology.[33] He had a longstanding private interest in the subject and was well aware of the criticisms made of the Survey's approach to the recording and mapping of antiquities. One of Close's innovations was to allow some trustworthy individuals – mainly historians and archaeologists – to act as 'honorary correspondents'. They would receive free copies of the 6-inch maps of their area, on which they would be expected to add archaeological and historical information. Periodically, the maps would be returned to the Survey so that this additional information could be copied and, where deemed appropriate, added to the Survey's own published maps.

Crawford and Close had first met as early as 1911 at a meeting of the Royal Geographical Society, though Crawford suspected that he was the only one who recalled the encounter. A more important meeting occurred during the war years. At the time Crawford was a lieutenant serving in the 3rd Army Survey Section in France under Major H St J L Winterbotham, a future Director-General of the Ordnance Survey. On one occasion, Winterbotham sent Crawford back to England to personally deliver some maps to Close. The relationship between Crawford and his superiors was not always harmonious, something common to almost all phases of Crawford's life. He later explained that the decision to dispatch him to Southampton for a few days 'was a kindly act of Winterbotham's, to give me a short change of scene after one of our periodical dust-ups; there were other ways of sending maps'.[34] Once Crawford's official business with Close had been quickly dispensed with, the pair settled down to a chat about archaeology.

During 1919 Crawford became a frequent visitor to the Ordnance Survey's Southampton headquarters, mainly to collect copies of maps (he acquired a full set of 6-inch maps covering Hampshire, Berkshire, Wiltshire, Dorset and Somerset). His visits allowed his

numerous annotations to be copied, but also ensured that his acquaintance with Close didn't lapse. Close was clearly impressed with both the quantity and quality of Crawford's fieldwork, which was also highlighting the shortcomings of the Survey's mapping of antiquities.

Coincidentally, questions over the general accuracy and reliability of archaeological information on the Survey's maps were being raised again. Close came to accept that there was a real need for an archaeologist to be employed to ensure that these concerns were properly addressed. He offered the post to Crawford before indulging in some behind-the-scenes manoeuvring, which included persuading the Minister of Agriculture that the appointment of a full-time archaeology officer to the Ordnance Survey was an urgent necessity. The minister was persuaded and Crawford finally took up the post in October 1920. It seems possible that the post wasn't entirely Close's idea – Mark Bowden points to Crawford's 'ability to persuade others to do what he wanted. There is more than a hint that Sir Charles Close was talked into creating the post of Archaeology Officer at the OS... .'[35]

Crawford's two decades at Southampton were characterised, perhaps predictably, by a less than harmonious relationship with colleagues and superiors. W F Grimes, later Crawford's assistant, referred to a 'state of armed neutrality that persisted between Crawford and some of his military colleagues' at the Survey.[36] His appointment certainly stirred up a fair degree of hostility among the Survey's staff. This was not his fault initially, although Crawford hardly possessed the temperament to calm matters. Years later, he was keen to stress, with just a hint of sarcasm, that

> the friction was official, not personal, so far as the authorities were concerned. In so far as it was, at times, personal, I must accept a large part of the responsibility, pleading in mitigation my enthusiasm and my identification of myself with my work. Looking back I can see what excellent fellows my colleagues were and how well we should have got on together if we had had more in common.[37]

His problems were twofold. First of all, many at the Ordnance Survey regarded archaeology as a relatively minor aspect of the organisation's work and hardly something that required a full-time member of staff, particularly someone as demanding as Crawford. He noted that 'the world of learning was one with which [the OS staff] had no contact. It consisted in their view of a few isolated eccentrics and cranks for whom and whose work they felt a politely-veiled contempt.'[38] The fact that his appointment was seen as a response to criticisms of their own work and, at a time when staffing levels were being cut back, cannot have helped.

The second problem, perhaps more significant in his early years, was that Crawford was a civilian. Although the Ordnance Survey had been the responsibility of the Ministry of Agriculture and its predecessors since 1890, it remained under the control of the military, and specifically the Royal Engineers, from which all its staff were drawn.[39] The appointment of civilians was another of Close's post-war innovations and Crawford was only the second 'outsider' to take up a post. According to Crawford, the opinion that in making such appointments Close had 'let down the Corps'[40] was not uncommon. It was an opinion that clearly angered Crawford, especially given his war record and his undoubted suitability for the post. Crawford's position remained a precarious one for some time and he wasn't helped by the fact that Close retired in 1922. Although archaeology remained a

Crawford and Cortez

In the immediate post-war years, Crawford had tried without success to get hold of aerial photographs taken in Britain, presumably by the RFC/RAF, before attempting to persuade the Earthworks Committee of the Congress of Archaeological Societies to take an interest and contact the Royal Air Force. Sadly, according to Crawford, 'through the failure of their then honorary secretary to do anything the Committee lost the chance of its lifetime'.[55]

Instead, progress had to wait until Crawford found his feet at the Ordnance Survey. The key moment came in 1922. Air Commodore Robert Clark-Hall, then based at RAF Weyhill, had shown Williams-Freeman some RAF aerial photographs taken in May of that year that had caught his eye. Williams-Freeman summoned Crawford from the Ordnance Survey to see them: 'What I saw far surpassed my wildest dreams, and I felt much the same excitement as, according to the poet, did stout Cortez on a memorable occasion. Here on these photographs was revealed the accurate plan of field systems that must be at least 2000 years old, covering hundreds of acres of Hampshire' (Fig 5.13 and compare with Fig 5.14).[56] Crucially, Crawford and Williams-Freeman realised immediately that these photographs alone were not enough. Over the next few months Crawford undertook fieldwork aided by additional RAF photographs, mainly taken by fliers based at Old Sarum and Netheravon in Wiltshire.

Figure 5.13 Traces of ancient fields photographed by the School of Army Co-Operation, Old Sarum, Wiltshire, from 10,000ft on 8 May 1922. [CCC 8566/340]

Crawford unveiled the new technique and its first discoveries in a lecture to the Royal Geographical Society on 12 March 1923, a lecture that he also viewed as a personal success: '…it established my reputation as an archaeologist in the eyes of the world, if not yet in those of the Ordnance Survey authorities'. As for the choice of venue, he claimed that it offered numerous advantages over the Society of Antiquaries, 'which had always appeared to be rather bored by prehistory'.[57] However, this wasn't the only reason: the Royal Geographical Society was also a learned body with a track record of hearing and publishing lectures about aerial photography and aerial survey. In the wake of the First World War, a number of those involved in aerial survey and mapping had stood before the same audience and described and discussed their methods, results and hopes for the future. Interestingly, their number included Colonel G A Beazeley of the Royal Engineers. Beazeley had published a paper in the Society's journal a full four years before Crawford. Entitled 'Air photography in archaeology', Beazeley explained how aerial photography had led to the discovery of archaeological sites in Mesopotamia. Recognising the need for following up the photographs with fieldwork, Beazeley's approach had been 'first to photograph the whole area from the air; then to reproduce 6-inch scale blue prints, transfer them to the plane-table; and carry out supplementary ground survey'.[58]

Crawford's paper to the Royal Geographical Society was published in the *Geographical*

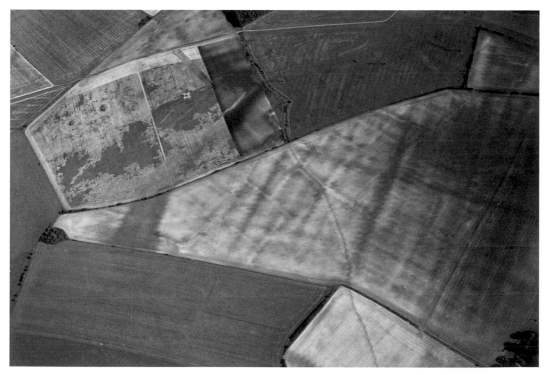

Figure 5.14 This photograph of the so-called 'Celtic' fields – dating to somewhere between the Middle Bronze Age and the Roman period – at Knoll Down, Hampshire was taken on 14 October 1999. The linear feature snaking across the photograph is part of Grim's Ditch, an extensive series of linear features on this part of Cranborne Chase that range in date from the Middle Bronze Age to the early medieval period. [NMR 18460/35, 14 Oct 1999]

Indeed, Crawford insisted that aerial photographs

> ...are *not* a substitute for fieldwork, but they are the most powerful ally of the field archaeologist ... As a revealer of almost vanished earthworks they are superior in every way to observation on the ground ... From my own point of view they are priceless. They will save a great deal of time and public money during the revision of the large-scale maps, for they show exactly where new or suspected earthworks are to be looked for, and thus they save one many hours of fruitless search. They tell one where to go, but, I repeat, they do not save one from the necessity of going there to make sure.[64]

Crawford's enthusiasm was more than evident as he moved from past and present to future:

> To reap the best results there is needed only a large number of air-photographs of regions which are archaeologically interesting. Owing to the close connection between air-photography and the archaeological work of the Ordnance Survey, it is my hope that a collection may gradually be formed there. The most friendly relations have already been established with officers of the Royal Air Force who have to take air-photographs as part of their regular routine of training. It is to be hoped that this arrangement may be continued. There is no special urgency in the matter ... It will be quite enough if, as must happen, some of the photographs taken are taken over what may be called 'archaeological' districts. In Wessex hardly any selection is necessary, for it is all an 'archaeological' district ... Other promising chalk regions are the North and South Downs of Kent and Sussex, and the Yorkshire Wolds.[65]

However, he also noted the potential of upland regions such as Dartmoor and Bodmin Moor as 'allurements for the future'.

The Stonehenge Avenue: Aerial photography vindicated

The Avenue – parallel ditches, each with an accompanying bank, and approaching Stonehenge from the north-east – is today a well-known feature of the Stonehenge landscape, although currently the course of the A344 prevents the modern visitor from entering the monument via this route. In the current chronological scheme for Stonehenge's development, the Avenue sits somewhere within Phase 3, the same period that saw the construction of the sarsen and bluestone arrangements whose remains are still visible today. The few radiocarbon dates available suggest that the Avenue was constructed somewhere between 2600 and 2400 BC, around half a millennium or so after the earthwork enclosure that surrounds the standing stones.[66] On the ground today, the Avenue is visible as earthworks running north-east from Stonehenge in an almost straight line for about 530m, before turning sharply eastwards across Stonehenge Bottom, although by this point the surface traces are slight and can be difficult to follow along the ground before they fade from view completely on King Barrow Ridge. Tracing the course beyond this point had to wait until the summer of 1921, when Crawford had the opportunity of examining some recently taken RAF photographs of the area.

Although the stones had long attracted attention, the earthworks at Stonehenge have always had a lower profile. It isn't clear when the Avenue first came to the attention of

antiquarians, but its presence was certainly noted in a rather sketchy fashion in Aubrey's plan of 1666.[67] In August 1721 Stukeley and Gale noticed parallel ditches running away from the entrance to Stonehenge, out past the Heel Stone and off to the north-east. Returning the following year, Stukeley was able to trace its course as it turned eastwards as far as King Barrow Ridge, after which it faded out in ploughed land. Beyond this point Stukeley could only speculate.[68]

Stukeley clearly believed he was the first to recognise the 'Avenue', as he chose to call it, writing: 'The Avenue of Stonehenge was never observ'd by anyone who have wrote of it, tho' a very elegant part of it, and very apparent.'[69] He was particularly concerned with the condition of the monument and expressed the hope that his published views 'will give us nearly as good a notion of the whole, as we can of this day expect, and perhaps preserve the memory of it hereafter, when the traces of this mighty work are obliterated with the plough, which is to be fear'd will be its fate. That instrument gaining ground too much, upon the ancient and innocent pastoritial life; hereabouts and everywhere else in England… .'[70]

When William Hawley began excavating at Stonehenge in September 1919, despite his fears, much of what Stukeley had seen was still traceable on the ground. Hawley was digging on behalf of the Society of Antiquaries, initially with the limited aims of examining small areas in advance of repairs and stabilisation measures planned by the Ministry of Works. However, Hawley's work soon became more extensive in nature, though consistently under-resourced, and by the close of the 1926 season a considerable portion of the monument's internal area had been uncovered, as had several key areas outside the enclosing ditch.[71]

Hawley had made enquiries about obtaining aerial photographs of the area as early as 1920. It is not entirely clear why he wanted them, but he may already have recognised that aerial photography offered the best means of finding out where the Avenue was headed. In 1920 he had made the short walk to the Stonehenge Aerodrome to see the commanding officer, who 'promised that it should be done when they had a pilot or men who took Photos, not having one at the time'.[72] Unfortunately, by the end of January 1921 the aerodrome had closed down and Hawley subsequently had trouble identifying the appropriate person to contact.

On 7 November 1921 Hawley mentioned a visit from a gunner officer, who apparently told Hawley that the RAF would certainly be interested in taking photographs of Stonehenge (Fig 5.16), 'especially of the Avenue which is just what we want & they say they can trace it a long way across country. There was a very big Plane over here on Saturday & from the way he kept continually passing over I thought he was probably taking Photos. [The gunner] is going to send me some of the Photos taken lately & I shall perhaps have them in a day or two.'[73] In fact, Hawley doesn't seem to have received any RAF aerial photographs until June 1923 – he observed that 'it is very interesting to see all the detail one gets from Aerial Photos', before suggesting that any future photographs 'should be taken late in the day or late in the year so the low sun can pick out the slighter earthworks better'.[74] Hawley was clearly unaware that Crawford had already made a significant discovery on RAF photographs taken as early as 15 June 1921 (Figs 5.17 and 5.18).[75]

While searching through the collection of negatives and prints at RAF Old Sarum early

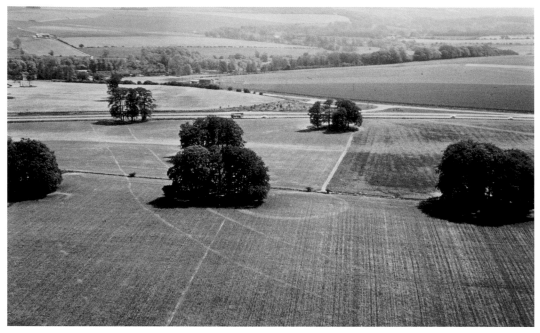

Figure 5.18 The Avenue's cropmark traces are more clearly visible in this photograph from the exceptionally dry summer of 1976. The section visible in this photograph overlaps with that seen in Fig 5.17. The trees, for the most part, remain the same. [PXG 1474/6; Reproduced by courtesy of Peter Goodhugh]

point encounter one of the Avenue's ditches. After digging for around 2½ hours, they found it, the ditch being 'clearly visible in the side of our trench as a V-shaped cutting filled with earthy soil'.[83] A while later, they found the opposite ditch some 84ft away: 'We felt satisfied … that we had found what we were digging for and that the evidence of the air-photos had been vindicated by a severe test.'[84] Two more trenches were dug that day, one on King Barrow Ridge and the other just north of the road from Amesbury to Stonehenge. Both of the Avenue's ditches were found in each. Two of the trenches were left open and two days later they were inspected by a number of other archaeologists who pronounced themselves happy that the course of the Avenue had been confirmed by Crawford and Passmore.[85]

As an encore, Crawford and Passmore explored five levelled round barrows that had also been revealed in the vicinity on the RAF aerial photographs, their surrounding ditches producing circular cropmarks: 'It was a little difficult to locate the first three. We had absolutely nothing to guide us except the air photos, and we were dealing now with a small circle, instead of a double line which we were bound to hit sooner or later.'[86] Few finds were made, although there was one more discovery to relate: 'Incidentally we learnt that the thick and thin rings on the air photos represented wide and narrow ditches respectively, a rather fine point which one would hardly have expected air photos to register.'[87] Again the potential of aerial photography was expressed in terms of its value as an aid to traditional archaeological techniques: 'The above facts are a sufficient testimonial to the value of air photography as an aid to excavation. They show that much unnecessary digging may be avoided by using them as a guide; for they tell you where to dig. They have emerged almost triumphantly from the severest possible test, three times repeated.'[88]

6 '...the allurement of strangeness'

Aerial archaeology takes off

The Ordnance Survey and aerial photography between the wars

While O G S Crawford was busily extracting as much new archaeological detail for the Ordnance Survey as possible from aerial photographs, Sir Charles Close was distinctly lukewarm on the idea of the organisation using aerial photography for its main mapping duties. As early as 29 December 1918, Close had been contacted on behalf of an experienced RAF reconnaissance pilot, a Captain Gethin, asking 'if there is likely to be any opening in air-photo survey work after the war'.[1] Close's reply expressed his willingness to see the pilot in question, but added that 'I don't like to commit myself to any definite opinion as to the future of air-photo survey work, though I can imagine circumstances in which it would be useful'.[2]

Close explained his cautious approach in a letter to Brigadier General Hearson of the Air Ministry: 'I think that there is a field for air photography in surveying, but not, as far as I am able to judge, on the Ordnance Survey.' He explained the shortcomings of the technique, as he saw them, in terms that would have been disappointingly familiar to his former colleague Henry Elsdale some 40 years earlier. Aerial photography would require verification on the ground and, indeed, much survey work could only be carried out on the ground: 'Boundaries, names, descriptions, limits of tidal waters, high water marks of ordinary tides, character of woods, direction of streams, boundary marks, divisions between houses in the same row or terrace, all must be determined on the ground.' Anxious not to appear too negative on the subject, he noted other possibilities, for example a proposed topographical survey of Trinidad or the use of aerial reconnaissance for observation of fisheries.[3]

Close offered similar arguments when responding to Lieutenant Colonel M N MacLeod's paper 'Mapping from air photographs', given to the Royal Geographical Society on 17 March 1919. MacLeod was concerned not just with the recent military experience of using aerial photographs but also with the peacetime potential of aerial survey. Close again concluded that 'I am sure there is a very great field for aerial photography; from my own point of view it is, however, difficult to say it would be of very much use to the Ordnance Survey'. Close again noted a few examples of situations where aerial photography might be useful: 'In the

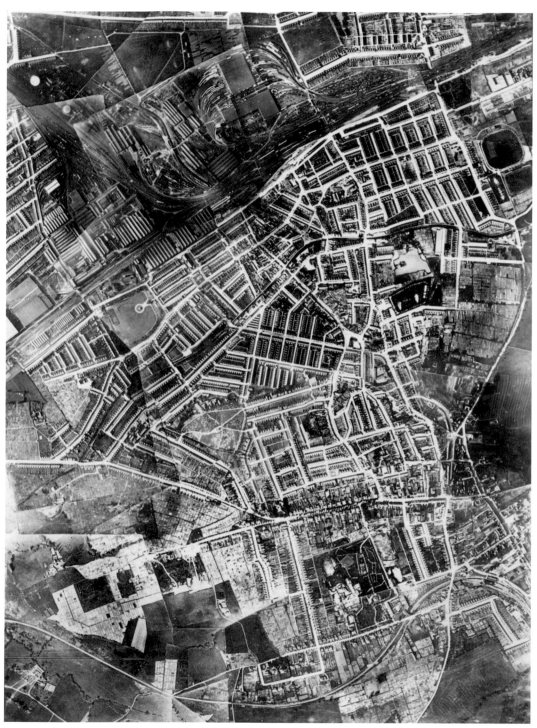

Figure 6.1 A mosaic of overlapping verticals, most if not all taken in July 1918, covering most of Swindon, Wiltshire. This was the mosaic – or rather, the town – that Close felt lacked commercial appeal. [Pulman Collection]

forward under MacLeod was the introduction of instrumental techniques in mapping from photographs, something that the Air Survey Committee had been encouraging and observing from the start but which Winterbotham in particular had been curiously reluctant to follow up. Nonetheless, despite the experiments under MacLeod, it was not really until the 1950s that aerial survey began to be established as an essential part of the Ordnance Survey's mapping work.

Restrictions on aerial photography 1918–39

When Davidson sent Close the Swindon mosaic, he made passing mention of some unresolved issues that might affect the ability of the Ordnance Survey and other organisations to pursue such ideas. As he explained:

> The subject is largely bound up with the question as to whether, or not, the Public are to be allowed to carry photographic apparatus in Aircraft, which has not yet been decided, and, if the decision is to prohibit the taking of photographs, it might be undesirable to publish pictorial drawings of towns as seen from the air, especially in view of the fact that such types of drawings were particularly useful to the Independent Air Force in their raids into Germany.[13]

The debate on restriction rumbled on without resolution until the outbreak of the Second World War, at which point the discussion became redundant. The principal protagonists were the War Office, the Air Ministry and the Admiralty, and the major concern – initially at least – was with Britain's foreign possessions, rather than Britain itself. For example, as early as 1920 aerial photographs of the Rock of Gibraltar were beginning to feature in magazines or on postcards, prompting complaints – one newspaper noted that 'the fact that Gibraltar can with impunity be photographed from the air by the subjects of a foreign power is hardly calculated to increase British self-esteem'.[14]

For much of the inter-war period, the Air Ministry was firmly of the opinion that sufficient controls were already in place, particularly within the British Isles. Opposition came from the War Office and the Admiralty, both of whom favoured prohibition of aerial photography except by licence.[15] Such proposals were addressed at a conference at the Air Ministry on 4 February 1925, held to discuss suggestions that some form of control was desirable from the point of view of:

(a) Safety – e.g. danger to magazines
(b) Espionage
(c) Our dignity[16]

Representatives from the War Office claimed that aerial photographs were frequently being taken of prohibited places and that 'most of the firms regularly engaged on this sort of work had been interviewed and warned, but even after this, Aero Films had continued to infringe the [Official Secrets] Act, possibly through inadvertence'. They added that '[a]ll Chief Constables had been instructed to obtain and submit a copy of any air photos exposed for sale which appeared to contain service information. It seemed evident that the taking of air photographs could not be stopped by explanations and good will alone.'[17]

The proposals floundered once it was realised, following legal advice, that new legislation

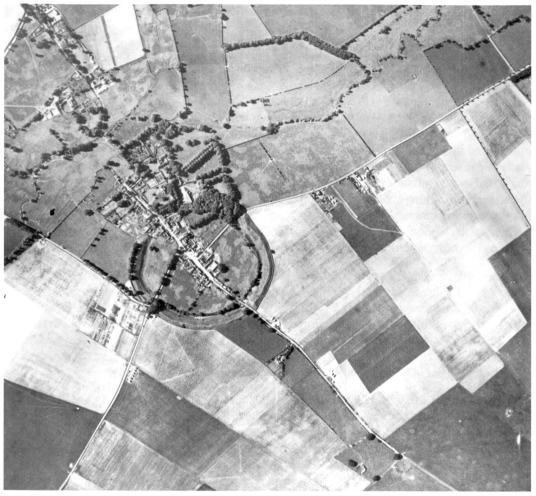

Figure 6.2 A vertical view of Avebury, Wiltshire, taken by the RAF on 2 September 1929, showing the henge and village shortly before Keiller began to 'improve' them by removing buildings and trees. [CCC 8952/02421]

making it easier for the camera operator to capture the intended target.[33] Flying continued intermittently throughout June and July, despite the variable weather, with Crawford and Keiller taking turns to take to the air and operate the camera.

Around 300 photographs were taken, while notes were also made of a number of sites observed from the air but not photographed. Then, following Crawford's own earlier advice that aerial photographs 'do not save one from the necessity of going there', a number of the more interesting sites were visited on the ground. *Wessex from the Air* was published in 1928 and featured 50 sites in all, each represented by at least one aerial photograph (Fig 6.3). Crawford noted:

> [I] had permission from Jack, the Director-General, to do the field-work and write the descriptive text during office hours; the field-work was, of course, of direct

use for correcting and completing the Ordnance Maps. I appreciated the concession, but I could not help feeling that neither he nor anyone else in the office really cared how I spent my time, provided I kept quiet and didn't worry them with new ideas.[34]

Opinion has been divided on the division of labour on the project. In her biography of Keiller, Linda Murray wrote that *Wessex from the Air* 'owes its conception solely to Keiller, who with O.G.S. Crawford as a guide and willing partner was able to implement his knowledge of both flying and photography during the course of the project'.[35] This view was rejected by Bowden, who argued: 'The implication that this was solely Keiller's idea and that Crawford's input was secondary is demonstrably false. Crawford knew every bit as much about flying and photography as did Keiller (and possibly more about their application), and a close study shows that Crawford did at least his share of the work.'[36] In fact, the impression one gets is that Crawford did considerably more. Clearly camera and aeroplane came courtesy of Keiller. The pair may have shared flying and photographic duties, but one presumes that Crawford was rather better placed to decide where to fly. In fact, Keiller's own log of the photographs taken

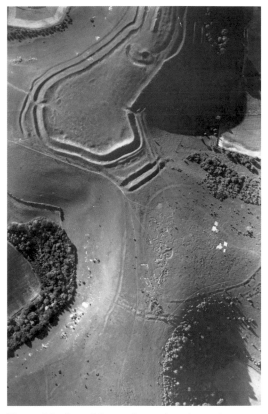

Figure 6.3 Part of the massive earthwork complex at Hambledon Hill, Dorset, as featured in *Wessex from the Air*. The substantial ramparts of an Iron Age hillfort can be seen at the top of the photograph and, within them, a Neolithic long barrow. The slighter earthwork enclosure right of centre, subsequently largely levelled by ploughing, has been shown by excavation to be an early Neolithic causewayed enclosure. [© Keiller Collection; ALK 7442/245, 14 Jul 1924]

has his initials against just 23 of the 297 listed, the remainder credited to Crawford.[37] In the published volume, the overwhelming majority of the text, where attributed to one or the other, is attributed to Crawford and Crawford's own comments elsewhere imply that he undertook a considerable amount of fieldwork between the summers of 1924 and 1926.

It was also Crawford who first presented the results of their aerial photographic work to the outside world. On 4 December 1924, he 'gave an account of some air photographs taken recently by Mr. Alexander Keiller ... and himself' to the Society of Antiquaries.[38] An anonymous correspondent reporting for *The Times* was particularly taken with what he had seen and heard: 'To fly over Hampshire and Wiltshire was a most impressive experience for a field-archaeologist. The Downs were everywhere scored with the marks of its prehistoric and later inhabitants. They were a palimpsest on which the expert could read history. The number of new sites to be discovered from the air must be enormous; every time they went up they made a discovery.'[39] Interestingly, the Society of Antiquaries own (brief) account of the lecture

states that the results of Crawford and Keiller's work would be published in the Society's *Antiquaries Journal*, suggesting that the decision to publish a book had not yet been made.[40]

Wessex from the Air was priced at 50 shillings,[41] meaning that while its impact on the academic world was considerable, it remained out of the reach of the general public. Reviews were generally positive – *The Times* pointed out:

> One need not be a professed archaeologist to find this a fascinating book; a knowledge of it will add interest to every walk or ride or drive taken near the spots photographed ... The whole thing has for the present, of course, the allurement of strangeness. Let that wear off, and these photographs and notes will retain the far more valuable qualities of archaeological discovery and of truth that could have been detected by no other means.[42]

Largely because of the poor weather encountered, few cropmarks (or 'streak-sites', as Crawford referred to them at the time) were featured in the book (Fig 6.4). Only around a quarter of the 50 chosen sites were represented partly or wholly by cropmarks or soilmarks, while earthworks dominated the list of sites photographed but not included, as well as sites observed but not photographed. However, Crawford was able to use the photographs at his disposal to show how much information could be gleaned from an aerial image and also to demonstrate the range of information available from other sources to assist in the interpretation. As well as being mapped and visited, previously recorded surface finds were noted, excavation records analysed and earlier discoveries in the general vicinity were taken into account. Moreover, historic Ordnance Survey mapping was also examined and, where appropriate and available, other historic documents including estate and tithe maps were consulted. Crawford was not interested solely in the most visible remains at each site, but in identifying and understanding all aspects of past activity visible on the photographs.

In describing this phenomenon – the presence of several phases of the past on a single photograph – Crawford employed the analogy of the palimpsest, comparing the surface of the British countryside to a vellum manuscript that had been periodically wiped clean and reused, but with traces of earlier writings still showing through in places. He seems to have used it first in 1923, in his 'Air survey and archaeology' lecture to the Royal Geographical Society, when he made passing mention of 'that palimpsest of British history – Salisbury Plain'.[43] Similarly, a decade or so later he wrote of Blandford Down in Dorset as another 'priceless palimpsest of British history'.[44] In both cases, he was merely pointing to particular areas where circumstances had contrived to ensure far better above-ground preservation of prehistoric, Roman and later monuments.

It was to be a while before Crawford explained more fully how he understood the term. In 1953 he wrote:

> The surface of England is like a palimpsest, a document that has been written on and erased over and over again, and it is the business of the field archaeologist to decipher it. The features concerned are of course the roads and field boundaries, the woods, the farms and other habitations, and all the other products of human labour; these are the letters and words inscribed on the land. But it is not easy to read them because, whereas the vellum document was seldom wiped clean more than once or twice, the land has been subjected to continual change throughout the ages.[45]

Figure 6.4 This is one of the few cropmarks photographed by Crawford and Keiller in the damp summer of 1924 – the enclosure was named 'Sparrow Croft' by them after one of the fields. Fieldwork showed some earthwork survival. [© Keiller Collection; ALK 7429/226, 12 Jul 1924]

Crawford originally highlighted two periods in history when he felt that 'the land' had been more or less 'wiped clean' – the enclosure movement of the 18th and 19th centuries, and the arrival of the Saxons some 14 centuries or so before that. Prior to that, of course, was the coming of the Romans and for prehistory, invasion was fairly well established as a favoured explanation for culture change. Crawford himself had already tried to associate the appearance of 'Celtic' fields with a prehistoric invasion of his own devising.[46]

The idea of the landscape being periodically wiped clean is no longer acceptable, of course. There has been no periodic and wholesale reworking of the landscape, while many features of earlier periods – hillforts, boundaries, field systems, roads, cemeteries and so on – are just as likely to have continued in use or to have influenced subsequent developments as they are to have been ignored or removed.

On another occasion, Crawford ignored the allusion to a layered or stratified landscape implied by the palimpsest analogy, claiming instead that '[a]n air-photograph ... is virtually a *manuscript* which may be read by those who will learn to interpret the hieroglyphs. A simple day's ploughing utterly destroys the fainter symbols, and blurs the more striking ones, so that the meaning cannot be deciphered altogether.'[47] Both analogies – landscape as palimpsest and landscape as text to be deciphered – remain in widespread use in archaeology, though their value has been much debated.

Civil aviation and aerial photography between the wars

It was to be some time before anyone in archaeology followed Crawford and Keiller's lead and actually took their own aerial photographs. During the inter-war years, the principal supplier to archaeologists remained the RAF (Fig 6.5), though on occasions some use was made of one of the many civil firms that sprang up during this period. Perhaps the best known is Aerofilms, although as noted earlier, there were plenty more testing the patience of various government departments. There was much work to be had abroad, particularly in the colonies, where aerial photography offered the most rapid, if not always the most accurate, route to providing some form of mapping in regions that had previously lacked anything other than the most basic cover (*see* Strip-mosaics and garter elastic, pp 154–5).

Within the British Isles, aerial survey work tended to occur on a much smaller scale. Much of the survey work that came the way of the many civilian survey companies resulted from the rather out-of-date nature of the available Ordnance Survey mapping. Due in no small part to the cutbacks that the organisation had suffered, especially in the immediate post-war period, map revision had failed to keep pace with modern development. Many local authorities and public services found the Ordnance Survey maps of their areas an inadequate base for planning purposes and began to commission aerial photography, the

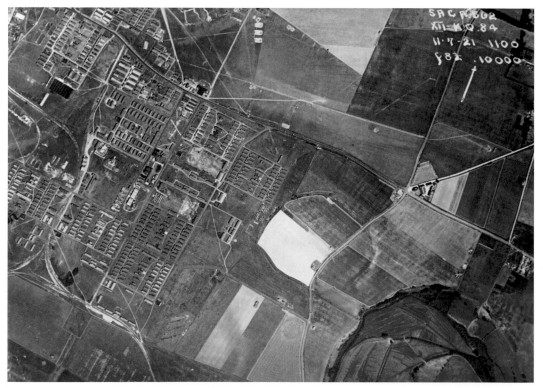

Figure 6.5 RAF vertical view of the Late Neolithic henge enclosure of Durrington Walls, situated between the River Avon and the military camp at Larkhill. Note a faint smaller circle just south of Durrington Walls. This is the site that became known as Woodhenge (see Figs 6.7–6.9). [CCC 8531/ORACLEE3, 11 Jul 1921]

finished product either taking the form of an air photo mosaic or a drawn map based on such a mosaic (plus the photographs, of course).

Aerofilms' activities during the period 1926–34 serve as examples of the sort of work being undertaken – for instance, they undertook survey work for town planning purposes for Doncaster Rural District Council (9,600 acres), the City of Leeds (5,120 acres), the Boroughs of Finchley (6,400 acres) and Wisbech (10,240 acres), and Chailey Urban District Council (2,560 acres). A further 12,800 acres were photographed for the City of Manchester for examination of planned changes to the city boundary. Public services included the Commissioner of the City Police, London requesting photography of 'traffic problems', plus coverage of planned railway extensions within the capital (Golders Green to Edgware and Finsbury Park to Cockfosters). Various engineering schemes also accounted for photography of a further 40,000 acres across the country.[48]

In addition, Aerofilms supplied aerial photographs for use on postcards, in advertising, as illustrations for books, magazines and newspapers, and for personal use (Fig 6.6). Despite the costs, archaeologists who could afford the service did indeed make use of it. Ian Richmond and F G Simpson commissioned Aerofilms to take aerial views of Cawthorn Camps in 1925, during their excavations of the Roman forts there (*see* pp 227–8).[49] They weren't the only ones – in 1929 alone, Aerofilms took photographs covering 12,800 acres for the purposes of 'archaeological research'. Some – and perhaps all – of this was

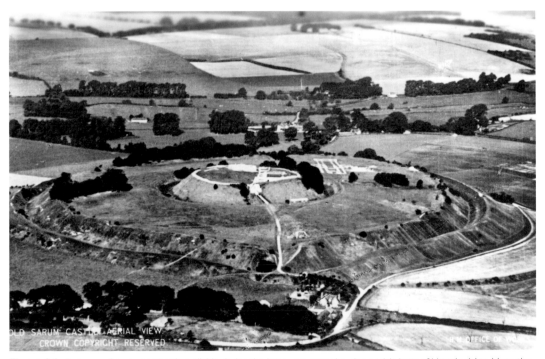

Figure 6.6 Just one of many postcards available during the inter-war years showing aerial views of historic sights. Here, the remnants of the castle and cathedral at Old Sarum, exposed by William Hawley prior to the First World War, can be seen (compare with Fig 4.17).

undertaken on behalf of Ivan Margary, who funded a vertical survey of the Weald as part of his lifelong quest for remnants of Roman roads.[50]

The story of Woodhenge

Despite the growth in civil aviation between the wars, many of the most significant aerial discoveries in Britain were made by military personnel. Squadron Leader Gilbert Stuart Insall VC[51] first came to the attention of the archaeological world in 1926, though he was already familiar to Crawford by this time (*see* p 156). Insall had joined the Royal Flying Corps soon after the First World War had begun, obtaining his flying certificate in April 1915. Once in France, he seems to have quickly earned a reputation for his 'fighting spirit', which generally involved making sure that he got as close as he could to enemy planes in order to give his gunner as straightforward a task as possible. During one flight, on

Strip-mosaics and garter elastic

An excellent account of working for a civil aerial survey company during this period has been written by J A Eden, who spent a number of years working for the Air Survey Company, one of Aerofilms' main rivals.[a] As with their major competitors, most of their survey work occurred in the colonies, although during the later 1920s and 1930s they undertook much work in Britain similar to that described for Aerofilms. They also won several contracts to carry out aerial photography for the Ordnance Survey. Eden, who began working for them in 1928, explained the mapping process in these early years. At this stage, the company's Grosvenor Place premises lacked a darkroom, so they used one belonging to a colleague of Eden, which involved a bus journey, followed by four flights up

> a rickety and very dark and dirty staircase ... Next to the darkroom was a little office with a penny in the slot gas fire, in front of which was a mat, caked stiff with black dirt. Each morning I would sweep the floor and dust the tables, from which I would remove a thick greasy layer of dirt which renewed itself each day. From the print drying room in the front there was a good view into the dressing room of the Adelphi, where there were sometimes some interesting sights.

Once the prints had been returned to Grosvenor Place, they were used to create strip-mosaics, each strip being held in place by drawing pins along one side. 'Each strip was then flapped up and a length of garter elastic was stretched underneath, secured by two pins, one at each end and each print was stuck to the elastic by means of blobs of Johnson's photo mountant. The length of the strips could now be adjusted so as to

7 November 1915, with his acting gunner Air Mechanic First Class T H Donald, he forced down a German plane, completing its destruction by dropping an incendiary bomb on it. On the return journey, German anti-aircraft fire damaged their petrol tank and Insall was forced to bring the plane down just a few hundred yards behind the Allied front-line trenches, but still within range of German shelling.

Overnight, after the arrival of a rescue team, the plane was repaired and early the following morning 'Gilbert restarted his engine and took off … lurching precariously over the uneven surface, applauded by the assembled French soldiery, who had gathered literally in their hundreds to watch his departure'.[52] The spectators then had to hurl themselves to the ground as the rising plane attracted a hail of bullets from the German trenches. Donald was awarded a Distinguished Conduct Medal for his part in the episode and Insall received a Victoria Cross. However, even before these awards had been announced, the pair came under fire once more during a routine patrol on 13 December 1915. Donald was wounded

occasion small but equal misfits between prints by simply altering the tension in the elastic.' Next, they would

> grid the table top to the mean scale of the photography and a few co-ordinated control points, fixed by … field surveyors, were plotted thereon. The strips of photographs were now assembled on the table. One photograph would be pinned down to its control and the elastic tensioned until the control at the other end of the strip was made to fit. Adjoining strips were fitted to each other in much the same way and other controls were picked up.

Once a reasonable fit had been obtained and everything was safely pinned to the table, '[t]he detail and grid were then transferred onto tracing paper … The final maps were drawn on Whitman's hand made paper by pantographing from the traces to the required scale.'[b] Techniques improved over time, though a preference for surveying relatively flat terrain, thus reducing the chances of significant error, was common to most aerial survey companies. Control, usually obtained by using traditional ground-based surveying techniques to establish the precise position of and distance between key landmarks in and around the area being mapped, was not always reliable: 'If a man is very hot and is being bitten by insects, kicked by elephants and under the impression that wild pig, rhinoceros or buffalo wait to attack him behind every bush, it is only too easy to miscount a chain or two when measuring a traverse leg.'[c]

Notes
a Eden 1976.
b All preceding quotes are from Eden 1976, 635.
c Ibid, 641.

in the leg, while Insall was hit when an anti-aircraft shell 'exploded a short distance below the machine, and the base of the shell came up through the nacelle and lodged itself in his left buttock'.[53] Despite briefly losing consciousness, Insall managed to land, though they were behind enemy lines and were taken prisoner.

Insall was initially taken to a hospital at Achiet-le-Petit in northern France, about 10 miles or so south of Arras, where the large piece of shell was removed (in Insall's own words, 'I had a slight operation under ether'), subsequently convalescing until February. He then had spells at camps in Mainz, Ingoldstadt, Heidelberg (where he underwent 'a serious but successful operation for appendicitis'[54]), Crefeld and Ströhen. He tunnelled out of Heidelberg and sneaked out of Crefeld, but on both occasions was recaptured. He was more successful in escaping from Ströhen, where with two colleagues (both, like Insall, serial escapers) he managed to get out on 23 August 1917. The trio spent nine days walking to the Dutch border, a distance of around 80 miles as the crow flies. His various escape attempts earned him a Military Cross.[55]

The early 1920s saw Insall at RAF Netheravon and at some point he made the acquaintance of Crawford. Insall later recalled that Crawford was not just examining RAF aerial photographs, but also 'was instrumental in the choice of pin-points taken by the RAF'.[56] It seems that Crawford was using place names as a guide:

> …these constitute a most durable clue to the discovery of ancient sites. The place name often remains when nothing can be seen on the site by the ground observer. Mr Crawford suggested the existence of an ancient camp near a place called Woodborough. The name led him to assume an ancient settlement, but there was nothing left on the ground to indicate the site. One day on my return from a flight around Salisbury Plain I came upon the spot. A large field was under corn, and I saw an extensive camp, enclosed with ramparts broken by entrances and lines converging. It was all sketched in the growing corn. At the next opportunity I took a camera, but the harvest was in full swing, and nothing was left. The next year the field was under roots, and again nothing was visible. Local archaeologists visited the spot on foot, but they could find nothing; so this site remains hidden until some airman with a camera passes over at the right time of the year, in the right year, and knows what to look for.[57]

Insall had considerably more impact on the archaeological world with another discovery. This time the site – soon to be named Woodhenge – was not unknown to ground-based archaeologists but had failed to attract anything more than cursory attention. In the early 19th century it had been described by Sir Richard Colt Hoare as 'the mutilated remains of an enormous druid barrow'.[58] By the early 20th century it was known as 'Dough Cover' because of its claimed resemblance to a lid for a bread pan. The transition from Dough Cover to Woodhenge was primarily due to Insall, who described to Crawford what happened in a letter written from Basra:

> I was flying a Sopwith Snipe on 12 December 1925, at about 2000 feet, over Stonehenge, when I noticed a circle near Durrington Walls. Stonehenge was visible at the same time, and the two sites looked similar from that height. I photographed it shortly afterwards; result – white chalk marks in the plough. Returning late one

evening as the sun was setting I noticed there was a distinct depression inside the outer circle, and a gradually rising mound in the centre, both of which were revealed by the shadows. Having been told that it was only a 'mutilated disc-barrow', and having looked it up in the Wiltshire Archaeological Magazine, I watched it to see what the crops might reveal.[59]

The circular soilmark is clearly visible on the earliest of Insall's photographs, taken on 16 December 1925 (Fig 6.7), though the claimed resemblance to Stonehenge was, at this stage, surely restricted to shape alone. It is not clear how often Insall flew over the site in the following months, but certainly he kept an eye on it, fully aware that a growing crop might display more detail:

In July when the wheat was well up over the site, there was no further doubt. Five or six or perhaps even seven closely-set rings of spots appeared and were photographed. I climbed on to a hay rick in the same field a few days later, and although a few dark patches could be seen in the standing wheat, no pattern was visible, and they would have passed unnoticed. From the air, the details of the site were as clear as shown on the photograph, if not clearer.[60]

Figure 6.7 Insall's first photograph of Woodhenge, showing a circular spread of chalk where the plough has bitten into the bank surrounding the monument and the slightly domed central area. [CCC 8726/282, 16 Dec 1925]

Figure 6.8 It isn't clear how many times Insall returned over subsequent months, but this is what he saw some six months after his first photograph of Woodhenge. [CCC 8751/7387, 30 Jun 1926]

In fact, Insall flew over the site not in July, but on 30 June 1926 (Figs 6.8 and 6.9). His photographs came to the attention of local archaeologist Maud Cunnington, who began excavations almost immediately, later describing the site as 'the most sensational archaeological discovery made by means of photography from the air'. Cunnington was told by farm workers 'that the peculiar and irregular way in which the corn grew at this spot was always noticeable at harvest time, for the corn grew so thick in patches that it got beaten down and consequently difficult to reap'.[61]

The name 'Woodhenge' was, according to Cunnington, invented during the excavations, once it appeared that the concentric circles of pits may have held posts and thus could have represented a timber version of Stonehenge. 'The name seemed to be "in the air" and no one person can be held responsible for it. It proved to be so convenient and descriptive that it was soon generally adopted.'[62]

Woodhenge was by no means Insall's only contribution to aerial archaeology. While in Iraq, he saw and photographed many sites and on his return to Britain he effectively picked up

Figure 6.9 A near vertical view of Woodhenge taken by Insall on the same day as Fig 6.8. [CCC 8751/7388, 30 Jun 1926]

where he had left off. On 18 June 1929, during a routine flight across Norfolk, he found another circular ditched enclosure with an inner circle of pits or postholes at Arminghall, just outside Norwich (Fig 6.10). As with Woodhenge, the discovery was loudly trumpeted by Crawford in *Antiquity*. The precise circumstances of discovery were slightly different from those of Woodhenge. Insall had photographed Woodhenge from a Sopwith Snipe, a single-seater biplane with an open cockpit – taking aerial photographs of the site was, therefore, something of a challenge. As Mike Pitts explained, 'the lower wing on the Snipe is raked back, but it is still fair and square below the cockpit. With his joystick in one hand and camera in the other, he would have had to put his plane into a sharp turn, with one wing down for the view, the wind in his face at 160kph, concentrating more than anything on avoiding a stall' (Fig 6.11).[63] Insall clearly wasn't joking when he remarked that 'a little knowledge of the possibilities of archaeology from the air can add interest to those long flights over familiar country when flying becomes monotonous'.[64] At Arminghall, however, Insall was neither alone nor dangling his camera over the side of the plane. Instead, he discovered the site while 'flying over it, pin-pointing'. Pin-pointing of relatively small

Figure 6.10 Arminghall, as first pin-pointed from an RAF bomber by Insall. [CCC 8926/1865, 18 Jun 1929]

Figure 6.11 A Sopwith Snipe, similar to the plane flown by Insall over Woodhenge. This view should give some idea of how difficult it would have been for Insall to take aerial photographs with a hand-held camera from a Snipe. [Pulman Collection]

archaeological monuments was, according to Insall, 'very good preliminary training for a bomber and pilot. The bomber is given a back and fore sight, and lies in a bombing position. When near the site he has to guide his pilot, by the speaking tube, dead over the objective, until his sights are in line. The photographic result is instructive to both concerned, and reveals their standard of ability.'[65]

Crawford introduced Arminghall to his readers as 'another Woodhenge'. He and Insall visited the site on 26 June 1929, when 'it was possible to see both circles and holes marked out in the grass with the utmost clearness; the line of division between brown and green was sharp and distinct, enabling the dimensions to be taken with considerable accuracy'.[66] Excavations began in the summer of 1935, directed by Grahame Clark, though by this time, and notwithstanding the extensive publicity the discovery had received in the national press, an electricity pylon had been erected on the site.[67]

Crawford, aerial photography and *Antiquity*

As already noted, in the years up to the Second World War, many of the new discoveries in Britain brought to the attention of archaeologists and the general public were made by serving officers of the RAF, either on or off duty. That many of the most significant were first published in the journal *Antiquity* – established by Crawford in 1927 – is as much an indication of Crawford's network of contacts as it is of the RAF's commitment to archaeology and the Ordnance Survey. Another example of the former concerns the Sassoon Trophy, established in 1932 by Sir Philip Sassoon, cousin of Siegfried and, from 1931–7, Under-Secretary of State for Air. The Sassoon Trophy was awarded annually to the winner of a contest among 'any regular unit in the home commands normally carrying out air photography (except the School of Photography)'.[68] To compete, each unit was required to submit an air photo mosaic of an area within a 30 mile radius of the unit's home aerodrome (Fig 6.12). Crawford's acquaintance with Sassoon may have been the reason for one additional stipulation. Each year, once the competition had ended, the various units were required to 'send the appropriate negatives direct to the Ordnance Survey, Southampton, as soon as possible so that all the archaeological information thereon may be transcribed to the particular maps which are to be produced'.[69]

Crawford's foundation of *Antiquity* proved crucial to maintaining the profile of aerial photography and its discoveries. Published four times a year, with Crawford as editor, his stated aims in the first issue began with the promise that '*Antiquity* will attempt to summarize and criticize the work of all those who are recreating the past' (*see also Antiquity*, art and aerial photography, pp 165–8). He continued:

> The uses of air-photography are only beginning to be properly appreciated, and they are many. Air-photographs reveal lost or unsuspected remains, such as 'Woodhenge' and the Stonehenge Avenue; they show the excavator where to dig for wells, ditches or pit-dwellings; they reduce a tangle of earthworks to order and may prove their relative ages; they are invaluable to the lecturer and writer to illustrate his thesis. In this last respect their uses will be apparent to readers of the present number. We intend to use air-photographs, whenever possible, for the purpose of illustrating

LONG COMPTON

Figure 6.12 Part of a 1935 air photo mosaic entry for the Sassoon Trophy. The village towards the top of the photograph is Long Compton, Warwickshire, with medieval ridge-and-furrow clearly evident in surrounding fields. Almost imperceptible, bottom left, are the Rollright Stones. [CCC 9142/01738, 3 May 1935]

articles, and, reversing the process, to select some of the best available photographs for use with explanatory text and diagrams.[70]

New discoveries from the air were a frequent feature of *Antiquity* under Crawford and his successor as editor, Glyn Daniel; aerial views were also used frequently for illustration.

Down to 1939, many of the photographs featured were taken from RAF aircraft by serving officers, coverage consequently reflecting the areas where the RAF was most active. For example, the second issue featured an article by Flight Lieutenant Maitland on ancient remains in the Arabian desert which happened to lie on the flight path of the Cairo–Baghdad airmail flights, close to some key landing strips.[71]

The earliest issues of *Antiquity* featured some of the most significant and enduring aerial discoveries from the British Isles, including the prehistoric monument complex near Dorchester-on-Thames, Oxfordshire. Well-known to prehistorians today, the threats caused by gravel quarrying led to a series of key excavations at a crucial point in the development of Neolithic studies. In fact, when Crawford published the first aerial photographs of these previously unknown sites, neither henges nor cursuses had been recognised yet as distinct classes of monuments and Crawford's struggle to identify the features captured on film is clear from the accompanying article, even after some trial excavation.

The photographs were taken around 10.30am on 16 June 1927, the sites having been spotted by an RAF pilot and his observer, Flight Lieutenants W E Purdin and B T Hood (Fig 6.13). According to Crawford, they had been taking some practice photographs in the area when they spotted the cropmarks and decided to photograph them as well, even though they lay beyond the area that Purdin and Hood were supposed to be operating in. The negatives arrived at the Ordnance Survey office in Southampton in September and Crawford was out in the field digging trenches with R G Collingwood in early October.

Crawford was particularly keen to publicise the sites near Dorchester-on-Thames because of the circumstances of their discovery, describing them as 'the first-fruits of the instructions issued recently by the Air Council, encouraging the selection of archaeological sites for photographical exercises'.[72] While this was clearly an important development, it was in fact an extension of an arrangement that had already been in place for several years. As noted earlier, Crawford had already been utilising RAF negatives since 1921 as well as making suggestions of places or sites that he wanted photographed. Subsequently, in July 1923, the RAF had received a formal request from the Ministry of Works for aerial photography of ancient monuments. The RAF agreed 'to take the views from time to time as opportunity occurred and this has been done and the work is still proceeding'.[73]

The whole question of whether the RAF should be taking aerial photographs for other bodies was one that had been rumbling for a while, with the prevailing view being that the RAF should not undertake work that could be done by private firms or individuals. However, one exception was accepted:

> [T]his principle need not exclude the carrying out of archaeological work for the Ordnance Survey or other responsible bodies. There is no money in such work for anyone and it is most unlikely that any serious sums would be forthcoming to pay civil aviation firms to do this work. Yet the results are of the greatest possible interest and it would I think be discreditable for the government to wash its hands of it on a point of punctilio. I assume therefore that, so far as such work can be genuinely worked into training flights without appreciable extra expense to the Royal Air Force, the present activities in this sphere will be continued.[74]

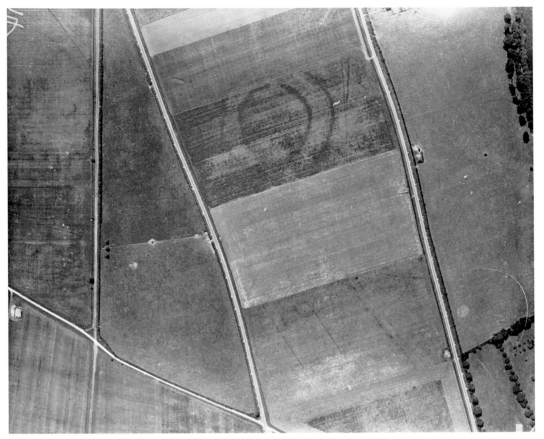

Figure 6.13 The first photograph of what became known as the 'Big Rings' henge and cursus monument at Dorchester-on-Thames, Oxfordshire. Far more detail would be photographed from 1933 onwards by Major George W G Allen, prompting excavations ahead of gravel quarrying and initiating a far better understanding of these previously unrecognised prehistoric monument classes. [CCC 8776/40, 16 Jun 1927]

One particular example noted was the case of the Somerset Archaeological Society, which had approached the Chief of Air Staff in April 1925 seeking RAF assistance 'as they had no money available to get the photographs done by civil firms'.[75] The request was readily granted.

In 1955 Crawford rounded off his autobiography by suggesting that the foundation and success of *Antiquity* was perhaps his most important achievement, particularly as it had helped 'to make known the remarkable results being achieved by air-photography … [It] wasn't till then that it really made good and became accepted as a powerful aid to the advancement of knowledge.'[76]

Antiquity, art and aerial photography

It was always O G S Crawford's intention that *Antiquity* should reach as broad an audience as possible, well beyond the readership attained by other archaeological periodicals. Certainly the wide-ranging subject matter contained on its pages suggests as much. In the editorial notes to the very first issue, he sought to distinguish *Antiquity* from the 'obscure publications' where 'intelligible' accounts of the past 'remain buried' and beyond the reach of the general public.[a]

One of the non-specialists to be drawn to the journal was the artist John Piper. What particularly caught his eye was Crawford's use of photography – and particularly aerial photography – partly for the ways in which it allowed past and present to be captured within a single image and partly for their aesthetic impact on the non-archaeologist.[b] In 1937 the eighth and final issue of the journal *Axis: A quarterly review of contemporary abstract painting and sculpture* contained an article by Piper entitled 'Prehistory from the air',[c] explaining not just the impact aerial photography was having on archaeology, but also comparing the aerial

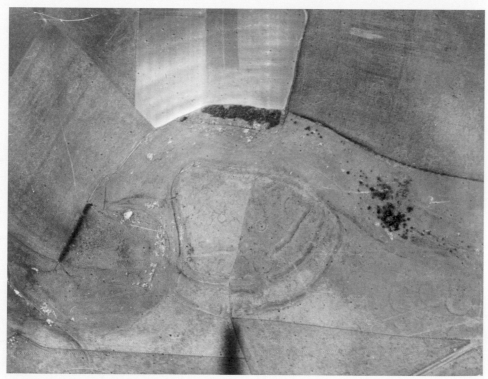

Iron Age hillfort on Whitesheet Hill, Wiltshire. This 1930 vertical view clearly shows the outline of the earthworks, but offers little indication of their scale or of the topography. [CCC 5232/278, 24 Mar 1930]

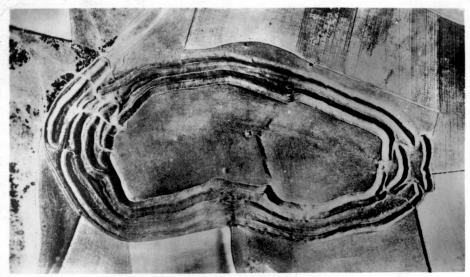

MAIDEN CASTLE, DORSET : VERTICAL AIR VIEW
(CROWN COPYRIGHT)

Vertical view of Maiden Castle, taken prior to Mortimer Wheeler's excavations of the 1930s and sold as a postcard. This photograph was used by the artist Paul Nash in his 1936 *Shell Guide to Dorset*.

Of course, appreciation of the aerial view was not restricted to artists such as Piper or to readers of *Antiquity*. Throughout the 1920s and 1930s, increasing numbers of people were experiencing the view from above as passengers on aircraft, while whole series of postcards featuring aerial views of well-known places and landmarks were widely available, as were books containing similar imagery. It was more than possible to frequently encounter and appreciate the aerial view without any knowledge of its value in understanding the past.

Notes

a *Antiquity* **1** no 1, Mar 1927, 1.

b The influence of *Antiquity* and aerial photography on the Neo-Romantic artists in particular is well covered by Kitty Hauser (2007), whose 2008 biography of Crawford is also recommended.

c The quotes in this text box are from Piper 1937, 5–8. The journal *Axis* was founded in 1935 by Myfanwy Evans, who would become Piper's second wife. Among the Pipers' circle of friends was Stuart Piggott.

Major Allen and the Thames Valley

Unusually for an aerial photographer during the inter-war years, Major George W G Allen[77] had no connection with the RAF or its predecessors. His First World War service had been in the Army Service Corps and, latterly, in the Tank Corps, returning once hostilities had ended to the family firm of Messrs John Allen & Sons (Oxford) Ltd, manufacturers of agricultural equipment. Although he was in due course to take charge of the company – and immersed himself in all manner of related interests – he still found himself with time on his hands. As Richard Morris noted, Allen may have been 'socially reticent and a bachelor of orderly habits', but he 'was also intellectually restless, a compulsive doer whose time outside the works … was crammed with hobbies'.[78] One of these involved visiting the various archaeological sites that were marked on Ordnance Survey maps.

In 1929 Allen began to take flying lessons. He later recalled:

> When I began flying I observed, especially in the summer, certain curious circles and other patterns outlined in the crops and on the bare earth. At first, I did not realise that these marks were the same sites as those which had so long interested me on the ground, and that now I was merely seeing them more clearly than had been possible before. Soon, I found that during my flights I could not only identify old sites already marked on the map, but also could discover new ones whose existence had never been suspected.[79]

Around the same time, Allen read about Crawford's work in an 'official', that is government, publication which he found in a hotel. The identity of this publication remains unclear – some have suggested that it was one of Crawford's Ordnance Survey publications, while others point to *Wessex from the Air*. It was almost certainly neither of these. Crawford later commented 'that it proves two impossibilities – that the lesser can produce the greater, and that neither Government institutions nor English hotels are wholly bad'.[80] After an initial meeting at the Ordnance Survey offices in Southampton, the two corresponded frequently, with Crawford offering every encouragement to Allen's plans to undertaken aerial photography himself.

In March 1931 Allen took ownership of a de Havilland DH80A Puss Moth, a monoplane with an enclosed cabin and, importantly as far as aerial photography is concerned, a high wing meaning excellent downward views of the ground. The aircraft was kept at Allen's own private airstrip at Clifton Hampden, a 5-mile drive from his home at Iffley and the base for Allen's photographic exploits over a sizeable chunk of the Thames Valley.

Much of this photographic work was undertaken during the summers of 1933–9, particularly the dry summers of 1933–5 when, according to Allen, he 'made a systematic search over certain parts of southern England, mainly in the neighbourhood of the Upper Thames, and gathered a considerable amount of information'.[81] As he put it more informally in a letter to his colleague A D Passmore: 'I have been overwhelmed with air work. The whole of the Thames valley and its tributaries have come out in a violent rash, circles and marks everywhere.'[82]

Allen's photography differed in one important respect from that of the RAF (and indeed, from that of Crawford and Keiller) – most were obliques rather than verticals. This was,

in part, a choice determined by practical considerations and brought both advantages and disadvantages. As Allen noted, obliques 'have the disadvantage of distortion in the vertical plane and make it difficult to plot accurately on the map the details of the sites on them. On vertical photographs, a scale can, of course, be readily calculated (by comparison with the map) for taking measurements of objects on the ground.'[83] At the same time, though, '[t]here is always one particular angle (generally at about right angles to the sun) from which the marks are best visible and the light strikes them best. This is readily found by flying a circuit of the site. At some points the marks may become almost invisible... .'[84] Another point Allen made in favour of obliques was that they 'are easier for the average person to understand'.[85]

However, it was primarily Allen's preference for flying solo that tilted the balance in favour of obliques: 'A hand-held camera was used and its operation required the use of both hands, but I found the "Puss Moth" a very stable machine and one which can be left to fly itself in calm air. There is no risk in letting-go of the controls; even on a bumpy day nothing serious will happen, though then the motion of the machine may be too erratic for the camera to be held steadily.'[86] The camera, constructed by Allen himself, used plates rather than film, increasing the amount of 'hands-off' time in the air. He also had a vertical camera built in to the machine, although the quantity of surviving verticals suggests he didn't make much use of it. Indeed, Allen complained that 'during the first few years, I could not take verticals with reasonable comfort and security'.[87]

As is frequently the case, Allen's successes with aerial photography benefited from a fair amount of good fortune. Not only did he happen to live and fly in a region where the ground conditions – soils, geology and plenty of arable agriculture – were particularly conducive to cropmark formation, but he was also blessed with several summers markedly drier than was the norm. However, his successes also owed a good deal to his reconnaissance technique. Encouraged by Crawford, Allen concentrated on the area of the Thames Valley within reasonable reach of his Puss Moth. Practical considerations again played a part – most of Allen's flying appears to have occurred during the late afternoon and early evening, after a full day's work, hence the frequent occurrence of long shadows on his photographs. Allen's systematic coverage of a relatively restricted geographical area – repeatedly flying over the same area and following up new discoveries over subsequent flying seasons to see what else might appear – introduced an aspect of aerial reconnaissance that had not previously entered archaeological service. This sort of approach had served the military well during the First World War, but Allen was able to demonstrate its value for past as well as present features of the landscape. Even given the right conditions, there is no guarantee that cropmarks will appear, but Allen's repeated flying over the Thames Valley allowed him to begin the task of building up a map of the archaeological landscape of the region from the fragments captured during each flying season (Fig 6.14).

Allen's work also represented a further and significant shift away from an emphasis in archaeology on upstanding monuments. Crawford and Keiller's work had begun to fill in the gaps in a region that was already a focus of research and fieldwork because of its plentiful supply of earthworks. Hints had been forthcoming during the 1920s, of course, but Allen's work demonstrated that a similar density of prehistoric activity existed in an area that had previously only attracted the attention of prehistorians when something turned up during gravel digging.[88]

Allen's willingness to spread the news of his discoveries was particularly noteworthy, his photographs frequently appearing in papers published either by himself or others. As Crawford later noted, 'the receipt of a parcel of air photographs from him was an exciting moment, like receiving a bundle of prehistoric manuscripts, as it were. On each were new facts, some of prime importance, about English prehistory.'[89] With Crawford's encouragement, Allen also began work on a book about aerial photography. Crawford was concerned about the need 'for a useful manual of archaeological air-photography, such as then did not exist'. He judged *Wessex from the Air* to be 'a big and expensive book and rather specialized', while his Ordnance Survey Professional Papers were 'rather out-of-date and badly illustrated'.[90] Unfortunately, Allen had not completed the task prior to his death in a motorcycle accident in November 1940, although many years later, a version did finally see the light of day.[91]

Figure 6.14 Major Allen's plot of the cropmarks he photographed in the vicinity of Dorchester-on-Thames during the later 1930s. Compare the 'Big Rings' henge and cursus with the level of detail visible on Fig. 6.13. [Reproduced from G W G Allen, 'Marks seen from the air in the crops near Dorchester, Oxon', *Oxoniensia* **3**, 1938, Fig 20; © Ashmolean Museum, University of Oxford]

However, something of an Anglo-German co-production appeared in 1938 instead. Crawford had been invited by the German archaeologist Gerhard Bersu to contribute to an exhibition of air photographs that Bersu was organising in Berlin. Crawford put together 100 photographs, including some taken by Allen, and wrote short summary descriptions of each. Realising that he had the basis for a book, he approached the Director-General of the Ordnance Survey: 'The proposal was very coldly received; he anticipated objections from the Stationery Office and I did not press the matter … It was very disheartening but I was getting used to that.'[92] On 18 March 1938, he was in Berlin, exhibiting and explaining his photographs to visitors. He was also required to give a lecture, which was translated into German by Bersu. The German text was read to the audience by someone else, while Crawford pointed at the screen at appropriate moments. The 400-strong audience was mainly drawn from the German military, with Crawford the only Briton present. Afterwards, a director of Lufthansa asked Crawford's permission to publish the lecture as an illustrated monograph. Crawford readily agreed, only to find that although the Ordnance Survey had rejected the idea of publishing it themselves, they would not allow Lufthansa to do so; they eventually relented to the extent that publication would be allowed so long as Lufthansa paid a copyright fee of 2s 6d for each photograph reproduced, a charge which would have brought the British Treasury some £5 2s 6d. The demand was eventually dropped, with Crawford musing about how the British Government would have enforced payment. The book appeared later in 1938 under the title *Luftbild und Vorgeschichte*. Crawford was presented with around 100 copies, all but one of which was destroyed by the Germans during a bombing raid in 1940.[93]

Little Woodbury: Aerial photographs and excavation

Since Crawford's work on the Stonehenge Avenue (*see* pp 136–40), it had become increasingly common for some form of trenching to be undertaken at new cropmark discoveries, although as the pace of discovery quickened, the ground-based archaeologist needed to become more selective. However, the situation at Woodhenge, where the site was uncovered almost in its entirety, remained a rarity. Excavation was generally small in scale, comprising a few judiciously placed trenches aimed firstly at actually finding the site and then hopefully revealing some clue to its date and function.

By 1938 Crawford was serving as president of the Prehistoric Society, succeeding the Irish-based German archaeologist Adolf Mahr, who had drunkenly revealed his pro-Nazi and anti-Semitic views after his Presidential Address to the Society the previous autumn.[94] Crawford had already persuaded the Society of the need to undertake a model excavation, using the highest available standards and techniques, setting his sights on the complete excavation of a prehistoric settlement. He was almost certainly influenced by the results of recent settlement excavations on the Continent and particularly in Germany, so it is likely that the decision to invite Bersu to direct the excavations was part of the plan from the outset. Crawford and other leading British prehistorians were clearly impressed with what they were hearing and reading about settlement excavations being undertaken in Germany, particularly when compared to standards in Britain.[95]

Crawford's initial preference was for a 'lake village' in the East Anglian fens and he set out with Charles Phillips on what was to prove a fruitless search for a suitable site. Crawford then visited Bersu in Germany taking a large batch of aerial photographs with him. The site they chose was one of two enclosures at Woodbury near Salisbury. The larger of these enclosures had first been photographed by Crawford himself on one of the *Wessex from the Air* flights in 1924. At the time, Crawford regarded it as 'amongst the most striking of our discoveries. It was evidently once a hill-fort of more than usual strength... .' He also noted the smaller enclosure in a nearby field, but was not able to get a photograph of it. Instead, it was first photographed from the air almost five years later by the RAF (Fig 6.15).[96]

Both enclosures at Woodbury were photographed by Pilot Officer Jonas somewhere between 11am and noon on 16 May 1929. When Crawford published the pictures in the December 1929 issue of *Antiquity*, he described them as representing 'the culminating point of archaeological air-photography'. Jonas was flying out of the RAF aerodrome at Old Sarum, which is where Crawford found the photographs, in the course of 'taking over obsolete negatives on behalf of the Ordnance Survey'. He added that they

> were taken during pin-pointing, as part of the ordinary routine of training; but that these particular sites were selected for practice is due to the keenness of the photographic section at Old Sarum, which has been closely associated with the development of this branch of air-photography from its birth ... Regarded merely as photographs, from a technical standpoint the negatives are as nearly perfect as possible.[97]

It appears that Jonas was not aware of Crawford's earlier discovery of both sites.

Figure 6.15 Little Woodbury photographed for the first time as cropmarks in May 1929. Note the main enclosure ditch, the 'antennae' ditches outside the entrance, and the smattering of pits and the more extensive darker splodge inside. [CCC 8907/3532, 16 May 1929]

Crawford was particularly pleased with the amount of detail visible on the photograph of Little Woodbury, as the smaller of the two enclosures became known. The 'mass of black spots' seen within the enclosure was suggested to represent 'without any doubt the vestiges of permanent habitation'[98] – pits and huts, something not previously identified on aerial photographs. In excavating the site in its entirety, Crawford and Bersu were aiming to uncover a complete settlement, houses and all, for the first time in this country.[99]

Crawford had hinted at a possible Iron Age date for the enclosure as early as 1924 and again in 1929. However, it wasn't until test excavations were undertaken in March 1938 by Phillips – after Bersu and Crawford made their selection – that this was confirmed. The plan was for Bersu to excavate the site in its entirety over several seasons, beginning in the summer of 1938. In the event, only one full and one truncated season were possible, with around one-third of the site examined (Fig 6.16). Bersu and his wife remained in Britain following the outbreak of the Second World War and, after accepting hospitality from various friends over the next few months, they were interned on the Isle of Man as enemy aliens for the duration of the war.

Figure 6.17 This cropmark of an enclosure at Barrock Fell, Cumbria – lying outside 'archaeological England' – was photographed by Insall in 1930. It was one of several sites he spotted around this time. [CCC 11757/7667]

straight on to six-inch maps – and it's even got a bar!'[108] A slightly different version of the story is recounted in Murray's biography of Keiller. Crawford merely commented that 'a friend of mine whose ideas are cast in an ample mould, once suggested hiring a Zeppelin … but personally I prefer not to expose my valuable camera to needless risks. The captive balloon is, to my mind, more suitable to the temperament of those who meditate upon the past.'[109]

Surveying all of 'archaeological England' from the air is something that was not to be approached seriously for a few more decades. The RAF was not in the business of providing systematic coverage at all, let alone at the right times of year, while privately owned planes operated by individuals with an interest in archaeology were few and far between. Added to that, of course, mapping techniques were still quite rudimentary. This was fine when dealing with vertical images over fairly flat ground, but less so over more complex topography and especially when dealing with obliques.

Crawford's first real attempt at mapping a landscape rather than individual sites occurred as early as 1923, but it was not until the 1930s that he returned to this more extensive approach. He had begun to build up quite a reference library of negatives and prints at the Ordnance Survey. Enlarged prints were made from all negatives and classified according to county and 6-inch map sheets. Most of these photographs came from RAF sources, although this was not a straightforward process. Many in the RAF and Air Ministry were

cooperative, but this wasn't always the case – 'My chief difficulty was the continual change of personnel; no sooner had I got the general principle approved and a routine of collection established than another officer was appointed and I had to begin all over again. There was no continuity of policy.' Despite all this, 'we did get a lot of unwanted but most valuable material from the RAF'.[110]

As the collection grew, it became standard practice for the aerial photographs to be consulted first when looking at a particular site or area. Crawford's base near Southampton, his own archaeological interests and the fact that the RAF bases he visited most frequently were in Hampshire and Wiltshire meant a considerable bias in favour of Wessex and particularly Salisbury Plain. In terms of archaeological survival, Crawford felt that there was nowhere else in Europe to compare, noting that 'it was possible to make an accurate map, from air-photographs, of the archaic field system, and I obtained approval to compile and publish a series of maps entitled "Celtic Fields of Salisbury Plain"'. This was a far from straightforward task – the plotting from aerial photographs was a considerable job in itself, but Crawford insisted that everything needed to be checked in the field as well. By 1935 Crawford had managed to acquire an assistant as well as two draughtsmen, all three of whom were also expected (by Crawford at least) to undertake fieldwork. These three 'rapidly acquired an excellent eye for recognizing earthworks in the field, and for distinguishing between ancient and modern ones'. However, only one map sheet – focusing on Old Sarum – was published, while a second, centred on Amesbury, had reached the proof stage when war broke out in 1939 and was never printed (Fig 6.18).[111]

Figure 6.18 An extract from the unpublished 'Amesbury' sheet in the planned series *Celtic Fields of Salisbury Plain*, showing fields, linear boundaries, barrows and other features in the vicinity of Tidworth Barracks. [AO 0715; Reproduced from the 1939 unpublished Ordnance Survey map]

Throughout the 1930s Crawford had also been undertaking sporadic fieldwork in Scotland, in line with the Ordnance Survey's general priorities for map revision. He completed this groundwork in April 1939, but 'very much wanted to look at all these Roman roads and sites from the air and see if I could fill in some of the missing links'.[112] A friend of Crawford who happened to own an aeroplane – Geoffrey Alington – had already expressed an interest in learning about aerial archaeology, so Crawford got in touch with him. Alington's terms were generous, asking only to be reimbursed for the cost of petrol and oil. Crawford applied to the Ordnance Survey for official approval:

> But my application caused a flutter of apprehension in the bureaucratic dovecotes, and the usual lengthy exchange of minutes. Though I had been using air-photographs for the purposes of Ordnance Survey archaeology for sixteen years, no one in the office seemed to have realized it or the advantages which the overhead view provided … I was asked to say how much it would cost to do the same work by taxi…[113]

In the end, Crawford had to pay the costs himself.

Alington and Crawford set out on 6 June 1939, returning to Southampton on 14 June. Around 50 new sites were discovered, including around a dozen of Roman date, some of them previously unrecorded stretches of road. Interestingly, Alington not only flew the plane (a Puss Moth similar to Allen's) but also took all the photographs. Crawford noted that non-Roman cropmark sites were so numerous that it was difficult to record them all and recommended further systematic survey to follow up this preliminary work. Crawford concluded that 'the exploration of ancient Scotland from the air has only begun. It is one of the most promising fields of research anywhere in the world', but reminded his readers that 'concentration and specialization are desirable to produce the best results; and that air observation is most profitable when one has previously familiarized oneself with the topography by fieldwork'.[114]

1939: A positive outlook?

Crawford's optimism was, of course, put on hold by the outbreak of war. He had been in Berlin as late as 20 August 1939, attending yet another archaeological congress. Back home, he found the pace of work slowing until it ended with the bombing of the Ordnance Survey during a raid on Southampton on 30 November 1940. Crawford spent much of the war working for the newly established National Buildings Record, photographing buildings of architectural or historic interest considered at risk. This continued until the end of 1945; the following October Crawford chose to retire from the Ordnance Survey at his first opportunity. This effectively ended his direct involvement with both fieldwork and aerial photography in this country. Apart from his continuing role as editor of *Antiquity*, aerial photography was to continue its intermittent development without his input.

The inter-war years had clearly seen tremendous progress as far as aerial photography was concerned, with Crawford the leading figure. It has been pointed out a number of times that British archaeologists would have become aware of the potential of the technique sooner or later, but one wonders how much progress would have been possible without someone like Crawford – undoubtedly the right person in the right place at the right time. Even in 1939

Crawford was still heavily reliant on RAF and Air Ministry cooperation for further additions to his collection of air photographs, despite Allen's photographic contributions. It is more than possible that without Crawford, aerial photography in Britain might have progressed no further than it had in other European countries over the same period, its potential as a tool for discovery and mapping largely unappreciated.

This is not to say that no work was being undertaken elsewhere, although across much of Europe little real progress occurred until after the Second World War and in a number of cases it took even longer. Further east, the experiences of the First World War had underlined the potential of discovery from the air in places that had seen little mapping, let alone archaeological exploration. Particularly noteworthy was one German initiative in Palestine – the *Denkmalschutzcommando* – created specifically to record archaeological sites, either on the ground or from the air, in advance of military action during the latter stages of the 1914–18 conflict. A major figure in Syria and Jordan during the inter-war period was Antoine Poidebard, a French Jesuit priest whose work and publications – focused on the Roman period in the region – represent real landmarks in the use of aerial photography for archaeological research.[115]

In his own summing up of achievements in the 1920s and 1930s, Crawford recognised that much remained to be done. Considerable impact had been made as far as prehistory and Roman Britain were concerned (Figs 6.19 and 6.20), but there had been considerably less impact on more recent periods. The pages of *Antiquity* frequently showed new and significant discoveries, but there is little to suggest that most archaeologists saw aerial photography as anything more than a novel means of finding interesting sites to dig. Crawford's pioneering work on the mapping of Salisbury Plain barely saw the light of day, while Allen's mapping of cropmarks in the environs of Dorchester-on-Thames appeared too late to stimulate any similar research before war broke out.

Crawford rightly praised Allen for a number of key advances that were to be developed further after the war: 'During the first few years, when we were mainly dependent upon chance observations, many notable finds were made; we were able to reach certain conclusions about the interaction of crops and climatic conditions with the underlying site; but we were powerless to experiment with seasons, lighting and the angle of view. Major Allen has changed all this.'[116]

But there were clear limits to what had been achieved. As Crawford also noted, 'many regions are virtually untouched, particularly those outside the normal range of a Puss-Moth based on Oxford'.[117] Ian Richmond was to spell out further limitations for the technique a few years

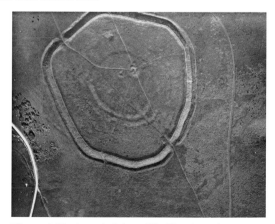

Figure 6.19 A vertical view of The Trundle, an Iron Age hillfort on St Roche's Hill, overlooking Goodwood racecourse near Chichester, West Sussex. In the light of Alexander Keiller's excavations at Windmill Hill, Wiltshire, Crawford suggested to Cecil Curwen that the earthworks visible within the hillfort might represent another Neolithic causewayed enclosure, something Curwen promptly demonstrated through excavation. [CCC 11752/209, 1925]

later, when he considered the reasons for the lesser impact of aerial photography away from the prime arable land of the south.[118] On the whole, though, by the end of the 1930s the general outlook as regards aerial photography seems to have been fairly positive. Every flight seemed to find something new and there seemed little reason to believe that this situation would change in the foreseeable future. At the same time, however, the point that the aerial photographer was capturing something in the process of being destroyed hadn't been grasped. Crawford had claimed that 'no site, however flattened out, is really lost to knowledge',[119] yet arable agriculture – and in particular ploughing – was both revealing and eroding buried archaeological sites. More general problems seem not to have been appreciated too. Writing in 1938 about his discoveries around Dorchester-

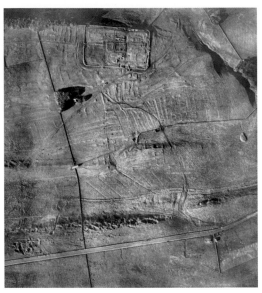

Figure 6.20 Vertical view from 1930 showing the Roman fort of Housesteads and its immediate environs, including parts of Hadrian's Wall. [CCC8991/09848, 9 Oct 1930]

on-Thames, Allen referred to gravel digging without apparently recognising the threat that increasing, and increasingly mechanised, extraction would pose to the sites he was recording.[120] Ironically, of course, Allen's own company operated gravel pits in the Thames Valley and sold extraction equipment to others.

7 'an easy … war of "women's work"'

Air photo intelligence and the Second World War

During the Second World War, aerial reconnaissance and aerial photography became indispensable – an essential element of all aspects of the war at land and sea, at home and abroad – although this isn't always apparent from the published literature. In his study of the history of military aerial observation and reconnaissance from 1785 to 1945, Peter Mead found the last few years of his period of interest particularly difficult to research: 'With a few exceptions, the Official Military Historians almost ignored air reconnaissance, seeming to regard it as a routine affair – like the soldiers' breakfasts, perhaps, a necessary preliminary to battle but hardly worthy of mention. Air Force chroniclers … concentrated on the aggressive roles.'[1]

During the war, and particularly the earliest stages, a certain amount of ignorance and scepticism also had to be overcome within sections of the military and government, especially as ever greater resources were put into both reconnaissance photography and air photo interpretation. Propaganda aimed at the sceptic within characterised the aerial camera as a 'one-eyed Mata Hari of the blitzkrieg era', able to penetrate enemy territory with a glass eye but 'without passport, false whiskers or invisible ink'. The resulting images represented 'an instantaneous record of all that goes on over an area of more than six square miles … [An] unposed, candid-camera portrait … of the enemy, with its bony structure of hills; its river arteries; its clothing of verdure and farm crops; its nervous system of transmission and communication lines; its prominent features of factories, cities, mines and airports.' Even more important was the interpreter: 'To the untrained eye, the aerial photograph is a coloured patchwork of the landscape's major features reduced smaller than the Lord's Prayer on a pinhead.' It was the job of the interpreter to identify features, produce reports, comment on unusual activity and offer thoughts on the likely significance of what had been observed: '[T]he interpreter knows it may be less important to blow up a steel and concrete pillbox fort than to destroy the plants supplying the steel and concrete.'[2] Ultimately, aerial photography was to prove its worth through practice and experience rather than through such efforts at arm's-length persuasion, but it took a while.

By 1938, despite the advances made by civilian firms, military uses of aerial photography had progressed little beyond the achievements of the First World War. One of those who became frustrated with the situation was Frederick Laws. At the Air Ministry after the First

World War, he had continued to take the lead in improving the cameras available to the RAF and was particularly pleased with the F8, which instead of plates took a roll of film holding up to 100 exposures, producing prints measuring 7 × 7in. However, with 30 on order, the Air Ministry decided that the cost of around £200 per camera was too high and the F24 was developed in its place. With a smaller picture format of 5 × 5in but capable of up to 125 exposures per roll of film, it was to remain the standard RAF camera until 1942 and continued in use for some time beyond that. Laws saw it both as a backward step and an indication of the way things were going at the Air Ministry. In 1933, following several years in charge of the School of Photography at Farnborough and a posting to Iraq, Laws left for a civilian job, having 'decided that to stay in the RAF was a waste of my time'.[3] After a few years in Australia prospecting for gold, he returned to Britain to work for a camera manufacturing firm. He did return to the military fold for the Second World War, serving initially as Senior Photographic Officer at RAF Headquarters in France before becoming Deputy Director of Photography within the Air Ministry.

The School of Photography had continued training photographic officers in the years after 1918, but it wasn't until 1925 that courses in air photo interpretation were added to the curriculum. The general approach remained largely unchanged from 1918 and the degree of importance attached to this particular skill is perhaps indicated by the fact that in 1935 the instructor, Captain T B L Churchill, had to spend time salvaging stereoscopes of First World War vintage after the War Office refused to pay for new ones. In her account of Second World War air photo intelligence, Ursula Powys-Lybbe's wry comment that Churchill was 'responsible for laying the foundation of the training required in the forthcoming war' may have referred to more than just course design and delivery.[4]

Cotton's Crooks

Fred Winterbotham, Chief of Air Intelligence at MI6, had experienced the joys of photographic reconnaissance during the First World War. Indeed, he saw out that conflict as a prisoner of war after being brought down while escorting a reconnaissance flight. Winterbotham recognised that aerial photography offered the best means of keeping an eye on German preparations for a war that was, though expected, still some months away. His opposite number in France, Georges Ronin, had managed some unofficial reconnaissance along the Rhine using a civilian pilot, an old aircraft and an even older photographer – 'a splendid old man with a flowing beard who was normally a portrait photographer in Paris'.[5] The results were promising, but both Winterbotham and Ronin felt that much more could be achieved with more modern planes, cameras and photographers.

Winterbotham recognised that the two essential features required for any reconnaissance aeroplane were that it should be fast and capable of flying at high altitudes; however, the latter presented a serious problem for photography. In 1938, despite the advances made in cameras and lenses since 1918, 'it was still not possible to take photographs above eight thousand feet because the camera lens got fogged with condensation from the cold air'.[6] In peacetime, the need had seldom arisen, but in wartime the plane would have to fly far higher than 8,000ft in order to avoid anti-aircraft fire and enemy fighter planes. More

pressing still was the fact that in 1938, there was as yet no war. Cruising visibly at no more than 8,000ft above German military installations was likely to arouse suspicion.

Winterbotham and Ronin settled on the Lockheed 12A as their ideal reconnaissance vehicle. A twin-engined executive aircraft with heated cabin and room for up to six people on board, it was very fast and capable of flying well above 8,000ft. Two – one for each of them – were ordered initially from America, the order being channelled through the commercial firm Imperial Airways. The French, a tad more paranoid than the British, paid for theirs with a sackful of high denomination banknotes rather than risk writing a cheque. Now all that was needed was a plausible civilian use and user.

What Winterbotham later referred to as his search for 'the right type of aerial James Bond' led him to Sidney Cotton.[7] Cotton was Australian by birth and had flown in the RNAS during the First World War. Subsequently he had tried his hand at a number of ventures in various parts of the world, many of them – such as airmail services and aerial survey – involving aeroplanes and some of them perfectly legal. By the late 1930s his business ventures included colour photography – a process known as Dufaycolor[8] – which saw him flying regularly to various European countries including Germany.

Dufaycolor was based on a technique devised by the Frenchman Louis Dufay in 1908. By the 1930s it was being used for both still and moving pictures, with Cotton as a major investor. However, both the product and its marketing were beset with difficulties, with Kodak in particular vigorously defending their position in the market. Typical of the sort of problems Cotton faced was that two days after apparently coming to some form of arrangement with George Eastman regarding Kodak, Eastman shot himself.

Cotton and Winterbotham adapted their Lockheed for aerial photography by fitting three cameras in the bottom of the plane. Initially these were German Leicas – each holding a roll of film capable of taking 250 exposures – before turning to the RAF's own F24s. One of the cameras pointed straight down, taking vertical views of the ground directly beneath the plane. The other two provided oblique views on either side, thus giving good all round coverage of the ground below and to either side of the flight path. When not in use, the camera lenses were concealed by a sliding panel in the fuselage. The problem of the lenses frosting at altitude was quickly overcome by circulating heated air from the cabin around and over them. Unusually for Cotton, he credited someone else with the discovery – his secretary and mistress of the time, Patricia Martin. Consequently they found they were able to take successful photographs from well over 20,000ft, altitudes at which the small plane was virtually invisible to anyone on the ground.

Cotton first flew several test missions to Berlin, using his business interests as cover. Initially, the cameras were fitted but no photographs were taken – if the Germans searched the plane and found the Leicas, they would be empty. However, no problems were encountered. Winterbotham believed that using an Australian to fly an American-built civil aircraft may have helped, although the cover story was apparently plausible enough for Cotton to be invited to demonstrate Dufaycolor to Hermann Goering at Goering's luxury retreat at Karinhalle, around 80km north of Berlin.[9] This remarkable lack of suspicion meant that during the summer of 1939, a number of photographic

missions were undertaken, with Cotton and his colleagues photographing various aspects of the German military build-up whilst flying to and from his various business meetings.

A more ambitious experiment had been undertaken in the spring of 1939 when Cotton and his chosen co-pilot, the Canadian Bob Niven, toured the Mediterranean region, flying direct to Malta before photographing Italian activity and interests in places such as Libya, Somalia and the Red Sea islands as well as Sardinia, Sicily and southern Italy. According to Winterbotham, there was probably not a single 'Italian aerodrome, barracks, naval base or other object of military interest in southern Italy, the eastern Mediterranean or North Africa which was not recorded in great detail by those splendid cameras'.[10] However, the sheer quantity of exposed film brought back by Cotton and Niven raised the question of how to deal with it.

By 1939 the Air Ministry had just one experienced interpreter of air photographs, Lieutenant Walter Heath, whose principal role was organising short courses in air photo interpretation. The need for specialist interpreters had not yet been appreciated – the situation at the Air Ministry and Farnborough reflected the long-held belief that any intelligence officer was capable of doing the job after a couple of weeks' training. However, even with Heath aided by a number of intelligence officers, a time lag began to develop between processing and interpretation, and there were also concerns about whether all pertinent detail was being recognised and understood.

Cotton turned to a former colleague for help. Major Hemming was managing director of the Aircraft Operating Company (AOC) and its then-subsidiary, Aerofilms. Hemming's firm possessed a Wild A5, a 'stereo-autograph' machine made in Switzerland that offered the user 9-times magnification of stereo pairs. This was far greater than was available to military operators, for whom ordinary stereoscopes were still the order of the day. The Wild (pronounced 'vilt') offered not only the opportunity to examine what was on the photographs in far greater detail, but also to measure in three dimensions and map. In 1939 only two of these machines existed in Britain. The other belonged to the Ordnance Survey and was seriously damaged during a bombing raid in 1940. Further models were extracted from Switzerland by various means during the war.

Michael Spender, the Wild A5's principal operator at the AOC, ably demonstrated the machine's potential in the early months of the war.[11] Spender, brother of the poet Stephen Spender, was already highly experienced in stereo-photogrammetric survey. He was best known for his role as a surveyor on several high-profile expeditions, including the Great Barrier Reef, Greenland and the Himalayas, the last two involving him in detailed mapping from aerial photographs. Immediately prior to joining the AOC in 1939 he had spent a year at the Royal Geographical Society as a part-time research assistant in photogrammetry. Spender was key in demonstrating to Cotton the need for both stereo photography and for regular and repeated reconnaissance.[12]

Hemming had in fact offered to put his company's premises, staff and equipment at the services of the military before Cotton came knocking, but had been turned down by the Air Ministry, Admiralty, War Office and Foreign Office. Cotton now found these facilities placed at his disposal by Hemming. This unofficial arrangement was to continue until the spring of

1940 when Winston Churchill, at the time still First Sea Lord, was informed by Cotton that the intelligence reports and plans he was receiving about German shipping (including the whereabouts of the *Tirpitz*) were based on work being undertaken by civilians. Churchill wrote to the Secretary of State for Air, Sir Kingsley Wood, making it clear that if the Air Ministry wasn't interested in taking over Hemming's operation, the Admiralty was. The result was that by May 1940, the AOC officially became part of the war effort, with Hemming given the rank of wing commander.

The British reconnaissance operation had, in the meantime, expanded from a single Lockheed by the time war had been officially declared. The Blenheims used by Bomber Command quickly proved unsuited to the task, with heavy losses suffered from the start, and Cotton recognised that the Spitfire was the most promising of the aircraft available to the RAF. After some wrangling, he managed to get hold of a pair, which were hastily adapted from a fighter reconnaissance role. They were stripped of anything deemed unnecessary, including weaponry, in order to maximise their potential in terms of speed and altitude, as well as being fitted with both oblique and vertical cameras. Painted a duck-egg blue, the reconnaissance Spitfires were also barely visible from the ground, especially when operating at 30,000ft or more, while their speed and manoeuvrability at such heights effectively put them out of reach of enemy fighters for the first couple of years of the war. They were later joined by Mosquitoes (Fig 7.1) as well as a range of US aircraft types once the Americans entered the war.

Cotton's reconnaissance operation was initially known as the No. 1 Camouflage Unit, though many of the team preferred an alternative. Cotton had issued badges to certain members of his reconnaissance team bearing the legend 'C.C. 11', the C.C. standing for Cotton's Crooks and the 11 referring to the 11th Commandment – 'Thou shall not be found out.'[13] They were based at Heston, London, a civilian airfield, though before long there were aircraft based at airfields in Scotland and Cornwall in order to increase the distance they could reach into enemy territory. Others spent time in France until it fell in May 1940, operating alongside French reconnaissance aircraft as the Germans closed in. One of the French reconnaissance pilots, Antoine de Saint-Exupéry, drew a contrast between the requirements of his military role and what he could actually see from his plane:

> The earth is empty. Man does not exist when you look at the earth from thirty-three thousand feet. His actions cannot be read on that scale. Our long-focus cameras serve as microscopes. Their task is to capture not men, who remain beyond their penetration, but the signs of human presence: roads, canals, goods trains, barges. Men can sow seeds on a microscope slide. I am a scientist of the ice-cold sky, and their war is a laboratory observation for me.[14]

After a series of bombing raids saw Heston – as well as the AOC offices at Wembley – suffering damage and casualties, more suitable accommodation was sought for both outside London. The flying side – the Photographic Reconnaissance Unit (PRU) – moved their main base from Heston to Benson in Oxfordshire, while the interpretation and mapping side, by now the Photographic Interpretation Unit (PIU), found their new home at Danesfield House, Buckinghamshire, overlooking the Thames between Henley and Marlow. Its official title for the duration of the war was RAF Station Medmenham (Fig 7.2), with the PIU becoming the CIU – Central Interpretation Unit – from January 1941 and later,

once Americans officially became part of the set-up, the Allied Central Interpretation Unit (ACIU).

By the time that Heston and Wembley had been left behind, so too had Cotton. His working methods, while undoubtedly successful, had proved unpopular with an array of senior figures both within the Air Ministry and beyond. It was also all too apparent that he was continuing to pursue some of his less orthodox 'business' interests, occasionally using the Air Ministry's Lockheed for the purpose. Cotton's use of the Lockheed to undertake aerial reconnaissance of neutral Ireland at the request of the assistant to the Director of Naval Intelligence, one Ian Fleming, also angered Winterbotham, as did Cotton's hint that he was considering Fleming's suggestion that he switch his allegiance to the Navy.[15]

Among the final straws was Cotton's decision to delay evacuation of planes and personnel from France in the summer of 1940, resulting in the capture of an intact reconnaissance Spitfire as well as examples of photography and intelligence reports. These included proof that he and his colleagues had been busily photographing still-neutral Belgium.

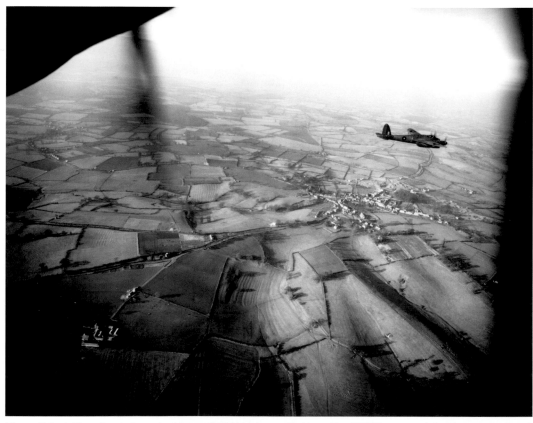

Figure 7.1 A Mosquito photographed from a P-38 Lightning on Christmas Eve 1943. The camera is looking westwards and the village beneath the Mosquito is Brill, Buckinghamshire. [MSO 31297 PO-0024]

Cotton's willingness to accept cash from civilians looking for a lift out of Paris didn't help matters either.[16] On 17 June 1940, Cotton was handed a letter from the Permanent Under-Secretary of State for Air thanking him for his efforts, for which he received an OBE in the 1941 New Year's Honour List.

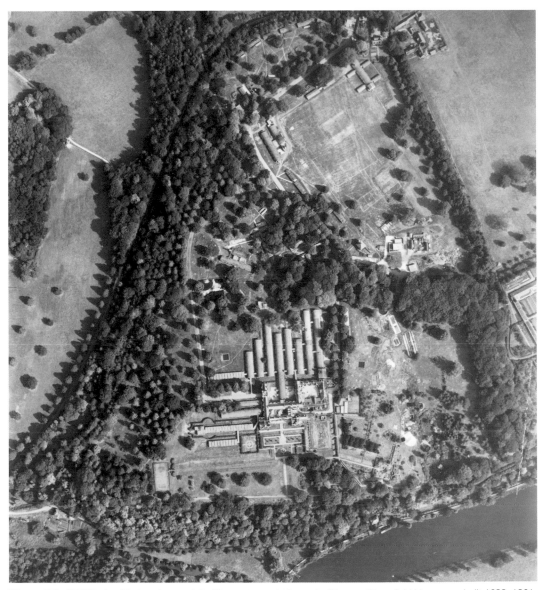

Figure 7.2 RAF Station Medmenham and the Thames towards the end of the war. Danesfield House was built 1899–1901 for the soap manufacturer Robert Hudson; it partly occupies Danesfield Camp Iron Age hillfort though this is not readily visible on this photograph. Note the numerous temporary military structures that had appeared since 1942 to accommodate staff of the ACIU. [RAF 106G/UK/692 frame 3012, 23 Aug 1945]

Evidence in camera

By 1941 the CIU had developed into a highly specialised operation keeping a careful watch on anything and everything of potential military significance in continental Europe (Fig 7.3). Staff were required to familiarise themselves with the physical landscape as much as human activity, while repeat cover allowed them to grasp what was 'normal' in any given place. As Michael Spender told newcomers: 'You must know at a glance what is normal, and then you can recognize the abnormal when you see it.'[17] Specialist teams focused on particular subjects – the German Army and Navy, shipping and shipyards, aircraft, aircraft industry, airfields, radar and wireless transmitters, camouflage, decoys, communications and transportation, general industry and so on. Techniques were perfected for measuring the height of structures according to the length of shadow thrown – heights of potential barriers were essential for those landing behind enemy lines for operations and also once various landings had taken the war to mainland Europe. It even proved possible to estimate the speed of ships through analysis of wave patterns on successive prints.

Figure 7.3 *Evidence In Camera* was an official weekly publication produced by CIU staff and issued to interested parties by the Air Ministry throughout the war. It generally contained examples of reconnaissance photography accompanied by detailed explanations of what was visible on them. A popular and invaluable aid to air photo interpretation, it was initially conceived as a vehicle for promoting such work among more sceptical sections of the military. [Air Ministry 1942 *Evidence in Camera* I (no 5), 16 Nov 1942]

In addition, a model-making section created remarkably detailed three-dimensional scale models to assist in the planning of raids and landings. Perhaps the largest job undertaken by the modellers concerned their part in the planning and preparation for D-Day. According to Constance Babington Smith, '[p]reliminary models of the whole Channel coast had been made from photographs as early as 1942. But for the actual D-Day briefings 340 models were mass-produced in synthetic rubber. Models were also made of typical waves that might be expected on the beaches, based on photographic data as to the beach gradients, and statistics on tides and currents.'[18]

The CIU played a key role in major operations, including keeping a close watch during the summer of 1940 on German preparations for the invasion of southern England; tracking down vessels such as the *Tirpitz* and *Bismarck*; identifying key targets such as radar installations; and planning for the landings in North Africa, Sicily, southern Italy and, ultimately, Normandy. They also searched for traces of V1 and V2 weapons, with the experimental station at Peenemünde first being photographed in May 1942 though its significance was not to

be realised for some time. The work at Medmenham was not undertaken in isolation – successful intelligence work required close liaison with other sources. For Medmenham, this meant a constant exchange of intelligence with Bletchley Park (although the highly secret nature of the decoding work at Bletchley meant that only the most senior staff at Medmenham saw their reports). In addition, using photographic intelligence to cross-check information coming in from sources on the Continent was essential not only in verifying those reports where possible, but also in identifying who the most reliable sources were.

Many of those who have written about their time at Wembley and Medmenham commented on the challenges such work presented. Powys-Lybbe, a professional photographer before and after the war, described how

> [f]amiliar objects become unfamiliar when seen from above, because recognisable perspective is non-existent, and therefore the shape of every object or topographical feature had to be learned so that it could be recognised … Trying to puzzle out enemy activity from photographs was a never-ending excitement for me, and the process of collecting clues seen on the prints and then to be in the position to formulate an hypothesis was immensely satisfying, particularly as there was always the chance of a dramatic discovery.[19]

The actor Dirk Bogarde, who, much to his own surprise, 'became a moderately accomplished specialist' in air photo interpretation, 'loved the detail, the intense concentration, the working out of problems, the searching for clues and above all the memorising. It was, after all, a very theatrical business … a long, silent, painstaking job.' Bogarde, however, had a rather more exciting time than the Medmenham staff – after D-Day, he joined one of the mobile photographic units accompanying the invading forces, experiencing Normandy, Paris, Arnhem, Belsen, Berlin and, finally, Luneberg Heath:

> It was a pretty confusing kind of war altogether. Fluid, sometimes dangerous, exciting, often uncomfortable but never, at any time, boring. There wasn't time for that … We were constantly on the move and the very nature of the work kept me fully occupied day and night, either working at the photographs which streamed into the truck hourly in fine weather, or down the line briefing brigades, companies, platoons, sections and even individuals on the terrain and hazards they could expect to find before them during their attacks; the depth of ditches, width of streams, minefield and lines of fire. We worked shifts day and night … fourteen to sixteen on, ten or eight off. If we were lucky.[20]

The interpreters' abilities were greatly aided by ongoing research into better cameras, producing ever clearer and sharper prints. After new 36in focal length cameras were introduced in 1942, Babington Smith discovered that it had become possible on occasions to

> see the tiny dark specks that represented the human beings so far below. They didn't really look like ants – the obvious simile – but more like grains of pepper, hardly noticeable individually, but springing to the eye when in the mass: for instance when a shift of workers was pouring out of the gates of an aircraft factory. I sometimes

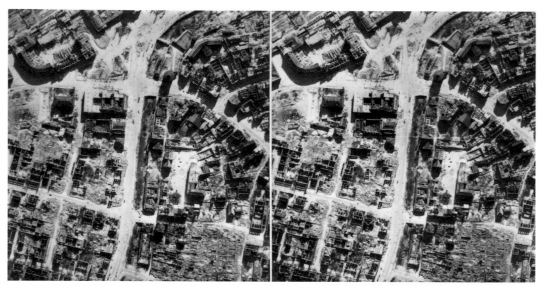

Figure 7.4 The centre of Nuremberg the day after the city finally fell and just a few weeks before the war in Europe ended. The black dots visible on the roads are, for the most part, people. South is to the top and the remains of the railway station can be seen top left. [RAF/AMPS/2927 frame 366, 9 Apr 1945]

used to think that photographic interpretation was a nice clean job, as even after the heaviest attacks, and even with the largest scale, you never saw any blood.[21] (Fig 7.4)

Another by-product of the improved cameras was the claim by 'some of the more agriculturally minded of our colleagues' that it was now possible 'to sex cattle from aerial photographs, that is to say determine the difference between a bull and a cow. However, there was an important proviso regarding lighting: the photograph would have to be taken during the early morning or late evening sun.'[22] According to Powys-Lybbe, German recognition of the effectiveness of the reconnaissance effort was demonstrated by a written directive found on a German officer captured near Ortona, Italy in 1943:

The enemy are taking photographs every day so that they know as much about our positions as any one of us. To reduce this leakage of information, you must avoid making footpaths, and you must carefully camouflage your positions. In particular you must avoid exposing your bare backsides during the daytime, as they would clearly be visible in the photographs and might pinpoint our positions.[23]

Bomber Command

Reconnaissance photography was essential not only for planning bombing raids but also for assessing their success. However, this task proved a source of friction right from the start. The first bombing raid on German territory was planned for the night of 19–20 March 1940. The target was the island of Sylt, one of the North Frisian islands lying just off the western

German coast of Jutland. Among other things, the island hosted a seaplane base. The raid was intended as a very public response to the recent German attack on Scapa Flow and aimed to show the British public and the wider world that the British forces were capable of landing a blow on German territory.

Late on the night of 19 March, while the raid was still in progress, Prime Minister Neville Chamberlain announced what was happening to the House of Commons. The following morning, and for several days after, the raid received widespread newspaper coverage with details provided by the RAF and, apparently, eyewitnesses who had watched the amazing spectacle from the Danish mainland. Germany responded by claiming that most of the bombs had actually fallen on Danish territory, claims that were dismissed as 'ludicrous' by *The Times*, despite apparent confirmation from neutral (that is, American) journalists taken to Sylt to see the absence of damage for themselves.[24] Such claims could have been dealt with by releasing some of the reconnaissance photographs taken the morning after the raid. However, on 22 March, the Air Ministry issued a brief press announcement stating: 'The photographs taken have been proved to be of no value in indicating the extent of the material damage inflicted in the course of the heavy attack.'[25]

The real story of those reconnaissance photographs of Sylt was not to emerge until after the war. Flight Lieutenant Peter Riddell was in charge of Bomber Command's photo intelligence section and led the damage assessment, while Bomber Command's photographic section waited to turn out special enlargements of the best images for the press. When the photographs arrived, Riddell shared them out among his team and then settled down with a batch himself. After painstaking analysis, Riddell's team identified a handful of possible craters in sand dunes and a single tiny hole in the roof of one of the hangars. Postponing a planned trip to Buckingham Palace with some enlargements, Riddell tried to explain the situation to his disbelieving superiors.

Riddell and his colleagues were locked in a room and told to look again for signs of damage. Even after this, a still unbelieving Arthur Harris, then Group Captain in command of No. 5 Bomber Command, insisted on further, extremely dangerous, low-altitude photo reconnaissance, which yielded exactly the same results. Most of the bombs dropped during the raid had indeed fallen on Danish territory. According to Powys-Lybbe, the treatment of Riddell and his colleagues by Bomber Command was fairly typical for the early years of the war.[26] Stella Palmer, a WAAF officer working in photo intelligence at the time, complained of constant pressure to produce reports of remarkable successes despite a constant stream of photographic evidence to the contrary. The real problem, of course, was the urgent need for better navigational aids. The night bomber crews all too often found themselves quite literally in the dark.[27]

Things began to change with a new development that allowed Bomber Command to see exactly where their bombs were falling. Night-time photography by the bombers themselves, with the aid of flash-bombs, was supposed to help with damage assessment, but instead it showed just how unsuccessful the raids were. However, matters didn't approach resolution until the summer of 1941. Some members of the Cabinet were suspicious that the scale of the problem was being withheld from them. One particularly suspicious individual was Professor Frederick Lindemann, personal assistant to Winston Churchill, who was by now prime minister. Lindemann arranged for detailed analyses to be undertaken of recent

night-time photography from bombing raids. In August 1941 he was able to report to Churchill that a study of night-time photographs taken on raids between 2 June and 25 July 1941 showed that barely one aircraft in three was managing to drop its bombs within five miles of its intended target.[28] Lindemann told Churchill that the figures underlined the need to improve aircraft navigation methods, while the whole episode also seems to have marked a real turning point in Bomber Command's attitude to air photo intelligence, which came to be accepted as indispensable.

Lindemann's report also provided support for another strategy that had been gathering favour within Bomber Command – if carefully targeted bombing raids were constantly thwarted by navigational problems, an obvious solution was to go for bigger targets, particularly following the realisation that towns and cities in this country, such as Coventry, were being bombed in an attempt to affect civilian morale. The response was 'a sacrifice of the concept of precision bombing, and an acceptance of that principle of indiscriminate plastering of German cities…'.[29]

Camouflage and decoys

From an early stage in the war, the Germans had been trying to deflect the attentions of bomber crews from their targets by constructing dummy buildings intended to resemble likely reconnaissance and bombing targets but, as a number of those who worked at Medmenham have attested, these could be quite simple to spot on aerial photographs. A greater problem lay in identifying the dummy structures created not to resemble specific structures but to give the appearance of burning buildings at night.[30] In fact, it was the success of these decoy structures that provided a vital clue as photographs began to turn up at Medmenham showing quantities of bomb craters some distance from any meaningful target, but apparently clustered around some curious-looking rectangular

structures. One of the Medmenham staff, Geoffrey Dimbleby, was given the job of finding out how these decoys worked (Fig 7.5).

Through his stereoscope, he could see that the rectangular structures were unroofed, calculating from the length of the shadows cast that the walls were no more than 5ft high. Within each were bundles of what looked like straw, arranged at regular intervals. Once lit, the impression given to bomber crews at night would be of burning buildings in a blackout, suggesting to them that they were above a target. The number of craters around some of them showed that they were working. Soon, Dimbleby was in charge of a specialist Decoy

Figure 7.5 Squadron Leader Geoffrey Dimbleby and Assistant Section Officer Helga O'Brien of Medmenham's Decoy Section posing for the camera. After the war, Dimbleby (1917–2000) was a pioneer in the field of environmental archaeology, becoming Professor of the Human Environment at the Institute of Archaeology, London, in 1964. [© Medmenham Collection]

Section, on the lookout for evidence of a German decoy network that was to become ever more elaborate and complex as the war progressed.

As raids on Germany were stepped up, and more decoys were recognised, the target folders that were provided to bomber crews began to feature details on the form and location of the known decoys en route. Again, this led to problems with Bomber Command, who complained that their crews' morale was being upset by being told about decoys.[31] This response to German night decoys seems especially curious once it is realised that similar tactics were already in use this side of the Channel by the summer of 1940 in order to deceive German bombers. In this, they quickly achieved some success, though this was not entirely due to the careful design and location of the British decoys. Captured Luftwaffe crews confirmed that in the early stages of the war at least, they were 'under orders to bomb lights opportunistically', just in case they represented something of military value.[32]

Decoys were just one of many techniques used to confuse the enemy, especially enemy aerial reconnaissance. Many of the methods in use during the Second World War had their origins in the First World War, when the problem of hiding positions and activity from aeroplane-based observers and cameras was first faced. During the Second World War, obvious bombing targets such as airfields, factories, canals, roads, railways, harbours, shipbuilding yards and so on were routinely disguised in some form or other, using a variety of techniques such as screening, painting or the construction of dummy replicas. The key, of course, was to avoid detection on black-and-white vertical photography rather than just simple concealment from the ground-based observer. It had been recognised during the First World War that as far as deceiving photography was concerned, shade, tone and shape were more important than colour. Greater emphasis was placed on using abstract patterns to break up outlines rather than purely attempting to blend in by matching background colours (Figs 7.6–7.8).

But how successful was camouflage in fooling the air photo interpreters? In Britain aerial photographs were taken in an attempt to judge the effectiveness of and guide improvements to many schemes. In late September 1939, the architect Raymond Myerscough-Walker went up to see for himself how successful various camouflage schemes were:

> I flew from Hendon to Derby and over certain parts of the Eastern counties. Flying at a height of 1,500 ft. in clear weather it is perfectly easy to detect camouflage schemes. I discussed the question of camouflage with the pilot, and apart from one or two exceptional cases he was not very impressed by the result and found its value to begin only when travelling at a great height, such as 20,000 ft.[33]

Of course, much reconnaissance photography was undertaken by the Luftwaffe in 1938 and 1939, well before key targets were camouflaged (see Luftwaffe photo reconnaissance, pp 197–9). After 1941 Luftwaffe reconnaissance photography over the British Isles was much less frequent, so the Germans may have had few opportunities to be deceived.

Comments made by Powys-Lybbe suggest that experienced air photo interpreters in an organisation as well run and efficient as the CIU were unlikely to be fooled. Again, extensive camouflage of obvious targets for Allied bombing was not in place at the start of the war. Repeated reconnaissance often meant that Medmenham staff could actually

observe the camouflage process from start to finish. Powys-Lybbe also noted the tendency for camouflage to make a potential target even more obvious to the photo-interpreter than if it had been left alone: '[I]f it is there, it means that something of military or industrial importance is under it.'[34]

Working in the section at Medmenham dealing with operational airfields, Powys-Lybbe was particularly intrigued by the often clumsy measures employed by the Luftwaffe to conceal their aircraft. For example, lengthy taxi tracks led to small estates of apparently suburban

Figure 7.6 The Military Vehicle Depot at Ashchurch, Gloucestershire, camouflaged for concealment from prying airborne eyes. Construction began in 1939, with photographic cover from 1940 charting its initial construction through to post-war developments. It still remains active as a military vehicle depot. By the time this photograph was taken in 1943, various other military functions were also based at the site, which occupied a greenfield site at the junction of two railway lines. Note the extensive ridge-and-furrow surrounding the site. [US/7PH/GP/LOC65 frame 1047, 18 Oct 1943]

houses which, on closer inspection, proved to be suspiciously tall, with unusually wide concrete driveways, doors and windows that seemed to be painted on and frontages that could slide open like hangar doors. As for the airfields themselves, camouflage paint on buildings faded rapidly through exposure to weather; paint on runways likewise wore off as a result of frequent take offs and landings, and tended not to blend in too well with its surroundings anyway. Moreover, complete concealment of something the size of an airfield was always going to be impossible. Dummy airfields were also easy to spot – for example, the fake hangars tended not to be built to scale; the dummy aircraft soon began to show

Figure 7.7 Military airfield at Kenley, near Caterham, Surrey. Photographed here early in the Second World War, the airfield began its life during the First World War. Note the still-visible landing target clipped by the line of one of the camouflaged concrete runways. [RAF/S653 frame 9, 7 Nov 1941]

GB 74 16 b
Nur für den Dienstgebrauch
Bild Nr.: (3) F 837 b 40 246
Aufnahme vom 12. 9. 40

Hucclecote
Flugzeugzellenfabrik The Gloster Aircraft Co. Ltd.
Länge (westl. Greenw.): 2° 10′ 30″ Breite: 51° 50′ 50″
Mißweisung: — 11° 31′ (Mitte 1940) Zielhöhe über NN 50 m

Maßstab etwa 1 : 9100
500 0 500 m

Genst. 5. Abt. Oktober 1940
Karte 1:100000
GB/E 27
N

Altes Werk

10 85

Neues Werk

Figure 7.8 Annotated Luftwaffe aerial photograph from a bombing target folder. The camouflaged buildings of the Gloster Aircraft Co Ltd are outlined as targets. Note that the camouflaged airfield immediately south is also identified as a potential target (10 85). In this case, not only field boundaries but fake shadows cast by non-existent trees had been used in an attempt to fool anyone who believed that the sun could shine in more than one direction at a time. [LFT01 GB07416]

signs of weathering; and track activity was far less than might otherwise be expected.[35] Overall, Powys-Lybbe suggested that '[i]f the German authorities had realised how much we knew about their methods of camouflage, and how we were able to watch every stage of the process, they might well have given it up as hopeless quite early on…'.[36]

Luftwaffe photo reconnaissance

Germany had been forbidden from possessing military aircraft under the terms of the Treaty of Versailles. Once in power, the Nazis had embarked almost immediately on transforming the bare bones of a flightless air force into a well-equipped and fully trained military organisation. Hermann Goering officially announced the Luftwaffe's establishment in March 1935, effectively making public a development that had already been apparent to other European governments for some time.[a]

The close links between the German Air Ministry and the country's leading civilian airline, Lufthansa – the airline's head, Erhard Milch, was also Goering's deputy at the Air Ministry – allowed clandestine photographic reconnaissance to be undertaken over many parts of Europe, often on the pretext of testing potential commercial routes for Lufthansa. During the late 1930s, this led to the acquisition of extensive coverage of Britain's North Sea and Channel coasts, plus key areas inland, as well as the Channel coast of France.

The successes and failures of German photo reconnaissance only really became apparent after the war. Quantities of photographs and target folders were recovered by the Allies and surviving German staff engaged in reconnaissance and interpretation work were interrogated, revealing an admittedly partial picture of an organisation that despite initial promise had entered serious decline by 1941. This seems particularly surprising given the oft-quoted statement in 1938 by General Werner von Fritsch, then chief of the German Army's High Command, that 'the military organization which has the most efficient photographic reconnaissance unit will win the next war'.[b]

The German intelligence side seems to have suffered from organisational problems throughout its life. More importantly, it lacked support at higher levels within the military and no central organisation comparable to Medmenham was ever established. On top of this, two more factors contributed to the decline of a service that prior to the war was far in advance of anything the Allies had in place – the failure of the Luftwaffe to achieve anything approaching air superiority over Britain during the summer of 1940 and the failure to realise the full intelligence potential of the aerial photographs themselves.

As already noted, by the time war broke out in September 1939, sizeable areas of Britain and France had already been photographed. This effort was stepped up during the early months of the war, with a considerable amount of photography being undertaken of key targets – naval bases and coastal harbours, airfields, factories and so on – but by the end of 1940 the number of reconnaissance missions appears to have been reduced considerably. Moreover, the Luftwaffe failed to develop high-speed, high-altitude reconnaissance aircraft to compare

Archaeologists at war

Many archaeologists passed through Medmenham and its offshoots during the war and there is room only to mention a handful here. After the war, Glyn Daniel was to become rather well known as an archaeologist – initially as a lecturer and ultimately professor at Cambridge and, for a while during the 1950s, a popular television personality through his regular appearances on *Animal, Vegetable or Mineral*, something that resulted in him being voted Television Personality of the Year in 1955. His first brush with the cameras came at Medmenham during the war, when the Central Office of Information made a film called *Target for Tonight*, aimed at showing how bombing raids were planned. According to Daniel: 'There had, of course, to be shots of photographic intelligence and they filmed Peter Riddell, Constance Babington Smith and myself. I had to draw the attention of Riddell to a particular target and was given some unfortunate piece to say such as "Here's a peach of a target for the boys." We managed to change the script.'[37]

In mid-1940, Daniel and a colleague had attempted to join the RAF only to be told that as university lecturers they were in reserved occupations and should wait to be called up. Almost immediately he was offered a commission in the Green Howards, to which he responded by asking the Air Ministry if they could use someone trained in geography and archaeology, and with some experience in using aerial photographs. He was asked to attend an interview, an experience that he described as pleasant and that ended with him being asked 'How soon can you come?'.[38]

After initial training, he ended up at the former AOC headquarters at Wembley – 'the splendid inspired madhouse of civilians and RAF and WAAF officers interpreting air photographs, making photographic mosaics, writing reports, sending out annotated air photographs … an ill-assorted collection of dons, artists, ballet dancers, newspaper editors, dilettanti, writers…'.[39] This miscellany was partly a product of the way the PIU had formed and developed, but was equally due to an early recognition of the sort of qualities needed. These included previous experience of using aerial photographs; an ability to be trained quickly in the relevant military uses and techniques; good analytical skills allied with an attention to detail; an ability to quickly produce concise and accurate reports; and, especially, sufficiently independent of mind to be able to report accurately and appropriately, whatever the reaction of senior staff.

Initially, recruitment depended to a certain extent on recommendation from someone already in the PIU. For example, Daniel was asked what his archaeological acquaintances were up to.[40] He immediately thought of Stuart Piggott and Terence Powell, both serving as privates (the latter in the Irish Fusiliers). Within three weeks, both were at Medmenham. Piggott had been living at Rockbourne, near Salisbury, when the war began and was serving in an anti-aircraft battery at Longford Castle. His duties there were not too onerous: 'When it was discovered that I could not only read and write, but type, I was made a clerk in the Battery Office, where, under the aegis of an agreeably eccentric and understanding Territorial Army sergeant-major, I found, once my not very demanding official duties of the day were duly performed, that I could continue to some extent to be an archaeologist… .'[41]

Like many other archaeologists engaged in air photo intelligence, Piggott was able to continue his studies even after moving to Medmenham. In Piggott's case this involved pursuing his

Figure 7.9 A Second World War reconnaissance photograph of Ban Pong, Thailand, one of the many images that passed through the Delhi-based unit headed by Glyn Daniel. The Burma–Siam Railway heading off to the right of the photograph is the one infamously built by Allied prisoners under Japanese control. [Diana Twist]

researches into the 18th-century antiquarian William Stukeley, hitch-hiking to Oxford on his days off to visit the Bodleian Library. However, in January 1942 he was one of a small group posted to Singapore to set up an air photo interpretation unit to assist in the war in the Far East: 'Fortunately for us, Singapore fell to the Japanese in February, by which time a delightfully leisurely air journey had brought us to Cairo. After some weeks of repeated but unanswered signals to the War Office I found myself allotted to India instead… .'[42]

The Central Photographic Interpretation Centre in Delhi had been set up by Daniel, who had been dispatched to the subcontinent with the task of establishing an outpost of Medmenham, initially to support the war in Burma (Fig 7.9): 'I left the blackout and austerity and bombs and spent four very happy years in the heat and sun of the great sub-continent and enjoyed enormously some of the last days of the British Raj.'[43] Terence Powell was also posted out there. As the new section grew – incorporating in the process many of the functions represented at Medmenham such as model-making as well as the various photographic and interpretative functions – they found themselves spacious

To my surprise its chairman, a group captain I believe, commented, 'I see from your application that you are interested in archaeology'. I replied, 'Yes, sir'. He then handed to me a flint implement which he had pulled out of his pocket and asked me to comment on it. I said that it was a flint scraper, found on the chalk downs as it had a white patina. He then gave a smile of approval to the rest of the selection committee and I was passed for the commission in air photographic intelligence.[57]

Grinsell spent five months at Medmenham before being posted overseas, spending the next few years in Egypt, mainly undertaking bomb damage assessments. He also took advantage of his posting to visit the obvious archaeological attractions of the region, including its museums.[58]

After a spell at the Admiralty tracking U-boat movements, Brian Hope-Taylor moved in 1943 to the RAF. After trying out as a pilot at Brize Norton, something that foundered on medical grounds, he found his way to Medmenham. There he worked in the model-making section, using his artistic skills to produce incredibly complex and detailed three-dimensional models from stereo air photo evidence. Hope-Taylor had been interested in archaeology before the war, but the encouraging presence at Medmenham of archaeologists such as Phillips led him to pursue the subject further. In fact, he undertook survey and excavation work during periods of leave, occasionally roping in Medmenham colleagues to help out.[59]

George Holleyman, a Sussex-based field archaeologist who had made use of aerial photographs to support his fieldwork on the South Downs before the war,[60] was commissioned into the RAF as a flight lieutenant and trained as an air photo interpreter. By mid-1941 he was on Tiree, the outermost of the Inner Hebrides, where he spent 20 months, undertaking a certain amount of archaeological exploration in his spare time before he eventually ended up at Medmenham, seeing out the war as librarian in charge of the vast collection of aerial photographs and related material.[61]

RAF photography 1944–51

During the war, photography over the British Isles was undertaken by both the RAF and USAAF for a variety of reasons, chief among them being the need to assess the effectiveness of various defensive and camouflage schemes and for assistance in future (military) planning, as well as providing training in the techniques of aerial photography for flight crews. All photographs taken over the British Isles (Figs 7.10–7.14) were sent to Medmenham, where the 'M' Section was responsible for assessing them.

Long before the war had ended, various government departments, including the Ministry of Housing and Local Government and the Ministry of Town and Country Planning, identified a need for considerable quantities of aerial photography to aid post-war planning. The Ministry of Town and Country Planning was also arguing that it should be responsible for maintaining a central library of aerial photographs. In addition, the Ordnance Survey recognised that aerial photography at a range of scales would be essential for its own post-war revision programme. By November 1944 the Air Ministry decided that the RAF would be responsible for all aerial photography required by government departments, with the commitment to provide photographs to the Ordnance Survey recognised as the largest such undertaking.[62]

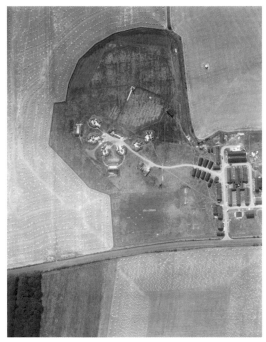

Figure 7.10 Anti-aircraft battery and associated buildings near Cleadon, north of Sunderland, photographed shortly after the end of the war in Europe. Note the baseball diamond. [RAF 106G/UK/745 frame 6255, 28 Aug 1945]

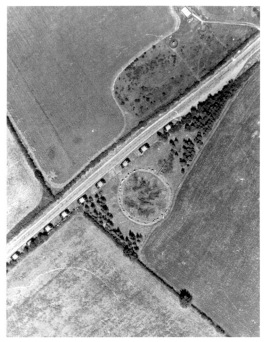

Figure 7.11 Wartime roadside storage running past the Rollright Stones. The road marks the Oxfordshire–Warwickshire county boundary. [Ashmolean Museum, University of Oxford; RCA 11406/16]

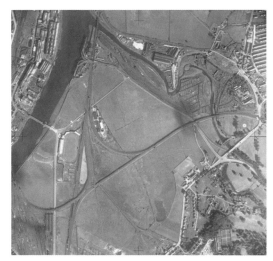

Figure 7.12a A wartime RAF vertical showing the River Derwent meeting the Tyne. Two barrage balloon sites can be seen – centre right and centre left – each with a balloon floating above them. [RAF/FNO/129 frame 1093, 1 Sep 1942]

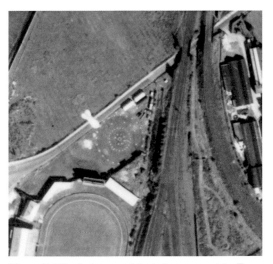

Figure 7.12b A close-up of the balloon nearest the Tyne. [RAF/FNO/129 frame 1093, 1 Sep 1942]

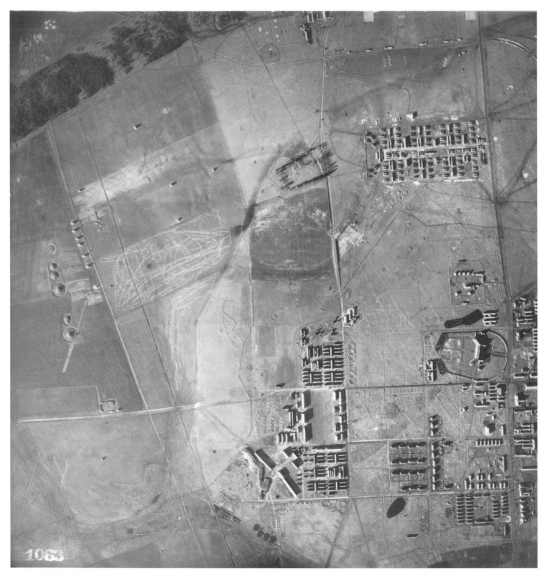

Figure 7.13 The low midwinter sun picking out prehistoric earthworks among the military activity at Larkhill on Salisbury Plain. The Stonehenge Cursus can be seen running down the left side of the photograph, while Bronze Age barrows can be seen amidst the traces of past and present activity within the military base itself. [US/7PH/GP/LOC122 frame 1063, 24 Dec 1943]

This policy was formally announced in the House of Commons on 21 March 1945 by the Secretary of State for Air.[63] It was recognised that this was a heavy commitment, not just in terms of the amount of survey flying required, but also in terms of processing, printing and supply. The photographs would, as far as possible, be taken according to the specifications of the commissioning department, who would receive the negatives and initial prints. Copies would be retained by the RAF where particular images were deemed to possess any intelligence value.

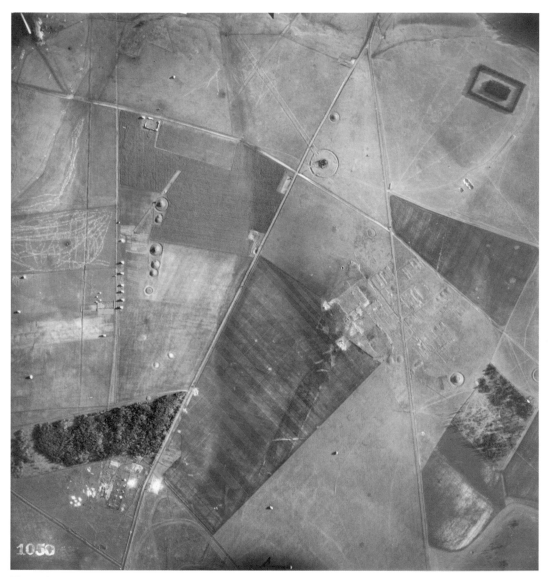

Figure 7.14 From the same flight as Figure 7.13, but this time the other side of the Cursus. Stonehenge is clearly visible as are the earthwork remains of the First World War aerodrome, which appears to have shared the same alignment as Stonehenge and its Avenue. [US/7PH/GP/LOC122 frame 1050, 24 Dec 1943]

Among the reasons put forward for the RAF undertaking this work was the fact that 'the RAF had the facilities and specialised equipment available, that the work would possess great training value for the Service, and that it could well be carried out more or less as a part of the ordinary training programme...'.[64] Influenced by the obvious success of the wartime reconnaissance and intelligence operations, the RAF insisted that not only should they continue to undertake military air photo-reconnaissance, in the process maintaining the skills that had been developed during the war, but they should deploy those skills for

all government needs. Commercial air survey companies, it was argued, simply were not in any position to undertake work on this scale in the immediate aftermath of the war, let alone during the final months of the conflict. However, announcement of the policy led to unsuccessful protests from commercial firms who felt more than capable of taking on the work.[65]

Principal post-war 'customers' were the Ministry of Housing and Local Government, the Ministry of Town and Country Planning, the Ordnance Survey and the Department of Health for Scotland. The RAF insisted that its own requirements should take precedence over those of government departments, followed in order of priority by 'requests by public authorities for public purposes' and 'properly sponsored scientific and learned societies'. Particularly urgent was the need for large-scale vertical photography of key towns and cities, followed by coverage of other towns and of rural areas.[66] Oblique coverage was also requested of some areas, principally to aid assessment of bomb-damaged urban areas. In the long term, the arrangement proved unsatisfactory as far as the Ordnance Survey was concerned. Although the RAF probably represented their only real means of obtaining the photography they wanted within a reasonable time scale, problems included a lack of continuity among air crews in the post-war period as the RAF reduced in size, leading to considerable variation in quality; the unsuitability of the military reconnaissance aircraft and cameras for civil mapping purposes; and a lack of control over the RAF's flying programme. Consequently, by the early 1950s the arrangement between the RAF and the Ordnance Survey had come to an end.

Although the bulk of the photography undertaken immediately after the war was for the Ordnance Survey, government departments or for the RAF's own purposes, a small amount of archaeological work was completed. Indeed, a list of possible uses for aerial photography, drawn up in March 1945, listed archaeology as item no. 9, noting that 'aerial photography often reveals the presence of buried ancient and prehistoric buildings etc'. It is not clear if the various possible uses were placed in order of priority, although government, military and survey needs headed the list. If so, it is perhaps worth noting that archaeology appeared higher up than 'education' and 'commerce', but below 'charting of pack ice' and 'ornithology'.[67]

It took a while before the RAF's real contribution to archaeology through its aerial photography was appreciated by archaeologists, although as early as 1943, Ian Richmond noted:

> During the present war the Royal Air Force must have photographed under different conditions (if not all conditions) many thousands of square miles of these islands. This is not the moment for archaeologists to pry into such archives. But the time will come when these photographs will be out of date for military purposes, and it should be emphasized now that they will never be out of date for archaeology … Many unrecorded discoveries must already lie buried in these records, and inspection by an archaeologist, as used to picking out features in his field of knowledge as the military observer in his, would almost certainly reap a rich harvest from material already in existence.[68]

This message was soon echoed by Dr J K S St Joseph, in what was probably his first major

contribution on aerial photography, during a lecture to the Royal Geographical Society:

> With the growth of air reconnaissance during the last five years it is probable
> that in all theatres of war great areas will have been photographed, some of them
> many times over. It should not be expected that all this material may contain
> archaeological information. Much of the photography will have been from great
> altitudes for quite another purpose and naturally without regard to such factors
> as soil, weather, and growth. Possibly its greatest value will be in the fields of land
> utilisation and geography … Nevertheless archaeological discoveries undoubtedly
> lie buried in these archives…[69] (Figs 7.15 and 7.16)

Kenneth Steer, another archaeologist who had worked in photographic intelligence during
the war, published a short note in *Antiquity* in 1947 alerting archaeologists to the existence
of the post-war photography. Steer described the RAF's photographic survey work as being
'of epoch-making importance for archaeological research in these islands' and noted that
while 'there is no immediate prospect of this material being made available to students of
archaeology', he suggested that the eventual creation of 'an Archaeological Air-Photograph
Library … can now be regarded as inevitable'.[70]

To Steer, the RAF photography had both advantages and disadvantages for archaeologists.
The latter included the scale of the photographs, generally around 1:10 000, which he felt
was 'bound to be a handicap to archaeological interpretation' due to the small size at which
lesser features would appear.[71] A bigger problem concerned the timing of the photography:

> While the best time for photographing surface remains is either at sunrise or
> sunset, when the low sun lengthens the shadows, the current sorties have not only
> been flown at all intermediate hours of the day but, one suspects, dawn and dusk
> photography have been deliberately avoided since long shadows are a serious
> obstacle to normal survey purposes. Moreover, as all students of the subjects are
> aware, the effect of crop markings depends not only on the season and the nature
> of the subsoil, but on the type of crop sown, and it is too much to expect that
> photographs taken for other purposes and ignoring all these considerations will
> yield the fullest information.[72]

However, Steer felt that these limitations were effectively outweighed by one simple
fact: the whole of the RAF's post-war photographic survey work was designed to produce
overlapping verticals for stereo viewing. Most archaeological interpretation of aerial
photographs up until this time (and, indeed, for some time beyond) had been carried
out on single prints, but the RAF photography opened the way for the day 'when the
stereoscope will be regarded as indispensable to the archaeologist as is the telescope to the
astronomer'.[73] The magnification provided even by the cheapest hand-held stereoscope
would overcome much of the difficulty caused by the scale of the photography, allowing the
detection of even the smallest mounds and lowest banks. Moreover, 'although practice is
required to make a skilled interpreter, any one with normal vision can master the principles
involved in a few hours…'.[74] Perhaps, Steer wondered, 'we may look forward to having
our archaeological reports illustrated not by two dimensional pictures or anaglyphs but by
annotated "stereograms" which appear in relief when viewed through the stereoscope'.[75]

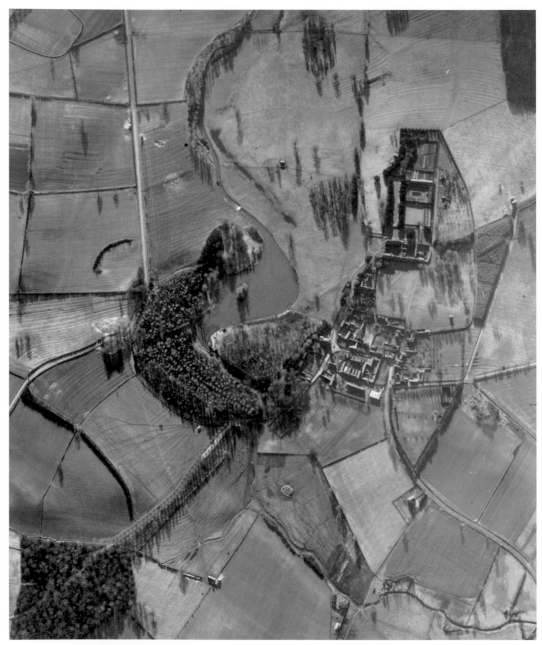

Figure 7.15 This post-war RAF vertical of Apethorpe Hall, Northamptonshire, shows the house and its gardens to have been imposed onto a well-developed medieval agricultural landscape, as evidenced by the extensive ridge-and-furrow and associated features. Most of these earthworks have since been levelled. [RAF/CPE/UK/1925 frame 3119, 16 Jan 1947]

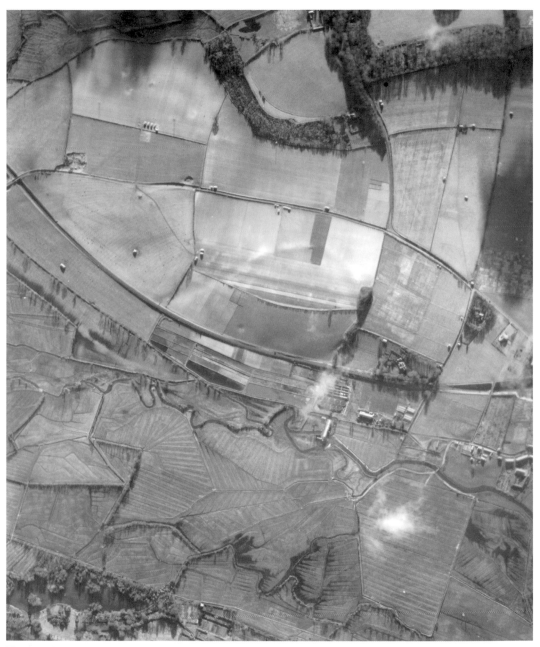

Figure 7.16 This RAF post-war vertical captures cropmark traces of the large Late Neolithic henge at Mount Pleasant on the outskirts of Dorchester, Dorset, as well as the extensive water meadows beside the River Frome. [RAF/CPE/UK/1934 frame 5082, 17 Jan 1947]

That archaeologists did not try to make more use of the post-war RAF photography may now seem surprising. Perhaps more surprising still was the fact that the archaeologists employed as air photo interpreters during the war made remarkably little use of aerial photographs once they had returned to being archaeologists. Glyn Daniel was to play a key role in promoting aerial reconnaissance in later years, but his direct involvement in air photo interpretation in this post-war period was limited. In his autobiography, he recalled only one occasion when his skills were called upon. In 1935 Katharine Maltwood had published a book explaining her discovery of the signs of the zodiac laid out in the landscape around Glastonbury, Somerset. Daniel was contacted soon after his return to Cambridge by Hunting Air Services offering him £100 to look at air photographs of the area and produce a report on the zodiac. It is not clear from Daniel's account whether it was Maltwood herself who would be paying, but this seems to be the implication. Daniel regarded the zodiac idea as 'palpable nonsense and when I studied the air photographs that had been taken, it was quite clear that this was observer-imposed fantasy. I sent the photographs back saying I could not undertake the task. This was a mistake: I needed that £100. I would not be so scrupulous today. I should write a report explaining that I could not see that the air photographs supported Mrs Maltwood's views. But I was young.'[76]

Today, wartime and post-war photography is invaluable to archaeologists and historians for a variety of reasons. The RAF and USAAF (and, of course, the Luftwaffe) have left us with a unique record of England. The near-complete coverage they provided allows us to study in detail the wartime defences of the home front (Fig 7.17). For some parts of the country, where good quality photography survives from successive stages of the war, sequences of photographs can show the growing complexity of defensive structures and other installations, as well as the changing nature of some defences in response to particular perceived threats. The surviving fragments of these defences visible in the landscape today can seem isolated and difficult to understand. Along with documentary sources, the aerial photography allows us to see them in their original context, as part of far more extensive networks of military structures. It can seem surprising, when viewing these photographs, to see just how heavily militarised some rural areas were during the war, particularly as so much of these defences have since been lost.

A good example of the military impact on southern Britain was provided in one of J B Priestley's famous *Postscripts* from 1940. Describing a journey from London through north Kent to Margate, he noted how

> for some time it was all quite ordinary, but after that it soon began to seem rather peculiar. Along the road there were things that weren't quite what they first appeared to be – if you see what I mean; the Bren guns seemed to be getting mixed up with the agricultural life of north Kent. The most flourishing crop seemed to be barbed wire. Soldiers would pop up from nowhere and then vanish again – unless they wanted to see our permits. Some extra large greenish cattle, quietly pasturing underneath the elms, might possibly have been tanks. It was a rum sort of farming around there! – and then as we came nearer the East Coast, the place seemed emptier and emptier. There were signs and portents. A field would have a hole in it, made at the expense of considerable time, trouble, and outlay of capital, by the German Air Force. An empty bungalow, minus its front-door and dining-room, stared at us in mute reproach.[77]

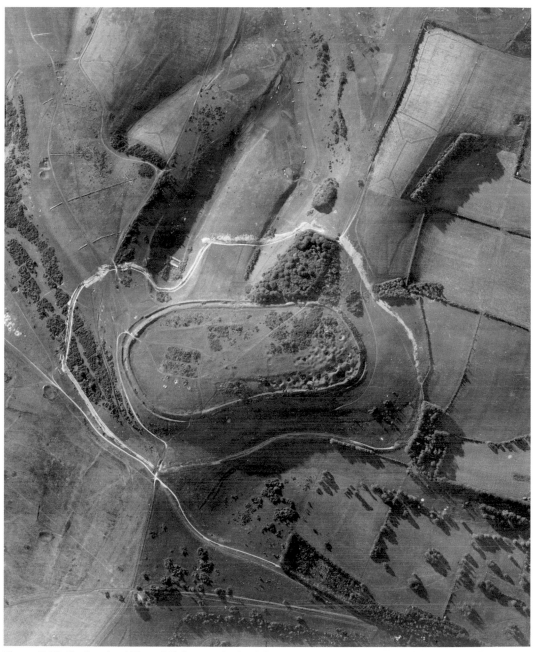

Figure 7.17 The Iron Age hillfort of Cissbury, on the South Downs near Worthing, found its defences temporarily strengthened during the war, the resulting earthworks being the latest in a sequence of activity stretching back to the Neolithic, that earliest episode most clearly visible as the backfilled shafts of flint mines on the right-hand side of the hillfort. [RAF/CPE/UK/1751 frame 4135, 21 Sep 1946]

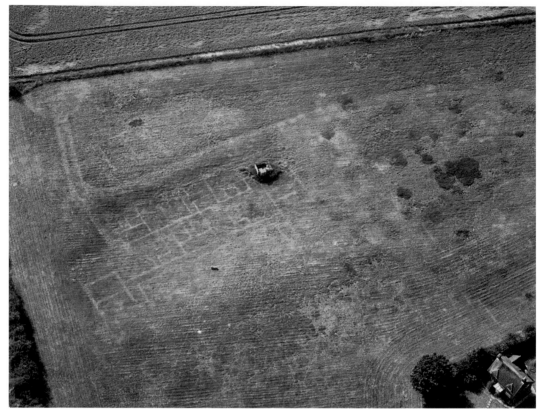

Figure 7.18 Traces of the Second World War are also frequently captured as cropmarks, soilmarks or earthworks on modern reconnaissance photography. This site at Houghton Down Farm, Hampshire, comprises parchmark traces of a WRAF accommodation block and associated buildings. [NMR 23220/09, 15 Aug 2003]

The photography from the 1940s also provides an invaluable record of the landscape at a key point in the 20th century. Wartime and post-war demand for agricultural produce had a considerable impact – agriculture was intensified, areas not previously considered suitable were brought under the plough, hedgerows and other field boundaries were removed. Historic and archaeological features in the landscape have suffered as a result. Sites now only visible as cropmarks might have been captured by the RAF as earthworks; some cropmark sites on these photographs may by now have been completely removed by quarrying or urban expansion. These photographs of the British Isles – held by the public archive of English Heritage and the National Monuments Records of Scotland and Wales – are an essential component of research seeking to understand the historical development of any block of landscape (Fig 7.18).

8 'The endless Variety of Objects'

Aerial photography into the 21st century

Wherever it is practised today, aerial survey for archaeology tends to have both 'tactical' and 'strategic' aspirations: reconnaissance, which involves looking for sites and taking new photographs, and mapping, which entails the interpretative analysis of both the new reconnaissance photography and the millions of historic images available for study.

Within English Heritage, for example, reconnaissance involves around 300 hours of flying each year from bases near York and Oxford, while most of the interpretative effort is put into the National Mapping Programme (NMP). The principal aim of the NMP appears straightforward – to interpret and map all archaeological and historic features of the landscape that are visible on aerial photographs new and old. Increasingly, of course, the photographs are being supplemented by other forms of imagery. Ultimately the aim of the NMP is to cover the whole of England in stages, with the resultant mapping continually updated through new reconnaissance (Fig 8.1).

Obviously reconnaissance and mapping – photography and interpretation – are not separate and distinct activities. Mapping projects rely greatly upon past and present reconnaissance, but reconnaissance itself is heavily influenced by the needs and results of past and present mapping projects. These are also tasks that can never be regarded as 'complete'. Leaving aside the obvious

Figure 8.1 A map showing the progress of the National Mapping Programme (NMP) to September 2010. More than 60 separate projects have so far accounted for over 42% of England. Pre-NMP mapping (Yorkshire Wolds and Dartmoor) is shown in magenta; the NMP pilot project (Kent, Thames Valley, Hertfordshire, Yorkshire Dales) in green; and full NMP projects in red.

susceptibility of earthworks and cropmarks to reinterpretation, some historical features of the landscape that were regarded as non-archaeological when the NMP began are now seen to be an essential element of new mapping projects. The most obvious examples are military structures of the Second World War. Meanwhile, previously unseen cropmarks and earthworks continue to be spotted either from the air or on newly accessible historic photographs.

Indeed it is doubtful if the likes of O G S Crawford and George W G Allen ever appreciated just how densely packed with archaeological and historic features the modern landscape really is. As a more recent photographer, Jim Pickering, explained, '[t]he context in which Crawford assessed his discoveries was that of a landscape in which archaeological material was scarce and dispersed. We must now consider the entire landscape as one single archaeological site.'[1] Yet even in apparently ideal conditions, the aerial photographer is faced not with field after field of overlapping and interlocking sites, but with scattered fragments – part of an enclosure here, a stretch of ditch there – and probably something different the following summer. The sheer density of archaeological sites in the landscape only becomes apparent once this accumulation of fragments has been identified and carefully mapped, with this mapping updated as more traces are photographed. Of course, deciding what to map is a further complication.

Reconnaissance: The war and beyond

In the immediate aftermath of the Second World War, reconnaissance was the one aspect of aerial survey to pick up where it had left off in 1939. Allen was dead and Crawford retired, but others emerged, often building on experience gained during the war. Derrick Riley began his career as an RAF bomber pilot in the summer of 1940 and spent the next five years alternating between active service and spells as a flying instructor. His archaeological 'career' began in 1942. As 'one of the lucky ones who got through to the end of their tour of operations', he was posted to Abingdon, near Oxford, where he taught experienced pilots to use new direction-finding equipment to aid landing in times of poor visibility. He also took the opportunity to keep an eye on the ground.[2]

Riley was not a complete novice as far as cropmarks were concerned. Aware of Allen's pre-war discoveries in the very same region that he was now regularly flying over, he began to keep a watch on the fields beneath him whenever possible. He saw his first cropmark in April 1942 – two concentric green rings in a field of clover – and showed one of his photographs to E T Leeds at Oxford's Ashmolean Museum. It turned out not to be a new discovery – Leeds had himself excavated the site a few years previously – but it wasn't long before more sites began to reveal themselves.[3]

At first Riley was often unable to photograph the sites he was seeing – leaving aside the practicalities, it was seldom easy to get consent to take a camera up with him. He had to be content with jotting down notes while airborne and writing them up properly in the evenings. However, a move to the airfield at Stanton Harcourt found him serving under a station commander more willing to give him permission to take photographs. The next problem was getting hold of film, which was rather scarce during the war. Fortunately,

Leeds managed to get hold of 10 rolls of 35mm film for him. The final difficulty to overcome
was actually operating the camera while airborne:

> It was not convenient to take obliques from the twin engined Oxford aircraft we flew,
> because the engines on either side of the cabin obstructed the view, so I took hand-
> held verticals through a camera hatch in the floor at the back of the cabin. My photos
> were often under- or over-exposed, but some were good enough for slides to be made
> for a lecture that I was invited to give late in 1942 at Burlington House to the Royal
> Archaeological Institute…[4]

Remarkably, Riley managed to get some articles on his discoveries in the Thames Valley
published during the war, with further notes on cropmarks in and around the Fens
of eastern England appearing after a posting to Upwood near Peterborough. A major
publication – 'The technique of air-archaeology' – followed in 1946, but his departure
from the RAF shortly after led to the loss of further flying opportunities and the need for
employment, which also led him away from archaeology. However, Riley was able to return
to aerial photography during the 1970s and was particularly busy after his retirement.[5]

Perhaps the best-known name from the post-war years is J K S St Joseph. St Joseph
had flown a few times during the war with Riley, initially 'as a passenger on one of my
instructional flights, on which we passed over many of the Upper Thames cropmarks'.
In the summer of 1945, Riley was one of several RAF pilots who ferried St Joseph around
the country:

> We covered many parts of southern Scotland, both the east and west sides, flew
> along the line of the Antonine Wall, and went up Strathearn and Strathmore, circling
> Ardoch and Inchtuthil on the way. I was just the pilot of the aircraft, a 'bus driver',
> while St Joseph read the map, guided us to a long succession of archaeological sites,
> and took photographs. The weather was not much good, with much cloud and
> some rain…[6]

Based at Cambridge, St Joseph was made Curator of Aerial Photography for the newly-
established Cambridge University Committee for Aerial Photography (CUCAP) in 1948.
A geologist by training, St Joseph had developed an interest in Roman archaeology and
subsequently in aerial photography prior to the war. Again, Crawford's role was crucial.
St Joseph credited him with stimulating and encouraging his interests, partly through
allowing St Joseph to participate in Crawford's pre-war reconnaissance flights with
Geoffrey Alington over Scotland.

St Joseph's first major contribution to the subject came in a lecture to the Royal
Geographical Society on 4 December 1944, which was published early the following
year (*see* p 209). As well as restating the successes and advances of the previous two
decades, drawing particularly on Allen's work and the potential of the RAF's own wartime
photography, he also turned his attention to the future. With an eye on the opportunities
offered by the wartime expansion of arable agriculture, and the potential loss of
agricultural land to post-war building and development, he suggested an archaeological
programme of aerial reconnaissance. He claimed that this would not be 'difficult to
formulate. The requirement is a series of flights undertaken in accordance with a specific

programme drawn up by a trained archaeologist and affording opportunity for reconnaissance in which the archaeologist would take part. Such a scheme might be prepared for a three or five year period, to cover risks of successive wet seasons, and to take advantage of all possible crop-rotations.'[7]

St Joseph's post-war flights, part of a programme that bore at least some resemblance to the one he suggested in December 1944, marked the beginnings of the Cambridge University collection of aerial photographs. In the early years, St Joseph remained reliant on the RAF (with the full agreement of the Air Ministry) to keep him supplied with planes and pilots. This was no small undertaking by the RAF. For example, in the summer of 1948 St Joseph made use of RAF planes (Proctors) and pilots for some six weeks from 16 June. Throughout, he used a hand-held F24 to take obliques. Initially flying from RAF Benson in Oxfordshire, 'many photographs were taken of hill forts on the Berkshire and Wiltshire Downs, crop markings, castles, cathedrals and abbeys, in the great part of the south and south west of England'. After 10 days, trouble with the brakes saw the first plane declared unserviceable and a replacement from Brize Norton, Oxfordshire, was made available. Soon after, St Joseph switched his base to Dishforth, North Yorkshire, and he spent three days flying over Yorkshire, Lincolnshire and County Durham. His next move was to Acklington, Northumberland, where he encountered some bad weather but still managed flights over south-western and eastern Scotland and the Lake District, before moving on again to Shawbury, Shropshire. From there he spent a week flying over Wales and the West Midlands, eventually returning to Benson via Newton in Nottinghamshire, Lakenheath in Suffolk and Manston on the Isle of Thanet, Kent, flying sorties from each. In total, he spent around 140 hours airborne that summer and took an estimated 13,000 photographs.[8]

His dependency on the RAF ended in the early 1960s when CUCAP acquired its own aeroplane, thanks to grants from the Nuffield Foundation. Initially they owned an Auster but soon replaced it with a twin-engined Cessna Skywalker. They also employed their own pilot, but photographic responsibilities remained with St Joseph. The aerial photography undertaken by CUCAP was not solely for archaeological purposes – geography, geology and other subjects taught at Cambridge began to make use of the growing collection and to request new photography that was better suited to their needs than the archaeological material. External organisations such as the Forestry Commission, the Nature Conservancy Council and the Soil Survey of England and Wales also funded photography and in time vertical survey photography was being undertaken on a scale to match that of the more traditional oblique reconnaissance surveys.

However, archaeology remained a significant focus and St Joseph undertook an annual programme of photographic survey until his retirement in 1980. The highlights were regularly published, initially in a series of articles in the *Journal of Roman Studies* (from 1950) and subsequently in *Antiquity* under the editorship of Glyn Daniel, who also sat on CUCAP. Over time St Joseph's post changed from curator to director to professor, as the importance of his work and the collection was recognised both within archaeology and outside.

Jim Pickering's flying experience actually began before the war. He qualified as a pilot in 1937 and was asked to take some aerial shots of a site his uncle was excavating the same year. His real interest in archaeology began while in the Middle East during the war. Then, 'when I got back I felt that I'd had a lot of experience at the tax payer's expense, although

it was wartime, and I didn't like throwing that away'. It took a few flights before he started getting results – 'I did what St Joseph did first, entirely the wrong thing ... and that was flying along Roman roads looking for sites. Of course, I found nothing – nobody ever does. Then I thought I'd have to learn something about it and started reading about geology. In about 1948 or 1949 I started recording systematically.'[9] Crucial experience was gained from flying alongside Riley and Arnold Baker, either together or separately over the same areas and comparing results. Pickering's RAF experience proved invaluable: 'I've watched crop marks develop, I've seen the effect of rain on them, I've seen them harvested ... I spent three months, a week at a time, at 12 different RAF stations in different parts of the country. So I got a very broad acquaintance with the effect of climate, temperature and height on the growth of crop marks, of the effect of rainfall on the lee of hills.'[10]

In the immediate post-war period it was not only planes but also cameras and film that could be difficult to obtain. Harold Wingham began taking aerial photographs in 1948, initially focusing on Gloucestershire, Wiltshire, Herefordshire and Worcestershire, before widening his scope to include Cornwall, Devon and other areas in the 1950s and 1960s. He had trained as a wireless operator and navigator in the RAF, but was unable to complete his navigation training as the war had ended before the course did. Once out of the RAF, his flying was self-funded, as it was for many others. He bought his lenses and shutters from a supplier of ex-government equipment, while the cameras themselves were built up from, or modified with, parts that had somehow avoided the hammer at a local scrap metal yard. Film was also ex-government stock. Up to 10 years old, it had seldom been stored properly, 'which explains the many failures ... New film stock was not available to me until 1959.'[11]

Arnold Baker began a lengthy career of archaeological reconnaissance and photography over the West Midlands in 1952. He had learnt to fly in 1948, for reasons unconnected with archaeology, courtesy of an RAF Training School at Rochester in Kent. The following year, he formed the Defford Aero Club in Worcestershire 'in order to keep in flying practice without the need to travel elsewhere'. The club managed to obtain four dismantled de Havilland Tiger Moth biplanes from disposal stores in South Wales. Including assorted spare parts, the price was £25 each. The Tiger Moth was Baker's main reconnaissance aircraft for a number of years and 'when correctly rigged it was a pleasure to fly'.[12]

The Tiger Moth had two cockpits; the position of the wings meant that the front cockpit offered better visibility for photography so the pilot sat in the rear. At first, communication between pilot and photographer took place via a voice tube, though this was soon replaced by more modern technology. Camera operation was also eased by either lowering or removing the side doors of the cockpit. Initially, Baker piloted the plane, but switched to being photographer in order to overcome the inevitable difficulties involved in telling someone else what to take a picture of.[13]

By the 1970s most archaeological reconnaissance involved high-winged aircraft with enclosed cabins and radio contact with the ground. Over time, the number of these 'private flyers' grew so that by the late 1970s more than 50 were active. Much of this flying was self-funded, although from the mid-1970s onwards fluctuating amounts of grant aid were available in England to subsidise their activities. This cash came initially via the Department of the Environment's Inspectorate of Ancient Monuments (essentially English Heritage's predecessor) and subsequently through the RCHME. Many of these individual flyers have

tended to focus on flying in particular regions, their photographs providing a crucial addition to those taken by the RCHME/English Heritage and CUCAP. Moreover, unlike the early days, the plentiful experience and literature available means that no one now need start from scratch. In fact many possess considerable archaeological knowledge and know-how before they first take to the air.

Reconnaissance and the state

Government departments, state-funded organisations and the military had been involved in aerial archaeology to varying degrees from the start. However, direct involvement in post-Second World War archaeological reconnaissance and mapping took some time to get off the ground. When it did finally begin, the initial impetus came not from any recognition that aerial photography was of value to understanding the past, but from the evidence the photographs provided about the very real threats to the future survival of archaeological sites.

In 1956 Maurice Barley offered an assessment of these threats to an audience of planners. He explained that while 'the picture of the past has been filled in with infinitely more detail than was available forty years ago' via aerial photography, there were major problems that needed to be addressed. He highlighted in particular the threats posed by gravel extraction and by increasingly intensive arable agriculture. There had been a considerable extension of the latter during the war, for obvious reasons, but financial incentives to farmers to plough up more scrub and pasture continued beyond 1945. Some of this land had not been ploughed for centuries. As a consequence, upstanding sites on, for example, the chalk downlands were now being worn down from earthworks to cropmarks.[14]

Figure 8.2 Ring ditches and other features at Standlake, Oxfordshire, photographed by Derrick Riley in 1943 just prior to destruction through quarrying. A different image of this area, taken on the same flight, was used as the cover of *A Matter of Time*. [Ashmolean Museum, University of Oxford; RCA 11409/12]

However, it was the threat of destruction through gravel extraction, rather than the more extensive but gradual erosion by the plough, that provoked a response from the archaeological world. Agriculture was a long-term threat and far more difficult to counter than quarrying, which could destroy all trace of a site within minutes. In 1960 the RCHME published *A Matter of Time*, which used aerial photographs and maps derived from them to illustrate both the wealth of archaeological remains on the river gravels of England and the dangers posed to those same remains from the increasing pace of gravel extraction (Fig 8.2). *A Matter of Time* made use of both the RAF's photographs and more

recent specialist obliques, mainly by St Joseph, in order to plot the newly discovered sites not just against a map background but 'a background of destruction'.[15]

The initial response to this very public demonstration of the threat was not to put more resources into photography and mapping, but to appoint more people to excavate some of the threatened sites. However, *A Matter of Time* did demonstrate to the RCHME a need to do something about the growing quantities of aerial photographs. In November 1965 John Hampton took up the post as head of the new aerial photography section of the RCHME's National Monuments Record (NMR), the aim being to 'use air photography to build up rapidly a record of field monuments throughout England and of selected areas of English towns…'.[16]

The RCHME began its own in-house reconnaissance just a couple of years later. Under Hampton, the NMR's Air Photographs Library complemented the RCHME's other principal sources of information – the results of its own fieldwork and the record cards of the Ordnance Survey's Archaeology Division – and focused mainly on the acquisition of new and recent photographs taken by the growing post-war network of private flyers such as Pickering, Baker, John Boyden and others, all of whose work was beginning to have considerable impact on archaeological knowledge in various parts of the country. However, in order to fully support the organisation's own project work, it was soon apparent that the RCHME would need to assume a more active reconnaissance role. Consequently, Hampton, having established the Air Photographs Library, became the RCHME's first aerial photographer.

Aerial photography for archaeological purposes presented some novel problems to the RCHME, with its traditional focus on ground-based survey. Getting to grips with taking obliques using a hand-held camera, rather than overlapping verticals from a fixed camera, would also require practice. The first plane used was an Auster, a high-winged aircraft, followed by a Piper Tripacer. The latter offered better opportunities for near-vertical views, but only by removing a door. In addition, the port landing wheel was in the way and appears in many of the early photographs. The aim of the first flight, which took place on 8 February 1967 from Fairoaks airfield near Chobham, Surrey, was simply to 'evaluate the economics, techniques and practicability of NMR air photography'. Lasting around 90 minutes, several soilmark and earthwork sites were spotted. The only real difficulty encountered was a lack of cockpit space due to the 'rather large pilot'. Otherwise there was 'no reason to think that an efficient tool could not be developed by the NMR' (Fig 8.3).[17]

Once the benefits of using a high-winged Cessna 172 instead of the Tripacer had been grasped, the problem of maximising visibility was solved by removing the luggage hatch.[18] Inevitably, rather safer methods of capturing targets were eventually adopted. Today, the photographer sits up front alongside the pilot. To take obliques, the photographer simply opens the adjacent window, while the pilot tilts the plane sufficiently to give the photographer the required view while circling the site at an appropriate altitude and distance. Taking near-verticals involves a similar process, except that the plane is tilted until the wing is pointing towards the ground and the pilot flies the Cessna in a tighter circle around and above the target. This is the kind of manoeuvre that helps determine whether one has the stomach for aerial photography.

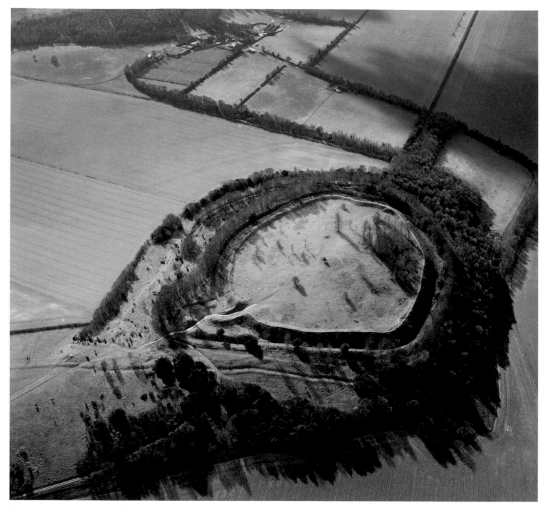

Figure 8.4 Danebury hillfort and associated earthworks and cropmarks viewed from the north in 2003. [NMR 21964/01, 4 Feb 2003]

little sense can be made of new reconnaissance photography – or indeed other forms of aerial imagery – without some idea of what has already been captured. The overall aim of the NMP, simply stated, is to map all archaeological sites in England that are visible on aerial photographs, in order to improve understanding of the historic environment and its change through time. To achieve this, both old and new photographs are of equal importance, with full use being made of English Heritage's vast archive of aerial photographs as well as all other appropriate and accessible collections.[23]

The first NMP projects were county-based and focused on cropmarks. Gradually the scope broadened – aided by the increasing availability of historic photography – to include earthworks as well as more recent industrial and military remains. This expansion in scope largely reflects the burgeoning interest in the archaeology of the post-medieval and modern

Figure 8.5 A crowded cemetery of Iron Age square barrows – many with their central grave pits clearly defined – in Grindale parish on the eastern Wolds, Yorkshire. [DNR 536/14, 27 Jul 1974]

periods, with the NMP providing a means for the location of these features to be assimilated rapidly into both national and local databases. Consequently the mapped information is available not just for interest and research, but for management, conservation and planning purposes.

More recently, individual mapping projects have concentrated on areas with particular management and conservation concerns – for example National Parks, Areas of Outstanding Natural Beauty and World Heritage Sites. A major priority in recent years has been England's coastline. Constant change caused by processes of erosion and deposition, as well as measures taken to manage or lessen their effect, inevitably impact on the visibility and even survival of historic features (Figs 8.6 and 8.7). Mapping projects have examined areas such as the coasts of East Anglia and Yorkshire, and estuaries such as the Severn and the Humber. A major theme to emerge has been the wealth of detail surviving on historic photography for the complex coastal defences of the Second World War, with later photography documenting what has happened to them subsequently, and showing just how little of these defences have survived into the present.[24]

The impact of quarrying is, of course, something that archaeologists have become well acquainted with and the role played by aerial photography in recognising the threat has already been outlined. The Aggregates Levy Sustainability Fund (ALSF) currently provides financial support for projects dealing with a wide range of issues associated with extraction

industries, including archaeology.[25] Several surveys have been undertaken to NMP standards in areas affected or likely to be affected by quarrying and related activities, including parts of County Durham, Hampshire, Gloucestershire, Somerset, South and West Yorkshire, and Warwickshire.

The environs of World Heritage Sites – such as Stonehenge and Avebury, and Hadrian's Wall – have been subjected to NMP projects, each resulting in substantial increases in the numbers of known sites of all periods, not just those associated with the principal attraction. Combined with the knowledge accumulated over centuries of discovery and excavation, analysis of several decades worth of aerial photographs offers real opportunities to reappraise even the best explored landscapes. For Stonehenge, the area mapped amounted to some 125km², making it one of the smallest NMP projects undertaken to date, but despite this and the already lengthy history of archaeological investigation, a considerable quantity of 'new' detail was recorded (*see* Stonehenge World Heritage Site NMP project, pp 230–2).

Of course, much archaeological research is also aimed not at huge geographical areas but on particular sites and their immediate environs. Reasons can be many and varied – a threat from development or quarrying, for example, or a particular site may have been chosen for research excavation with air photo interpretation aiding the process of providing a broader landscape context. Within English Heritage, such smaller-scale projects may also arise from discoveries made either in the course of NMP project work or during the ongoing reconnaissance programme, particularly if such discoveries are felt significant enough to warrant closer attention than might be possible within the confines of the NMP.

Figure 8.6 The hamlet of Shingle Street on the Suffolk coast. In the foreground is a Martello tower, built *c* 1810–12. [NMR 21851/11, 19 Oct 2002]

Figure 8.7 Despite its name, Flower's Barrow is an Iron Age hillfort. Situated in remarkably close proximity to the Dorset coast, it has been suggested that as much as a third of the monument may have been lost to coastal erosion. Documentary evidence suggests that substantial loss had already occurred prior to the 18th century. [NMR 23144/22, 11 Jul 2003]

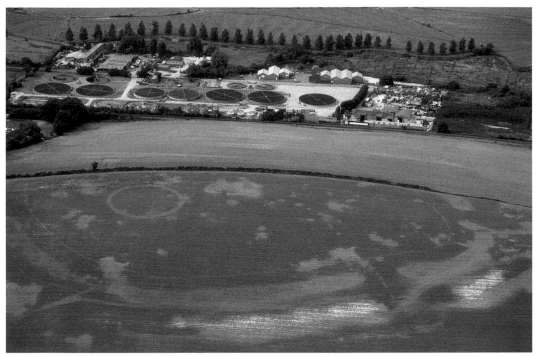

Figure 8.8 The southern half of the henge enclosure at Mount Pleasant, photographed as cropmarks by Francesca Radcliffe in 1996. Among the 'new' features visible here are a previously unsuspected gap or entrance through the enclosure ditch (bottom left), which is partially blocked by two irregular lines of pits, and indications of an external as well as an internal ditch (bottom centre and bottom right). [198/30, Francesca Radcliffe]

Good examples include the large henge enclosure at Mount Pleasant near Dorchester in Dorset (Fig 8.8), where new reconnaissance photographs and previously unstudied historic photographs revealed a considerable amount of new information about an apparently well-known monument. Similarly, the late Neolithic palisaded enclosures at West Kennet near Avebury in Wiltshire have continued to produce a trickle of new cropmark details over the years and have now been mapped on no less than five separate occasions since the late 1980s (Fig 8.9).[26]

Undoubtedly the best results come when aerial photography is used in conjunction with other survey techniques in order to squeeze the maximum amount of information out of a site. Cawthorn Camps, located on the southern edge of the North York Moors, is a cluster of Roman military sites surviving as substantial earthworks – a camp and two forts, one of the latter also featuring a sizeable adjoining annexe. In addition there are numerous more subtle earthwork remains scattered within and around. Aerial photography was used alongside geophysical survey, ground-based earthwork survey and excavation during a recent programme of research undertaken by English Heritage in conjunction with the North York Moors National Park.[27] The aerial survey input included the commissioning of new colour vertical photographs with sufficient overlap to enable the whole complex to be viewed in three dimensions. The scale and quality of the photographs allowed an incredibly detailed

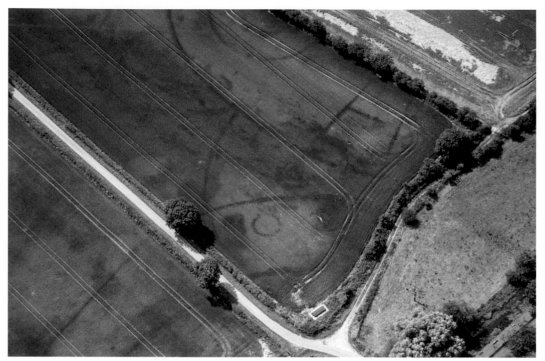

Figure 8.9 Among the new detail seen at West Kennet in the summer of 2000 was the small pit- or post-circle featured in the centre of the photograph. [NMR 18725/14, 15 Jul 2000]

plan of the earthworks to be created – features surviving to heights as little as 100mm were identified – and viewed in three dimensions within a computer (Fig 8.10).

Interpretation was aided not just by the results of the carefully targeted excavation trenches and the other survey techniques, but also by the use of recent and historic aerial photographs of Cawthorn Camps. As well as the expected Roman features, it was possible to identify the locations of the trenches and spoil heaps of the 1920s excavations at the site (*see* p 153) and later features such as mortar craters and possible Nissen hut bases from the Second World War, when the area was used for military training. From a site management perspective, the various surveys have also provided a valuable record of the progress and current levels of erosion at the site caused by both visitors and grazing animals.[28]

A similar combination of techniques was used within the North York Moors National Park more recently. In September 2003 two areas totalling over 250ha on Fylingdales Moor were affected by serious fires, which resulted in the near total destruction of ground vegetation. Both of the affected areas were already known to contain a considerable quantity of archaeological remains ranging in date from the Bronze Age to the Second World War. The fires meant that an assessment of the condition of the known sites would be necessary before reseeding and they also provided an opportunity to see what else had been hidden by the

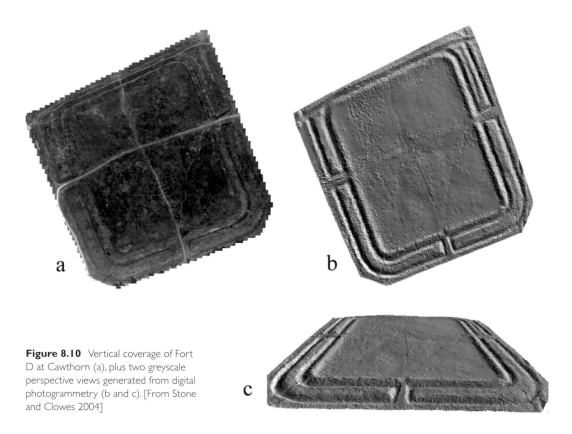

Figure 8.10 Vertical coverage of Fort D at Cawthorn (a), plus two greyscale perspective views generated from digital photogrammetry (b and c). [From Stone and Clowes 2004]

vegetation. Again, aerial photography was used in conjunction with ground-based survey and some carefully targeted excavation.

As with Cawthorn Camps, new vertical photographs were commissioned. Together with new reconnaissance obliques, these offered the most rapid means available of examining the entire area. New features spotted during the aerial and ground-based surveys included enclosures, house sites, ring cairns and possible cultivation traces and field boundaries, all potentially of Bronze Age date. Additional examples of the well-known prehistoric rock art were also discovered on the ground. The rock art itself was not visible on the photographs, of course – it can be difficult enough to see from inches away – but the individual boulders generally were.

Of more recent date was a complex network of leats and ponds associated with an alum works which had been operational from the mid-17th to mid-19th centuries, as well as a considerable quantity of features of Second World War origin – well over 200, in fact – including numerous slit trenches, weapons pits and ordnance craters, as well as some vehicle tracks. Subsequent reconnaissance flights were undertaken to chart the progress of the vegetation regrowth and its impact on the visibility of the archaeological sites.[29]

Stonehenge World Heritage Site NMP project

The surviving prehistoric earthworks around Stonehenge had been mapped at the beginning of the 19th century by Sir Richard Colt Hoare and William Cunnington.[a] From the middle decades of the 20th century onwards, numerous fieldworkers continued to add sites and findspots, but it was the publication in 1979 of the RCHME's *Stonehenge and its Environs* that really emphasised just how busy a landscape this has been. Combining for the first time the evidence available from aerial photographs with the results of ground-based survey and excavation, the remarkable density of archaeological remains in the area was more evident than ever before.[b]

The Stonehenge Environs Project, undertaken between 1980 and 1986 by Wessex Archaeology and directed by Julian Richards, added another level of detail.[c] This time the principal means of investigation was fieldwalking – the systematic collection of objects brought to the surface by the plough – aided by carefully targeted excavation. The abundance of prehistoric ceremonial and funerary monuments around Stonehenge had led to the area being described as a 'ritual landscape'. The fieldwalking evidence in particular showed this to be an oversimplification, a result of considering only the most visible archaeological remains. The project recovered considerable evidence for activity characterised as 'domestic' and 'industrial' in between and all around the visible monuments, mainly in the form of lithic material – worked flint tools and flint-knapping waste – mostly belonging, like the monuments, to the Neolithic and Early Bronze Age.

When the Stonehenge World Heritage Site NMP project commenced in 2001, the English Heritage archaeological database contained details of 2,062 sites, monuments and findspots within the project area. A few months later, when the mapping had ended, that total had risen to 2,601, an increase of around 25 per cent. Around three-quarters of the 'new' sites were recorded either partly or wholly as cropmarks. Of course, the project was not solely concerned with the Neolithic and Bronze Age monuments for which the World Heritage Site is best known. Over a third of the 'new' sites were of prehistoric date, many of them probably Bronze Age (ring ditches, field systems and enclosures), but still more belonged to the medieval period or later, and plenty to the 20th century.

The Stonehenge landscape was not abandoned after the Bronze Age – it continued, and continues to be, incredibly busy with plenty of cropmark, earthwork and artefactual evidence for a wide range of activities. The 20th-century component is dominated by remnants of military activity. For more than a century Stonehenge has had airfields, army camps and the like as near neighbours and today lies only just outside the southern boundary of the Salisbury Plain Training Area. Meanwhile, demonstrating one of the limitations of air photo interpretation, around 10% of the sites identified on the photographs could not be assigned to any period at all, while for a similar number nothing more precise than a 'prehistoric' date could be suggested.

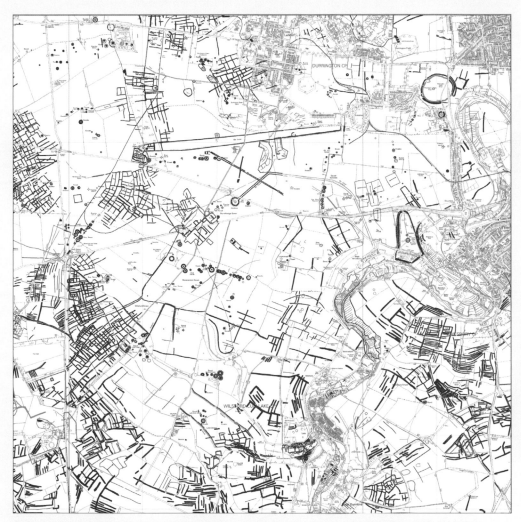

Archaeological features visible on aerial photographs examined in the course of the Stonehenge World Heritage Site NMP project. The colours represent not current condition (for example earthworks or cropmarks) but refer to the original character of the various sites. Thus banks, lynchets and mounds – 'positive' features – are mapped in red; ditches (including those of the water meadows along the Avon) are green. Purple primarily represents military structures dating from the First and Second World Wars. The magenta rectangles with arrows inside mark the location of levelled ridge-and-furrow. [Air photo mapping © English Heritage.NMR; topographical detail based on Ordnance Survey mapping (© Crown Copyright and database right 2011. All rights reserved. Ordnance Survey Licence number 100024900)]

The history of investigation of the same landscape underlines further the limitations of aerial photography, emphasising that the best results will always be obtained when a variety of methods are employed. Fieldwalking has clearly added an extra dimension to the prehistoric landscape in particular, while geophysical survey techniques which, like aerial survey, work better on some soils and geological zones than others, can sometimes offer greater detail than is provided by the cropmarks. Excavation offers the possibility of establishing date and function. For an area like the Stonehenge landscape, which seems as busy with archaeologists today as it was with barrow builders in the Bronze Age, there is also an enormous wealth of existing information to take into account. English Heritage's Excavation Index currently lists well over 700 excavations, geophysical surveys and other fieldwork projects from the last few centuries and the investigations continue.

Recent excavations in the area have resulted in some spectacular discoveries, prompting major reappraisals of Stonehenge itself as well as the wider landscape, but ongoing survey using non-intrusive methods – earthwork survey, geophysics and aerial survey – is also having some impact (*see* pp 253–4). There is still much to be discovered even in the most heavily explored landscapes.

Notes

a Colt Hoare 1812–21, Vol I.

b RCHME 1979.

c Richards 1990.

Understanding the photographs

With the advent of more extensive mapping projects, including the NMP, inevitable questions have arisen concerning both methodology and the all-important matter of how to characterise and classify what was being identified and mapped. Interpretation and analysis could not proceed on a visual basis alone.

A major problem with the detail seen on aerial photographs is that it is not easily reducible into a series of clearly defined site types. Classification schemes centred on physical form have been central to archaeology right from its beginnings – the best known being the countless efforts to arrange the main artefact types into sequences – partly to provide some chronological backbone to a past that was largely lacking one until the advent of scientific dating techniques from the mid-20th century. These methods are of more limited use when dealing with sites rather than objects. Certain site types may be characteristic of particular periods, but generally there is little of the long-term sequential development identified for, say, prehistoric metalwork or pottery.

Of course, some sites are of quite distinctive appearance – the causewayed enclosures of the early Neolithic; the so-called banjo enclosures of the Iron Age; Roman forts and camps; airfields and so on. Others appear distinctive but offer traps to the unwary. A good example is the henge of the late Neolithic, often regarded as being visually distinctive – a circular or oval enclosure, defined by a ditch with external bank, and usually with a single entrance or two opposed entrances (Fig 8.11). In fact, not only is there considerable variety among

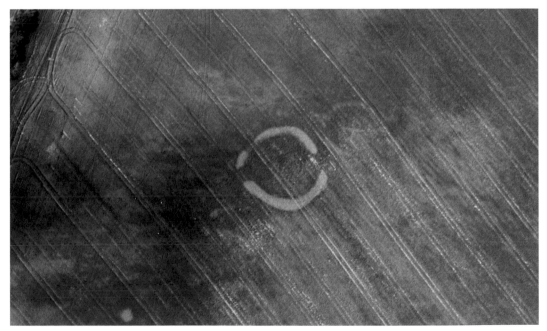

Figure 8.11 Is it a henge? This cropmark at Bredgar near Sittingbourne, Kent, has been claimed as one, but other explanations are possible in the absence of excavation. In this case, the presence of a smaller but morphologically similar enclosure immediately next to it, and with the tell-tale central cross of a post-mill clearly present, is obviously of interest. [NMR 21050/33, 16 Jul 2001]

sites identified as henges, they actually possess no morphological features unique either to henges in particular or to the late Neolithic period in general. No phase of the past holds a monopoly on circular enclosures with one or two entrances. Medieval post-mills and certain defensive structures of the Second World War are among the cropmark sites to have been mistaken for henges on the basis of aerial evidence alone.

Nonetheless, in the absence of excavated evidence, classification of earthworks and cropmarks relies heavily on morphology, so efforts at assigning a date or a function are seldom foolproof. While some fairly distinct monument forms have been identified, many of the sites recognised in the British Isles do not fall neatly into any clear-cut categories. They are effectively undated.

Meanwhile, NMP-style mapping takes us far beyond the individual site and the attendant problems with interpretation. By piecing together the fragmentary clues of thousands of photographs taken over several decades, it becomes possible to examine spatial and physical relationships between what would once have been studied as individual, discrete and dispersed sites. Of course, on the basis of aerial evidence alone, much remains undated, but we can begin to make plausible suggestions about sequence, connections and relationships. We can take a broader landscape-based view and separate out the visible fragments of, say, the Roman period from the 'palimpsest' presented by the mapping. We can tentatively assign to the same period further fragments undated in their own right but which may give an appearance of 'belonging' to the same period, based on clues provided by their size, shape, orientation, location and relationship with earlier or later features. By doing the same for other periods, we can at least begin to build up a picture – however imperfect and incomplete – of what has happened in the landscape over six millennia of human activity.

The scope of aerial archaeology

The earliest human remains from the British Isles are around half a million years old, while other indications of human activity are a couple of hundred thousand years older still. In contrast, aerial photography has yet to identify anything older than around 6,000 years. The reason is quite simple. Until the early Neolithic, the population of the British Isles appears to have indulged little in the sort of behaviour likely to leave an earthwork or cropmark signature. People of the Palaeolithic and Mesolithic – highly mobile groups who relied on hunting, gathering and fishing for subsistence – may have developed striking and varied forms of material culture and complex socio-economic structures and relationships, but seem to have had little need for large permanent constructions. Scatters of pits and lithic material may be encountered during ground-based survey or excavation but are unlikely to be observed from altitude.

Recently some pit alignments – pits dug in a line – have been shown by excavation to date to the Mesolithic period[30] though most excavated examples have proved to be much more recent – some Neolithic, but many more Iron Age. It would be impossible to date such features precisely from aerial photographs unless they were clearly linked to other dated or datable landscape features, something that is, of course, most unlikely for the Mesolithic. The enormous pits or postholes discovered close to Stonehenge and dating to the early Mesolithic were certainly substantial enough to have produced a cropmark trace – though none has been seen so far on any of the existing photographs of the area – but again, even

if they had been visible they could not have been reliably dated at all, let alone to the Mesolithic, without excavation. In fact, had they been photographed as cropmarks, the temptation may have been to associate such sizeable features with Stonehenge itself, a monument whose construction was not to begin until more than 5,000 years after the pits had been dug.[31]

The beginning of the Neolithic period saw the first earth-moving activities on a scale substantial enough to leave a physical trace in the landscape today – large enclosures were constructed, monumental tombs built, standing stones erected, mine shafts dug for flint (Fig 8.12). However, the relative permanence of these structures contrasts considerably with the slighter, more ephemeral traces of everyday living which, generally, were barely more substantial than those of the preceding Mesolithic period. Consequently, even now the monuments of the 4th and 3rd millennia BC can seem isolated on the interpretative mapping as well as out in the landscape itself. Although the Neolithic saw the introduction of arable agriculture, it was to be some time before subsistence practices left any lasting and recognisable physical trace on the land.

This situation – ceremony, ritual, funerary and gathering places visible as earthworks or cropmarks, but everyday life recoverable only by excavation or surface survey – persists well into the Bronze Age. The familiar burial mounds – the round barrows and cairns, singly or in cemetery groups (Fig 8.13) – began to appear in the late Neolithic and proliferated during the Early and Middle Bronze Age but the accompanying settlements remain invisible from the air until the Middle Bronze Age (from *c* 1600 BC onwards). This is the point at

Figure 8.12 A portion of the Neolithic flint mines at Long Down, West Sussex, surviving as visible earthworks between woodland and arable. [NMR 23353/17, 24 Jan 2004]

Figure 8.13 A couple of ring ditches – east of Goldington, Bedfordshire – probably representing levelled Bronze Age round barrows, surviving in an island of arable surrounded by dual carriageway, quarrying and the course of a former railway. [NMR 21648/00, 4 Jul 2002]

which Crawford's so-called 'Celtic' fields and their upland equivalents such as the reave systems of Dartmoor begin to become more visible and to expand, showing how widespread the exploitation of the landscape had become. However, excavated evidence is increasingly hinting at earlier origins for some of these field systems, suggesting that any transition from a mainly monumental to a predominantly domestic and agricultural landscape was a far more complex and lengthy process than has been presumed.

With the farms and fields, contemporary monuments appear less isolated and, equally importantly, settlements are more visible, though only as long as the occupants enclosed their houses within a bank and ditch. It is these that leave earthwork and cropmark traces. The roundhouses common to British prehistory were generally post-built in the lowland regions and the individual postholes are seldom substantial enough to produce a cropmark. In upland regions, where suitable stone is available, the circular stone-built bases of houses can survive, leaving a trace visible both on the ground and from the air.

In general, the landscape becomes even busier during the Iron Age and Roman periods, with earlier features sometimes respected but seemingly left alone, sometimes continuing in use in some form or another, and sometimes being replaced by something else entirely (Fig 8.14). Things change again, at least from the air, with the end of the Roman period. From the departure of the Romans until the arrival of the Normans, there is little that can be comfortably identified on the basis of aerial evidence alone. Even the return of a

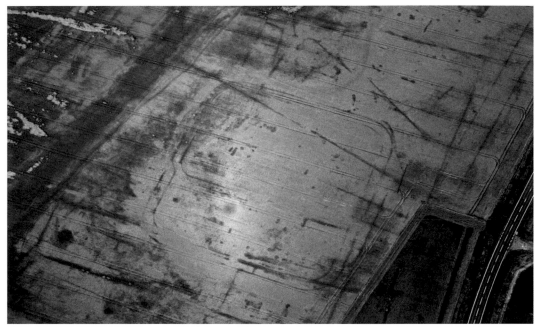

Figure 8.14 Until the late 1960s, this site at Grandford, Cambridgeshire, close to the Fen edge, comprised the earthwork remains of 3rd–4th century AD Roman settlement. Over 30 years of ploughing have removed all trace of these earthworks, but have begun to reveal underlying earlier features as cropmarks, including this two-phase Roman fort. [NMR 21269/21, 20 Jul 2001]

tradition of burying some of the dead beneath round barrows surrounded by a ditch can create difficulties, as it is seldom easy to distinguish these from the earlier Bronze Age round barrows without excavation.

The medieval period is marked by an abundance of earthworks (Figs 8.15 and 8.16), particularly on the historic photographs including those taken by the RAF during the 1940s, which captured many areas of settlement and ridge-and-furrow that no longer survive above ground. The real impact of aerial photography on medieval archaeology came after the Second World War, though the pioneer of medieval settlement studies, Maurice Beresford, singled out Crawford's publication in 1925 of some earthworks at Gainsthorpe, Lincolnshire, as the starting point of the 'use of air photography for the detection of lost villages and the elucidation of their earthworks'.[32]

Crawford had been tipped off by the Reverend Alfred Hunt, vicar of Welton, Lincolnshire, about some earthworks at Gainsthorpe that he considered to represent a possible Roman camp. Hunt had arranged for a vertical aerial photograph to be taken of the site by someone at the RAF (Cadet) College, Cranwell, and had sent a copy to Crawford, who spotted straight away the distinctly un-Roman appearance of the site (Figs 8.17 and 8.18). On this occasion, it was documentary sources that Crawford turned to rather than fieldwork. He uncovered some late 17th-century accounts making it clear that the earthworks actually represented the surviving remnants of an abandoned medieval settlement.[33]

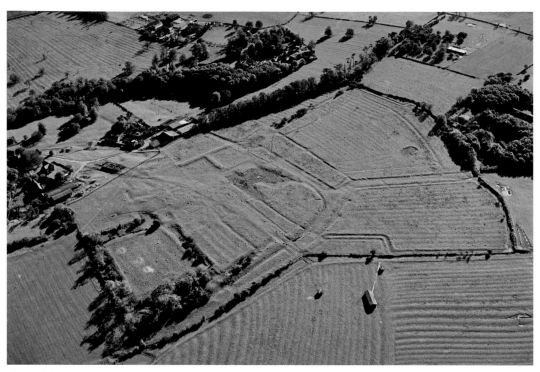

Figure 8.15 Burton Lazars, Leicestershire, was once the chief leper hospital in England. Founded c 1147–62 by Roger de Mowbray for the Order of St Lazarus of Jerusalem, it was dissolved in 1546. Today, the surviving earthwork remains chiefly comprise a dry moat, fishponds, hollow ways and field boundaries, plus fields of ridge-and-furrow representing former arable. [NMR 21855/00, 24 Oct 2002]

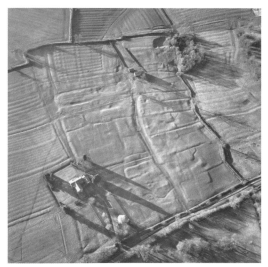

Figure 8.16 Earthwork remains of a former medieval settlement south of Carlton Curlieu, Leicestershire. Visible features include hollow ways, tofts and crofts, and ridge-and-furrow. [NMR 21977/20, 5 Feb 2003]

When Beresford began his researches into 'lost villages' after the Second World War, he made extensive use of aerial photography, noting that '[o]nly with the excavators' spades or in the air photographs is clarity restored and coherence brought to the intermingled mounds, depressions, hollows and lumps'. He was particularly impressed with the RAF's post-war coverage, which he began to consult while the photographs were still at Medmenham. The photographs were subsequently made accessible to accredited researchers at the Whitehall headquarters of the Ministry of Housing and Local Government. Beresford also bestowed praise on St Joseph, saying that his 'oblique angle of vision admirably displays the topography of deserted sites'.[34]

The most abundant remains mapped from aerial photographs belong to the 2nd millennium AD and particularly the last two or three centuries. The remains of the Second World War and the Cold War are popular topics for researchers and public alike, making them a priority for mapping and recording. In fact, many of these 20th-century remains are mapped not from recent reconnaissance photographs but from historic photographs taken when these places and structures were still in use. Today considerable effort goes into mapping features that had yet to be built when Crawford began his pioneering work in the 1920s.

Recognising that not everything that has occurred in the past will leave physical traces visible from the air is one thing. There is also the problem that even if vestiges remain, they may be beyond the reach of aerial photography. Large areas

Figure 8.17 Gainsthorpe as photographed from 4,000ft by a flyer from the RAF (Cadet) College, Cranwell. According to one 17th-century observer quoted by Crawford, 'I fancy that the town has been eaten up with time, poverty and pasturage.' [CCC 11750/172, 3 Mar 1925]

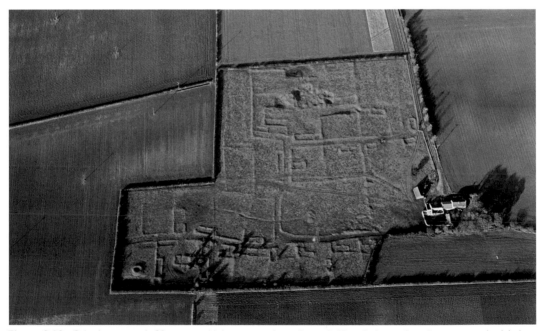

Figure 8.18 Gainsthorpe nearly 80 years on. Little seems to have changed, although the earthworks are now scheduled and a Guardianship monument in the care of English Heritage. As both photographs demonstrate, the remainder of 'Gainstrop' was flattened by the plough long ago. [NMR 17774/23, 4 Nov 2002]

of England are, of course, home to forms of land use unsuited to archaeological aerial photography – extensive areas of woodland, for example, or urban or industrial expansion. Sometimes, photography exists from a time prior to urban or industrial expansion, or vertical surveys such as those undertaken by the RAF or the Ordnance Survey may have accidentally captured occasional clearances of areas of woodland, offering a brief glimpse of the surface. Historic photography of such areas can also provide a valuable insight into their development over time, but earlier periods may still remain beyond our reach.

Figure 8.19 Arbury Banks, a probable Iron Age enclosure on the outskirts of Chipping Warden, Northamptonshire. Medieval ploughing has utilised the enclosure's earthworks as field boundaries, helping to preserve its outline if not its interior. More recent ploughing ignores its presence altogether. [NMR 21405/25, 26 Nov 2001]

Quarrying may have removed archaeological features before archaeologists (or, indeed, anyone else) ever had the chance to fly over them. There are countless reported discoveries made prior to the advent of aerial photography that now lack any sort of physical provenance – we can no longer discover how they relate to the archaeological features that may be known in surrounding areas. Ironically, examples of quarrying – particularly pre-20th century – may now themselves be regarded as important features of the historic industrial landscape.

There are plenty of other examples of instances where one particular phase of land use has masked or obliterated all that went before. Urban and industrial landscapes are notable destroyers of earlier features, although geophysical survey and excavations in such areas repeatedly show that archaeological features can survive in abundance – they just cannot be identified from the air. A classic example of historic land use, the traces of which are of archaeological importance but whose presence can conceal earlier activity, are the sometimes extensive remains of medieval and post-medieval arable agriculture, usually visible in the form of earthwork ridge-and-furrow (Fig 8.19). Its extent has declined considerably in recent decades; however, in some areas it remains and in others it dominates the photographic cover from the 1940s and earlier, documenting the rural landscape of the medieval or post-medieval periods (Fig 8.20). Where it has been ploughed up in recent times, cropmark traces of earlier periods have been photographed, underlining the aerial archaeologist's reliance on destructive processes to reveal traces of the past.

Even in areas of favourable soils, where earthworks have been levelled, it is important that the current land use is conducive to cropmark formation. This normally means arable agriculture, although in extreme conditions even grass can respond to the presence of archaeological features, as demonstrated by the 1906 photographs of Stonehenge. There are also, of course, many areas where soils and geology are unfavourable to cropmark formation. Consequently, much more effort in terms of time and resources is necessary to capture the occasional glimpses visible when conditions are right.

There are also restrictions on when and where one can fly. Unlike the pioneering days of aviation, the skies over England are no longer completely open. Restricted air space exists around both civilian and military airfields, meaning much less flying is possible in these areas and consequently there are fewer opportunities to cover those areas with anything like the frequency one might regard as ideal (Fig 8.21). The same applies to military training areas, such as Salisbury Plain, which are known to contain considerable quantities of archaeological sites and monuments.

Figure 8.20 An extract from the recent North Cotswolds NMP project (north to top). Extensive traces of ridge-and-furrow dominate the mapping, whether visible on photographs as earthworks (cyan) or cropmarks (magenta). In both cases, the arrows represent the direction of ploughing. Other colours represent features that either pre-date or post-date the ridge-and-furrow. Note particularly the features mapped in green towards the south-eastern corner of this extract, which represent cropmark traces of prehistoric and Roman activity visible because the ridge-and-furrow here has been levelled by ploughing. [Air photo mapping © English Heritage.NMR; topographical detail based on Ordnance Survey mapping (© Crown Copyright and database right 2011. All rights reserved. Ordnance Survey Licence number 100024900)]

Figure 8.21 This probable Iron Age enclosure, and the former watercourse with which it clearly had a close relationship, is located right against the boundary fence of the former military airfield at Upper Heyford, Oxfordshire, and was effectively beyond the reach of archaeological reconnaissance while the airfield was in use. [NMR 21048/28, 2 Jul 2001]

Adjusting the focus

The early use and success of aerial photography was, as we have seen, demonstrated on the Wessex chalk, first for recording earthworks and then cropmarks. This was followed from the early 1930s onwards by a growing realisation of the sheer intensity of past activity on the gravels of lowland river valleys. The geographical scope of archaeological aerial survey widened as a result, but still tended to focus on broadly similar landscapes. Essentially, reconnaissance was concentrating on the areas expected to be productive, but it was a while before such preconceptions were recognised and addressed.

Aerial photography had helped to lure archaeologists away from places such as Salisbury Plain, where earthworks survived in abundance, to regions like the Thames Valley, where they didn't. As the photographs clearly showed, the apparent lack of earthworks in these places was the result of the sheer intensity of later land use on the valley sides and terraces, and it was the continuing intensity of arable agriculture, particularly during and in the wake of the Second World War, that was now revealing a previously hidden past to the airborne camera.

This shift in archaeological attention was not a complete surprise. The gravel terraces of river valleys were a recognised source of discoveries, mainly in the course of quarrying. It was known that these areas had been occupied at times in the past, but the precise nature

and extent of that occupation was more difficult to grasp because of the fragmented nature of the picture revealed by the opportunistic investigations carried out alongside the still largely unmechanised extraction industries. Also of importance here were contemporary ideas about the influence of the physical environment on the geographical spread of human activity within the British Isles in history and prehistory.

Particularly influential was the work of Cyril Fox, whose *Personality of Britain*, first published in 1932, went through several editions over three decades. Building on prevailing ideas within the fields of geography and geology as well as archaeology, and making extensive use of the sort of distribution maps previously pioneered by Crawford, Fox sought to demonstrate that the uneven spread of certain selected archaeological phenomena – megalithic tombs, flint daggers and so on – and by extension the cultural groups they represented, could be satisfactorily explained in terms of geology, topography, climate, flora and fauna. At a time when anything new in the British archaeological record was usually considered to have been introduced by invaders from continental Europe, distance from the English Channel also played a part. As Fox argued, 'the effect of the vulnerability of Britain to invasion is that she has always tended to present successive strata of culture, and a very mixed population, the latest arrivals being dominant, and the novel culture more strongly marked in the eastern and southern part of the island…'.[35]

This vulnerability was blamed on the same factors that made the south-east attractive to settlement: 'Lowland country, with its insignificant hills and easy contours, is more easily overrun by invaders than highland. The difficulties which mountainous country represents to an invader are well known… .'[36] Overall, however, he noted that

> the distribution of population in prehistoric times is controlled by physiographical conditions. In the Lowland Zone a pervious subsoil, resulting in open country, parkland, scrub, or forest with not too dense undergrowth, is the chief factor. Low hills of easy contour and plateaux possessing such subsoil (chalk and limestone) form the framework of lowland Britain, and thus provide the main field for man's activities; but gravel terraces by rivers are equally suitable, sandy heaths are sometimes occupied, and harbours offering opportunities for commerce are not neglected.[37]

It has been accepted for some time now that archaeological distribution maps do not necessarily offer a realistic snapshot of the geographical spread of settlement in the past. Instead, they are influenced by numerous factors that affect the visibility of archaeological sites and finds in different regions. In Fox's day, the two main influences were (i) the relative visibility of archaeological monuments – earthworks survived far better in some places than in others, but it had yet to be grasped that this was largely due to the nature of more recent land use, especially as Fox was mainly concerned with prehistory; and (ii) variable rates of discovery of unsuspected sites and finds, also now recognised as partly due to the intensity of recent and modern land use, mainly in the form of arable agriculture, quarrying and urban development. In other words, finds are most likely to turn up where disturbance of soil and subsoil is at its greatest.

Fox argued, on the basis of his distribution maps and the ideas underlying his thesis on the influence of soils and geology, that 'the areas shunned by Early man in the Lowland Zone are the impervious clay-lands, which are very extensive…'. But what about the traces of activity

known to survive on the clays? He explained this by noting that '[a]ll human communities, of course, throw off groups and families below the poverty line of their particular culture, who scratch a miserable living how they can in less desirable areas. Evidences of such will certainly be found from time to time on the clays … but they are negligible.'[38]

Consequently, past human activity was considered to have been concentrated in precisely the places most likely to yield cropmarks. Many of the early pioneers of aerial photography, including Allen before the war as well as those who took it up in the immediate post-war years, were unconsciously reinforcing Fox's thesis by concentrating on the lowland river valleys. A good example is the publication by Graham Webster and Brian Hobley in 1964 of a detailed paper on the cropmark evidence along the course of the River Avon in Warwickshire, largely based on photographs taken by Baker and Pickering since the late 1940s. While they were able to show for the first time the density, complexity and variety of prehistoric activity in particular along the Avon valley, their analysis – and indeed the photography itself – was largely influenced by ideas about where precisely traces of prehistoric activity were most likely to be found.[39]

Over the next 40 years, many more sites have been discovered in the region and more detail photographed at sites already known, but until recently the general distribution of recorded sites remained predominantly tied to the Avon Valley and its lighter soils. In other words, archaeological distribution maps were now highlighting the areas that had seen the most flying. Indeed, Webster and Hobley's paper included a distribution map of the lighter, more permeable soils of the West Midlands in an attempt to show the potential of the region for further reconnaissance. Echoing the views of Fox and others, they suggested that those lighter soils represented not only the areas most easily cultivated in prehistory, but also the areas where they believed most prehistoric settlement would have been situated. As for the remainder of the region, 'the heavy subsoils of the Keuper marl and boulder clay occupy considerable patches, and those areas of thick natural woodlands would have been avoided by the early settlers, while remaining a valuable source of food for the hunters of wildlife'.[40] In fact, of course, the known spread of cropmarks is to a considerable extent the result of choices made about where to fly and those choices were being influenced by prevailing ideas about where people would have been living in the past. Intensive reconnaissance over areas containing soils that are generally considered less conducive to the production of cropmarks has been shown to be effective, given the right conditions.

New ways of seeing

Today, anyone with access to the internet can examine aerial imagery of most parts of the world with a few clicks of a mouse. It is no longer necessary to fly or to visit specialist collections of photographs to see what particular places look like from above. Satellite imagery, a Cold War development and once the sole preserve of the military, is increasingly becoming commercially available and the same is true of other technologies developed for viewing and recording the surface of the earth. What is the potential of these resources for archaeological research and how much use is being made of them?

With accessible satellite imagery, resolution and cost have been longstanding concerns. Some recent studies suggest that it is now possible, with the higher-resolution images available, to identify relatively small earthwork and cropmark sites, although scale and

resolution still fall short of what is achievable through conventional or digital aerial photography. Multi-spectral imaging, with its origins in satellite imaging, can also present problems of cost and resolution, although again matters are improving. Multi-spectral methods capture light from frequencies beyond the range visible to the human eye – infra-red, for example – which means that on occasions cropmarks might be 'visible' at times when there is insufficient colour differentiation within a crop to be captured by normal photographic techniques.

The best-known and most accessible sources of aerial imagery today are websites such as Google Earth, which provide near-seamless coverage of much of the earth's surface at varying resolution. As with the other methods, these websites offer predominantly vertical coverage, which may not be ideal as far as visibility of archaeological features is concerned. In addition, it may not have been taken at the right time of day, let alone the most suitable time of year for archaeological purposes. Nonetheless, archaeological and historical sites are visible – many of them are already known and, in some cases, have been for a considerable time. However, these are little different to the issues faced when dealing with historical survey photography, such as the vertical cover taken by the RAF in the 1940s. Previously unknown and unsuspected features will turn up.

By far the most promising – and most talked about – of the new techniques available to archaeology is airborne lidar (light detection and ranging), a tool for surveying the earth's surface that has been around since the 1960s but whose potential for archaeological survey has only been realised relatively recently. Lidar measures the distances travelled by pulses of light, capturing variations and undulations in the earth's surface and anything upon it by recording the time taken for individual pulses to reach the ground and return. A pulsed laser beam, scanning the ground from side to side as the aircraft passes overhead, measures between 20,000 and 100,000 points per second, allowing for the creation of a high-resolution three-dimensional model of the ground surface with a computer.[41]

The potential of the technique for archaeology was first realised in this country in the late 1990s when the earthwork remains of a Roman fort at Newton Kyme, North Yorkshire, proved to be visible on lidar imagery processed by the Environment Agency, despite the fact that field investigation of the site had reported no surveyable remains on the ground for at least half a century. Using false sunlight on the lidar ground model at an extremely low elevation, it was possible to make out the outline of the heavily eroded ramparts of the fort, which had been mapped by the RCHME in 1995 entirely as cropmarks. The case of Newton Kyme demonstrated that lidar offered considerable potential for recording surviving earthworks at sites previously considered to have been levelled – and, of course, for identifying slight earthworks previously missed by ground or aerial survey.[42] However, one often overlooked fact is that the 1995 RCHME aerial survey mapped far more detail in, around and adjacent to the fort from photographs than was visible via lidar.

Within English Heritage, the first real use of lidar came when the Environment Agency was commissioned to provide lidar data for the Stonehenge World Heritage Site, in order to compare the results with those of the recently completed NMP project (Fig 8.22).[43] Lidar was able to record many, but by no means all, of the known sites, but importantly it did increase the known detail and extent for some. It proved particularly useful for adding extra information about things like prehistoric field systems still surviving as slight earthworks in grassland. Such earthworks are normally detected, if at all, through the shadows cast

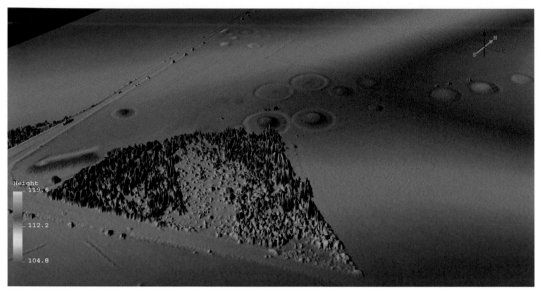

Figure 8.22 Lidar-derived image of the Winterbourne Stoke barrow cemetery, located about 2km west of Stonehenge at the junction of the A303 and A360. Here the lidar data is presented in the form of a low-level oblique view, as seen from the south-east, with the landscape lit from the north-west and no height exaggeration. [© English Heritage, source: Environment Agency, Dec 2001]

in low sunlight. Of course, the real sun can only shine from one direction at a time, which means that not all slight earthworks will be casting sufficient – or any – shadow at the same time. Within the computer, the ground surface model created from the lidar data can be examined by changing the direction and angle of the light source or, indeed, sources. In addition, the vertical scale can be adjusted, increasing the height of potential features to enhance their visibility.

Analysis of lidar data also followed NMP mapping for the Witham Valley in Lincolnshire.[44] Lidar proved particularly adept at identifying palaeochannels – former courses of rivers and streams. These can also yield cropmarks, but capturing them during the lidar survey enabled a closer analysis of the relationships between archaeological sites and the broader landscape, past and present. Again, lidar was able to recognise many of the previously known sites plus some additional slight earthworks. At the same time, the Witham Valley project also highlighted some of the limitations that had been revealed by the Stonehenge project.

A Bronze Age barrow cemetery east of Barlings Abbey was well known prior to analysis of the lidar survey data. More than a dozen barrow mounds survive as very slight earthworks protruding through the alluvium, while still more have been mapped as soilmarks or cropmarks. It might have been expected that at the very least, the barrows with surviving above-ground traces would be captured by the lidar. In fact, not only did the survey fail to recognise any residual earthworks for the cropmark barrows, it was difficult to identify any trace of the extant mounds. Given the nature and limitations of lidar survey, this shouldn't come as a complete surprise, but the point needs emphasising that lidar can only detect the

presence of archaeological features where sufficient above-ground remains are still present. It cannot see through the ground, and any site that has been levelled – or that has been reduced sufficiently in height or never had an above-ground component – is unlikely to be recognised by lidar.[45]

The variations recorded in the level of the ground surface by lidar can be due to any number of causes. They may reflect the natural topography, vegetation cover, buildings, vehicles, people and so on; however, lidar does not identify or interpret the causes of these variations – it simply measures. For archaeological survey purposes – as with traditional air photo interpretation – the experience of the human interpreter is required alongside maps, conventional aerial photography and other sources of information to assist in the analysis. For example one of the features noted when analysing the Witham Valley lidar appeared to display the characteristic 'playing card' shape commonly associated with Roman fortifications. This interpretation seemed to be supported by its landscape setting – on a slight ridge with a commanding view of the valley below. However, historic aerial photographs taken during and immediately after the Second World War showed an area of hardstanding associated with a hangar or storage building attached to a military airfield.

There is one area where lidar can definitely reach beyond the gaze of traditional aerial survey techniques: it can often see the ground beneath trees. Areas of woodland are, on the whole, impenetrable to ordinary airborne cameras, although regular felling and replanting in managed woodland provide occasional windows through to the ground surface and, on occasions, important archaeological detail has been photographed. With lidar, some of the pulses will be able to penetrate the canopy, particularly when dealing with deciduous woodland in autumn and winter. Consequently a three-dimensional model of the surface beneath the trees is achievable, although it will not be continuous. Also, as this surface is beyond the reach of aerial photography, there is an even greater need to visit on foot to ensure that there really is something there and to try and identify what it represents. Consequently, wooded areas are no longer beyond the reach of airborne survey, but there are caveats – the ability of lidar to penetrate the tree canopy sufficiently to produce a useful and reliable model of the ground below depends on the nature and density of the canopy itself (Fig 8.23).[46]

Lidar has some other benefits, though. Unlike aerial photography, lidar survey doesn't need sunny cloud-free skies in which to operate and it can often be used to locate a site far more accurately on the ground than is possible from oblique and even vertical photographs. It may only be a matter of a few metres, but this can be extremely important when it comes to defining protected areas or planning an excavation trench. It also provides a means of examining topographical relationships within a three-dimensional model of the landscape far in advance of what was previously practicable. There are also things it cannot do, of course. Its inability to find sites with little or no above-ground trace has already been noted, as has the need for careful analysis and interpretation of the data generated by lidar survey. In addition, it can only record things that still exist. Something levelled or quarried away years or decades ago cannot be spotted by lidar, but may have been captured on aerial photography or other forms of imagery at some point in the past. Lidar does not remove the need to consult either modern or historic aerial photography. As with satellites, multi-spectral imaging and other available resources and techniques, it is not a replacement for traditional aerial survey but an

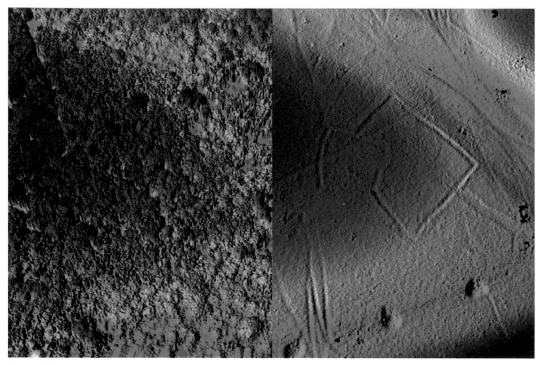

Figure 8.23 Lidar image of part of the Savernake Forest, Wiltshire, with and without tree cover. [Lidar © Forestry Commission, source: Cambridge University ULM, May 2006]

additional, complementary source of information, albeit an extremely useful and significant one – perhaps the most significant since the introduction of aerial photography itself.

Recognition of the human factor and the complementarity of different techniques in aerial archaeology is also worth recalling when thinking about the future of aerial reconnaissance. No matter how it seems today, 2nd Lieutenant Sharpe's combination of tethered hydrogen balloon plus plate camera represented the most advanced technique available to the Royal Engineers at the time. In the mid-1920s, Crawford and Keiller's use of a DH9 and modified German camera wasn't far behind contemporary (British) military capabilities, and around 300 photographs in under three months represented a pretty good return. In the financial year 2009–10, 280 hours worth of English Heritage reconnaissance flights resulted in over 20,000 new photographs. In 2009, it has been estimated, unmanned American military drones flying over Afghanistan and Iraq captured enough imagery to keep a human observer busy for 24 years.[47] Ongoing technological improvements are expected to yield considerable increases in future years. Clearly such quantities of data cannot be analysed within a reasonable timescale by a human observer, hence the use of computer software – a process known as data-mining (or, increasingly within industry and commerce, as 'business intelligence') – to evaluate the data, identify patterns and extract meaningful information before any human eyes get to see it.

Remote sensing techniques as used by archaeologists, including aerial photography, lidar and satellite imaging, have all borrowed heavily from the military. Aerial archaeology, as currently practised, seems rather remote from current US military methods, although the situation is

changing as data derived from technologies originally developed by the military becomes accessible to archaeology. Interpreting such data requires completely different analytical approaches. Lidar, for example, does not produce something equivalent to a traditional photograph, although that is how lidar data is often presented. The airborne camera, today generally digital, is just one source of information and the amount of time and resources necessary to process and analyse everything available is increasing all the time.

Aerial survey and archaeology: Back to the future

'Let me make my position quite clear before concluding. My object in reading this paper is to give an example of the use of air-photography for archaeological survey. A paper of this kind seems called for to inaugurate what will prove to be a new epoch in the history of British archaeology.'[48]

That Crawford did indeed help to inaugurate a new epoch that night is clear, but only with hindsight. Much of his early 'groundwork' was not really built upon until after the Second World War, when a greater number of individuals were able to take to the air on a regular basis. Mapping from aerial photographs only saw sporadic uptake prior to the 1970s.

Nonetheless, the contemporary impact of Crawford's 1923 paper to the Royal Geographical Society was clear from the reaction it provoked among the audience once he had finished speaking. The Society's president, for example, offered the 'somewhat solemn thought that in the year 1923 A.D. we can take from the air photographs of the agricultural systems prevalent in this country some 500 years before Christ'.[49] That solemnity might have turned to astonishment had he known the full range of archaeological traces visible from the air, as well as the even earlier date now accepted for some of them.

Some particularly perceptive comments came from H St J L Winterbotham, who had been Crawford's wartime superior and who would soon be in charge of him again at the Ordnance Survey, where he would do 'much to impede the adoption of air survey both in Britain and … in the colonial territories'.[50] Winterbotham praised Crawford's 'wonderfully clear examples of the way in which air-photography integrates, as it were, those small marks on the ground which outline an old work or part of a work, and brings them to one's eye as a whole in a fashion one could never get from the ground itself'. He also spotted 'the advantage to future generations of photographs taken today', capturing as they would landscape features which would themselves in time pass into the realms of archaeology.[51] And as the Royal Geographical Society's President reminded the audience: 'The lecturer does not maintain, of course, that air-photography will do away with the necessity of fieldwork in archaeology.'[52]

To some of those present, what Crawford had shown them represented a fair degree of wish fulfilment. J P Williams-Freeman recalled a day

> many years ago at Cranborne Chase driving up to the old hill-fort of Winklebury. I noticed nothing on the hills. As far as I could see the Downs looked perfectly smooth – an expanse of close-cropped down turf. On my way back in the evening when the sun was just westering and casting shadows on the hills, the whole thing below my

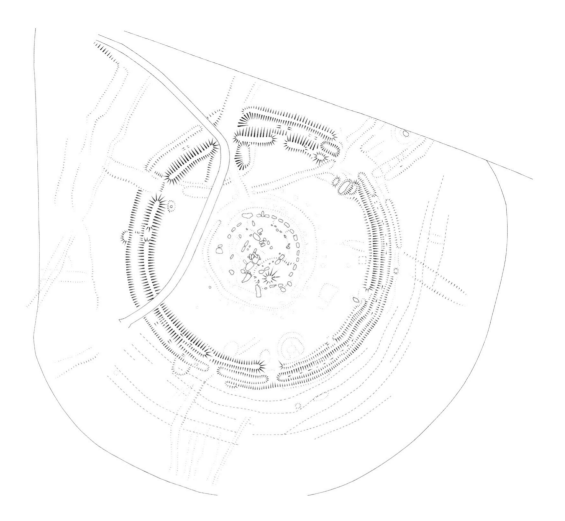

Figure 8.24 The recent earthwork survey of Stonehenge, undertaken in 2009, 90 years after the Ordnance Survey visited. Particularly noteworthy are the two slight banks encircling the more prominent stone settings. Previously unnoticed despite considerable activity at Stonehenge throughout the 20th century, parts of both can – with hindsight – be identified on Sharpe's 1906 balloon photographs.

That this part of the ditch was still visible as an earthwork in the mid-20th century was suggested to be down to Hawley – instead of backfilling completely after his excavations, he had instead 'restored' this section of the ditch to resemble the remainder. However, this ditch section appears to be extant as an earthwork on the 1906 photographs. In addition, Sharpe's published oblique clearly shows that the eastern ditch of the Avenue on the southern side of the A344 follows a slightly different alignment to the same ditch on the other side of the road. Typically, the junction between the two, the investigation of which may shed light on the sequence of events here, lies beneath the tarmac.

These are, of course, all observations that arose from close engagement with the monument on the ground, using a variety of survey techniques. All are very subtle features and can be

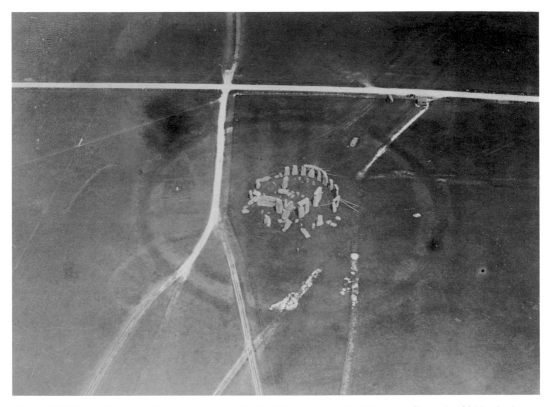

Figure 8.25 This aerial view of Stonehenge, along with Fig 8.26, was taken by 2nd Lieutenant Sharpe in 1906 but both remained unknown until recently. This photograph is not too different from Fig 2.15, the balloon being a little further from Stonehenge in the latter. [The National Archives, ref COPY 1/500 (148)]

difficult to identify on the 1906 photographs without prior knowledge of their existence. However, the same cannot be said for the full range of parchmarks evident on the grass within and outside the monument. The bank and ditch are particularly clear on Sharpe's photographs because of the extremely dry ground conditions at the time. The vegetation appears darker over 'negative' features such as the enclosure ditch, and lighter over 'positive' features such as the banks on either side of that ditch. What should be immediately evident is that areas of darker and lighter growth are not restricted to the obvious earthworks. Perhaps the most noteworthy is the sizeable circle beyond the A344 and to the west of the Avenue, something that is most clearly visible on the published oblique. Anyone looking carefully at all three 1906 photographs should be able to make out a number of other intriguing shapes, all requiring further consideration and, perhaps, investigation.

The essential difference between 1906 and now is not the means of getting airborne, or the type of camera used, but the procedures for archaeological analysis of aerial photographs that have developed over the years. Expectations about the possibilities of aerial images are radically different today compared to 1906. Additionally, of course, renewed work on the ground prompted a need to reappraise images that had previously

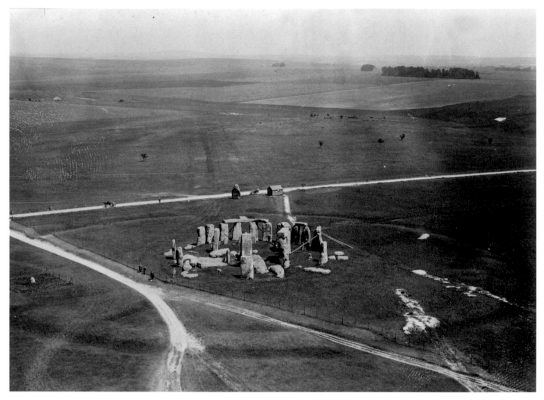

Figure 8.26 This recently uncovered 1906 view by Sharpe is of considerable interest, showing far more of the landscape beyond the monument than the others and also capturing many more visitors than are present in Sharpe's other photographs. It also appears that Sharpe has attempted to wait for the balloon to line up with the Stonehenge Avenue to the north-east. [The National Archives, ref COPY 1/500 (148)]

been overlooked as potential sources of detail – overlooked perhaps because of their familiarity, perhaps because a discipline that has often presented itself as being allied to technological improvement had little time for something taken so long ago with a plate camera held beneath a balloon made of ox intestines.

A final point, of course, is that so many 'old' aerial photographs await discovery, with Sharpe's 1906 images being a case in point. In 2005 we knew of two photographs – those printed in *Archaeologia* in 1907 (*see* Figs 2.1 and 2.14). By 2006, thanks to Bernard Nurse at the Society of Antiquaries, a third had come to light (*see* Fig 2.15). More recently, the appearance of Colonel Capper's copyright claim at The National Archives, Kew, revealed the existence of further photographs – in total, five prints were attached to the form he filled in: the three already known about, plus two 'new' prints (*see* Figs 8.25 and 8.26). In this case, of course, the interest lies not so much in what they might tell us about Stonehenge, but in what they might tell us about that day (or days) when they were taken, and the broader context of military balloon photography.

Notes

Chapter 1

1 Bladud was credited with founding Bath, apparently after its healing waters cured him of leprosy. He was 'a most ingenious man who encouraged necromancy throughout the kingdom of Britain. He pressed on with his experiments and finally constructed a pair of wings for himself and tried to fly on the upper air. He came down on top of the Temple of Apollo in the town of Trinovantum and was dashed into countless fragments' (Thorpe 1966, 80–1).

2 Wenceslaus Hollar (1607–77) was described in the antiquary John Aubrey's *Brief Lives*, compiled in the late 17th century, as 'very short-sighted, and did worke so curiously that the curiosity of his Worke is not to be judged without a magnifying-glasse. When he tooke his Landskapes, he, then, had a glasse to help his Sight ... He was a very friendly good-natured man as could be, but Shiftlesse to the World, and dyed not rich' (Aubrey 1982, 165–6).

3 *See*, for example, the Avebury examples in Ucko *et al* 1991.

4 Jackson-Stops 1991, 11–12; Strong 2000, 137. Leendert Knijff's name is occasionally anglicised to Leonard Knyff.

5 *Airopaidia* – or, to give it its full title, *Airopaidia: Containing the narrative of a balloon excursion from Chester, the eighth of September, 1785, taken from minutes made during the Voyage: hints on the improvement of balloons, and the mode of inflation by steam; means to prevent their descent over water; occasional enquiries into the state of the atmosphere, favouring their direction: with various philosophical conjectures. To which is subjoined, mensuration of heights by the barometer, made plain: with extensive tables, the whole serving as an introduction to Aerial Navigation, with a copious index* – is, in the words of L T C Rolt (1985, 75), 'extravagant, prolix and boring'. Baldwin's text can be viewed free of charge via a number of websites. The quote in the chapter title, 'summer scenes of fairy-land', can be found on p 135 of *Airopaidia*.

6 Baldwin 1786, 37–8. The quote used in the title of Chapter 8 is from this extract. Note that the quotes from Baldwin are as printed in *Airopaidia* with the sole exception that the letter 's' is rendered according to modern practice, rather than 'f', in a probably futile attempt to make it an easier read.

7 Baldwin 1786, 133–4.

8 Robert Barker (1739–1806) – details on his life and career can be found on DNB. For a discussion of the panorama, *see also* Crary 2002.

9 Bold *et al* 2009, 32. The 'Rhinebcck' panorama was discovered lining a barrel of pistols in a house in Rhinebeck, New York, in the early 1940s and was acquired by the Museum of London in 1998.

10 Brewer 1884, 530.

11 Ibid.

12 Newhall 1969, 19.

13 Cole nd (Cole's *The People's Stonehenge* is undated but it was printed in 1895 by John Doney, High Street, Sutton, Surrey). The quote about slaughtered animals and hungry priests is on p 10; the reference to scaffolding is on p 6. The quoted review can be found in the *Wiltshire Archaeol Natur Hist Mag* **XXVIII**, 1896, 271–2.

14 The thatched roof idea is mentioned in a letter from Cole's son, Mr R Langton Cole, FRIBA, to the Ministry of Works (2 Oct 1918, TNA AM 71786/1).

Chapter 2

1 Daniel 1952, 295: 'These two photographs are interesting as curiosities…' provides the chapter title.

2 *Proc Soc Antiq London* **XXI** ser 2 (1906–7), 262. Adrian James (Soc Ants) kindly provided a list of attendees, or at least those who signed in. Capper's signature, for instance, is not present.

3 Capper 1907, 571.

4 Deuel 1969, 10.

5 Chippindale 1994, 175.

6 Evans 2002, 184–8 and 293.

7 Grover 1863a and 1863b; Beaumont 1863. *See also* Dobinson (forthcoming) for a detailed account of the long gestation of British military ballooning.

8 Evans 2002, 300–3; Beaumont 1863. Beaumont is perhaps better known today for his role in the 1880 attempt to bore a tunnel beneath the English Channel.

9 The first volume of the official history of the Royal Engineers (Whitworth Porter 1888, 190) notes that on receipt of the memorandum from Grover concerning the use of balloons for military reconnaissance 'the usual dose of cold water was administered…'.

10 Watson's sometimes colourful military career is told in some detail in Lane-Poole 1919. His role in writing some of the earliest official accounts of Army ballooning led to his contributions being downplayed somewhat.

11 Mackersey 2004, 242; Jenkins 2000, 97–8.

12 Watson 1902, 45–6.

13 Whittington 1893, 299. The details about goldbeater's skin are from Walker 1971, 13–14 and Rolt 1985, 180.

14 Walker 1971, 33.

15 Templer had pioneered the use of steam-traction engines to pull the balloon wagons to compensate for a lack of horses. Walker (1971, 16) reported locals recalling Templer taking his wife shopping in Aldershot in a trailer pulled by a steam engine.

16 John Edward Capper (1861–1955). During the Boer War, his roles included deputy assistant director of railways and commandant of Johannesburg. Capper left the balloons in 1910 on promotion, becoming the commandant of the School of Military Engineering, Chatham. During the First World War he served in several roles, including as director-general of the Tank Corps in 1917.

17 Henry Elsdale (1843–1900) joined the Royal Engineers in 1864, becoming captain in 1877 and major in 1884. He served in the Ordnance Survey between June 1873 and January 1879 (TNA WO 25/3915 f84).

18 Elsdale published considerable detail on his experiments – *see* Elsdale 1883a, 1883b and 1883c – while additional detail survives in The National Archives, eg TNA WO 32/6068. An outline patent application was also made by Templer on Elsdale's behalf on 18 October 1882. *See also* Barber 2006a for a more detailed look at aspects of Elsdale's balloon photography, and Barber and Wickstead 2010 and Wickstead and Barber forthcoming for more on the wider background to Elsdale's experiments and the relationship between aerial photography and cartography.

19 The case received widespread press attention and was the subject of much debate in Parliament. *See*, for example, *The Times*, 6 Apr 1888 and subsequent days. It transpired that Elsdale was actually with Templer on one of the occasions when Templer was supposedly offering vital

bal+ooning secrets to foreign military visitors, who had in fact already been given full access to the balloons by his superiors. Otherwise, the only real evidence against Templer came from ex-employees who were paid a retainer by the War Office in return for promising to give their wholly unreliable testimony.

20 Some further details of Elsdale's subsequent career can be found in TNA WO 25/3915 f84.

21 Charles Close (1865–1952) joined the Royal Engineers in 1884, with spells in Chatham, India, West Africa and the Ordnance Survey. He became Director-General of the Ordnance Survey in 1911, retiring in 1922. He changed his surname to Arden-Close in 1938 in order to meet the terms of a bequest. Outside interests included the Royal Geographical Society, Palestine Exploration Fund, Hampshire Field Club and the Eugenics Society (DNB).

22 Close mentioned the episode on several occasions, usually from memory, leading to both lack and variability of detail. *See*, for example, TNA OS 1/11/1, letter 4/1/1919; TNA OS 1/11/1, letter 6/1/1919; TNA OS 1/11/2, letter 28/8/1920; and Arden-Close 1985, 270.

23 Walker 1971, 29.

24 The *Manual of Military Ballooning*, published by the School of Ballooning, Aldershot, was largely written and compiled by Captain B R Ward RE in 1896. A facsimile edition was published in 2006 by Rediscovery Books.

25 Ward (School of Ballooning, Aldershot) 1896, 71–4.

26 One aerial photograph, described as showing 'a British camp under Boer artillery fire', was reproduced in Watkis 1999, 7, but both source and purpose of the photograph are unclear.

27 TNA AIR 1/728/176/3/11: 'Report on Summer Training 1903 – Balloon Section'.

28 TNA AIR 1/2310/220/1: 'Personal Reminiscences, Colonel H B Jones RE, 1884–1895'.

29 TNA AIR 1/728/176/3/9: Letter, A H W Grubb to Major Trollope, 20 Mar 1902, re: Royal Engineers' balloons in South Africa.

30 NAM 7611-50: 'Ballooning 1905–8. Memoirs of Lt Col Westland RE'.

31 Ibid.

32 TNA AIR 1/1608/204/85/36: 'Technical Training, Balloon Sections 1902–5' (Capper, Jan 1905). *See also* TNA AIR 1/824/204/5/70 and TNA WO 32/6059.

33 TNA AIR 1/728/176/3/26: 'Reorganisation of work in Balloon Companies 1905' (Capper, 26 Oct 1905).

34 Ibid.

35 TNA WO 25/3918 f387: 'Statement of the Services of Philip Henry Sharpe of the Royal Engineers'.

36 Capper's copyright claim came to light recently, when the form he filled in was catalogued at the National Archives (TNA Copy 1/500/148). The Copyright Registry form was signed and dated by Capper on 31 July 1906 and stamped as received on 11 August. Sharpe was named as 'author of work' and his place of abode given as the Royal Engineers' Mess, Aldershot. Previously (eg Barber 2006b) a late September date had been suggested for Sharpe's photographs based on (a) Capper's claim that they were taken 'recently'; (b) the assumption that Bulford was a more likely base for ballooning on Salisbury Plain than Aldershot and therefore that the photographs must have been taken after Sharpe moved there on 15 September; (c) the evidence for parching, which suggested that September was more likely than October or November; and (d) the fact that the Society of Antiquaries were made aware of the photographs' existence by 22 November (info courtesy of Adrian James, Society of Antiquaries). The copyright form also brought to light the fact that at least five photographs were taken by Sharpe. Only three were known until recently (*see* Chapter 8, Figs 8.25 and 8.26 for the additional pair). Capper's request for funds for equipment purchases, made on 18 June 1906, appears in TNA WO 32/21861 (Extracts from the

Proceedings of the Royal Engineer Committee. Part II. During the Half-Year July to December 1906). He was awarded £50.

37 TNA AIR 1/823/204/5/57: 'Photography from Balloons 1904'.

38 *The Times*, 31 May 1907, 10 and 24 Jun 1907, 9.

39 Stonehenge had been surveyed at 1:500 scale by the Ordnance Survey – then a part of the Royal Engineers – in 1873 (Beagrie 1996). Four years later, archaeologist Flinders Petrie surveyed the monument 'using a specially made chain [and] plotted the stones to the nearest tenth of an inch' (Chippindale 1994, 137), a degree of accuracy that would be impossible to reproduce on a scale drawing.

40 List of attendees courtesy of Adrian James, Society of Antiquaries.

41 The annual Gordon Bennett contest, sponsored by James Gordon Bennett, proprietor of the *New York Herald*, is an international contest for free balloons, the winner simply being the balloon that travels furthest from the start point in a single flight. The annual prize was initially 12,500 francs. The competition, in its original form, continued until 1938 and has recently been revived.

42 There is more than one story explaining the general absence of prints and especially negatives from the Royal Engineers balloonists. For example Walker (1971, 4) reported claims that their glass negatives had been crushed deliberately with a steam roller during the Second World War.

43 Some, for example, can be seen in an album of photographs apparently compiled by Templer and now in the National Army Museum (NAM 1975-02-55-1).

44 *See*, for example, Ceraudo 2005. Other pre-1906 aerial views of archaeological sites exist. A photograph of the pyramids of Giza, taken by Eduard Spelterini from a balloon on 21 November 1904 can be seen at http://en.wikipedia.org/wiki/File:Spelterini_Pyramids.jpg, last accessed 26 Apr 2011. *See* Palmer 2011 for pertinent comment and Stadler 2011a and 2011b for more on Spelterini's ballooning and aerial photography.

45 Samuel Cody (1867–1913) was born Franklin Samuel Cowdery, the name change often presumed to have been a deliberate attempt to persuade people of a link with Buffalo Bill. He has been the subject of two recent biographies (Jenkins 2000 and Reese 2006), which detail in full his eventful life (and death, of course). There is also a wealth of material available on the web, eg www.sfcody.org.uk. Incidentally, according to Jenkins (2000, 98), after their first meeting in 1902, 'Cody was so struck by Templer's moustache he frequently waxed his own from then on'.

46 TNA AIR 1315/204/14/8: 'Trials of Mr Cody's Man Lifting and Signal Kites, 30 Jun 1904'.

47 Ibid.

48 Ibid.

49 NAM 7611-50: 'Ballooning 1905–8. Memoirs of Lt Col Westland RE'.

50 TNA AIR 1/812/204/4/1254: 'Balloon School, Historical Record of…, 1907'.

51 *See* Newhall 1969, 41–5 for kites. Much information can also be found through the Drachen Organisation (www.drachen.org).

52 Batut 1890, which also discussed the potential of the technique for military reconnaissance, exploration and archaeology. *See also* Newhall 1969 and the Batut Museum's website: www.espacebatut.fr/.

53 For Eddy's kiting adventures, *see* Newhall 1969, 42–3 and Eddy 1897.

54 John William Dunne (1875–1949). Today he is probably best remembered, if at all, for his subsequent career as a writer/philosopher, his most successful work being *An Experiment With Time*, in which he attempted to establish a scientific explanation for premonitions in dreams.

Among those influenced by his work, and ideas on time in particular, were J B Priestley and H G Wells, who featured Dunne as a character in his book *The Shape of Things To Come* (DNB; Mackersey 2004, 287–8; Walker 1974, chapter 7; Priestley 1964). *An Experiment with Time*, first published in 1927, went through various revised editions and remains in print. It was his second book. His first was on fly fishing.

55 When his military career came to an end, O'Gorman impressed himself on the UK population at large by coming up with the idea of a Highway Code for motorists during the 1930s in his guise as a longstanding member of the RAC.

56 Mackersey 2004, 242; DNB.

Chapter 3

1 Bacon 1907, 151. The Reverend John Mackenzie Bacon (1846–1904) had made a start on his autobiography before his death in 1904 and it was completed by his daughter Gertrude (1874–1949) in 1907 (Bacon 1907). The account of his first balloon flight was among the passages John Bacon had completed.

 The title quote of this chapter – 'Quick! The Kodak!' – is taken from a piece of 'poetry' in an article entitled 'Up in a balloon', written by Walter Browne and published in 1891, though so far I have been unable to track down the original article (BPC). For those interested, the inspired piece of verse is, in full:

No longer of the earth, earthy
We are of the air, airy.
See that small cluster of people,
A swarm of human ants,
The tiny ground dotted with Lilliputian dolls,
The toy buildings, the pygmy lake, the tiny lighthouse;
How insignificant; how paltry!
Quick! The Kodak!

2 Bacon 1907, 169.

3 For example, Bacon wrote an entertaining history of flight (Bacon 1902a) and an account of his ballooning adventures (Bacon 1900a), as well as beginning his autobiography (Bacon 1907).

4 It is not clear if Dale's use of 'Captain' represents genuine military service.

5 Bacon 1907, 155

6 Ibid, 157.

7 Ibid, 159–60. *See also* Barber and Wickstead 2010, in which Bacon's experience of London from above is compared and contrasted with earlier balloonists.

8 Ibid, 164.

9 *The Times*, 30 Jun 1892, 9 and subsequent days.

10 *See*, for example, Bacon 1928, an autobiographical account of her flying experiences.

11 Bacon 1899; Bacon 1907, 320.

12 Anon 1891, 492–8. Griffith Brewer (1867–1948) was a patent agent by profession, as well as being a key figure in early aviation and aerial photography. He maintained a close friendship with the Wright family throughout his life and acted for them with regard to their British patents and other dealings. During the First World War, Brewer was appointed 'Honorary Adviser to the Kite Balloon and Airship Services', a role that involved him in experiments, lectures and training.

13 By the end of the 19th century, the Spencer brothers – Percival and Stanley – were among the best known and most active balloonists in Britain. Ballooning was well established in the family

– their grandfather Edward shared numerous adventures with Charles Green (probably Britain's foremost balloonist during the early to mid-19th century; *see* DNB for further information on his ballooning adventures) in the middle decades of the 19th century, while their father Charles Green Spencer not only flew but was responsible for various innovations aimed at improving the balloonists' lot. By the 1890s the Spencers' family firm supplied balloons and ballooning equipment to civilian and military customers, while Stanley and Percival seem to have flown at every opportunity. Some of their other brothers were also involved in aerial exploits. Percival, like Bacon, was also a keen and prolific aerial photographer. By 1902 the brothers had recognised that the future lay with powered flight and Stanley not only constructed an airship but became the first person to successfully fly one in Britain. Stanley died in 1906, while his brother Percival died in 1913.

14 Anon 1891, 492.

15 Brewer 1946, 25–9.

16 Newhall 1969, 41–2.

17 Nadar (1820–1910) had initially studied medicine until his father's publishing business went bankrupt in 1838. Subsequently he was variously a smuggler, poacher, clerk, secretary, incumbent in a debtor's prison and, finally, a journalist, before becoming a caricaturist for humorous magazines.

18 This particular statement of Nadar's has been widely quoted (and translated). *See*, for example, Virilio 1994, 54. The version quoted here was found at http://w2.eff.org/Misc/Publications/Bruce_Sterling/Catscan_columns/catscan12, accessed 22 Apr 2009.

19 Patent Office 1861, 123–4. Nadar's application in the UK, for provisional protection only, was made on his behalf by one John Henry Johnson.

20 Newhall 1969, 20–1. Some accounts suggest that Nadar was naked at the time of this first successful exposure. Presumably his heavy winter clothing was hindering his efforts to elevate himself.

21 Ibid.

22 Ibid, 27; Wells 1860, 168.

23 Nadar is occasionally presumed to have influenced Verne's first novel, although Verne's first story involving balloons had been written over a decade earlier ('Un voyage en ballon', 1851), while the balloon stories of Edgar Allan Poe, translated along with Poe's other works into French by Charles Baudelaire in 1854, will have been another source of inspiration. A principal character in Verne's *From the Earth to the Moon* (1865) has the surname 'Ardan', an anagram of Nadar.

24 Newhall 1969, 31.

25 McMahon 2002, 3.

26 The information relating to Coxwell and Glaisher can be found in Rolt 1985, 193–7, with additional detail in Newhall 1969, 278 and Doty 1983, 11. Note that estimates of altitude for untethered balloons at this time cannot be regarded as completely reliable because a barometer of some kind was the instrument normally used to make the measurements.

27 Henry Negretti (1818–79) was Italian by birth but was brought to England as a child. A long-term partnership with Joseph Zambra, as makers of scientific instruments, began in 1850; they quickly became instrument makers to the queen, Greenwich Observatory and the Meteorological Society (DNB).

28 Newhall 1969, 28–9; Negretti 1863, 2.

29 Newhall 1969, 29.

30 Glaisher and Negretti's experiments are summarised in an anonymously written feature in

Samuelson 1863, 576–7.

31 Newhall 1969, 29.

32 Leith 2005, 51–3, which includes a Negretti & Zambra photograph of Nadar's partly inflated balloon within the Crystal Palace.

33 Walter Woodbury (1834–85). He is best known for his invention of the Woodburytype process (c 1864), an early means of mechanically reproducing photographic images intended for use in printed media. Despite income from his numerous patents, Woodbury appears to have spent all his money on further experiments, leading to a somewhat impoverished and mobile existence for his family. At the inquest following his death in Margate, it was revealed that he regularly used laudanum, but no clear evidence of an overdose was found (DNB).

34 Newhall 1969, 34–5.

35 *Royal Engineers J* **XI**, 1881, 248–9.

36 Newhall 1969, 34–5.

37 *The Times*, 18 Feb 1879, 10. Woodbury's letter is one of several responding to events at Isandlwana and Rorke's Drift during the Zulu War of 1879.

38 Details and quotes about Shadbolt (here and in the next paragraph) are from Newhall 1969, 36–7 and *The Photo-Miniature* **V** no 52.

39 *The Times*, 9 Oct 1882, 8. Shadbolt's vertical photograph of Stamford Hill is reproduced in Newhall 1969, 37.

40 *The Times*, 16 Sep 1884, 6.

41 Brewer 1946, 31.

42 Ibid, 32–3.

43 Crossing the Channel by any available means was a reasonably popular pastime. Those who managed it included Samuel Cody who used one of his kites to tow his boat across in late 1903 (Jenkins 2000, 114–9). *See also* Brewer 1946, 41–8. The quote about the excited padre comes from *The Times*, 17 Apr 1969, 9.

44 Brewer 1946, 55–6.

45 Ibid, 57. Brewer seems to be implying a lack of commercial interest in his photographs, rather than his photographic equipment.

46 Guy 1932, 148.

47 Ibid, 148.

48 Pringle 2006, 185.

49 Mackersey 2004, 386.

50 Brabazon 1956, 58–9. John Theodore Cuthbert Moore-Brabazon (1884–1964), like his friend Charles Rolls, combined interests in aviation and automobiles until 1910 and was the recipient of the first aeroplane pilot's certificate to be issued in Britain (by the Royal Aero Club in 1910). His other aviation firsts included winning a prize offered by the *Daily Mail* for the first English aeroplane to fly a mile (October 1909); around the same time he took a pig – named Icarus II – up as a passenger. After the First World War he entered politics, initially as Conservative MP for Chatham and subsequently as a peer. He spent the early years of the Second World War as Minister of Aviation Production but was dismissed in 1942 for allegedly expressing the hope that the Russian and German armies would wipe each other out (DNB; Brabazon 1956).

51 As well as Mackersey 2004 and numerous other biographies of the Wrights and histories of aviation, there is considerable detail about the Wrights on the web. *See*, for example, www.centennialofflight.gov.

52 For example Reese 2006, 157–8, refers to an account in the *Daily News* (30 Mar 1910) of a lecture given by Cody in Ramsgate.

53 Quoted in a variety of sources, including Newhall 1969, 50.

54 Rockets and pigeons are described and illustrated in Newhall 1969, 43–8.

Chapter 4

1 *See*, for example, Henderson 1914. This – the third edition of a textbook on military reconnaissance – was the first to feature aerial reconnaissance. There is no mention of aerial photography.

2 It is important not to overlook work undertaken elsewhere in Europe around the same time. Both German and French military had long taken a more organised approach to both photogrammetry and aerial photography, and the French would demonstrate their initial superiority over RFC photography in the early stages of the war. Meanwhile, the Italians had made use of aerial photography during their 1911–13 conflict with the Turks in Libya. Mounted cameras – including a cine camera – were used to film enemy positions and camps, the resulting photography proving particularly valuable in a country poorly served by traditional mapping. Indeed, the British military attaché in Rome commented favourably on the quality of Italian aerial photography, noting particularly a 'mosaic' of overlapping photographs joined together to make a map, a technique that would be used to great effect during the First World War (Paris 1992, 108, 115; TNA AIR 1/2133/207/154/15: 'Development of Aviation in Italy During 1911').

3 Laws 1959, 25–6.

4 TNA AIR 1/2397/267/7: 'The Technical Aspects of British Aerial Survey During the War 1914–18, by Charles W Gamble, 27 May 1927'. *See also* Chasseaud 2009, 104.

5 Laws 1959, 29.

6 Chasseaud 2009, 105.

7 Chasseaud 1999, 29–30.

8 Brabazon 1956, 85–6.

9 Ibid, 91.

10 Salmond, in Hamshaw Thomas 1920, 371.

11 Insall 1970, 155.

12 Laws 1959, 30.

13 Insall 1970, 45.

14 TNA AIR 1/727/148/1: 'Reminiscences of Air Commodore C A H Longcroft'. This was written in 1920 following a request from Sir Walter Raleigh – tasked with writing the official account of the RFC's war (Raleigh 1922) – who, according to Longcroft, 'was rather depressed this morning because he says he cannot get good accounts from anybody of the early days of the Flying Corps'.

15 Ibid.

16 Ibid.

17 Brabazon 1956, 86.

18 Baring 1985, 209. Some sources clearly overstate the degree of antipathy alleged to have existed between artillery and fliers. Also, there were other ground-based techniques for directing artillery fire – particularly when dealing with enemy guns, including flash-spotting and sound-ranging – which would have enabled a more rapid response than aerial observation (*see*, for example, Chasseaud 1999, 94–9).

19 Lewis 1936, 61.

20 Ibid, 55.

21 Ibid, 63–4.

22 Crawford 1955, 123.

23 Ibid, 124.

24 Ibid, 126. *See also* Hauser 2008, 38–49 for Crawford and Wells.

25 Crawford 1955, 126.

26 Ibid, 129.

27 Masefield 2006, 94.

28 Ibid, 150; *see also* 100–2 and 110 for discussion of lynchets on the Somme battlefields.

29 Crawford 1957, 85.

30 *See* Barton 2008 for the role of panoramic photographers on the Western Front; Crawford can be found on pp 55–6.

31 Winterbotham, quoted in Crawford 1923a, 365.

32 Crawford 1955, 116–7.

33 Ibid, 119.

34 Brabazon 1956, 94.

35 Ibid, 95.

36 Ibid, 93.

37 Ibid, 94.

38 Malcolm Neynoe MacLeod (1882–1969) served as a surveyor in the Royal Engineers during the First World War, before becoming chief instructor (survey) at the School of Artillery, Larkhill. In 1923 he joined the Ordnance Survey. Later, he was to serve as Director-General of the OS from 1935 to 1943.

39 Both quotes are taken from MacLeod 1919, 382; *see also* TNA OS 1/11/1: 'Mapping from Air Photography, by Lieutenant Colonel M N MacLeod, 17 Mar 1919'.

40 MacLeod 1919; TNA OS 1/11/1: 'Mapping from Air Photography, by Lieutenant Colonel M N MacLeod, 17 Mar 1919'.

41 Brabazon 1956, 94–5. Moore-Brabazon's copy of the aerial photo interpretation book, still bound in its gaudy ribbon, is held by the RAF Museum, London (Brabazon Collection, AC71/3, Box 87).

42 This quote is taken from a typed note from Moore-Brabazon, pasted in the front of the album held by the RAF Museum, London (Brabazon Collection, AC71/3, Box 87).

43 *Notes on the Interpretation of Aeroplane Photographs* was 'prepared by the General Staff' (General Staff 1917). The manual went through several editions during the war and the Americans also produced a version, again based on the French original and using the same title as the British manual. Copies of the British version survive in various locations. The one I consulted was the revised edition of March 1917, held by the RAF Museum, London. Many other guides and manuals, official and unofficial, appeared during the war. Notable examples include *The Interpretation of Aeroplane Photographs in Mesopotamia*, printed in Baghdad in early 1918 (TNA AIR 10/1001) and Lieutenant E Pepin's *Treatise on the Study and Interpretation of Aerial Photography* of October 1916 (TNA AIR 20/6466).

44 Crawford 1955, 118. It has often been claimed that this phenomenon is peculiar to the stereoscope and is connected to the sequence in which the photographs are viewed. For

instance, John Bradford (1957, 62) explained that '[t]he prints must be examined in the order in which they were taken and in accordance with the line of flight, otherwise hills may sink into the ground as valleys, or the sea appear to hang in space'. Texts on air photo interpretation often lay out clear guidance on how to arrange, sequence and view photographs in order to obtain the 'correct' three-dimensional view. This emphasis on instruments and procedure rather overlooks the role of the observer. The phenomenon, sometimes described as 'reversible relief', was noted long before the advent of either the stereoscope or photography, hence occasional reference to it as the 'cameo-intaglio illusion'. It was experienced by users of a range of optical devices including microscopes and telescopes and, in one experiment, an empty tube. The cause is related primarily to the perceptions and expectations of the viewer – recognising the direction of the light source in the image can be a significant factor, as well as things like unfamiliarity with the image being viewed and/or its subject. Like the stereoscopic image itself, reversible relief is an illusion created entirely in the mind of the observer. *See* Hindle and Hindle 1959 for an account of 18th-century explorations of the phenomenon.

45 General Staff 1917, 5.

46 Ibid.

47 Ibid.

48 Ibid, 9.

49 Ibid, 10.

50 TNA AIR 1/834/204/5/240: 'Notes on Aerial Photography, 1 Nov 1914–4 Jan 1915, by Lieutenant I M Bonham-Carter, RFC'.

51 Blunden 2000, 33.

52 General Staff 1917, 10.

53 Brabazon 1956, 104.

54 Priestley 1949, 110. Priestley's reminiscence about the joys of the stereoscope was sparked by the rediscovery of some old stereo views during the Second World War. One decades-old scene of an idyllic Alpine landscape had particularly caught his eye: '…and the name of this delightful place was Berchtesgaden … To think they are all there, Hitler, Goering, Goebbels, Himmler, all the black brutes of the S.S. waiting to enter this scene at their appointed place along the time track!'

55 *See* Chasseaud 2009 and Collier 2002.

56 TNA AIR 1/506/16/3/45: This file includes 'Stereoscopic Photography for Aeroplanes', dated Dec 1915.

57 Brabazon 1956, 104.

58 TNA AIR 1/506/16/3/45: 'Stereoscopic Photography Dec 1915–Aug 1918'. Sadly, no anaglyphs – either prints or lantern slides – from the First World War have been located to date.

59 *See* Hamshaw Thomas 1920.

60 TNA AIR 1/724/91/1: 'Early Aviation Work 1907–1910: Reminiscences by J T C Moore-Brabazon', written *c* Oct/Nov 1918.

61 All statistics in this section are taken from a series of documents compiled by, or via, Moore-Brabazon and Laws: TNA AIR 1/724/91/2: 'Photography in the RAF'; TNA AIR 1/724/91/3: 'Statement Showing the Number of Photographic Prints Issued in 1915–1918'; TNA AIR 1/724/91/5: 'Personnel of the Photographic Section 1918'; and TNA AIR 1/724/91/10: 'Returns of Photographic Work Done since December 1917…'. The numbers of cameras and staff are clearly estimates.

62 Estimates vary from source to source, but for British Empire forces, the totals are around

900,000 killed and 2 million wounded. For the Allied Powers overall, the figures are around 5 million and 12.5 million respectively. As for the main European participants (Germany, Austria-Hungary, Turkey and Bulgaria) from the 'enemy', the totals are around 3.3 million and 8.3 million respectively.

63 Lewis 1936, 93.

64 Winterbotham 1919b, 16. Winterbotham's fascination with aerial survey during the war contrasts markedly with his subsequent resistance to its use by the Ordnance Survey in peacetime.

65 Winterbotham 1919a, 265.

66 Salmond, in Hamshaw Thomas 1920, 372.

67 Salmond, in Hamshaw Thomas 1920, 372.

68 The information before the quote in this paragraph is from MacLeod 1923, 413; the quote is taken from MacLeod 1919, 396.

69 Saunders 2007, 2.

70 For recent studies using First World War aerial photographs, *see* various papers in Stichelbaut *et al* 2009.

Chapter 5

1 A full discussion of the nature and causes of cropmarks, soilmarks and the like isn't possible here. For more detail, the reader is referred to any number of publications on aerial photography in archaeology, including Wilson 2000 and Riley 1987 and 1996.

2 Quoted in Fagan 1959, 279. Chandler (1998, 211) offers the following modern rendering: 'A curious phenomenon observed at Silchester is that in some parts of the land enclosed by the wall the corn appears to the eye to be of wonderful quality, but as it is about to reach maturity it rots.'

3 Quoted in Fagan 1959, 279, who is in turn quoting from Edmund Gibson's 1695 edition of Camden's *Britannia*. *Britannia* was first published in Latin in 1586, with enlarged editions subsequently appearing in 1587, 1590, 1594, 1600 and 1607. Its first publication in English was Philemon Holland's translated edition of 1610, although Gibson's 1695 edition is often held to be a far superior translation. Camden died in 1623, but this didn't prevent further editions appearing.

4 Quoted in Wilson 1996, 42, who is in turn quoting from Holland's 1610 English translation of *Britannia* (*see* note 3). St Augustine is traditionally believed to have landed in the vicinity of Richborough in AD 597.

5 Aubrey 1665–93, Vol I, 440–1. The 'two learned prelates' were the bishops of Salisbury and Chester.

6 Quoted in Fagan 1959, 279.

7 Quoted in Wilson 1996, 44. Wilson appears to have been the first to note Plot's discussion of these 'rings we find in the grass'.

8 Ibid, 45.

9 Ibid, 44. Wilson 1996 provides a full discussion of Plot's interpretations, as well as identifying archaeological cropmarks in the Thames Valley that closely resemble some of the phenomena described by Plot.

10 Quoted in Fagan 1959, 280.

11 The Stukeley quotes in this paragraph can be found in Piggott 1985, 52–3 and Wilson 1996, 42–3, among other sources.

12 For discussion of Stukeley's methods and the broader background to his work and ideas, *see* Ucko *et al* 1991 and Haycock 2002.

13 Wilson 1996, 42–3; Way 1849, 15.

14 Boon 1974, 22–4; *see also* Fagan 1959, 280–1.

15 John Kenyon (1784–1856) was a patron of the arts who published three volumes of poetry during his lifetime; he acquired a reputation 'as a wealthy dilettante with a genial disposition and generous purse' rather than as a poet. His death certificate claims he died of 'natural decay' (DNB). This poem has been noted by archaeologists before, for example Bradford 1957, 19.

16 Mary Russell Mitford (1787–1855), writer and playwright, is best remembered today for the country sketches in *Our Village*, the first volume of which was published in 1824, and for a 'malicious observation about [Jane] Austen' (DNB). Her poem about Silchester was apparently published in 1811 (Mitford, M R 1811 *Poems*, 2 edn. London: John Lane, The Bodley Head, 248–54). It included the observation that agricultural land was far more fertile within Silchester's walls than outside them (5 quarters of wheat per acre inside, but only 3½ outside).

17 Colt Hoare 1812–21, Vol II, 25.

18 Stone 1857, 99–100.

19 *The Times*, 12 Aug 1893, 10.

20 Haverfield 1899, 10–11. *See also* Freeman 2007, 474–5 for a brief account of Haverfield's involvement at Northfield Farm.

21 Haverfield 1899, 14.

22 *The Times*, 23 Sep 1893, 11.

23 Henry Joseph Moule (1824–1904) was an antiquary, watercolour artist and, from 1879 to his death, curator of Dorchester Museum.

24 Moule 1897, 169. I would like to thank Christopher Sparey-Green for bringing Moule's paper to my attention. The Old Sarum parchmarks are described and illustrated in the August 1835 issue of *The Gentleman's Magazine*.

25 Ibid.

26 Ibid, 170–1. It is possible that what Moule saw was something associated with the Roman aqueduct, which ran past Poundbury – parallel to the hillfort's eastern side – before turning west.

27 Ibid, 171. This barrow is still extant as a mound within the hillfort's south-west corner. Others have since been recorded as parchmarks.

28 *The Times*, 19 Aug 1924, 8.

29 *The Times*, 5 Dec 1918, 9 – 'Three specimens of the German brute'.

30 Crawford 1955, 26. Marlborough had been his father's school and the young Crawford spent the years 1900–4 reluctantly following in his footsteps. The school comprised 'a horde of six hundred savages' where 'bullying was rampant and savage … entirely pointless and almost impersonal, and it went entirely unchecked by the masters'.

31 Ibid, 142. The story of the escape is told by H G Durnford, one of Crawford's fellow prisoners, in his book *The Tunnellers of Holzminden* (1920) and in Barry Winchester's *Beyond The Tumult* (1971). Twenty-nine prisoners managed to get out through the tunnel, with 10 successfully reaching Britain or a neutral country.

32 Ibid, 148; Crawford 1921.

33 Bowden (2001, 32) suggests that when it came to archaeology, Close's interest was probably

greater than his knowledge.

34 Crawford 1955, 151.

35 Bowden 2001, 33–4.

36 Grimes 1980, v.

37 Crawford 1955, 154.

38 Ibid, 158.

39 It had passed initially to the Office of Works in 1870 and then to the Board of Agriculture in 1890. The last Royal Engineers didn't leave the Ordnance Survey's staff until 1983, by which time it had passed to the Department of the Environment.

40 Crawford 1955, 154.

41 Ibid, 166.

42 Ibid, 158.

43 Ibid.

44 Phillips 1980, 30; Seymour 1980, 239.

45 Crawford 1955, 63; *see also* Bowden 2001, 30–1.

46 Crawford 1912.

47 Crawford 1955, 101–2.

48 Crawford and Keiller 1928, 5.

49 Crawford 1955, 64; Bowden 2001, 30; DNB.

50 Williams-Freeman 1915.

51 Ibid, xx–xxi.

52 Crawford 1953, 45–6.

53 Blaker 1902, 202.

54 DNB (Williams-Freeman's entry was written by Crawford).

55 Crawford 1953, 46; *see also* Crawford and Keiller 1928, 5. At the time, the Honorary Secretary of the Committee on Ancient Earthworks and Fortified Enclosures, to give it its official title, was Albany F Major, OBE (1858–1925) and late of the War Office, who listed 'field archaeology' as his main recreation in *Who's Who*, but whose major publications revolved around Vikings and their sagas.

56 Crawford 1955, 46. '[S]tout Cortez' appears in Keats' 'On First Looking Into Chapman's Homer'.

57 Ibid, 168–9. Crawford was prone to making digs at the Society of Antiquaries later in his life, but it is not clear precisely when this disenchantment began. He was elected a Fellow on 2 June 1921 and admitted on 1 December 1921; for several years he was a regular contributor both at meetings and to the *Antiquaries Journal*, though by the late 1920s he was more focused on his own journal *Antiquity*. His most explicit public statement on the subject came in 1956, when he complained that 'during the growing years of archaeology between the wars the Society was completely out of touch and sympathy with all that was best in growth. It was dominated by a clique of narrow-minded medievalists and collectors who had neither the wits to comprehend anything outside their own special interests, nor to conduct any worthwhile researches within them … The contempt for prehistory shown, sometimes openly, at meetings was heartily reciprocated … It is a sign of the better and more scientific spirit of modern archaeology that the Prehistoric Society has not been troubled with the absurd quarrels that bedevilled the Society of Antiquaries, nor has it been made to look ridiculous by a bogus ritual display at its meetings' (Crawford 1956, 232). Crawford, along with Gordon Childe, resigned his Fellowship in 1949

following the Society's failure to elect Mortimer Wheeler as its president (Crawford 1955; Green 1981, 118; Hawkes 1982, 265–6).

58 Beazeley 1919, 330.

59 Crawford 1923a; Crawford 1923b; Crawford 1924.

60 Crawford 1923a, 358. Today, the origins of 'Celtic' fields are placed around a millennium earlier than Crawford's estimate, during the Early-to-Middle Bronze Age.

61 Ibid, 344.

62 Ibid.

63 Crawford 1957, 86.

64 Crawford 1924, 10. Unlike Beazeley's follow-up fieldwork in Mesopotamia, Crawford's is most unlikely to have involved plane-table survey, something he seems to have had little taste for, and which in any case would have been ill-suited to a largely plough-levelled landscape. In fact, although Crawford repeatedly stressed the need for fieldwork throughout his time at the Ordnance Survey, he never explained precisely what form it took. Field-checking seems more plausible than field survey. If we take him at his word – that his methods were the same as those used for mapping German trenches on the Western Front – then any form of measured ground survey seems doubtful.

65 Ibid.

66 Parker Pearson *et al* 2007, 627.

67 Aubrey 1665–93, Vol I, 80.

68 Burl and Mortimer 2005, 90, 92.

69 Stukeley 1740, 35.

70 Ibid.

71 Cleal *et al* 1995, 12–15.

72 TNA AM 71786/1 WORK 14/2463: Letter from Hawley to Charles Peers, Chief Inspector of Ancient Monuments, Office of Works, London, 15 Jun 1921.

73 TNA AM 71786/1 WORK 14/2463: Letter from Hawley to Charles Peers, Chief Inspector of Ancient Monuments, Office of Works, London, 7 Nov 1921.

74 TNA AM 71786/1 WORK 14/2463: Letter from Hawley to J P Bushe-Fox, Chief Inspector of Ancient Monuments, Office of Works, London, 1 Jul 1923.

75 15 June 1921 was, of course, the same day that Hawley wrote of his difficulties in trying to arrange for RAF photography of Stonehenge (*see* note 72). Crawford repeatedly refers to a July 1921 date for the first cropmark images of the Avenue, but he is clearly mistaken.

76 TNA AM 71786/1 WORK 14/2463: Letter from Hawley to Charles Peers, Chief Inspector of Ancient Monuments, Office of Works, London, 7 Nov 1921.

77 Crawford 1923b, 13.

78 Ibid.

79 Ibid.

80 Ibid.

81 Crawford 1923c, 16. Crawford's determination to 'vindicate' this new technique with a more traditional one underlines his apparent need to persuade the doubters, although he never stated who they were or the reason for their doubts. It may have been based on a mistaken belief that the mechanised vision of the camera was 'seeing' something completely invisible to the human eye. This would, of course, have had a particular resonance in the years immediately after the First World War.

82 Arthur D Passmore (*c* 1873–1958) was the son of a Swindon antique dealer. Passmore had taken over the family business, as well as developing a greater interest in archaeological fieldwork – for example, he assisted Crawford in his work on the Neolithic long barrows of the Cotswolds and later aided Major George W G Allen in identifying on the ground sites seen during aerial reconnaissance. The bulk of his collections, including some of the finds from the Avenue excavations, are in the Ashmolean Museum, Oxford.

83 Crawford 1923c, 16.

84 Ibid.

85 The visiting archaeologists included William Hawley (*Antiq J* **4**, 1924, 57–9).

86 Crawford 1923c, 16.

87 Ibid.

88 Ibid.

Chapter 6

1 TNA OS 1/11/1: Letter, Lieutenant Colonel F J Salmon MC RE, 3rd Field Survey Battalion to Charles Close, 29 Dec 1918.

2 TNA OS 1/11/1: Letter, Close to Salmon, 4 Jan 1919.

3 TNA OS 1/11/1: Letter, Close to Hearson, 6 Jan 1919.

4 Close's remarks on MacLeod's paper (1919, 397–8) were read out by Lieutenant Colonel G F A Whitlock RE on behalf of Close who was unable to be present.

5 Quote from Close's comments on Crawford's paper (1923a, 363) to the Royal Geographical Society on 'Air survey and archaeology'.

6 The main sources for the Air Survey Committee are War Office 1923, War Office 1935 and Collier 2006.

7 TNA OS 1/11/1: Letter to Close from Davidson, 12 Feb 1919. For archaeology and aerial photography within the Ordnance Survey between the wars, the main sources used here are Crawford 1955, Phillips 1959, Phillips 1980, Seymour 1980, MacDonald 1992 and Collier and Inkpen 2003.

8 TNA OS 1/11/1: Letter from Close to Davidson, 18 Feb 1919.

9 Prior to his appointment in 1922, Evan MacLean Jack had served as head of the Geographical Section, General Staff (GSGS). Instrumental in the establishment of the Air Survey Committee, he had also been its first chairman. He had spent almost the entire war in charge of the Topographical Section and in 1920 had written the *Report on Survey on the Western Front*.

10 TNA AIR 2/292: Extract dated 15 Mar 1926.

11 Winterbotham had been a Royal Engineer since 1897 and had served in the war as maps officer with the 3rd Army until 1917, when he joined GHQ. Prior to his move to the Ordnance Survey in 1929, he had been head of GSGS among other posts.

12 MacLeod had also been involved in survey during the war and published 'Mapping from air photographs' in the *Geographical Journal* in 1919, drawing on his wartime experiences. After, he had spells at the School of Artillery, the Ordnance Survey and as head of GSGS following Winterbotham.

13 TNA OS 1/11/1: Letter to Close from Davidson, 12 Feb 1919. The 'Independent Force', as it was generally known, had come into being on 6 June 1918 with a simple objective – to take the war into Germany itself, undertaking bombing raids aimed at industry, commerce and the German people themselves. Its origins lay in a combination of ideas about the potential of strategic

bombing and a desire for retaliation after the Gotha bombing raids on London in June and July 1917 (*see*, for example, Barker 2002, 476 and Liddle 1987, 179–84).

14 *Daily Chronicle*, 30 Jan 1925.

15 TNA AIR 2/1432: 'Restrictions on Air Photography – Policy' (Air Ministry file), extract dated 29 Jan 1925.

16 TNA AIR 2/1432: 'The Control of Air Photography: Minutes of a Conference held in the Air Ministry on 4 Feb 1925…'.

17 Ibid.

18 TNA AIR 2/1432: 'Restrictions on Air Photography – Policy' (Air Ministry file), extracts dated 3 Sep 1925, 11 Nov 1926 and 7 Jan 1927.

19 Ibid, extract dated 1931.

20 TNA AIR 2/1433: 'Restrictions on Air Photography – Policy' (extracts).

21 Ibid and TNA AIR 2/1434: 'Restrictions on Air Photography – Policy' (extracts).

22 TNA AIR 2/1434: 'Restrictions on Air Photography – Policy', extracts dated 6 Oct 1936 and 24 Jun 1937.

23 TNA AIR 2/3508: 'Control of Air Photography: Proposal to Licence Photographers' (Air Ministry file).

24 Ibid.

25 Keiller's interest in the Avebury region stemmed from Crawford's 1923 campaign to prevent the Marconi wireless company from erecting radio masts in the area. Marconi eventually abandoned the plan – not because of the protests about potential damage to archaeological sites, but because of concerns that the masts might prove a hazard to flying (Murray 1999, 23–5).

26 Crawford and Keiller 1928, v.

27 Murray 1999, 20.

28 Crawford 1955, 169.

29 Crawford and Keiller 1928, v.

30 *The Times*, 5 Dec 1924, 11.

31 The camera was described as a 'German Service Pattern, Type F.K. 1, unused and in excellent condition' (Crawford and Keiller 1928, vi).

32 Crawford and Keiller 1928, vi.

33 Ibid; Murray 1999, 28.

34 The first quote in the paragraph is from Crawford 1924, 10; the extract is from Crawford 1955, 171–2.

35 Murray 1999, 1.

36 Bowden 2001, 37. Murray is also incorrect in claiming that Crawford did not mention Keiller in his autobiography 'when referring to *Wessex from the Air*, or in any other context' (Murray 1999, 47). Crawford actually introduced the subject as follows: 'Best of all, my *Observer* article was read by Alexander Keiller, who wrote to me and suggested financing a special expedition to take archaeological air-photographs of Wessex from a hired aeroplane. That was to culminate in our joint publication of *Wessex from the Air* in 1928' (Crawford 1955, 169).

37 NMR 0000102: A copy of Keiller's ledger for May–Jul 1924.

38 *The Times*, 5 Dec 1924, 11; *see also Antiq J* 5, 1925, 218. The Society of Antiquaries was an

interesting choice of venue given his comments about his 1923 paper at the Royal Geographical Society (*see* p 133).

39 *The Times*, 5 Dec 1924, 11. The correspondent was presumably using or paraphrasing Crawford's own words when employing the palimpsest analogy (*see* pp 150–1).

40 *Antiq J* **5**, 1925, 218.

41 According to www.measuringworth.com, based on the retail price index, 50 shillings in 1928 equates to a little over £100 today.

42 *The Times*, 22 Jun 1928, 10.

43 Crawford 1923a, 353. *See also* Crawford 1924, 7, Bowden 2001, 42–3 and Johnson 2006, 57–8.

44 Bowden 2001, 43.

45 Crawford 1953, 51.

46 Crawford 1922a.

47 Crawford 1929b, 5.

48 War Office 1935, 155–6.

49 *See*, for example, Richmond 1932.

50 War Office 1935, 155–6. *See also* Margary 1965, plates XI and XII and Margary 1930. Aerofilms took verticals over the Weald from 4,000ft in early evening light, so that shadows cast by banks or in sunken tracks would be visible.

51 The best published source for Gilbert Insall's wartime service is his brother Algernon's book *Observer* (Insall 1970), while further details can be found in Pitts 2000.

52 Insall 1970, 102.

53 Ibid, 103.

54 TNA WO 161/96/24: The two quotes about Insall's operations are from Insall's post-escape interview.

55 A detailed account of Insall's successful escape can be found in Harrison and Cartwright 1940 (first published in 1930), chapter VI.

56 Insall 1929, 174.

57 Ibid. This cropmark enclosure – on a hill between Alton Priors and Woodborough, Wiltshire – was listed as 'Insall's Camp' by the archaeologist Leslie Grinsell on one of his own Ordnance Survey maps, though one suspects the inspiration, if not the actual source, of the name was Crawford. The enclosure has been photographed on a number of occasions since Insall's visit. It seems most likely to represent a tree enclosure ring of medieval or post-medieval date (NMR monument uid 221220).

58 Colt Hoare 1812–21, Vol I, 170, no 123.

59 Insall's letter to Crawford was published in *Antiquity* **1** no 1, Mar 1927, 99–100. The quoted text can be found on p 99.

60 *Antiquity* **1** no 1, Mar 1927, 100.

61 Cunnington 1929, 4. Maud Cunnington's interim account of the 1926 excavations was published in the first volume of *Antiquity* (Cunnington 1927).

62 Ibid, 3.

63 Pitts 2000, 34.

64 Insall 1929, 175.

65 Ibid.

66 Crawford discussed the site in the editorial section of the September 1929 issue of *Antiquity* (**3** no 11, 257–9). The quote can be found on p 257.

67 Clark's excavations were fully published as Clark 1936.

68 TNA AIR 2/528: 'Trophy Presented by Sir Phillip Sassoon for Competition Between RAF Squadrons in Air Photography'.

69 Ibid.

70 The short quote in the paragraph is from *Antiquity* **1** no 1, Mar 1927, 1 and the extract is from p 3.

71 Maitland 1927.

72 Crawford published and described the photographs in *Antiquity* **1** no 4, Dec 1927, 469–74. The quote can be found in Crawford's editorial in the same issue (p 388).

73 Extracts from the debate within the RAF and Air Ministry on the taking of aerial photographs for archaeological purposes can be found in TNA AIR 2/292 (entry dated 4 Mar 1926). *See also* Crawshaw 1998.

74 TNA AIR 2/292 (entry dated 15 Mar 1926).

75 Ibid (entry dated Apr 1925).

76 Crawford 1955, 311–12.

77 Much biographical detail for Allen can be found in the introduction and forewords to Allen 1984.

78 Morris 2004.

79 Allen 1984, 39.

80 Crawford 1938, 236. *See* Hauser 2008 for plenty of insights into Crawford's opinions on both government institutions and English hotels.

81 Allen 1984, 33.

82 From Riley's introduction to Allen 1984, 7.

83 Allen 1984, 87.

84 Ibid.

85 Ibid, 33.

86 Ibid, 40.

87 Ibid, 33.

88 During the 1930s, much gravel extraction in the region was still largely unmechanised, working at a pace that enabled archaeologists to respond should anything of interest emerge along with the gravel. Not until the 1960s did archaeologists fully grasp how much was likely to be lost as the pace of extraction quickened.

89 From Crawford's foreword to Allen 1984, 17.

90 Crawford 1955, 249.

91 After Allen's death, two drafts of the planned book were found among his papers. Crawford attempted to bring it to publication, but in 1946 handed the task over to J S P Bradford. It was finally brought to publication in 1984 by Derrick Riley and Derek Edwards as 'Discovery from the air' in volume 10 of the now-defunct journal *Aerial Archaeology* (Allen 1984). Despite its age, it remains an excellent short introduction to the subject.

92 Crawford 1955, 249.

93 Ibid. *Luftbild und Vorgeschichte* appeared as No 16 in the series *Luftbild und Luftbildmessung,*

published by Hansa Luftbild in 1938. It featured an introductory essay (in German) by Crawford, plus 63 vertical and oblique black-and-white aerial views of archaeological sites in Britain. Seventeen were credited to Major Allen; the bulk of the remainder were jointly credited to the Ordnance Survey and the RAF, although three photographs from the *Wessex from the Air* flights were also included. A smaller section on German aerial photography included 29 photographs, 3 of them anaglyphs – a pair of anaglyph glasses were included in the publication.

94 Phillips 1987, 65–6. Phillips recounted how, after Mahr's Presidential Address to the Society, assorted 'senior and influential members entertained him to dinner at the Imperial Hotel in Russell Square. All went well during the dinner and we adjourned for drinks and conversation … Mahr proved to be a heroic drinker, downing an incredible quantity of Drambuie liqueur whisky which we had provided at his request. The drink made him increasingly loquacious so that before long he abandoned discretion and the truth began to come out. He praised the Nazi system to the skies, gloried in Hitler's recent triumph and when someone mentioned Menghin, one of his former colleagues at Vienna, he vilified him as a Jew. We left the hotel in a state of shock. It was the last that we ever saw of Adolf Mahr.' This incident is not mentioned in Gerry Mullins' 'sympathetic, though not uncritical' biography of Mahr (2007).

95 The general background to the Little Woodbury excavations can be found in Crawford 1955, 252–3, Phillips 1987 and Evans 1989. Phillips noted the problems of appointing a German in late 1938 to undertake an excavation 'at a spot which entirely overlooked the city of Salisbury, the headquarters of Southern Command' (1987, 67). Phillips was convinced that they were under constant surveillance and blamed the disappearance of a bundle of plans on this.

96 Crawford and Keiller 1928, 80–1.

97 The two quotes in the para and the extract are from Crawford 1929a, 452. Crawford memorably described the photographs as 'the heralds of innumerable queer resurrections' (Crawford 1929a, 455).

98 Crawford 1929a, 452.

99 The Little Woodbury excavations were published in interim form in 1938 and more fully in 1940 and 1948 (Bersu 1938 and 1940; Brailsford and Jackson 1948).

100 The quotes in this paragraph are from Bersu 1938, 308.

101 Bersu used a 'greatly enlarged photographic print made from the original air-photograph' as a guide during the excavations (Crawford 1955, 271).

102 Bersu 1940, 63.

103 Ibid.

104 Ibid, 69

105 Ibid, 78.

106 *The Times*, 16 Aug 1924, 11. A reader's letter responding to this item suggested considering 'the Fen country, with its features of prehistoric British life, then of Roman rule, and all that ebbed and flowed up across from the Wash to around and about the Soke of Peterborough' (*The Times*, 19 Aug 1924, 8).

107 The two quotes are taken from Crawford 1929a, 455. General William Roy (1726–90) was a military surveyor and a pioneering authority on Roman Scotland. His *Military Antiquities of the Romans in North Britain*, published posthumously in 1793, contained detailed surveys of numerous Roman earthworks, most appearing in print for the first time and some no longer extant. Crawford (1953, 36) stated that '[m]odern field archaeology began with General Roy … who was the effective, if not the actual, founder of the Ordnance Survey'.

108 Piggott 1983, 32.

109 Murray 1999, 78. Crawford was, of course, commenting after the spectacular demise of the *Hindenburg*.

110 Crawford 1955, 214.

111 The quotes in this paragraph are from Crawford 1955, 215–6.

112 Crawford 1955, 269.

113 Ibid, 269–70. Similar failures to understand archaeology caused problems for Crawford's successors. Charles Phillips, who held the post after the Second World War, once told of how his intended print run for the *Map of Monastic Britain* was drastically reduced because of a belief that only Catholics would buy it (Phillips 1980, 35).

114 The 'fieldwork' was published as Crawford 1939. The quote is from p 290.

115 For summaries of work outside Britain at this time, *see*, for example, Deuel 1969 and papers in Bourgeois and Meganck 2005.

116 Crawford 1938, 237.

117 Ibid.

118 Richmond 1943.

119 Crawford 1929a, 455.

120 Allen 1938.

Chapter 7

1 Mead 1983, xi. Key sources for wartime air photo intelligence work are Babington Smith 1958 and Powys-Lybbe 1983. The 'official' history can be found in the 3 volumes prepared by F H Hinsley and colleagues: *British Intelligence in the Second World War*, published in 1979, 1981, 1984 and 1988 by HMSO. Spooner 2003 and Foster 2004 are good examples of the pilots' perspective. Useful general sources for air photo reconnaissance and air photo intelligence include Leaf 1997, Mead 1983, Nesbit 1997, Price 2003, Smallwood 1996, Staerck 1998 and Stanley 1998.

2 The quotes in this paragraph are taken from Anon 1941, 1–4. It is, of course, this publication that inspired the title of this book. However, this was not the only occasion on which the famous Belgian spy was called into service on behalf of aerial photography. For example, after the Second World War, Arthur Lundahl, at the time in charge of the US Naval Photographic Interpretation Center, wrote a paper entitled 'Consider the Mata Hari with the Glass Eye', in which he explained the potential of aerial photographic intelligence for the Cold War. It brought him to the attention of the CIA, who in 1953 made him head of their own Photographic Intelligence Division (Richelson 2002, 28–9).

3 Laws 1959, 36. *See also* Nesbit 1997, 63.

4 Powys-Lybbe 1983, 20.

5 Winterbotham 1969, 125–6.

6 Ibid, 126.

7 Ibid, 126. Sidney Cotton was born in 1894 in Goorganga, Australia; he died in East Grinstead, West Sussex, in 1969. Cotton's colourful life story was told in part by the man himself with the assistance of Ralph Barker in 1969 and more recently by Watson 2003.

8 *See* Watson 2003, chapter 5.

9 Ibid, 124–34.

10 Winterbotham 1969, 128–9. The story is also told in Babington Smith 1958, 20–1, and Watson 2003, 105–6, among others.

11 Spender did not stay with air photo interpretation but remained within military intelligence. By 1945 he was a squadron leader in the RAF. He was killed in a plane crash in Germany on 6 May 1945, two days before the war in Europe ended.

12 Balchin 1987, 172.

13 Babington Smith 1958, 52.

14 Saint-Exupéry 1995, 36. Antoine de Saint-Exupéry (1900–44) is perhaps best known as the author of the children's story *The Little Prince*, along with some remarkable accounts of his flying exploits in the 1920s and 1930s. His account of a single, pointless and near-suicidal reconnaissance mission over Arras was first published in 1942. He was killed while on a reconnaissance flight over southern France on 31 July 1944.

15 Watson 2003, especially 116–18 and 151–4.

16 Babington Smith 1958, 63–4; Watson 2003, 198–201.

17 Babington Smith 1958, 84.

18 Ibid, 233–4.

19 Powys-Lybbe 1983, 49.

20 The quote in the preceding paragraph is from Bogarde 2006, 60 and this extract is from p 62. Dirk Bogarde's wartime exploits are covered somewhat briefly in his second volume of memoirs, *Snakes and Ladders*, first published in 1978.

21 Babington Smith 1958, 105.

22 Powys-Lybbe 1983, 50–2.

23 Ibid, 132.

24 The story of the raid and its aftermath is told by Babington Smith 1958, 88–95 and Powys-Lybbe 1983, 25–9. The account here also draws on reports published in *The Times* on 20 Mar 1940 and subsequent days.

25 Babington Smith 1958, 93.

26 Powys-Lybbe 1983, 26.

27 Ibid, 26–7.

28 Lindemann's role is described in Fort 2004, chapter 12. Lindemann's report was actually researched and compiled by his secretary, David Bensusan Butt (Fort 2004, 238).

29 Fort 2004, 239–40. The quote comes from a reply by Sir Charles Portal, Chief of Air Staff, to a minute from Churchill about the Butt report.

30 The story of wartime decoys is told in detail in Dobinson 2000, with the Medmenham role described by Babington Smith 1958, 109–10 and Powys-Lybbe 1983, 86–9.

31 Powys-Lybbe 1983, 89.

32 Dobinson 2000, 69.

33 Myerscough-Walker 1939, 489–90.

34 Powys-Lybbe 1983, 79.

35 Ibid, 82.

36 Ibid, 91. *See also* Newark 2007, 74–9.

37 Glyn Daniel (1914–86) held a research fellowship at St John's, Cambridge, prior to the war and returned to it on his return to Britain from Delhi. Subsequently a lecturer in the department of archaeology, he became Disney Professor of Archaeology and head of department in 1974 until his retirement in 1981. The *Target for Tonight* anecdote comes from Daniel 1986a, 135. Incidentally, the line actually delivered by Daniel in the film is 'Certainly is a peach of a target, isn't it sir.'

38 Daniel 1986a, 107. Daniel wrote extensively about his wartime experiences in his autobiography, with a chapter devoted to his Wembley and Medmenham days and another to his spell in India.

39 Ibid, 132.

40 Ibid, 135.

41 Piggott 1983, 33.

42 Ibid, 33. Piggott's *William Stukeley: An Eighteenth Century Antiquary* was published in 1950 (revised edn 1985).

43 Daniel 1986a, 137.

44 Ibid, 163. In her biography of Mortimer Wheeler, Jacquetta Hawkes published a slightly different version of this story, although curiously her main source also appears to have been Glyn Daniel (Hawkes 1982, 222–3, 233). The title for this chapter is, of course, based on Daniel's account of this incident. Referring to Wheeler's reaction on hearing of Daniel's election to the Disney Chair of Archaeology at Cambridge in 1974, Daniel (1986a, 410) wrote: 'I think he was jealous of the easy archaeological and general life I had had. No Passchendaele, an easy Second World War of 'women's work', no grinding away at great excavations, no slaving away at hideous excavational reports, no museum drudgery. It all seemed unfairly easy, an early College Fellowship and a soft don's life in Cambridge.'

45 Piggott 1983, 34. In 1946 Piggott succeeded Gordon Childe as Abercromby Professor of Archaeology at Edinburgh University, remaining there until 1977.

46 Babington Smith 1958, 74.

47 Ibid, 66.

48 Ibid, 66.

49 Quoted in Smith 2005.

50 Sarah Oliver, née Churchill (1914–82), actress. Her presence on the Medmenham staff appears to elicit little comment beyond the fact of her parentage, despite Churchill and Lindemann's well-known concerns with intelligence and Bomber Command.

51 Information and quote from Christine Halsall, who has kindly provided much useful detail on the archaeologists at Medmenham.

52 Daniel 1969, 1.

53 Phillips 1987, 82.

54 Ibid.

55 Daniel 1986b, 53–4.

56 Fagan 2001, 112, quoting Claire Wilson, who had been on the staff at Medmenham.

57 Grinsell 1989, 14.

58 Ibid, 18–19. Grinsell's spell in Egypt led to *Egyptian Pyramids* (1947) and the more wide-ranging *Barrow, Pyramid and Tomb* (1975), among others.

59 Obituary, *The Independent*, 10 Feb 2001.

60 *See*, for example, Holleyman 1935.

61 Information from Christine Halsall and *The Times* obituary, 10 Nov 2004.

62 TNA AIR 2/5659: 'RAF Air Photograph Organisation – Civilian Requirements', 14.11.1944.

63 TNA AIR 2/5659, 'Provision of Air Photography for Civilian Purposes'.

64 Ibid.

65 Ibid, 31.8.44.

66 Ibid, 10.9.45.

67 TNA AIR 20/8064: 'Possible Use of Air Photography in the Post War Years', 20.3.45.

68 Richmond 1943, 46.

69 St Joseph 1945, 57–8.

70 The first quote in this paragraph is from Steer 1947, 50; the other two quotes are found on p 51. Steer had joined the staff of the Royal Commission on the Ancient and Historical Monuments of Scotland (RCAHMS) in 1938, returning to them in 1946 and becoming Secretary in 1957, a post he held until his retirement in 1978.

71 Ibid, 51.

72 Ibid, 52.

73 Ibid, 53.

74 Ibid, 52.

75 Ibid, 53.

76 Daniel 1986a, 246. Despite Daniel's views, and other similar opinions expressed by those who have looked at the photographs and the landscape, Maltwood's zodiac continues to live on in a growing number of books, articles and, inevitably, websites.

77 Priestley 1940, 29–30.

Chapter 8

1 Pickering 1983, 1.

2 Riley 1990, 35.

3 Ibid, 36.

4 Ibid, 38–9.

5 Riley's wartime articles included two on cropmarks in the Thames Valley (Riley 1942 and 1943–4) and two on Fenland sites (Riley 1945 and 1946). Post-retirement and based at Sheffield University, his publications included studies of cropmarks in Yorkshire (Riley 1976) and Yorkshire and Nottinghamshire (Riley 1980), as well as more general works (for example Riley 1982 and 1987). A bibliography can be found in Kennedy 1989. Riley died in August 1993.

6 Riley 1990, 40–1.

7 St Joseph 1945, 59.

8 TNA AIR 2/5967: 'RAF Air Photography Development Unit – Conferences and Reports'.

9 Palmer 1994, 29.

10 Ibid.

11 Hall 1997 and Harold Wingham *pers comm*.

12 Baker 1992, 11, 15.

13 Ibid, 15–19.

14 Barley 1956, 7. The quote earlier in the paragraph is from p 2.

15 RCHME 1960. The quote 'a background of destruction' is from Hampton 1989, 17. The striking image used for the cover of *A Matter of Time* was one of a sequence of images taken by Derrick Riley one day in the late summer of 1943. Fig 8.2 belongs to the same sequence. These ring ditches at Standlake were among the group of cropmarks investigated by Stephen Stone in 1857 (*see* pp 119–20). According to Riley, 'This site was under the circuit at Stanton Harcourt, when I

was then an instructor, flying over the gravel pit every day & lamenting the destruction. Aided by my wife (was just married) I did some salvage work … We cleaned up the post holes ready for photography & I managed to get some shots with my Leica, hand-held verticals from the camera hatch in the floor at the back of the Oxford aircraft at 800ft. Probably a long-suffering pupil had to fly the aircraft' (letter, Derrick Riley to Bob Bewley, 14 Nov 1992). The 'salvage work' was published in Riley 1946–7.

16 RCHME 1960; Hampton 1989, 17.

17 Featherstone 1997, 9–10; *see also* Hampton 1989, 18–19.

18 Hampton 1989, 19.

19 For the Roman Fens, *see* Phillips 1970. For the Thames Valley, *see* Benson and Miles 1974, Gates 1975 and Leech 1977.

20 Palmer 1984.

21 Ibid, vii.

22 Stoertz 1997.

23 Details of individual NMP projects can be found at www.english-heritage.org.uk/aerialsurvey.

24 *See*, for example, Newsome and Hegarty 2007.

25 In December 2010, the Department for Environment, Food and Rural Affairs (DEFRA) – the UK government department responsible for administering the ALSF – announced that although the government continues to collect the levy from the aggregates industry, it would no longer use the money to fund projects, including archaeology, that aimed to reduce the impact of the extraction industries. The statement can be seen on the archived version of the old DEFRA website at http://archive.defra.gov.uk/environment/quality/land/aggregates/index.htm, last accessed 26 Apr 2011.

26 For Mount Pleasant, *see* Barber 2004 and Barber 2011. For West Kennet, *see* Whittle 1997 and Barber *et al* 2003. *See also* www.francesca-radcliffe.com for more information about her aerial photography.

27 The research programme undertaken by English Heritage and the North York Moors National Park began in 1998, the first report on the aerial photographic research being published four years later (Stone 2002; *see also* Stone 2003 and Stone and Clowes 2004).

28 Stone 2003.

29 *See* www.english-heritage.org.uk/aerialsurvey.

30 *Brit Archaeol* **93**, Mar/Apr 2007, 7.

31 The Mesolithic postholes at Stonehenge are discussed in Cleal *et al* 1995, chapter 4.

32 Beresford 1971, 74.

33 Crawford 1925, 432–3.

34 The first quote is from Beresford 1954, 28; the second is from Beresford 1971, 74.

35 Fox 1959, 19.

36 Ibid, 33.

37 Ibid, 88.

38 Ibid, 57–8.

39 Webster and Hobley 1964.

40 Ibid, 2.

41 For lidar and archaeology, *see* Crutchley and Crow 2010. Other sources include, for example, Bewley *et al* 2005, Devereux *et al* 2005 and Crutchley 2006. As with many scientific techniques

adapted for archaeological use, airborne lidar has military origins. In the late 1960s, the US Navy's Office of Naval Research experimented with using airborne lasers as a means of detecting underwater anomalies, in particular submerged submarines. Lidar itself has a much longer history – the acronym, which stands for light detection and ranging, was first coined in 1953, several years before the first laser. Experiments in using beams of light to measure distance (for example, to calculate the height of the base of clouds) were occurring before the Second World War (*see*, for example, Wandinger 2005).

42 Newton Kyme is discussed in Holden *et al* 2002.

43 Bewley *et al* 2005.

44 Crutchley 2006 discusses the use of lidar in the Witham Valley.

45 Ibid. A more detailed assessment of the potential and limitations of lidar can be found in Crutchly and Crow 2010.

46 *See*, for example, Devereux *et al* 2005.

47 'The data deluge'. *The Economist*, 25 Feb 2010 (accessed on www.economist.com/opinion displaystory.cfm?story_id=15579717).

48 Crawford 1923a, 360.

49 Ibid, 360. Lawrence John Lumley Dundes, Earl of Ronaldshay, was the president of the Royal Geographical Society at the time (DNB).

50 Collier 2002, 164.

51 Crawford 1923a, 365.

52 Ibid, 360.

53 Ibid, 361.

54 Crawford 1922b; Crawford 1921, 190.

55 Crawford 1921, 46.

56 *See* Stout 2008 and Hauser 2008, 73.

57 Others discerned connections between the aerial view and contemporary art movements, particularly Cubism. For example, Gertrude Stein (1984, 49–50) wrote: 'When I was in America I for the first time travelled pretty much all the time in an airplane and when I looked at the earth I saw all the lines of cubism made at a time when not any painter had ever gone up in an airplane.' Meanwhile, Ernest Hemingway said of a flight from Paris shortly after the First World War: 'The ground began to flatten out beneath us. It looked cut into brown squares, yellow squares, green squares, and big flat blotches of green where there was a forest. I began to understand cubist painting' (Lynn 1987, 179).

58 Hotine 1930, 160.

59 Ibid.

60 Stepney 2005; Hauser 2007. For further discussion of this and other issues surrounding the adoption of aerial photography by archaeology, *see* Wickstead and Barber forthcoming and Barber and Wickstead 2010.

61 *See* Field *et al* 2010 for a summary of some of the discoveries from recent survey work at Stonehenge.

Beresford, M W 1954 *The Lost Villages of England*. Oxford: Lutterworth Press

Beresford, M W 1971 'A review of historical research (to 1968)', *in* Beresford, M W and Hurst, J G (eds) *Deserted Medieval Villages*. Oxford: Lutterworth Press, 3–75

Bersu, G 1938 'Excavations at Woodbury, near Salisbury, Wiltshire (1938)'. *Proc Prehist Soc* **4**, 308–13

Bersu, G 1940 'Excavations at Little Woodbury, Wiltshire'. *Proc Prehist Soc* **6**, 30–111

Bewley, R H, Crutchley, S P and Shell, C A 2005 'New light on an ancient landscape: Lidar survey in the Stonehenge World Heritage Site'. *Antiquity* **79** no 305, Sep 2005, 636–47

Blaker, R 1902 'Ancient cultivations'. *Sussex Archaeol Collect* **45**, 198–203

Blunden, E 2000 *Undertones of War*. London: Penguin

Bogarde, D 2006 *Snakes & Ladders*. London: Phoenix

Bold, J, Hinchcliffe, T and Forrester, S 2009 *Discovering London's Buildings with Twelve Walks*. London: Frances Lincoln

Boon, G C 1974 *Silchester: The Roman Town of Calleva*, rev edn. London: David & Charles

Bourgeois, J and Meganck, M (eds) 2005 *Aerial Photography and Archaeology 2003: A century of information. Papers presented during the conference held at the Ghent University, December 10th–12th, 2003* (Archaeological Reports Ghent University No 4). Ghent: Academia Press

Bowden, M 2001 'Mapping the Past: O.G.S Crawford and the development of landscape studies'. *Landscapes* **2** no 2, 29–45

Bowman, M 1999 *Mosquito Photo-Reconnaissance Units of World War II*. Oxford: Osprey Books

Brabazon, J T C (Lord Brabazon of Tara) 1956 *The Brabazon Story*. London: William Heinemann Ltd

Bradford, J 1957 *Ancient Landscapes. Studies in field archaeology*. London: G Bell and Sons

Brailsford, J and Jackson, J W 1948 'Excavations at Little Woodbury, Wiltshire (1938–39)'. *Proc Prehist Soc* **14**, 1–23

Brewer, G 1946 *Fifty Years of Flying*. London: Air League of the British Empire

Brewer, H W 1884 'London in 1584 and 1884'. *The Graphic*, 31 May 1884, 530

Brophy, K and Cowley, D (eds) 2005 *From the Air: Understanding aerial archaeology*. Stroud: Tempus

Burl, A and Mortimer, N (eds) 2005 *Stukeley's 'Stonehenge'. An unpublished manuscript 1721–1724*. London: Yale University Press

Capper, J C 1907 'Photographs of Stonehenge as seen from a war balloon'. *Archaeologia* **60**, 571

Castro, T 2009 'Cinema's mapping impulse: Questioning visual culture'. *The Cartographic J* **46** no 1, 9–15

Ceraudo, G 2005 '105 years of archaeological aerial photography in Italy (1899–2004), *in* Bourgeois, J and Meganck, M (eds) 2005, 73–86

Chandler, J 1998 *John Leland's Itinerary: Travels in Tudor England*. Stroud: Sutton Publishing Ltd

Chasseaud, P 1999 *Artillery's Astrologers: A history of British survey and mapping on the Western Front 1914–18*. Lewes: Mapbooks

Chasseaud, P 2009 'Imaging Golgotha: Photogrammetry on the Western Front 1914–1918', *in* Stichelbaut, B, Bourgeois, J, Saunders, N and Chielens, P (eds) *Images of Conflict: Military aerial photography and archaeology*. Newcastle upon Tyne: Cambridge Scholars, 87–119

Chippindale, C 1994 *Stonehenge Complete*, 4 edn. London: Thames & Hudson

Clark, G 1936 'The timber monument at Arminghall and its affinities'. *Proc Prehist Soc* **2**, 1–51

Clarke, N J 1995 *Adolf Hitler's Holiday Snaps: German aerial reconnaissance photography of Southern England 1939–1942*. Lyme Regis: Nigel J Clarke Publications

Cleal, R M J, Walker, K E and Montague, R 1995 *Stonehenge in its Landscape. Twentieth-century excavations* (Engl Heritage Archaeol Rep 10). London: English Heritage

Cole, J J nd *The People's Stonehenge* (privately published)

Collier, P 2002 'The impact on topographic mapping of developments in land and air survey: 1900–1939'. *Cartography and Geographic Information Science* **29** no 3, 155–174

Collier, P 2006 'The work of the British Government's Air Survey Committee and its impact on mapping in the Second World War'. *The Photogrammetric Record* **21**, 100–9

Collier, P and Inkpen, R J 2003 'Photogrammetry in the Ordnance Survey from Close to MacLeod'. *The Photogrammetric Record* **18**, 224–43

Colt Hoare, R 1812–21 *The Ancient History of Wiltshire*, 2 vols (facsim edn E P Publishing with Wiltshire County Library 1975)

Coxwell, H T 1889 *My Life and Balloon Experiences, 2nd Series*. London: W H Allen & Co

Crary, J 2002 'Géricault, the panorama, and sites of reality in the early nineteenth century'. *Grey Room* no 9 (Fall 2002), 5–25

Crawford, O G S 1912 'The distribution of Early Bronze Age settlements in Britain'. *Geogr J* **40** no 2, 184–203 and **40** no 3, 304–17

Crawford, O G S 1921 *Man and His Past*. London: Oxford University Press

Crawford, O G S 1922a 'A prehistoric invasion of England'. *Antiq J* **2**, 27–35

Crawford, O G S 1922b 'Archaeology and the Ordnance Survey'. *Geogr J* **59** no 4, 245–58

Crawford, O G S 1923a 'Air survey and archaeology'. *Geogr J* **61** no 5, 342–66

Crawford, O G S 1923b 'Stonehenge from the air'. *Observer*, 22 Jul 1923, 13

Crawford, O G S 1923c 'The Stonehenge Avenue: Missing branch found; air photography vindicated; the excavation test'. *Observer*, 23 Sep 1923, 16

Crawford, O G S 1924 *Air Survey and Archaeology* (Ordnance Survey Professional Papers, New Series No 7). London: HMSO

Crawford, O G S 1925 'Air photograph of Gainstrop, Lincs'. *Antiq J* **5**, 432–3

Crawford, O G S 1929a 'Woodbury. Two marvellous air-photographs'. *Antiquity* **3** no 12, Dec 1929, 452–5

Crawford, O G S 1929b *Air Photography for Archaeologists* (Ordnance Survey Professional Papers, New Series No 12). London: HMSO

Crawford, O G S 1938 'Air photography, past and future. Presidential address for 1938'. *Proc Prehist Soc* **4**, 233–8

Crawford, O G S 1939 'Air reconnaissance of Roman Scotland'. *Antiquity* **13** no 51, Sep 1939, 280–92

Crawford, O G S 1953 *Archaeology in the Field*. London: Dent & Sons

Crawford, O G S 1955 *Said and Done: The autobiography of an archaeologist*. London: Weidenfeld and Nicolson

Crawford, O G S 1956 'Review of Joan Evans, *A History of the Society of Antiquaries*'. *Antiquity* **30** no 120, Dec 1956, 230–2

Crawford, O G S 1957 'Archaeology from the air', *in* Wheeler, M (ed) *A Book Of Archaeology: Seventeen stories of discovery*. London: Cassell & Co, 83–9

Crawford, O G S and Keiller, A 1928 *Wessex from the Air*. Oxford: Clarendon Press

Crawshaw, A 1998 'Plus ça change'. *AARGnews* **17**, Sep 1998, 38.

Crutchley, S 2006 'Light Detection and Ranging (lidar) in the Witham Valley, Lincolnshire: An assessment of new remote sensing techniques'. *Archaeol Prospection* **13**, 251–7

Crutchley, S and Crow, P 2010 *The Light Fantastic: Using airborne lidar in archaeological survey*. Swindon: English Heritage

Cunnington, M 1927 'Prehistoric timber circles'. *Antiquity* **1** no 1, Mar 1927, 92–5

Cunnington, M 1929 *Woodhenge*. Devizes: George Simpson

Daniel, G 1952 *A Hundred Years of Archaeology*. London: Duckworth

Daniel, G 1969 'Editorial'. *Antiquity* **43** no 169, Mar 1969, 1–6

Daniel, G 1986a *Some Small Harvest. The memoirs of Glyn Daniel*. London: Thames & Hudson

Daniel, G 1986b 'C W Phillips 1901–1985'. *Antiquity* **60** no 228, Mar 1986, 53–4

Deuel, L 1969 *Flights Into Yesterday*. London: MacDonald

Devereux, B J, Amable, G S, Crow, P and Cliff, A D 2005 'The potential of airborne lidar for detection of archaeological features under woodland canopies'. *Antiquity* **79** no 305, Sep 2005, 648–60

Dobinson, C 2000 *Fields of Deception. Britain's bombing decoys of World War II*. London: Methuen

Dobinson, C forthcoming *Building for Air Power: Britain's military airfields, 1905–1945*. Swindon: English Heritage

Doty, R M 1983 'Aloft with Balloon and Camera', *in* Martin, R (ed) *The View From Above: 125 Years of Aerial Photography*. London: The Photographers' Gallery, 9–13

Eddy, W A 1897 'Photographing from kites'. *The Century: A popular quarterly* **54** issue 1, May 1897, 86–91

Eden, J A 1976 'Some experience of air survey in England between the two World Wars'. *The Photogrammetric Record* **8**, 631–45

Elliott, C R 1980a 'Luftwaffe PR in World War II'. *Air Pictorial* **42** no 11, 436–40

Elliott, C R 1980b 'Luftwaffe PR in World War II'. *Air Pictorial* **42** no 12, 478–81

Elsdale, H 1883a 'Balloon photography from small balloons, and its applications in war and peace, memorandum 1'. *Royal Engineer Committee Extracts for 1883*, appendix no 1, 18 Oct 1882

Elsdale, H 1883b 'Balloon photography from small balloons, and its applications in war and peace, memorandum 2'. *Royal Engineer Committee Extracts for 1883*, appendix no 1, 26 Jul 1883

Elsdale, H 1883c 'Balloon photography from small balloons, and its applications in war and peace, memorandum 3'. *Royal Engineer Committee Extracts for 1883*, appendix no 1, 9 Aug 1883

Evans, C 1989 'Archaeology and modern times: Bersu's Woodbury 1938 & 1939'. *Antiquity* **63** no 240, Sep 1989, 436–50

Evans, C M 2002 *The War of the Aeronauts. A history of ballooning during the Civil War*. Mechanicsburg: Stackpole Books

Fagan, B M 1959 'Cropmarks in antiquity'. *Antiquity* **33** no 132, Dec 1959, 279–81

Fagan, B M 2001 *Grahame Clark: An intellectual life of an archaeologist*. Oxford: Westview Press

Featherstone, R 1997 'Thirty years in the air: The thirtieth anniversary of the first aerial reconnaissance by RCHME'. *AARGnews* **14**, Mar 1997, 9–10

Field, D, Pearson, T, Barber, M and Payne, A 2010 'Introducing 'Stonehedge' (and other curious earthworks)'. *Brit Archaeol* **111**, Mar/Apr 2010, 32–5

Fielding, A G 1990 'A Kodak in the clouds'. *History of Photography* **14** no 3, Jul–Sep 1990, 217–30

Fort, A 2004 *Prof: The life and times of Frederick Lindemann*. London: Pimlico

Foster, R H 2004 *Focus on Europe. A photo-reconnaissance Mosquito pilot at war, 1943–45*. Ramsbury: Crowood Press

Fox, C 1959 *The Personality of Britain: Its influence on inhabitant and invader in prehistoric and early historic times*, 4 edn. Cardiff: National Museum of Wales

Freeman, P W M 2007 *The Best Training-Ground for Archaeologists: Francis Haverfield and the invention of Romano-British archaeology*. Oxford: Oxbow Books

Gates, T 1975 *The Middle Thames Valley: An archaeological survey of the river gravels* (Berkshire Archaeological Committee Publication No 1). Reading: Berkshire Archaeological Committee

General Staff 1917 *Notes on the Interpretation of Aeroplane Photographs*, rev edn (Mar 1917)

Going, C 2002 'Spoils of war – air photography in captivity'. *GI News* **5** no 2, Apr/May 2002, 28–34

Green, M 1981 *Prehistorian. A biography of V Gordon Childe*. Bradford-on-Avon: Moonraker Press

Grimes, W F 1980 'Foreword', *in* Phillips 1980, v–vii

Grinsell, L V 1989 *An Archaeological Autobiography*. Gloucester: Alan Sutton

Grover, G E 1863a 'On the uses of balloons in military operations'. *Royal Engineers Professional Papers* **XII**, 71–86

Grover, G E 1863b 'On reconnoitring balloons'. *Royal Engineers Professional Papers* **XII**, 87–93

Guy, P L O 1932 'Balloon photography and archaeological excavation'. *Antiquity* **6** no 22, Jun 1932, 148–55

Hall, G 1997 'Harold Wingham: Pioneer aerial photographer'. *AARGnews* **15**, Sep 1997, 9–11

Hampton, J N 1989 'The Air Photography Unit of the Royal Commission on the Historical Monuments of England 1965–1985', *in* Kennedy, D (ed) 1989, 13–28

Hamshaw Thomas, H 1920 'Geographical reconnaissance by aeroplane photography, with special reference to the work done on the Palestine front'. *Geogr J* **55** no 5, 349–76

Harrison, M C C and Cartwright, H A 1940 *Within Four Walls*. Harmondsworth: Penguin

Hauser, K 2007 *Shadow Sites: Photography, archaeology and the British landscape 1927–1955*. Oxford: Oxford University Press

Hauser, K 2008 *Bloody Old Britain. O G S Crawford and the archaeology of modern life*. London: Granta Books

Haverfield, F 1899 'Account of some Romano-British remains in the Upper Thames Valley'. *Proc Soc Antiq London* 2 ser, **18** (1899–1901), 10–16

Hawkes, J 1982 *Mortimer Wheeler: Adventurer in archaeology*. London: Weidenfeld & Nicolson

Haycock, D B 2002 *William Stukeley: Science, religion and archaeology in eighteenth-century England*. Woodbridge: The Boydell Press

Henderson, D 1914 *The Art of Reconnaissance*, 3 edn. London: John Murray

Herbert, S and McKernan L (eds) 1996 *Who's Who of Victorian Cinema: A worldwide survey*. London: British Film Institute

Hindle, B and Hindle, H M 1959 'David Rittenhouse and the illusion of reversible relief'. *Isis* **50** no 2, Jun 1959, 135–40

Hinsley, F H *et al* 1979–88 *British Intelligence in the Second World War: Its influence on strategy and operations* (Vol 1: 1979, Vol 2: 1981, Vol 3, pts 1 and 2: 1984 and 1988). London: HMSO

Holden, N, Horne, P and Bewley, R 2002 'High-resolution digital airborne mapping and archaeology, *in* Bewley, R H and Raczkowski, W (eds) *Aerial Archaeology: Developing future practice*. Amsterdam: IOS Press, 166–72

Holleyman, G A 1935 'The Celtic field-system in south Britain: A survey of the Brighton District'. *Antiquity* **9** no 36, Dec 1935, 443–54

Holmes, O W 1859 'The stereoscope and the stereograph'. *Atlantic Monthly* **3** no 20, Jun 1859, 738–48

Holmes, O W 1863 'Days of the sunbeam'. *Atlantic Monthly* **12** no 69, Jul 1863, 1–15

Hotine, M 1930 'The application of stereoscopic photography to mapping'. *Geogr J* **75** no 2, 144–66

Insall, A J 1970 *Observer: Memoirs of the RFC 1915–1918*. London: William Kimber

Insall, G S M 1929 'The aeroplane in archaeology'. *Journal of the Royal Air Force College* **9** no 2, 174–5

Jack, E M 1920 *Report on Survey on the Western Front*. London: War Office

Jackson-Stops, G 1991 *An English Arcadia 1600–1990*. Washington, DC: American Institute of Architects Press

Jenkins, G 2000 *'Colonel' Cody and the Flying Cathedral*. London: Touchstone

Johnson, M 2006 *Ideas of Landscape: An introduction*. Oxford: Blackwell

Kennedy, D (ed) 1989 *Into the Sun: Essays in air photography in archaeology in honour of Derrick Riley*. Sheffield: John R Collis

Knight, C 1895 'War ballooning'. *Strand Magazine* **10**, Jul–Dec 1895, 309–12

Lane-Poole, S 1919 *Watson Pasha: A record of the life-work of Sir Charles Moore Watson, KCMG, CB, MA, Colonel in the Royal Engineers*. London: John Murray

Laws, F C V 1959 'Looking back'. *The Photogrammetric Record* **3**, 24–41

Leaf, E 1997 *Above All Unseen: The Royal Air Force's photographic reconnaissance units 1939–1945*. Sparkford: Patrick Stephens

Leech, R H 1977 *The Upper Thames Valley in Gloucestershire and Wiltshire: An archaeological survey of the river gravels* (Committee for Rescue Archaeology in Avon, Gloucestershire and Somerset, Survey No 4). Bristol: CRAAGS

Leith, I 2005 *Delamotte's Crystal Palace: A Victorian pleasure dome revealed*. Swindon: English Heritage

Lewis, C 1936 *Sagittarius Rising*. London: Peter Davies

Liddle, P H 1987 *The Airman's War 1914–18*. Poole: Blandford Press

Lynn, K S 1987 *Hemingway*. New York: Simon & Schuster

MacDonald, A S 1992 'Air photography at the Ordnance Survey from 1919 to 1991'. *The Photogrammetric Record* **14**, 249–60

Mackersey, I 2004 *The Wright Brothers. The remarkable story of the aviation pioneers who changed the world*. London: Time Warner

MacLeod, M N 1919 'Mapping from air photographs'. *Geogr J* **53** no 6, 382–403

MacLeod, M N 1923 'The adjustment of air photographs to surveyed points'. *Geogr J* **61**, 413–19

Maitland, Flight Lieutenant, RAF 1927 'The "Works of the Old Men" in Arabia'. *Antiquity* **1** no 2, Jun 1927, 197–203

Margary, I D 1930 'Roman roads in Ashdown Forest'. *Sussex Notes & Queries* **III** no 1, Feb 1930, 1–5

Margary, I D 1965 *Roman Ways in the Weald*. London: Phoenix House

Masefield, J 2006 *The Old Front Line*. Barnsley: Pen & Sword Military

Mason, W H 1839 *Goodwood: Its house, park and grounds... .* London: Smith, Elder and Co Cornhill

McMahon, A 2002 *Alice Guy Blaché: Lost visionary of the cinema*. London: Continuum International Publishing Group Ltd

Mead, P 1983 *The Eye in the Air: History of air observation and reconnaissance for the army 1785–1945*. London: HMSO

Mills, J and Palmer, R (eds) 2007 *Populating Clay Landscapes*. Stroud: Tempus

Morris, A 1970 *The Balloonatics*. London: Jarrolds

Morris, R 2004 'Flight to the Past'. *Oxford Today* **16** no 2 (consulted online at http://www.oxfordtoday.ox.ac.uk/2003-04/v16n2/04.shtml)

Moule, H J 1897 'The assistance of the sun in finding traces of destroyed earthworks and buildings'. *Proc Dorset Natural History and Antiquarian Field Club* **XVIII**, 169–73

Mullins, G 2007 *Dublin Nazi No. 1: The life of Adolf Mahr*. Dublin: Liberties Press

Murray, L 1999 *A Zest for Life: The story of Alexander Keiller*. Wootton Bassett: Morven Books

Myerscough-Walker, R 1939 'The camoufleur and his craft'. *The Builder* **CLVII** no 5043, 29 Sep 1939, 489–90

Negretti, H 1863 'Photographic balloon trip'. *The Standard*, 1 Jun 1863, **2**

Nesbit, R C 1997 *Eyes of the RAF: A history of photo-reconnaissance*. Godalming: Bramley Books

Newark, T 2007 *Camouflage*. London: Thames & Hudson

Newhall, B 1969 *Airborne Camera: The world from the air and outer space*. London: The Focal Press

Newsome, S and Hegarty, C 2007 *Suffolk's Defended Shore: Coastal fortifications from the air*. Swindon: English Heritage

Nichol, I (Butler, V) 1906 'Ballooning for ladies'. *The World*, 17 Jul 1906, Aero Club supplement

Palmer, R 1984 *Danebury: An Iron Age hillfort in Hampshire. An aerial photographic interpretation of its environs* (Royal Comm Hist Monuments Engl Suppl Ser 6). London: RCHME

Palmer, R 1994 'AARG Conversation No. 1: James Pickering and Rog Palmer'. *AARGnews* **9**, Sep 1994, 25–33

Palmer, R 2011 'Cropmarks'. *AARGnews* **42**, Mar 2011, 37–8

Paris, M 1992 *Winged Warfare. The literature and theory of aerial warfare in Britain, 1859–1917*. Manchester: Manchester University Press

Parker Pearson, M *et al* 2007 'The age of Stonehenge'. *Antiquity* **81** no 313, Sep 2007, 617–39

Patent Office 1861 *Patents for Inventions: Abridgments of specifications relating to photography*. London: HMSO

Phillips, C W 1959 'Archaeology and the Ordnance Survey'. *Antiquity* **33** no 131, Sep 1959, 195–204

Phillips, C W (ed) 1970 *The Fenland in Roman Times* (RGS Research Series No 5). London: Royal Geographical Society

Phillips, C W 1980 *Archaeology and the Ordnance Survey*. London: Council for British Archaeology

Phillips, C W 1987 *My Life in Archaeology*. Gloucester: Alan Sutton

The Photo-Miniature: A magazine of photographic information **V** no 52, Jul 1903

Pickering, J 1983 'A survey of current air reconnaissance: The achievement, the failure', *in* Maxwell, G (ed) 1983 *The Impact of Aerial Reconnaissance on Archaeology* (CBA Res Rep 49). London: CBA, 1–4

Piggott, S 1983 'Archaeological retrospect 5'. *Antiquity* **57** no 219, Mar 1983, 28–37

Piggott, S 1985 *William Stukeley. An eighteenth-century antiquary*, rev edn. London: Thames & Hudson

Piper, J 1937 'Prehistory from the air'. *Axis: A quarterly review of contemporary abstract painting and sculpture* **8**, 5–8

Pitts, M 2000 *Hengeworld*. London: Century

Powys-Lybbe, U 1983 *The Eye of Intelligence*. London: William Kimber & Co Ltd

Price, A 2003 *Targeting the Reich: Allied photographic reconnaissance over Europe 1939–1945*. London: Greenhill

Priestley, J B 1940 *Postscripts*. London: William Heinemann Ltd

Priestley, J B 1949 *Delight*. London: William Heinemann

Priestley, J B 1964 *Man and Time*. London: Aldus

Pringle, H 2006 *The Master Plan. Himmler's scholars and the holocaust*. London: Fourth Estate

Raleigh, W 1922 *The War in the Air: Being the story of the part played in the Great War by the Royal Air Force*, Vol 1. Oxford: Clarendon Press

RCAHMS 1999 *Scotland from the Air 1939–49, Vol 1. Catalogue of the Luftwaffe Photographs in the National Monuments Record*. Edinburgh: RCAHMS

RCHME 1960 *A Matter of Time: An archaeological survey of the river gravels of England*. London: HMSO

RCHME 1979 *Stonehenge and its Environs: Monuments and land use*. Edinburgh: Edinburgh University Press

Reese, P 2006 *The Flying Cowboy: Samuel Cody, Britain's first airman*. Stroud: Tempus

Richards, J C 1990. *The Stonehenge Environs Project* (Engl Heritage Archaeol Rep 16). London: English Heritage

Richards, J C 2007 *Stonehenge. The story so far*. Swindon: English Heritage

Richelson, J T 2002. *The Wizards of Langley. Inside the CIA's Directorate of Science and Technology*. Oxford: Westview

Richmond, I A 1932 'The four Roman Camps at Cawthorn, in the North Riding of Yorkshire'. *Archaeol J* **89**, 17–78

Richmond, I A 1943 'Recent discoveries in Roman Britain from the air and in the field'. *J Roman Stud* **33**, 45–54

Riley, D N 1942 'Crop-marks in the Upper Thames Valley seen from the air during 1942'. *Oxoniensia* **VII**, 111–14

Riley, D N 1943–4 'Archaeology from the air in the Upper Thames Valley'. *Oxoniensia* **VIII–IX**, 64–101

Riley, D N 1945 'Aerial reconnaissance of the Fen basin'. *Antiquity* **19** no 75, Sep 1945, 145–53

Riley, D N 1946 'The technique of air-archaeology'. *Archaeol J* **101**, 1–16

Riley, D N 1946–7 'A late Bronze Age and Iron Age site on Standlake Downs, Oxon'. *Oxoniensia* **XI–XII**, 27–43

Riley, D N 1976 'Air reconnaissance in central and southern Yorkshire in 1976'. *Yorkshire Archaeol J* **49**, 19–43

Riley, D N 1980 *Early Landscapes from the Air: Studies of crop marks in South Yorkshire and North Nottinghamshire*. Sheffield: University of Sheffield

Riley, D N 1982 *Aerial Archaeology in Britain* (Shire Archaeology no 22). Princes Risborough: Shire

Riley, D N 1987 *Air Photography and Archaeology*. London: Duckworth

Riley, D N 1990 'Wartime reminiscences'. *AARGnews* **1**, Sep 1990, 35–41

Riley, D N 1996 *Aerial Archaeology in Britain*, 2 edn (revised by R Bewley). Princes Risborough: Shire

Rolt, L T C 1985 *The Aeronauts. A history of ballooning 1783–1903*. Gloucester: Alan Sutton

St Joseph, J K 1945 'Air photography and archaeology'. *Geogr J* **105**, 47–61

Saint-Exupéry, A de 1995 *Flight to Arras* (trans and with an introduction by W Rees). London: Penguin

Samuelson, J (ed) 1863 *The Popular Science Review* **2**, 576–7

Saunders, N J 2007 *Killing Time. Archaeology and the First World War*. Stroud: Sutton Publishing

Seymour, W A (ed) 1980 *A History of the Ordnance Survey*. Folkestone: Dawson

Smallwood, H R 1996 *Spitfire in Blue*. London: Osprey Aerospace

Smith, P J 2005 'From "small, dark and alive" to "cripplingly shy": Dorothy Garrod as the first woman Professor at Cambridge', www.arch.cam.ac.uk/~pjs1011/Pams.html, accessed 25 January 2006

Spooner, T 2003 *Warburton's War: The life of maverick ace Adrian Warburton*, 2 edn. Manchester: Goodall

Stadler, H 2011a *Eduard Spelterini and the Spectacle of Images: The colored slides of the pioneer balloonist*. Chicago: University of Chicago Press

Stadler, H 2011b *Eduard Spelterini : Photographs of a pioneer balloonist*. Chicago: University of Chicago Press

Staerck, C 1998 *Allied Photo Reconnaissance of World War Two*. San Diego: Thunder Bay Press

Stanley, R M 1998 *To Fool a Glass Eye*. Shrewsbury: Air Life

Steer, K 1947 'Archaeology and the National Air-Photograph Survey'. *Antiquity* **21** no 81, Mar 1947, 50–3

Stein, G 1984 *Picasso*. New York: Dover Publications (originally published 1938)

Steinmeyer, J 2005 *Hiding the Elephant: How magicians invented the impossible*. London: Arrow Books

Stepney, E 2005 'The effect of aerial photography as a structured perception upon terrestrial archaeological survey'. Published online at http://humanitieslab.stanford.edu/29/330, last accessed 8 Feb 2011

Stichelbaut, B, Bourgeois, J, Saunders, N and Chielens, P (eds) 2009 *Images of Conflict: Military aerial photography and archaeology*. Newcastle upon Tyne: Cambridge Scholars

Stoertz, C 1997 *Ancient Landscapes of the Yorkshire Wolds. Aerial photographic transcription and analysis*. Swindon: RCHME

Stone, J 2002 *Cawthorn Camps, North Yorkshire: Air photographic evaluation (Phase II)*, (English Heritage Aerial Survey Report Series AER/8/2002). Swindon: English Heritage

Stone, J 2003 'Cawthorn Camps, North Yorkshire – A photogrammetric approach'. *Archaeol Prospection* **10**, 153–7

Stone, J and Clowes, M 2004 'Photogrammetric recording of the Roman earthworks "Cawthorn Camps", North Yorkshire'. *The Photogrammetric Record* **19**, 94–110

Stone, S 1857 'Account of certain (supposed) British and Saxon remains, recently discovered at Standlake, in the County of Oxford'. *Proc Soc Antiq London* **4**, 92–100

Stout, A 2008 *Creating Prehistory: Druids, ley hunters and archaeologists in pre-war Britain*. London: Wiley Blackwell

Strong, R 2000 *The Artist and the Garden*. London: Yale University Press

Stukeley, W 1740 *Stonehenge, A Temple Restor'd to the British Druids*. London: Printed for W Innys and R Manby

Thorpe, I (ed) 1966 *Geoffrey of Monmouth: History of the Kings of Britain*. Harmondsworth: Penguin

Ucko, P J, Hunter, M, Clark, A J and David, A 1991 *Avebury Reconsidered from the 1660s to the 1990s*. London: Unwin Hyman

Virilio, P 1994 *The Vision Machine*. Bloomington: Indiana University Press

Walker, P B 1971 *Early Aviation at Farnborough. The history of the Royal Aircraft Establishment Vol 1: Balloons, kites and airships*. London: MacDonald

Walker, P B 1974 *Early Aviation at Farnborough. The history of the Royal Aircraft Establishment Vol 2: The first aeroplanes*. London: MacDonald

Wandinger, U 2005. 'Introduction to lidar', *in* Weitkamp, C (ed) *Lidar: Range-resolved optical remote sensing of the atmosphere*. New York: Springer, 1–18

Ward, Captain B R (School of Ballooning, Aldershot) 1896 *Manual of Military Ballooning* (facsim edn Rediscovery Books 2006)

War Office 1923 *Report of the Air Survey Committee No 1*. London: HMSO

War Office 1935 *Report of the Air Survey Committee No 2*. London: HMSO

Watkis, N C 1999 *The Western Front from the Air*. Stroud: Sutton Publishing

Watson, C M 1902 'Military ballooning in the British Army'. *Professional Papers of the Royal Engineers* **28**, 39–59

Watson, J 2003 *Sidney Cotton: The last plane out of Berlin*. Sydney: Hodder

Way, A 1849 'Memoir on Roman remains and villas discovered at Ickleton and Chesterford, in the course of recent excavations by the Hon Richard C Neville, FSA'. *Archaeol J* 6, 14–26

Webster, G and Hobley, B 1964 'Aerial reconnaissance over the Warwickshire Avon'. *Archaeol J* **121**, 1–22

Wells, D A (ed) 1860 *Annual of Scientific Discovery: or, year-book of facts in science and art for 1860*. Boston: Gould & Lincoln

Whittington, B 1893 'The war-balloon at Aldershot. A visit to the School of Ballooning'. *The Graphic*, 2 Sep 1893, 299

Whittle, A 1997 S*acred Mound, Holy Rings: Silbury Hill and the West Kennet palisade enclosures: A later Neolithic complex in north Wiltshire* (Oxbow Monograph 74). Oxford: Oxbow Books

Whitworth Porter, Major-General 1888 *History of the Corps of Royal Engineers*. Chatham: Royal Engineers

Wickstead, H and Barber, M forthcoming 'A spectacular history of survey by flying machine'. *Cambridge Archaeol J* **22** no 1

Williams-Freeman, J P 1915 *An Introduction to Field Archaeology as Illustrated by Hampshire*. London: MacMillan & Co Ltd

Wilson, D R 1996 'Ring ditches and fungus rings in the 17th century'. *AARGnews* **13**, Sep 1996, 42–9

Wilson, D R 2000 *Air Photo Interpretation for Archaeologists*, 2 edn. Stroud: Tempus

Winterbotham, F W 1969 *Secret and Personal*. London: William Kimber

Winterbotham, H St J L 1919a 'British survey on the Western Front'. *Geogr J* **53**, 253–71

Winterbotham, H St J L 1919b 'Geographical work with the Army in France'. *Geogr J* **54**, 12–23

Index

Page references in **bold** refer to illustrations and their captions.